INSPIRATIONAL
GARDENS

Editor: Donna Wood
Designed by Creative Plus Publishing Ltd; www.creative-plus.co.uk
Copy editor: Helen Ridge
Proof reader: Fiona Wild
Cartography provided by the Mapping Services Department of AA Publishing.
Mountain High Maps® Copyright© 1993 Digital Wisdom, Inc.
Picture researcher: Mel Watson
Image retouching and internal repro: Michael Moody
Production: Lyn Kirby

Produced by AA Publishing
© Copyright Automobile Association Developments
Limited 2008

ISBN: 978-0-7495-5865-9 and 978-0-7495-5887-1

Published by AA Publishing (a trading name of Automobile Association Developments Limited, whose registered office is
Fanum House, Basing View, Basingstoke RG21 4EA; registered number 1878835).

AO3644

Colour separation by MRM Graphics Limited, Winslow
Printed in China by C & C Offset Printing Co. Ltd

The AA's website address is www.theAA.com/travel

INSPIRATIONAL
GARDENS

SPECTACULAR DESIGNS *and* PLANTING *from around the world*

PAMELA WESTLAND

CONTENTS

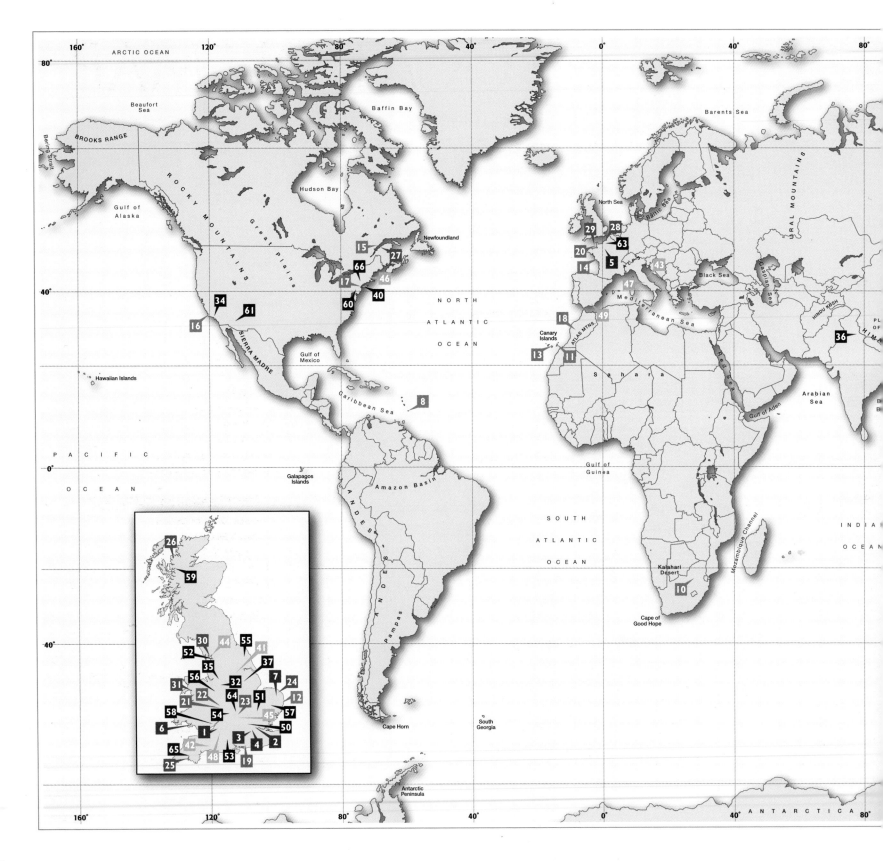

LOCATION MAP

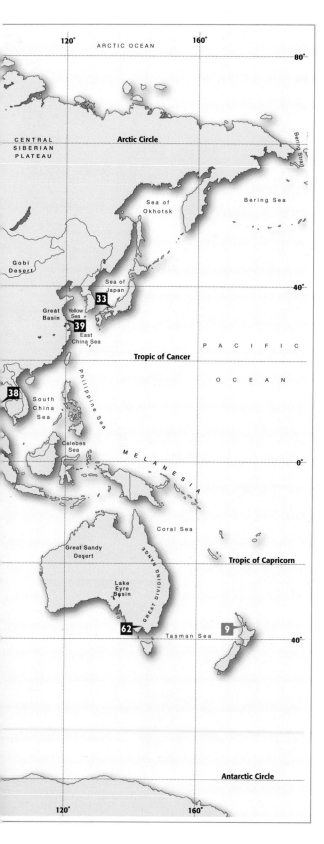

KEY

TOWN GARDENS

1 Beechwell House
2 Helter Skelter Garden
3 Little Lodge Garden
4 The Raworth Garden
5 La Maison Picassiette
6 Ridler's Garden
7 The Exotic Garden

EXOTIC GARDENS

8 Andromeda Botanic Garden
9 Ayrlies
10 Brenthurst Gardens
11 César Manrique Foundation
12 Henstead Exotic Garden
13 Jardin Canario
14 Le Potager Extraordinaire
15 Les Quatre Vents
16 Lotusland
17 Wave Hill
18 Le Jardin Majorelle

COTTAGE GARDENS

19 Bayleaf Farmstead
20 Creux Baillot Cottage
21 Eastgrove Cottage Garden
22 Little Larford Cottage
23 Woodchippings

COASTAL GARDENS

24 East Ruston Gardens
25 Ince Castle
26 Inverewe
27 Jardin de Métis
28 Le Bois des Moutiers
29 Mille Fleurs
30 Yewbarrow House
31 Portmeirion

ORIENTAL GARDENS

32 Biddulph Garden
33 Daitokuji
34 Huntington Library
35 Tatton Park Japanese Garden
36 Mogul Gardens of Srinagar
37 Pureland Japanese Gardens
38 Jim Thompson's House
39 Wang Shi Yuan Garden
40 Humes Japanese Stroll Garden

CLASSICAL GARDENS

41 Brodsworth Hall
42 Forde Abbey Gardens
43 Giardino Buonaccorsi
44 Levens Hall
45 Rousham House
46 The Mount
47 Villa d'Este
48 Peto Garden, Iford Manor
49 Alhambra and Generalife

ENGLISH-STYLE GARDENS

50 Chenies Manor Garden
51 Docwra's Manor
52 Gresgarth Hall
53 Heale Garden
54 Hidcote Manor Garden
55 Scampston Hall
56 Wollerton Old Hall
57 Wyken Hall
58 Veddw Garden

LANDSCAPE GARDENS

59 Attadale
60 Chanticleer
61 Desert Botanical Garden
62 Katandra Gardens
63 Les Jardins Agapanthe
64 Pettifers
65 The Garden House
66 Innisfree

FOREWORD

BY CLIVE NICHOLS

For the past 15 years I have worked as a professional flower and garden photographer, supplying countless magazines, books and calendars with horticultural photographs. During that time I have amassed over 40,000 images from all over the world and I have been lucky enough to visit and photograph some of the world's finest gardens – many of which are featured in this beautiful new book. Because I am a professional photographer, I have been able to access many of these earthly paradises 'out of hours', when the public was not present – often at dawn and dusk, when the low angle of the sunlight is more flattering to garden subjects.

Although several of the gardens featured in the book are world-famous – the Alhambra in Spain, Wave Hill in the US and Le Jardin Majorelle in Morocco, for example – there are many more featured that are not. Little-known gems such as Tony Heywood's ultramodern Helter Skelter Garden in London, Les Jardins Agapanthe in Normandy, France, and the idyllic woodland garden at Woodchippings in Northamptonshire are examples of gardens that deserve to be better known than they are currently. This book gives these special places a status that they richly deserve.

As a 20 year-old I would read and dream about visiting some of the world's best gardens – places like Brenthurst Gardens in South Africa and Villa d'Este in Italy – gardens that I would drool over in books and magazines but that I have still not managed to see or photograph, even today!

I hope that you can use the delightful images in this book alongside Pamela Westland's wonderfully evocative text to dream about gardens that you might one day have the chance to visit and enjoy.

Clive Nichols

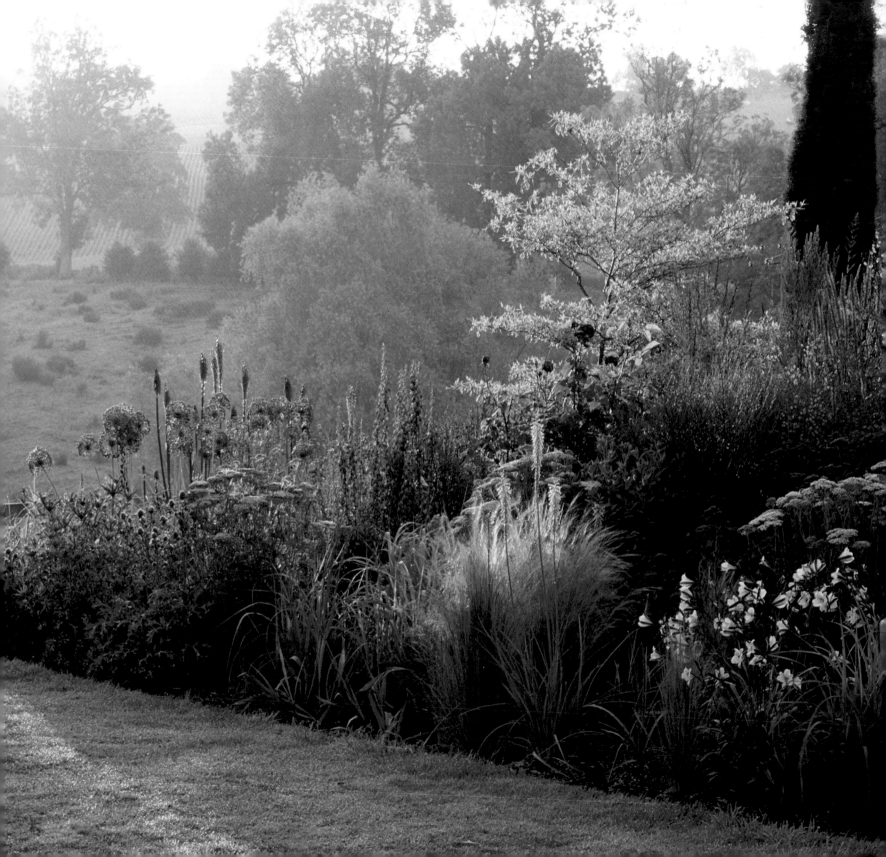

INTRODUCTION

Great gardens; glorious gardens; inspirational gardens. Some that are known, admired and visited by thousands of enthusiasts every year and others that, thrillingly, are yet to be discovered. I hope that this book will help you to renew your acquaintance with some of your own favourites – I wish we had space to include them all – and encourage you to visit others for the first time.

Every one of the gardens is a rich source of inspiration, and many are a source of encouragement and even courage. I have found it immensely exciting to discover the dedication and determination of some owners to overcome the disadvantage of inhospitable terrain or an unfriendly climate. You will find many examples where gardeners who refuse to take 'can't' for an answer have created a more favourable microclimate, defeated notoriously punishing gales, salt spray or relentless drought and created gardens that have an other-worldly quality. The message is that if you yearn to create an exotic haven on a windswept hillside or in the midst of an urban sprawl, go for it! There is plenty of practical help in these pages.

CLIMATE CHANGE

The awareness of climate change and its continuing effects on the environment has caused many gardeners to rethink what is appropriate and sustainable to grow in their own backyards. Garden design, even classical styles, has always evolved over time, largely through fashion and personal taste, but now there are greater forces to consider. Many garden owners are replanting existing borders with more drought-tolerant plants, and even creating arid and xerophytic areas for plants that need next to no water. This is an exciting challenge that many of us might care to take up.

It is a far cry, now, from the times when the wealth and power of the great Mogul and Moorish rulers could be reflected by the acres of water that enhanced their gardens. As water becomes an ever more precious commodity in many parts of the world, it is the judicious and responsible reuse of minimal amounts, be it in cascades or rills, pools or fountains, that has that therapeutic, satisfying, sought-after effect.

ILLUSION OF SPACE

The scale of our featured gardens varies enormously. Some have been created on large estates or in parkland while others have been planted in confined, even cramped areas. Paradoxically, it seems to me, gardeners on whatever scale aim to meet the same

challenge: to keep the viewer guessing ('What's around the next corner?') and never allow the whole garden, or even a large part of it, to be seen at a glance. So it is that in even the largest gardens there are autonomous outside 'rooms' concealed behind high hedges that, taken individually, could be recreated in almost any garden anywhere. It is in these compartments, often, that you will find alluring colour schemes and plant combinations, the exciting juxtaposition of contrasting and competing foliage shapes and textures, and, sometimes, expressions of uninhibited and exuberant individuality. The more a garden is sub-divided, the more opportunity there is to experiment on a small scale with varied and even daring themes.

Where space is limited the designer meets a similar – 'keep them guessing'– challenge. One gardener told us that his intention was to 'create the illusion of taking a very long walk through what is essentially quite a small area'. He achieved this magnificently with twisting, turning paths, high hedges and arches, and, through skilled planting, the management of light and shade. It is a concept that is achievable in an even smaller space.

EVERGREEN STRUCTURES

If there is a constant theme that links many of the gardens in this book, it is the varied and imaginative use of evergreen and – in the case of the Hidcote Manor Garden – tapestry hedges to form compartments, enhance perspective, frame and 'borrow' views and, on a more practical level, act as windshields; not only evergreen hedges, but topiary structures too. From the magnificent, centuries-old topiary forms at Levens Hall to the geometric, fanciful or verging-on-random shapes deployed in less formal gardens, topiary forms are horticultural statuary. Whether they are grown in rows with almost military precision, are encroached upon – embraced, almost – by rambling plants or upstaged by unrestrained neighbouring planting, these elements seem to me to represent horticultural versatility at its finest.

Just as some gardeners have created oases with the look of far-away places, others have sought to design gardens that are at one with the environment and, running wild on the boundaries, seem to merge with the landscape or seascape beyond. As you will find throughout the book, where the imagination of gardeners is concerned, there are no boundaries.

Pamela Westland

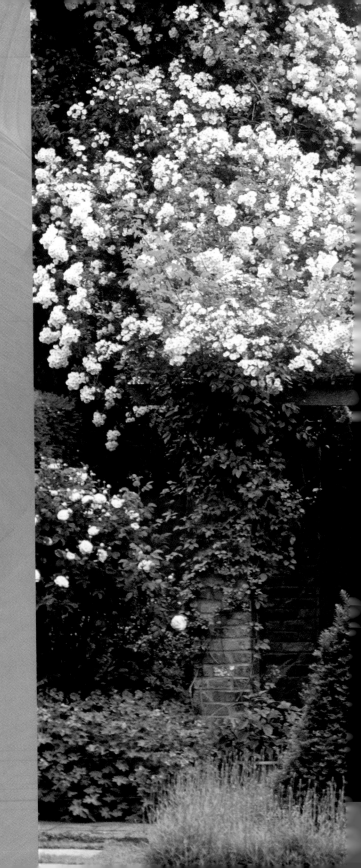

CHAPTER 1

TOWN GARDENS

Limited perhaps by space restrictions and with minimal scenic views, an urban garden can nevertheless be a haven for outdoor dining; creating, variously, the impression of an exotic hideaway or a rural idyll.

 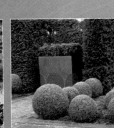

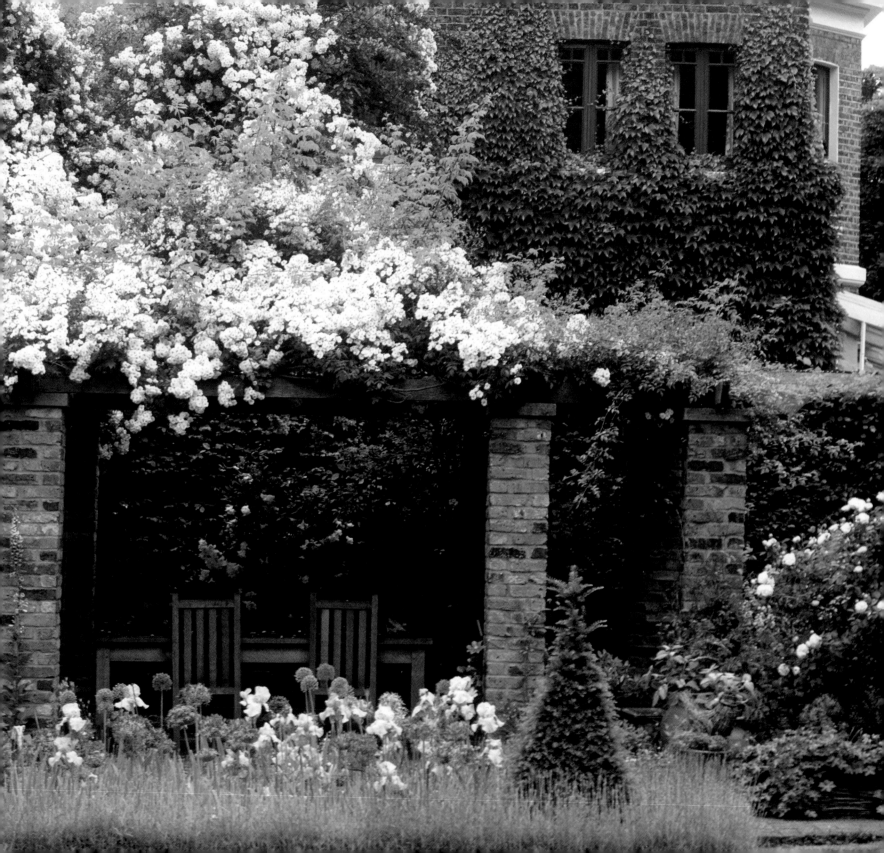

BEECHWELL HOUSE

FROM CHILD-FRIENDLY BACK GARDEN TO LUXURIANT PALM-FILLED HAVEN

A small enclosed garden, Beechwell House has sub-tropical planting and exciting colour and textural contrasts.

This quarter-acre garden behind a town house near Bristol is as much about structure and the ground plan as about the knowledgeable sub-tropical planting. Tim Wilmot developed a taste for architectural plants in the late 1980s and took over part of what had been a child-friendly garden to give the area a horticultural make-over. This involved clearing apple trees and *leylandii* cypress, some roses, too, and minimizing the grassy area – 'making way for monster foliage', as he puts it.

Tim used a variety of hardscaping for short paths that snake and curve and lead always to another prize specimen plant or pleasing group of container-grown succulents. Some paths are stone or gravel – one gravel path has stepping stones of large log slices – and some paths are grass. This is because, Tim says, in some

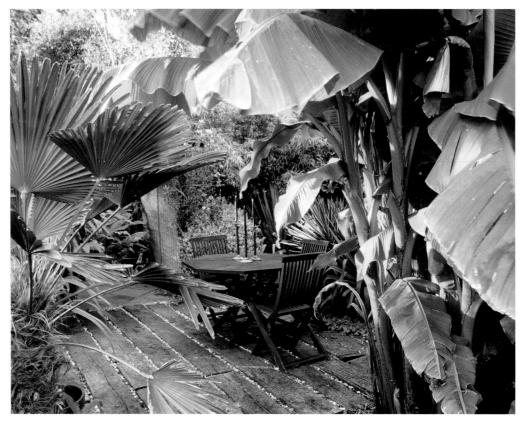

ABOVE **Railway-sleeper seating area**

BELOW **Yatay palm**

WHAT'S THERE:	¼-acre enclosed garden with 16th-century well, sub-tropical plants; koi carp pool
WHERE:	51 Goose Green, Yate, Somerset BS37 5BL
GETTING THERE:	16km (10 miles) NE of Bristol
WHEN TO VISIT:	Open Sun afternoons mid-Jun to end Oct, 1–5pm; open for coach parties at other times by arrangement
CONTACT DETAILS:	01454 318350

situations grass is a kinder contrast to palms and other exotics.

SPLIT-LEVEL GARDEN

In parts, this is a two-level garden. A low wall built of irregular stones edges a raised bed of low-growing succulents and large statement plants, and a raised platform lifts a shady seating area above ground level. Another sitting-out terrace is formed of edge-to-edge railway sleepers, and the sides of a small summerhouse are formed with rattan window blinds, giving it an oriental look.

As a further example of two-level gardening, two large palm-like *Dasylirion* plants, like two widespread fans, are growing one above the other, one in a raised bed and one in a container on the ground below it. Pots of succulents arranged in the gravel complete a visually interesting group.

VISUAL FEAST

Skilful contrasts of plant size and form, colour and texture are what make this garden such a visual feast. One of the highlights, a yatay palm (*Butia yatay*), like a giant, frondy pineapple, is set in a circle of pebbles surrounded by terracotta phormium, the flat, palest pink flower heads of ice plant (*Sedum spectabile*) and small succulent rosettes, while another, set in gravel, is surrounded by a ring of low-growing, yellow- and white-flowering succulents. Flowers are not high on Tim's wish list but he grows tubs of ginger lily (*Hedychium gardnerianum*) especially for their scent in September.

In an unusual juxtaposition of plant form and foliage shape, there is a sphere of neatly clipped box beside the huge fan-like leaves of Chusan, or windmill, palm (*Trachycarpus fortunei*).

With more than a dozen healthy palm trees in the garden, Tim insists that they are easy to grow, with some such as the fat-trunked Chilean wine palm (*Jubaea chilensis*) and the jelly palm (*Butia capitata*) being fully frost-hardy. Others, including the blue-leaved European fan palm (*Chaemaerops humilis* var. *argentea*) from Morocco and the spiny *Trithrinax acanthocoma*, are more tender. Keeping a careful watch on the weather forecast, Tim covers them with fleece when the temperature is likely to drop below -4°C (25°F).

COLOUR SCREEN

A large Japanese banana (*Musa basjoo*), eye-catching in any situation, is especially so here, planted in front of a bright pink wall that contrasts thrillingly with every stage of the plant's development, through pale yellow flowers in summer to green fruits in autumn. In other equally effective colour pairings, there are agaves and phormiums in bright blue glazed pots, exactly the same shade as some of the garden furniture.

WATER FEATURES

Perhaps a jungle-style garden would not be complete without water and, apart from the 12m (40ft) deep 16th-century well, there is both a wildlife pond and a koi carp pool, which contribute delightful sound and movement.

ABOVE **The pink wall heightens the drama**

FOOTNOTE

Almost two decades ago, Tim Wilmot envisaged how his small back garden could look – almost exactly as it does now.

HELTER SKELTER GARDEN

A VIVID CONCEPT OF THE GROWTH OF PLANTS AND IDEAS, AND OF URBAN RENEWAL

A tiny urban garden full of allegories, Helter Skelter gives pause for thought at a busy London street junction.

On a room-sized patch of land on one of Central London's busiest road junctions, there is an arresting garden that perhaps redefines the term. There are few plants, no footpaths and no seating area, for this is not a garden to be walked in, or even entered. You stand on the footpath, look over the fence, and marvel at the ingenuity of a design that combines a variety of inert materials with clipped yew and hummocky grasses in such a thought-provoking way. The garden is both art and architecture, and is difficult to take in at a glance. You are not meant to do that, so allow a little time to stand and stare!

The entire landscape – in fact, an area of only approximately 10m (33ft) by 8m (26ft) – appears to tip and tumble towards a molten glass pool. Rectangular and domed topiaries of yew are positioned at

ABOVE **Slate hurtles down in a blue glass tide**

WHAT'S THERE:	Tiny half garden, half sculpture, at busy road junction
WHERE:	Junction of Sussex Gardens and Edgware Road, near Marble Arch, London, W2
GETTING THERE:	Underground to Edgware Road, Paddington or Marble Arch station; or bus along Edgware Road
WHEN TO VISIT:	The garden can be viewed from the pavement
CONTACT DETAILS:	020 7402 6884; www.conceptualgardens.co.uk

RIGHT **Reflections in the marine steel curve**

acute angles, and the spiralling hedges, concrete forms and iron fences seem to disappear into the ground.

IN A SPIN

The surrounding walls, positioned at angles of 45 degrees, become climbing screens for vegetation that creates a living abstract. Thrusting sheets of slate like giant sails appear to traverse up the side of another wall, and the impression is that the whole site has been spun, creating a vortex, centred on a highly polished marine steel curve.

REFLECTIONS

As you move along, the reflections in the steel curve present a completely different scene, scarcely recognizable as the one before you, sometimes resembling many-coloured marbling, sometimes a modern abstract, but always conveying movement, as in the busy street outside.

ALLEGORIES

Large pieces of slate like leaning monoliths thrust out of blue-green grasses, and others like fins or sails appear to be carried down in a hurtling tide of blue glass. A volcanic 'mountain' of pumice stone and red glass erupts in one corner, and a river bed of blue-grey paddle stones collides with the back wall and appears to splash upwards. A central pool of bubbling water reflected in a curved mirror results in an image of a river receding into the landscape.

The garden is full of allegories of natural landscapes and architectural imagery and, like abstract art, is subject to many interpretations. It is a garden that creates new horizons within its own limited space.

THE BRIEF

The Helter Skelter site is adjacent to a residential development known as The Water Gardens and owned by the Church Commissioners. Tony Heywood of Conceptual Gardens was asked to come up with a plan for the site that would both reflect and be in sympathy with the urban environment. He describes the garden as having 'structures that rise and roll and tumble, toss and turn. One element is absorbed, another rises to replace it (urban renewal). It represents a cycle of growth not just of plants but also of ideas.'

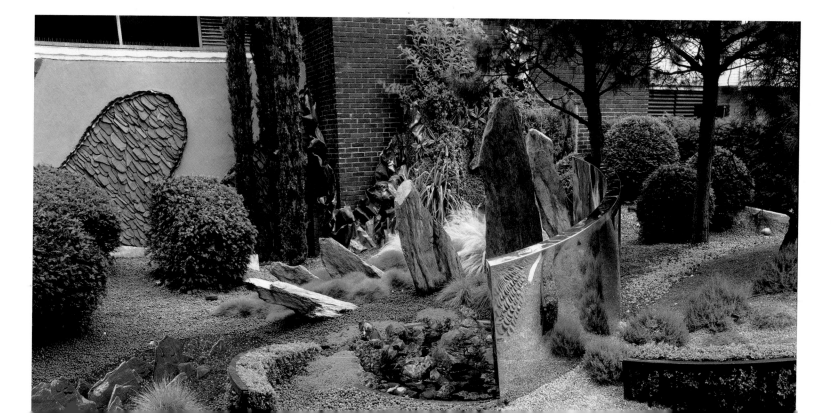

LITTLE LODGE GARDEN

A CHARMING GARDEN COMBINING ELEGANCE, TRANQUILLITY AND PRODUCTIVITY

From the very first glance, this pretty partly walled town garden has an inspiring blend of traditional and innovative features.

The approach to Little Lodge is intriguing. It is almost as if the house is the background scenery for a sumptuous stage set. Season by season, it is thickly curtained in the pale green leaves of wisteria and then with cascades of the mauve flowers. The narrow border along the front of the house – the stage – is defined with a low box hedge, grown by the owners from cuttings. But this is no ordinary hedge. It has dips and rises, like an exquisitely draped garland, and is unusually attractive. Set behind the hedge are the undisputed stars of the show, standard bay trees and pots of clipped box topiaries, each decorated with a perching bird.

Opposite the house, where once there was an air-raid shelter and then a rock garden, there is now a wildlife pond

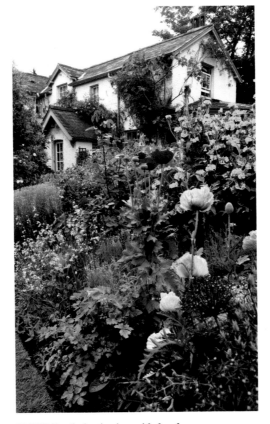

ABOVE **Mixed planting in a wide border**

packed with moisture-loving plants and adding an extra dimension to this third-of-an-acre garden.

Julia and Peter Hickman bought the property 40 years ago, and he insists that the garden 'really did just happen'. His plan has always been to concentrate on soft colours and on plants that do well during the summer where they are in southern England. 'Nothing too garish,' he said with feeling. Gradually over time, areas of lawn have given way to richly planted herbaceous borders, and features have been added – a secret garden, pergolas and arches, a productive vegetable garden and a great many containerized plants 'to fill the terrace and paths'.

SECRET GARDEN

An archway in a yew hedge (formed over a hazel twig support) leads to a secret garden, at its best in early summer. A stone cherub birdbath in a circular bed rises

WHAT'S THERE:	Partly walled informal flower garden, small secret garden, roses, topiary, containers, kitchen garden
WHERE:	Watts Road, Thames Ditton, Surrey KT7 0BX
GETTING THERE:	3.2km (2 miles) SW of Kingston
WHEN TO VISIT:	Open for charities. Visitors welcome by appointment
CONTACT DETAILS:	020 8339 0931

RIGHT **The shaded water feature**

from a thick carpet of lily-of-the-valley and, creating a luxuriantly verdant group, there are hellebores and Solomon's seal (*Polygonatum*). Tall purple and white spires of goat's rue (*Galega* 'Her Majesty') look stately beside a large, hummocky bush of white tree poppy.

A thick, enveloping canopy of yellowy-green ivy (*Hedera algeriensis* 'Marginomaculata') covers an arch around a shady water feature where ferns flourish. Completing the cameo, there are the delicate pansy flowers of *Viola* x *wittrockiana* 'Silver Princess', lime-green nicotiana and grouped terracotta pots of rock, alpine and succulent plants.

POTTED SUCCULENTS

More and more areas of the brick terrace at the back of the house are covered as containers of mainly succulents are added. Stone shapes cut from lumps of solid rock from the Isle of Purbeck and made into garden sinks, together with terracotta pots and dishes, compose an eclectic group. They display the bright green glossy rosettes of *Aeonium arboreum* 'Zwartkop', the dark green, red-tinted rosettes of *Sempervivum grandiflorum*, the aubergine-coloured leaves of *S. tectorum*, and bishops' weed (*Aegopodium podagraria* 'Variegatum'). Dainty pink viola flowers dangling over the group provide a charming textural contrast. Other planters close to the house display dwarf acers and dwarf conifers, and large standard hollies that the Hickmans grew and shaped themselves.

PEACEFUL ATMOSPHERE

Borders in an informal, partly walled garden and edging a lawn are richly stocked with shrubs and herbaceous plants, creating the tranquil atmosphere that is Julia's stated aim. They also capture the essence of summer. In one, the plant associations – almost all in Peter's declared preference for subtle shades – include field poppies (*Papaver rhoeas*) and the bushy tree poppy (*Romneya coulteri*), lavishly spattered

ABOVE The giant pear sculpture

with fragrant white flowers, mingling with tall white spires of *Verbascum chaixii,* and dusky pink valerian (*Centranthus ruber*).

Elsewhere, there is an inspired partnership as tall, elegant, yellowy-green globes of angelica provide background height and interest against clusters of mauve and white *Campanula persicifolia,* white *Salvia officinalis* and everlasting pea (*Lathyrus grandiflorus*), which so delightfully twines around anything and everything in its path. Peter says he

does his best to 'casual train' it and does sometimes succeed. The cheerful welcome he gives to self-sown annuals does mean that plants 'pop up all over the place' in a charmingly naturalistic way.

SCENT OF ROSES

In a garden that especially celebrates summer, roses have an important role to play. Long thick ribbons of the 1917 species rambler *Rosa mulliganii* (formerly *R. longicuspis*) eventually overcame an old

apple tree and now entwine a pear tree that Peter grew from a cutting. The white flowers have an unusual banana-like scent. The hybrid musk roses 'Buff Beauty', with large trusses of fragrant apricot-yellow flowers, and the sweetly scented pink blooms of 'Felicia' blend with other flowers in the borders.

VEGETABLE GARDEN

The productive vegetable garden is planted against a background of the delightful climbing *Rosa* 'Dortmund', its flat, single red flowers having the appearance of wild roses growing in the hedgerows. Neat rows of canes support runner beans, some vegetable beds are bordered with box hedges – not garlanded here – and there are peas, broad beans, brassicas, a profusion of crops too numerous to mention. A jokey feature in this seriously productive part of the garden is a huge terracotta sculpture of a pear; if it were real it would surely be a world prize-winner!

WILD FLOWER MEADOW

Beyond the lawn, there is a small area where Peter is creating a wild flower meadow, although at present the soil is not poor enough. His first step was to sprinkle the seeds of yellow rattle, an annual parasite, over the grass and to place two steamer chairs among the seedheads. It looks the perfect place from which to contemplate this delightful garden.

RIGHT **Garlands in front of the house**

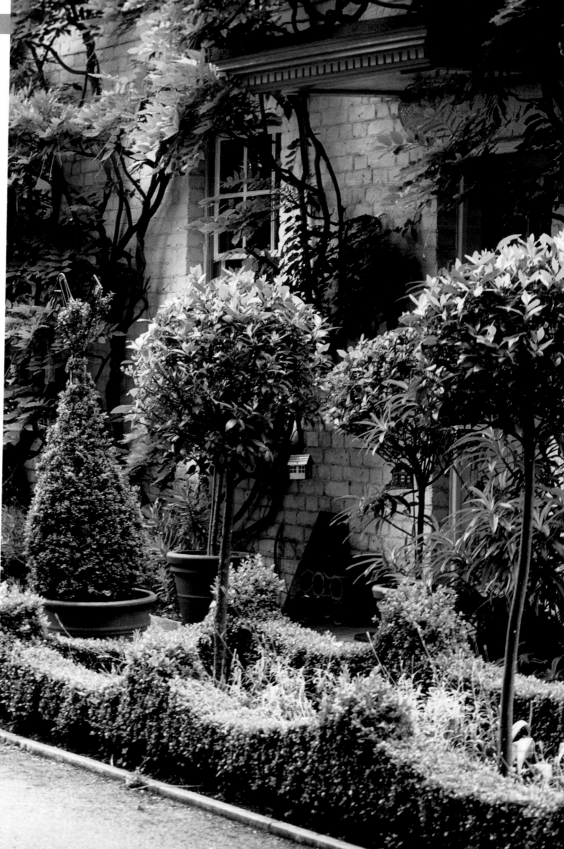

CREATING THE LOOK YOURSELF

* One of the most striking plant associations among many in the Little Lodge garden is the juxtaposition of a deciduous purple-leaved shrub and, almost reaching up to touch the overhanging foliage, pink and maroon poppies (see above).

* The shrub is Eastern redbud (*Cercis canadensis* 'Forest Pansy'), which can have a height and spread of 10m (30ft). In spring, it has pale pink, pea-like flowers, which are followed by the spectacular show of heart-shaped, reddish-purple leaves.

* Peter and Julia have partnered this showy shrub with a fast-growing annual, the opium poppy (*Papaver somniferum*), which has erect stems up to 75cm (30in) long. The flowers, which are usually single but there are double forms, can be red, pink, purple or white. Here, so perfectly complementing the richness of the leaves, they are pink splashed with maroon.

THE RAWORTH GARDEN

A PROFUSION OF SOFT SHADES AND GENTLE SHAPES CREATES A ROMANTIC AURA

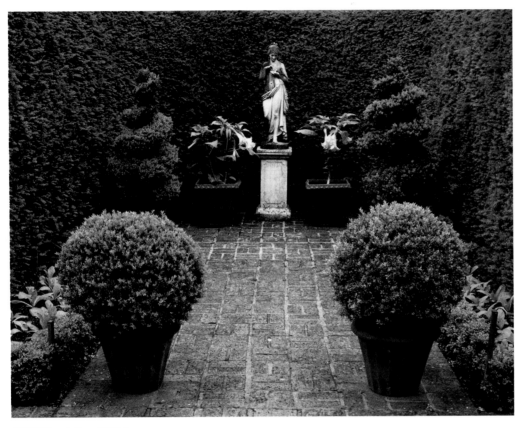

ABOVE **The statue of Thisbe**

Pastel colours and topiary shapes come together in perfect harmony in this pretty garden close to London.

Sweetly scented old roses; an intimate knot garden; elegant statuary; delightful, full-to-bursting herbaceous borders, and an ingenious bog garden – Jenny and Richard Raworth's garden encapsulates the traditional charm and romance of an English country garden, on a half-acre site south of the River Thames.

When the Raworths moved there 35 years ago, the garden was run down and overgrown, which necessitated a completely fresh start. At the time, Jenny was working for London florist Malcolm Hillier, who designed the initial layout, and the garden has been evolving ever since. The overall impression is of a quintessentially English scene, with drifts of pastel pinks, blues and mauves, very little pale yellow and, Jenny insists, definitely no orange. It is beautiful.

WHAT'S THERE:	Unusual perennials, rare plants, old English roses, sunken knot and bog gardens, conservatory
WHERE:	7 St George's Road, St Margaret's, Twickenham, Middlesex TW1 1QS
GETTING THERE:	Just off A316, between Twickenham Bridge and St Margaret's roundabout
WHEN TO VISIT:	Open for National Gardens Scheme charity. Other times by appointment, groups of 10 or more
CONTACT DETAILS:	020 8892 3713; www.raworthgarden.com

The garden is divided into distinct areas by protective yew hedging, which also ensures privacy. The way the buildings – the house and the pergola – play host to prolific climbing plants means that they are absorbed into the whole garden scheme. In May, the house is garlanded with pale mauve wisteria, and a month later, the pergola is almost lost to view in a cloud of dainty white 'Rambling Rector' rose. In front of the pergola, there is a low lavender hedge planted with taller *Allium cristophii* and *Iris* 'Jane Philips'.

SYMPHONY IN GREEN

The one formal feature in this luxuriant scheme is a symphony in greens and cream – cool, sophisticated and intriguing. A small knot garden designed by Richard Raworth and their younger daughter, Kate, actually has knots! Four square parterres set in gravel paths and composed of *Buxus sempervirens* frame intricate, almost Celtic designs of knots and twists shaped with *B*. 'Elegantissima Variegata' and 'Green Mountain'; each parterre has a clipped globe in the centre. In an adjacent enclosure bordering the knot garden, against a tall hedge of yew (*Taxus baccata*), a statue of Thisbe is flanked on each side by a terracotta pot of *Brugmansia rosea,* its cream, pendulous, trumpet-shaped flowers forming pretty side curtains to the central figure.

Jenny and Richard use box and yew topiary in different sizes and designs in various ways to give height and form, and often to complement the soft, pastel-coloured planting. Without ever

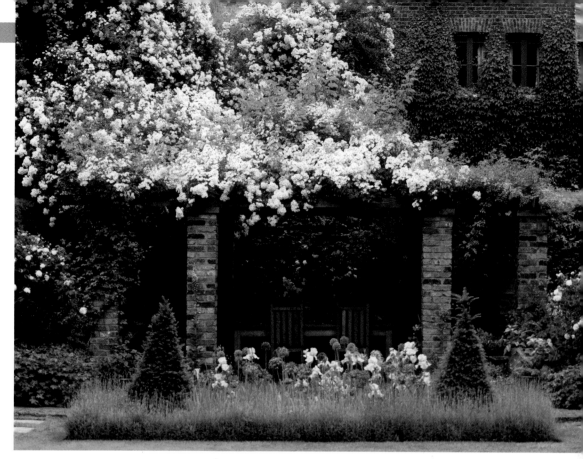

ABOVE **'Rambling Rector' rose garlands the pergola**

dominating, tall yew cones preside over a romantic profusion of flowers in borders that edge a lawn. Two large square stepping stones set into the grass at the edge of one border strike an interesting note of geometric hardstanding before romance takes over!

WATERCOLOUR PASTELS

This border throbs with a delightful confusion of watercolour tints, including rose-red campion (*Silene fimbriata*), red valerian (*Centranthus ruber*), the delicate, violet-blue *Geranium pratense* 'Mrs Kendall Clark', *Papaver* 'Cedric Morris', purple and white alliums, and *Crambe cordifolia*. This is one of Jenny's signature plants, which she

specially enjoys for its misty, cloudy effect and the height it provides – it can grow to 2m (6ft) – with such delicate transparency.

In June, when the tiny white fragrant crambe flowers are at their prettiest, the roses proliferate in all their midsummer glory. The clear pink, bushy shrub *Rosa* 'Pink Grootendorst', the lilac-to-purple *R*. 'Reine des Violettes' and the single crimson *R*. 'Dusky Maiden', among others, make this a border to delight the senses.

Short, wide topiary pyramids edge the path to the front door of the house, the solid, green structures emphasizing the subtlety of the mixed planting behind them – purple and cream irises, purple and white allium, and pale pink roses.

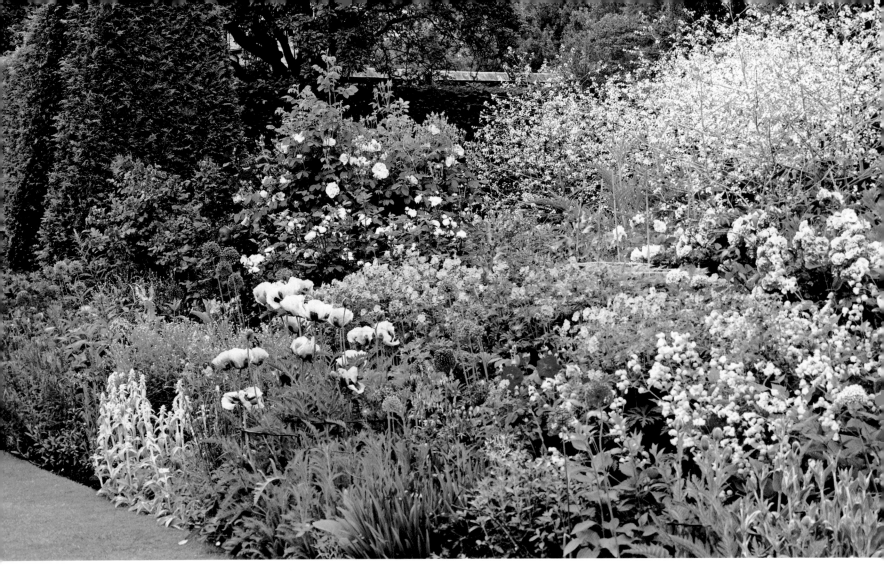

ABOVE **Jenny's signature scheme, soft romantic colours**

CONTAINER GARDENS

In the garden at the front of the house, a sunken garden and a sink garden celebrate the wide variety of succulents, from tiny bright green rosettes to expansive bronze-going-on-purple ones. There is a wide variety of ways to display them, too: in sinks of all shapes, sizes and materials, terracotta dishes, bowls and tall urns. Large paving squares have gaps planted with grasses, their slender, breeze-catching foliage contrasting extremely effectively with the large, close-to-the-ground succulents. An irregularly shaped terracotta dish makes a perfect exhibition-stand for a cluster of pinwheel succulents (*Aeonium haworthii*), with their layered rosettes of red-tinged, blue-green leaves, and a tall urn is crowned with a neat cap of closely planted golden rosettes.

BOG GARDEN

And then there is the bog garden. This small, circular area, edged with bricks, was once a pond but, Jenny says, it is now so much more successful as a bog garden. Pink and purple candelabra primulas flourish beside glossy-leaved hostas in varying shades of green, and a striking, wide, planked boardwalk crosses the contained garden at a sharp angle.

RIGHT **Pyramid perspective to the front door**

Beside it there is a magnificently showy dogwood, which has cream flowers in spring and variegated green and white foliage that becomes fiery red in autumn.

PAINTBOX COLOURS

Step inside the conservatory, originally built by Richard, on the north side of the house, and the flurry of paintbox colours is dazzling. Pelargoniums, fuchsia – including statuesque standard ones in pots – pink-flowered streptocarpus, violas, white roses and ferns create an aura of Edwardian grandeur. In a way, though not in its colour scheme, the conservatory encapsulates the ambience of the garden as a whole – one of luxuriant profusion, planted with an artist's eye for a perfect picture.

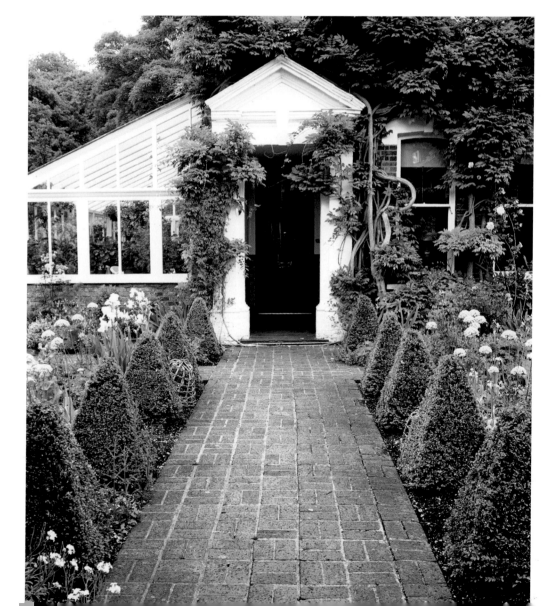

ROSE GALLERY

Visit Jenny and Richard Raworth's garden in June and you will experience the beauty and fragrance of an abundance of old and old-fashioned roses. These are some of their favourites.

The cupped, fully double flowers of *R.* 'Constance Spry', a shrub rose bred in 1960, have 'old-fashioned rose' characteristics and a very strong, myrrh-like scent.

R. 'Céleste' (syn. 'Celestial'), an old rose of unknown origin, is a classic Alba shrub rose. Its exquisite shell-pink, semi-double blooms have a sweet scent.

A hybrid musk shrub rose, *R.* 'Penelope' dates from 1924. It has trusses of sweetly scented, creamy-pink flowers and small coral-pink hips in autumn.

LA MAISON PICASSIETTE

SEEING IS BELIEVING IN THIS INCREDIBLE GARDEN OF 'A THOUSAND PIECES'

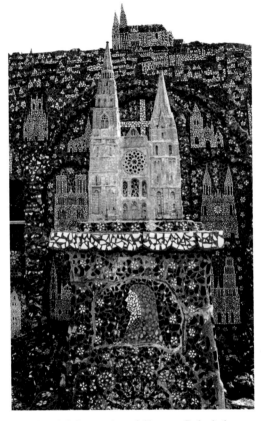

ABOVE **Artist's impression of Chartres Cathedral**

A manual worker turned naive artist has transformed his house and garden into a remarkable work of art.

Plants seem an afterthought, an intrusion even, in this garden that is created entirely from mosaics. The exterior walls of the long, narrow house (the interior and furniture, too), the paving, statues, models and outdoor seating are all covered with fragments of china and glass set in cement. This is neither random work, nor the creation of a professional artist. It is naive art carried to almost incomprehensible lengths.

The entire enterprise is the creation of Raymond Isidore, a manual worker living in the French city of Chartres, who bought the plot of urban land in 1929 and built a conventional house. It is said that one day in 1938, when he was walking home, he picked up a broken green bottle he found on the roadside. And that is when the idea came to him.

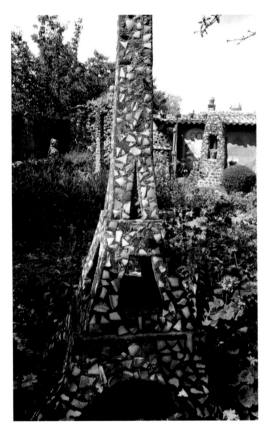

ABOVE **A kaleidoscopic Eiffel Tower**

WHAT'S THERE:	Garden, courtyard, walls, paving, statuettes, outdoor furniture, all covered with mosaics
WHERE:	22 Rue de Repos 28000, Chartres, France
GETTING THERE:	80km (50 miles) SW of Paris
WHEN TO VISIT:	Usually open daily as follows: 10am–12pm, 2–5pm, April, Nov; 10am–12pm, 2–6pm, May to Oct. Closed Tue and Sun am. Closed for some festivals
CONTACT DETAILS:	(0033) 02 37 34 10 78

RIGHT **Intricate detail in a mural**

RELIGIOUS SIGNIFICANCE

The complexity and execution of the designs are astonishing; truly, they have to be seen to be appreciated. Many of them have a religious or ecclesiastical significance, while others depict famous buildings or animals and people. Few of the designs are abstract and all are carefully colour co-ordinated. It is clear that Isidore sorted through what must have been like a mountain of shards to find just the colours he wanted to compose the front of a cathedral or a giraffe's head.

There are two large representations of the Rose Window of Chartres Cathedral, one on a wall behind the mosaic-covered summerhouse and the other set in the mosaic-covered courtyard paving.

A wall panel features a large portrait of the Madonna created from white and floral ceramic pieces set in an eight-point star made up of dark glass. Another mural, of a woman, a shepherd and a dog, which also seems to have biblical connotations, is thought to be the artist's impression of a dream. Behind a wall in the garden and worked almost exclusively in blue and white, there is a small enclosed shrine known as the Spirit's Tomb.

FAMOUS LANDMARKS

A pictorial strip along the top of one wall depicts the Wall of Jerusalem with its unmistakable skyline. Beneath this, the edge-to-edge mosaic artwork depicts the Leaning Tower of Pisa, the Colosseum in Rome and other world-famous landmarks. In a similar vein, another wall features the skyline of the city of Chartres above a

WHAT'S IN A NAME?

There are differing theories about how Isidore's house became known as La Maison Picassiette. The most likely is that it is an adaptation of two French words: 'piquer' meaning to walk off with, and 'assiette', a plate, a reference to the artist's known habit of scavenging for crockery and glass on waste sites.

collage of other cathedrals and places of worship, each one depicted in intricate detail on a background made up of mainly black glass fragments.

ANIMAL PORTRAITS

Around the garden, there are free-standing models of, for example, the Eiffel Tower and of various people, perhaps portraits of the artist's family, and also heavily decorated, if not ergonomically-friendly, furniture. Domestic and wild animals figure frequently in both statues and murals. A black and white owl is hanging on a paling fence, and a large blue and mauve crocodile is skulking on one of the mosaic paths; an elephant has a blue and white body, and a head of kaleidoscopic colouring. In several murals, there are depictions of, for example, a donkey, camel, rabbit and cat.

LABOUR OF LOVE

La Maison Picassiette is also referred to as The House of a Thousand Pieces, but many, many more than that were used in Isidore's creations. It has been estimated that, from 1938 until his death in 1964, he would have worked on the projects for some 29,000 hours and used 15 tons of crockery and glass, most of which he picked up from public waste sites. In 1981, the house and garden were purchased by the city of Chartres authority and, in 1983, Raymond Isidore's creation was classified as a Historic Monument.

RIDLER'S GARDEN

A WELL-ORDERED GARDEN WITH A CLEAR GROUND PLAN AND PRECISE OUTLINES

ABOVE **A bed of hellebores beneath the stencilled panel**

Flowers are scarcely needed in this rhythmic garden of immaculate topiary and intriguingly artistic paths.

This is a precision garden of almost perfect symmetry. The owner ensures this by buying plants in twos, fours and sixes. There is not a leaf out of place, and with so many clipped hedges and innovative topiary shapes, there are a great many leaves. Paths lead directly to sculptures and other decorative or architectural features – it is as if the eye dare not wander.

Tony Ridler, a graphic designer, has created the garden over some 15 years. He has the patience to wait while hedges

WHAT'S THERE:	½-acre garden of immaculate and inspirational topiary
WHERE:	7 St Peter's Terrace, Cockett, Swansea, Glamorganshire, SA2 0FW
GETTING THERE:	Off M4 at junction 47, then towards Swansea West
WHEN TO VISIT:	Open first Sun afternoon May, Jun, Jul; otherwise by appointment. Not suitable for children
CONTACT DETAILS:	01792 588217

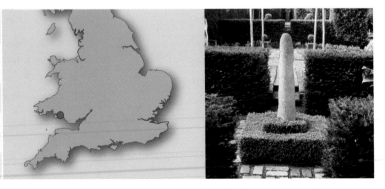

RIGHT **Shell and ball topiaries; beyond, ammonite sculpture**

develop as he intends them to, and to wait seven years until standard hollies are tall and thick enough to shape like lollipops. But he is restless with the effect created in other areas and never reluctant to make changes, so any description of his garden is likely to go rapidly out of date.

PAVING ART

The long narrow plot, which widens at the end, is completely enclosed on all sides. It has a formal framework of paths, many of them works of paving art because of the ingenious way natural and recycled materials have been used together to create patterns and textural contrasts. Dressed stone from a deconsecrated chapel, old paving stones, cobbles, railway sleepers, granite and chunks of wood from the Swansea dockyard set the stage for the real stars of this garden – the topiary.

TOPIARY ROOMS

Clipped yew, box and holly hedges divide the garden into separate rooms and define the gradual changes in the level. Walking from one enclosed area to the next, one wonders how much more can be achieved with topiary; how many more effects and representations can be wrought from the evergreen plants.

One area enclosed by yew walls and divided by a central path has rows of box clipped into helter-skelter shapes that represent shells, a reference to the cockle fishing industry of Penclawdd on the Glamorganshire coast. In further tribute, the evergreen shapes are planted in beds covered with cockle-shells.

WALL-TO-WALL TOPIARY

A narrow path leads through an avenue of mop-headed Portugal laurels (*Prunus lusitanica*) underplanted with edge-to-edge box balls. These hummocky shapes form scalloped lines along their tops and catch the light in intriguing ways, creating uniform patterns of light and shade. Beyond the 'ball park' is another more open enclosure with four lawn segments each planted with an elegant, weeping ash and, beyond them, a dark blue door with faux steps made of clipped box. Standard hollies stand guard on either side like proud sentries.

STONE SCULPTURE

At the head of a gravel path, there is a large red sandstone ammonite sculpture mounted on a tall, narrow block of wood retrieved from Swansea pier. Another path is interrupted by a monolith on a stepped box plinth flanked by red-flowering standard camellias.

OCCASIONAL FLOWERS

There is scant need for the intrusion of flowers in any quantity to disturb the rhythm of this evergreen, geometric garden. One artistic exception is a large horizontal stencilled panel depicting blue, mauve, pink and white hellebores on a matt black wall. A thick ribbon of hellebores is planted beneath it.

Other flowers are occasionally permitted. Tony Ridler plants 500 parrot tulips to flower in spring, and species lilies that will radiate colour and scent in summer. But they are behind a hedge.

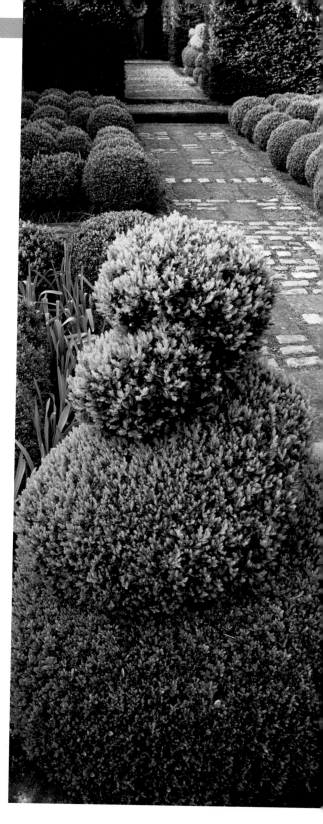

THE EXOTIC GARDEN

A SLOPING SITE ON THE CITY OUTSKIRTS HAS THE LOOK OF FAR-AWAY PLACES

It would be all too easy to lose one's sense of place in this intimate East Anglian city garden, so lushly planted with tropical and sub-tropical species that it seems to be in another climate zone.

Where would you expect to see towering, dark purple Abyssinian bananas (*Ensete* 'Maurelii'), groves of lush tree ferns, a desert garden, bromeliads tenaciously clinging to tree branches, and an enormous treehouse that appears to float in the middle of a lush, steamy jungle? Probably not in the centre of Norwich – but there it is!

In his one-acre plot on a south-facing slope, surrounded on three sides by tall hedges and trees, Will Giles has amassed a collection of tropical, sub-tropical and hardy species, and planted them in such a way that you truly feel that you have been transported to the tropics.

When Will bought the property in 1982, the plot was waist-deep in brambles

ABOVE **Familiar species mingle with exotics**

BELOW *Brugmansia* x *candida*

and tree saplings, the soil knotted with bindweed, ground elder and other pernicious perennial weeds.

Once there was an immaculate lawn in front of the house but, in a fit of passion, Will replaced the green sward with pea

shingle that has inevitably been colonized by the ever-encroaching exotics. The borders appear to float among the shifting and meandering rivers of gravel, which lead the visitor to unexpected corners of hidden delights.

WHAT'S THERE:	1-acre exotic garden with tropical, sub-tropical and hardy exotic plants; plant stall; tea and cakes
WHERE:	126 Thorpe Road, Norwich, Norfolk NR1 1UL
GETTING THERE:	10min walk from Norwich Thorpe railway station, or park behind Alan Boswell Insurance
WHEN TO VISIT:	Open Sun afternoons mid-Jun to end Oct, 1–5pm; open for coach parties at other times by arrangement
CONTACT DETAILS:	01603 623167; www.exoticgarden.com

RIGHT **Dappled light emphasizes leaf shape**

EARLY EXPERIMENTS

Will's travels around the world fuelled a passion for exotic plants, prompting him to experiment with those on the edge of hardiness. This hidden town garden has its own microclimate, where the temperature rarely drops below -3°C (26.6°F), thus giving him great scope with more tender plants. Will sees his early experiments with supposedly ludicrously tender plants as pioneering, perhaps even foolhardy! Nevertheless, time has proved that many borderline plants are far tougher than he originally thought, and his garden proves the point.

JUNGLE LOOK

In this steamy, jungle-like environment, he has planted many exotics that, in the northern European climate, are normally considered tender houseplants. The cast iron plant (*Aspidistra*) – such a familiar feature of Victorian drawing rooms – thrives in the shade of a stately *Magnolia grandiflora*, together with a prayer plant (*Maranta*), *Guzmania* and the well-known Swiss cheese plant (*Monstera deliciosa.*)

Large-leaved rice paper plants (*Tetrapanax papyiferus*), lush tree ferns and the enormous hardy banana (*Musa basjoo*), with their gargantuan paddle-like leaves, form a canopy so dense that you feel as though you are walking through a time tunnel into another dimension. Here and there, light penetrates the tall leaf canopies in various ways, sometimes casting spotlights on the plants beneath, occasionally dappled shade in mesmerizing patterns. In high summer, the garden is a haven of secret corners, plant hideaways, dramatically contrasted with the excitement of tantalizingly exotic colours. Then it is heady with the intoxicating scents of jasmine, angels' trumpets (*Brugmansia*) and the many species of ginger lilies, with their seductive blooms.

Bold cannas and large-leaved colocasias form an impenetrable-looking jungle with their vibrantly coloured foliage and grand stature. Bromeliads, chlorophytum, philodendron and platycerium are tied to tree branches during the summer months, where they hang down in swathes, while Spanish moss (*Tillandsia usneoides*) and other epiphytic air plants garland old, ivy-covered trees.

COLOUR AND FORM

Leaf colour plays a significant role, and it is mainly foliage that spans the colour

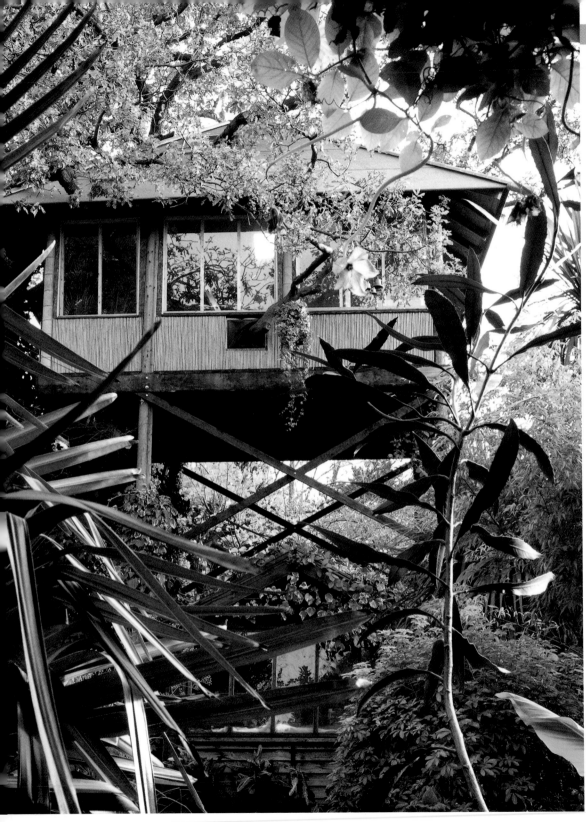

spectrum. 'Joseph's Coat', which grows to a height of 60cm (2ft), contributes intense primary colours with its red, green and yellow foliage, while the leaves of *Strobilanthes dyerianus* are a rich mauve with silvery-metallic veining. Aeoniums, a genus of perennial succulents, are given a raised bed of their own, where they can be admired for their rosettes of bright green, blue-green to dark purple, almost black, leaves. They are overlooked by three towering pale blue-leaved and intensely spiky *Yucca rostrata*.

Of equal importance is the way plants have been set in juxtaposition to one another: glossy-leaved plants overlap those with small, matt foliage, while spiky-leaved forms are set against those with flat, round leaves. And, among so much of the bold statement planting, there are contrastingly shy-looking plants, such as felicias with their small, pink, daisy-like flowers growing through the large fronds of the European fan palm (*Chamaerops humilis*) – an attraction of opposites.

DESERT GARDEN

In 2007, at the highest part of the garden, some 15.25m (50ft) above the lower level, Will converted a rough wooded area into a xerophytic landscape – an exceedingly well-drained desert garden for plants that need minimal water. Formed around sunken paths and raised flint-walled beds, this new garden has proved remarkably resilient to the elements. It even coped well in its first season – a summer with record rainfall! Here can be found a large collection of cacti and succulents,

ABOVE **The tree house has a city view**

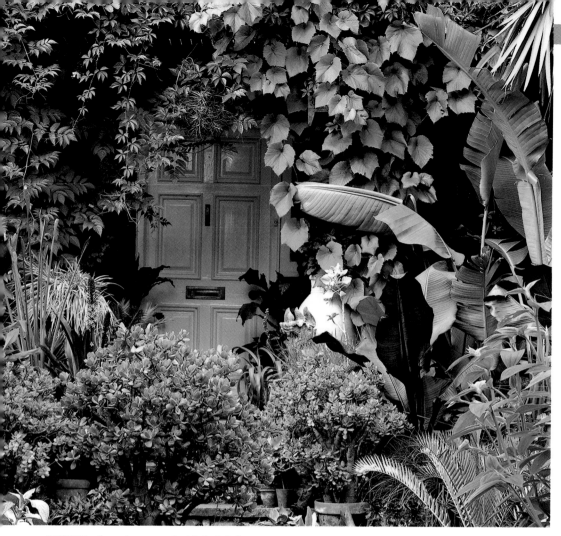

ABOVE The front door, wreathed in lush foliage

including giants like 90cm (3ft) tall *Trichocereus pasacana* and 1.2m (4ft) tall and wide *Agave americana*, underplanted with a fine array of other spiky, drought-tolerant species. Overlooking the garden is an Italianate loggia with glazed blue roof tiles and thick flint walls. On the York stone steps are more arid-tolerant gems, which thrive on neglect, heat and sun.

GARDEN STRUCTURES

Buildings are few within the Exotic Garden and those that are there are very discreet. A Caribbean-style balcony spans the width of the house, dripping with luxuriant climbers. A thatched Edwardian summerhouse is tucked away in a shady corner, and high up in the boughs of an old oak tree one of the largest treehouses in Norfolk towers above the garden, with stunning views across the city rooftops to the Norfolk countryside beyond. It is important to have this perspective, a reminder that this is an East Anglian city garden, not a wild jungle outpost. It would be so easy to forget.

CHAPTER 2

EXOTIC GARDENS

Encapsulating the aura and mystery of the tropics
or the steam-heat of a botanical glasshouse,
wherever they are created exotic gardens,
with their palms and ferns, brilliant blooms and
luscious fruits, may seem luxuriously other-worldly.

ANDROMEDA BOTANIC GARDEN

CREATED BY AN ISLANDER WITH A PASSION FOR HER NATIVE AND EXOTIC FLORA

ABOVE **A splash of colour enhances the sea view**

Some of the most vibrant and exotic flowers and trees in the world luxuriate in this tropical paradise.

The heady perfume of countless tropical plants; collections of dazzlingly beautiful flowers; the sound of waves breaking on the shore below; the whisper of breeze rippling through palms, and rare specimen trees growing among rocks that are millions of years old – it is perhaps to be expected that many people liken this botanic garden to an earthly paradise.

The garden was created from 1954 by Iris Bannochie, an eminent horticulturist, on land that had been in her family since the mid-18th century. An indefatigable plant collector, she travelled the world seeking rare plants to add to her collections and to enhance the rugged hillside garden, which is divided into a series of mini landscapes. Giant trees and Pleistocene rocks create varying environments, allowing native

WHAT'S THERE:	6 acres of tropical plants on a rocky hillside overlooking the east coast of the island
WHERE:	St Joseph parish, Bathsheba, Barbados
GETTING THERE:	Situated near Bathsheba, off Highway 3; can be reached by the coast road or from St Elizabeth village
WHEN TO VISIT:	Usually open daily; closed 12–2pm
CONTACT DETAILS:	(001 246) 426 2421; www.andromedagardens.com

ABOVE **Garlic vine**

and non-native exotic species to be grown in juxtaposition.

EXOTIC MIX

The water-loving paper reed or papyrus plant (*Cyperus papyrus*), native to Africa, grows beside a varied and colourful selection of smaller day and night lilies. Lotus lilies thrive in the shade of the huge banana-like leaves of the fan-shaped traveller's tree (*Ravenala madagascariensis*), a member of the bird-of-paradise family. A rock garden created on porous coral limestone has an eclectic mix of species, some of which would normally be considered as houseplants, including agaves, aloes, sansevieria with their rosettes of stiff, fleshy leaves, peperomia with their beautiful foliage, haworthia and adiantum ferns.

IDENTITY PARADE

For visitors without the time to meander around all six acres of this luscious tropical garden, there are two designated walks named, respectively, Iris's Walk,

WHAT'S IN A NAME?

One of the most remarkable native tree species at Andromeda, the ancient bearded fig tree (*Ficus citrifolia*), with its fibrous aerial roots hanging almost to the ground, is said to have prompted the Portuguese sailors, the first Europeans to discover the island, in 1536, to name it Los Barbados, 'the bearded ones'. The island was previously known to the native Arawak tribe as Ichirouganaim.

RIGHT **The bearded fig tree**

ABOVE **The Princess Irene Palm Garden**

THE TALIPOT PALM

A palm native to Sri Lanka and the Malibar coast of India, the talipot palm (*Corypha umbraculifera*), which can be seen at Andromeda in the Princess Irene Palm Garden, can reach a height of 25m (80ft) and have leaves 5m (16ft) across. There may be as many as several million small flowers clustered on a branched stalk, resembling a hanging bunch of feathers. In South-East Asian countries, the leaves were written on with an iron stylus, and also used for thatching. The sap was tapped from the trunk to make wine.

ABOVE **Orchid** *Dendrobium* 'Easakul'

which takes about 30 minutes, and the hour-long so-called John's Path, named after the former owner's late husband. Visitors are given a plant list to help them identify and appreciate many of the trees, shrubs and plants on the walks and elsewhere in the gardens.

Identifying some of the highlights of the gardens is like taking a virtual reality tour of the tropical horticultural world. From Java, there is the octopus tree (*Schefflera actinophylla*), and from tropical East Africa, the fern pine (*Afrocarpus gracilior*). The sago palm (*Cycas revoluta*) originates in Japan. From Madagascar, there is the Madagascar periwinkle (*Catharanthus roseus*), and from Indonesia, the bilimbi (*Averrhoa bilimbi*). The aromatic garlic vine (*Mansoa alliacea*), which has deep lavender-coloured flowers, is native to South America. Another spectacular vine, the jade vine (*Strongylodon macrobotrys*), has cascading pendants of large, turquoise claw-like flowers. A plant that gives rise

ABOVE *Tecomanthe venusta* 'New Guinea Creeper'

to some amusement is the Mexican firecracker plant (*Echeveria setosa*), which has long, narrow mid-green leaves covered in curving white hairs likened to cats' whiskers, and there is the amusingly named shaving brush tree, a rare *Bombax ellipticum*.

FLOWER POWER

Individual gardens are devoted to Iris Bannochie's major collections of tropical plants. There are orchids in outstanding and breathtaking variety, including an expanding collection of dendrobiums, which complement the vandas and cattleyas; hibiscus with their large, trumpet-shaped flowers basking in the tropical sun (there is even a grey hybrid form); and heliconias, known as lobster claws, with their spikes of bright, waxy flowers. Cascades of bougainvillea paint walls with vibrant, vivacious colours, and, at nightfall, frangipani (*Plumeria*) trees announce their proximity with the sweet fragrance of their yellow and white flowers.

WELCOME SHADE

Palms of almost unimaginable variety cast their umbrella-like shade over many areas of the garden. In the Princess Irene Palm Garden, there is the talipot palm (*Corypha umbraculifera*) (see box below left), the queen palm (*Arecastrum romanzoffianum*) and the taraw palm or serdang (*Livistona saribus*). A lily pond is surrounded by palms – spindly, sealing wax, bottle and golden cane palms among them – casting their shade over moisture-loving species, and coconut palms are amassed behind a cluster of annual bedding plants.

WATER AND WILDLIFE

A small stream bisects the garden and, except in the dry season, creates a waterfall that sparkles over jagged rocks. There is a koi carp pond where bullfrogs sun themselves on lily pads, where dragonflies flit and swoop, and one might catch a fleeting glimpse of a hummingbird.

MYTHOLOGICAL LINKS

Andromeda, the name given to the 6-acre tropical gardens, has mythical origins. Since the garden, created on a rocky hillside, is said to be 'chained to the rocks', it was named after the Greek goddess Andromeda, who was chained to a rock as a sacrifice to the gods. She was rescued by Perseus, who flew by on his winged horse Pegasus and fell in love with her.

WHO WAS IRIS BANNOCHIE?

Known as the doyenne of Caribbean horticulture and a legendary figure throughout the islands, Iris Bannochie was a passionate horticulturist, who won many awards at the RHS Chelsea Flower Show and other flower shows around the world. She was honoured by the Royal Horticultural Society and elected a Fellow of the Linnean Society, a rare honour for a non-botanist. On her death in 1988, she bequeathed Andromeda to the Barbados National Trust on condition that it would be maintained as a botanic garden and become a centre for tropical horticultural education and training.

MEDICINAL USES

The Barbados National Trust is building up a collection of plants known to have been used for centuries in Barbados and other Caribbean islands for medicinal purposes. Captions tell the visitor where and how the plants were used; much of the information originated in West Africa and has been handed down through generations.

LASTING LEGACY

Just as Iris Bannochie stipulated, this garden is being managed with a strong educational ethic. Her energy and enthusiasm, knowledge and vision have also ensured that it retains the element that impresses the visitor most of all – the wow factor.

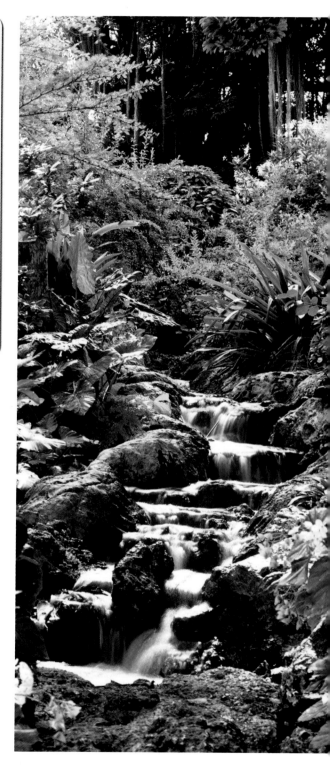

RIGHT **Water rushes down the rocky hillside**

AYRLIES

STUNNING VISTAS AND THRILLING COLOURS SEEM TO BE ENTIRELY NATURAL

A thrilling garden on the edge of the Tamaki Strait has been created by an artistic gardener able to see past the bare New Zealand terrain.

When Beverley McConnell shows visitors around her gloriously colourful coastal garden, one has the feeling of being conducted around her studio by an accomplished painter. It is as if every bed, border, pool, pathway and vista is a canvas on which she has painted her vision of how a garden should be. Indeed, Beverley sees herself as a garden artist rather than a plantswoman or plant collector, and says that from the outset her idea was to go for visual effect.

When she and her late husband Malcolm bought the property in 1964, she mapped out the first three acres of the garden on paper, almost to the last plant and tree, so that she could visualize the contours and colours before a spade was turned. Sculpting the land from bare

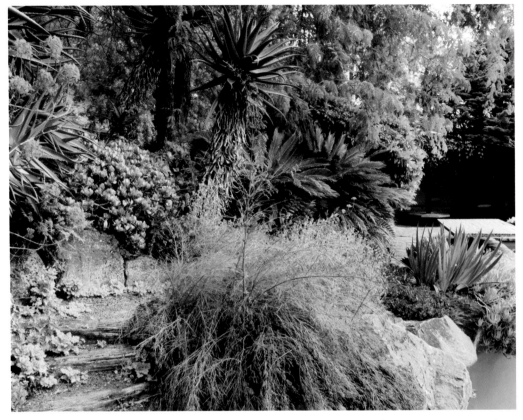

ABOVE **Orange orchids and coral plant in complete harmony**

BELOW *Clematis florida* **var.** *sieboldiana*

WHAT'S THERE:	12 acres country garden, 30 acres woodland; plant nursery
WHERE:	125 Potts Road, Whitford, RD1, Howick 2471, Auckland, New Zealand
GETTING THERE:	5.5 km (3 miles) from Whitford
WHEN TO VISIT:	Open all year Mon to Fri by appointment, occasionally Sat. No dogs or children under 12
CONTACT DETAILS:	(0064) 9 530 8706; www.ayrlies.co.nz

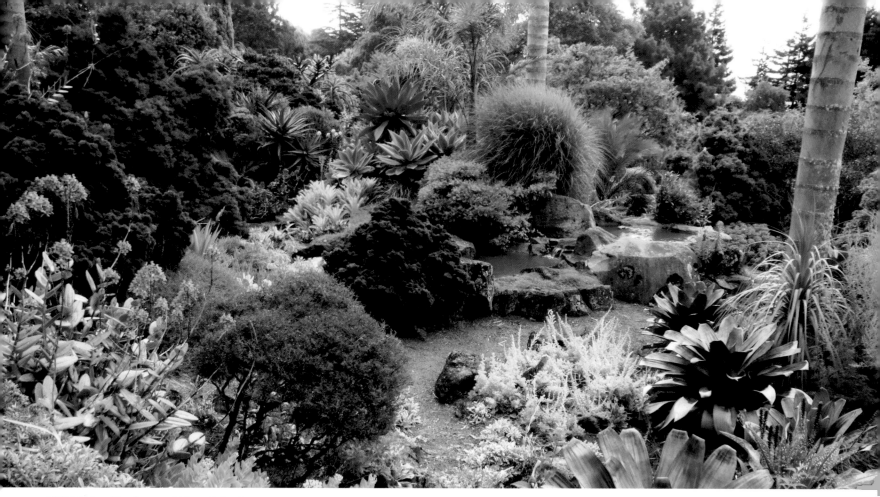

ABOVE **Pink epidendrum orchids steal the show**

paddock, Beverley used the same natural materials – stone, rocks and brick – throughout the garden to give continuity, although each area has a distinctly different characteristic. It has been an expansionist programme. A further seven acres were developed in 1978 when three large ponds were added to the mix, and then, in the millennium year, 35 acres of swamp flats below the homestead were transformed into wetlands, linking the garden with the sea, an ambitious enterprise undertaken as a celebration of the life of Beverley's late husband Malcolm McConnell.

JUST LIKE HOME

Beverley's intention was to create a large, informal country garden reminiscent of the homestead gardens of her Hawkes Bay childhood, where the lie of the land dictated the basic plan and there was space for large trees to be planted in family groups. Another of her ideals was that in every week of the year some plant or vista in the garden would be seen at its best. For example, in December, at the height of the New Zealand summer, a gloriously prolific, small-flowered *Clematis* 'Victoria' throws a bluey-mauve cloak over three heritage roses once they have bloomed.

MOOD AND COLOUR

The artistic approach to gardening is ever present. Colour is used to dramatic effect to create a variety of moods and to vary the ambience from one area to another. In the Lurid Border and around a poolside gazebo the hues could not be more fiery. Here, the hottest of hot colours – red, orange and coral kniphofias, dahlias, cannas, purple cabbage trees, gazanias and kangaroo paw (*Anigozanthos*) – are as dazzling as they are thrilling.

In the arid zone created for cactus and succulents there are flashes of bright yellow, orange and red flowers among the

mainly grey-green foliage and structural plants. *Aloe bainesii* is the tallest succulent, and the tree aloes, *Aloe thraskii* and *A. Ferox* x *arborescens*, are also fairly dominant. And then the mood changes. In walkways and borders, where pink, violet and cream roses, wisteria, clematis and the Mexican sandpaper vine *Petrea volubilis* drape over archways and obscure pillars, there is fragrance and romance.

WATER COURSE

A cool lemon, green and white scheme encircles the canal bog where decorative grasses, hostas, *Iris louisiana* 'Clyde Redmond', candelabra primulas (*Primula helodoxa*) and arum lilies (*Arum childsiana*) flourish in dappled sunlight, partially overshadowed by waterside tree cover, and it is as if the still, silent pool and the planting are entirely natural. Elsewhere, water creates energy and a cool ambience as it cascades into pools, gushes through rills and rushes over steps flanked on either side by lush green foliage.

GARDEN STRUCTURES

Separating areas of dense planting and exciting plant combinations there are sweeping lawns creating neutral zones and, throughout the gardens, there are gazebos, summerhouses and other shelters where visitors can sit in the shade. One of these, a tiled shack called a 'sitooterie' – the Scots way of saying a place to sit out – seems almost engulfed in yucca and other spiky plants that are actually at a comfortable distance. A small Temple House created

RIGHT **A cluster of swamp cypress 'knees'**

ABOVE **Splash of colour: 'Queen Victoria' lobelia**

from elegant pillars and capped by a wrought iron dome, where there is a statue of Aphrodite, is surrounded by glossy-leaved acanthus, their tall spires echoing the vertical lines of the temple supports.

BACK TO NATURE

The eight-acre lake that links the garden to the sea, a haven for native and visiting wildfowl, can be seen from several parts of the garden as a bright mirror on the world. There is a one-hour walking route around the lake and back through an area of native bush, where 15,000 indigenous species have been planted to provide cover for nesting birds. It is an area of random islands, snaky-shaped pools and clusters and swathes of trees and shrubs. So much of the garden, created with the vision of an artist, has been painted with flowers. Here, as the wetland merges with the sea, it is as if the environment has claimed back this part of the land as its own.

AS RUDYARD KIPLING SAID...

Throughout her gardening life, Beverley has been inspired by the words of Rudyard Kipling: 'Gardens are not made by saying, "Oh how beautiful", and sitting in the shade.'

RIGHT **Pool of gold:** *Sedum adolphii*

BRENTHURST GARDENS

HALF A CENTURY OF NATURAL PLANTING HAS CREATED AN ECO-FRIENDLY GARDEN

ABOVE **A rare note of formality**

Planned by a prominent South African landscape architect and enhanced by three generations of the Oppenheimer family, this garden combines exotic planting with a back-to-nature approach.

The sharpest of greens and yellows, the deepest reds and purples mingle in the lush plantings. Water gushes in rills and cascades over lichen-green rocks. Irregular paths of cobbles and stones seem to meander randomly and terminate in moss-covered bridges. There is a Japanese garden and a children's garden, a significant sculpture collection, acres of woodland and, often, birdsong. All this so thoughtfully constructed over 45 acres in Parktown, one of Johannesburg's oldest residential suburbs.

THREE GENERATIONS

Built by Sir Herbert Baker in 1906, the Brenthurst estate was described by the then owner as having 'terraces, pergolas,

WHAT'S THERE:	45-acre estate with intimate gardens, pools, sculpture, wild garden, indigenous plants
WHERE:	Parktown, Johannesburg, South Africa
GETTING THERE:	Above M1, near Johannesburg Hospital
WHEN TO VISIT:	By appointment; groups of up to 20 people; visits conducted by Dawid Klopper or one of his team
CONTACT DETAILS:	(027) 11 646 4122; www.brenthurstgardens.co.za

RIGHT **Floral tapestry below the house**

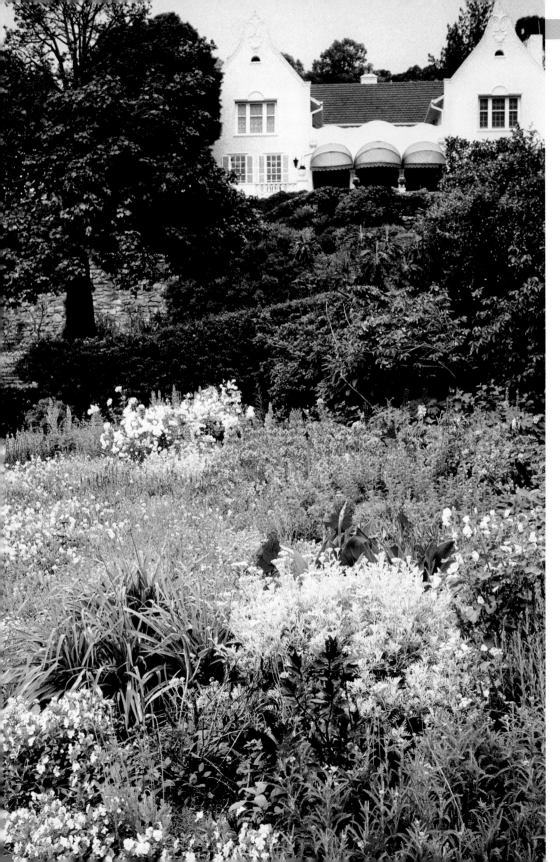

water pools and a natural rock garden'. It has those features still. The estate was acquired by Ernest Oppenheimer, a diamond merchant, in 1922 and has been in that family ever since. In the late 1950s his son Harry commissioned Joane Pim, a prominent South African landscape architect, to redesign the gardens. Her foundation design and organic gardening principles survive to this day, when Strilli Oppenheimer, Harry's daughter-in-law, works with head gardener Dawid Klopper to refine and develop the garden.

Under Joane's direction, a terrace was constructed at the front of the house to link with the lower lawns and take advantage of the view. A hillside above became an indigenous garden planted with native trees. The many and extensive paths were modified and bridges erected to make distant parts of the garden more easily accessible. Small circular drill cores, relics of the South African gold mines, have been inlaid to embellish some granite paths.

GROWING WILD

Following Joane's natural style of planting, Strilli describes herself as working with nature, not trying to confine or restrict it, and so plants once considered weeds are encouraged, seedheads are left to ripen, and fallen branches left to decay, forming a habitat for wildlife.

In addition to the elegant avenues of plane and oak trees and the many miniature forests, there are many more wild areas where indigenous grasses are left undisturbed with only necessary, and then very narrow, paths cut. Worried about the

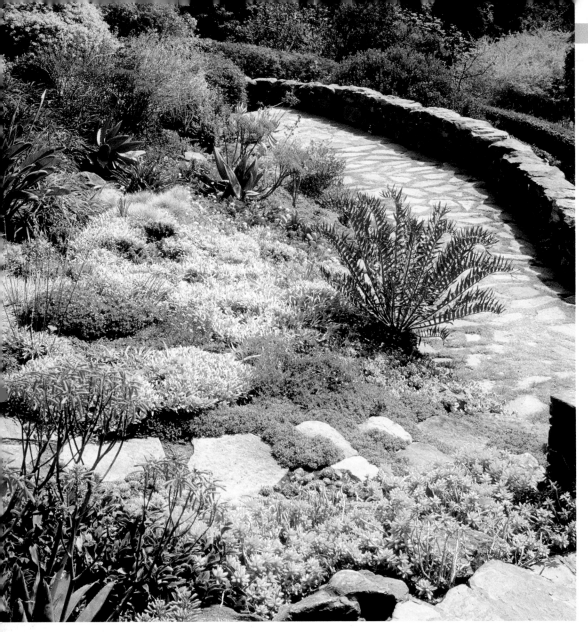
ABOVE **Silver leaves among the gold**

outstretched, sculpted by his mother, and another, called *The Enchanting Child*, of a young girl situated in the centre of a pond. Surrounded by immaculate lawns and tall trees, there is a sculpture on a grander scale of a male and female figure, the male 6m (18ft) tall, by South African artist Louis le Sueur.

ORIENTAL INFLUENCE

A recent and ongoing innovation at Brenthurst is the Japanese garden to the east of the main house, designed by Yasuo Kitayama, gardener to the Emperor of Japan. Opened in 2002 and decorated with several original Japanese sculptures, this garden has been created with nearly 400 tons of rock carried from all over the estate and includes an 18m (60ft) waterfall that cascades into a lake below. The central feature is a teahouse constructed in Japan, with a traditional white maple frame, and now furnished with two Ndebele stools outside. Although in the classic Zen tradition, the teahouse, with its highveld-style thatched roof, also incorporates traditional features of an African mud hut.

VEGETABLE GARDEN

A large vegetable garden, cultivated using biodynamic principles, supplies not only the estate but also customers in the city beyond, and all money raised goes to charity. To discourage bugs, marigolds and nasturtiums are planted between rows of vegetables and, as a further deterrent, are sprayed with a mixture of garlic, onion and vegetable oil. This garden, like the rest of the estate, is watered from a borehole.

decline in bird and insect life on the estate, Strilli had all exotic plants and shrubs removed from these grassed areas. The strategy worked. The garden is increasingly becoming a haven for other wildlife, too, for mongoose, small rodents, reptiles and frogs and exotic creatures including peacocks and vulturine guinea fowl.

SCULPTURE COLLECTION

Several pieces of the family's sculpture collection are given prominence in the garden, including a cast of Auguste Renoir's *Venus Victorious*; the sculpture by James Butler of Strilli's grandchildren; a bronze statue of the late ornithologist Peter Scott as a child standing, arms

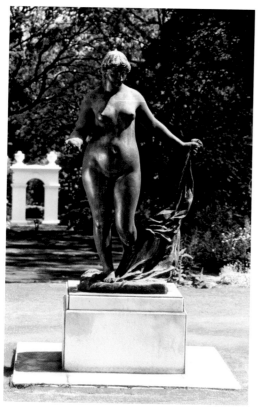

ABOVE **Venus holds the golden apple**

TALKING POINT

Renoir's bronze statue *Venus Victorious*, of which there is a cast in the Brenthurst gardens, is based on the image of the goddess depicted in the artist's own painting *The Judgement of Paris*. In Greek mythology, Aphrodite, known as Venus to the Romans, won the prize of a golden apple. She achieved this by promising Paris that he could marry Helen of Troy, considered to be the most beautiful woman in the world. Renoir's sculpture shows the goddess's moment of triumph as she holds the apple.

RIGHT **On the rise: a snaking stairway**

CÉSAR MANRIQUE FOUNDATION

A TRULY REMARKABLE GARDEN BUILT ON A STREAM OF PETRIFIED LAVA

This extraordinary house and garden, created by a passionate islander, was built on the site of a volcanic eruption.

What César Manrique, an artist, architect and fierce protector of the Lanzarote landscape, created at Tahiche was not simply an aesthetically beautiful house and garden. It was a phenomenon built on a stream of petrified lava. César discovered the site by chance in 1966 when, travelling around the island, he saw the top of a fig tree growing on barren wasteland that had been created by an 18th-century volcanic eruption. In fact, the tree was growing in one of five interlinked volcanic bubbles – formed by lava flowing around a vacuum – each of which now composes a room 8m (27ft) across and 5m (16½ft) high in the lower floor of the house.

UNITY OF DESIGN

So interlinked are the house and garden that they must be viewed as one entity.

ABOVE **Doors leading to a courtyard**

WHAT'S THERE:	Small garden around a house built in 5 lava bubbles; museum, cafe, shop
WHERE:	Tahiche, Lanzarote, Canary Islands
GETTING THERE:	From Puerto del Carmen take LZ2, take exit for LZ1, follow signposts to Tahiche and Orzola
WHEN TO VISIT:	House and garden open daily 10am to 7pm, Jul to Oct; at varying times, Nov to Jun. Check before visiting
CONTACT DETAILS:	(0034) 928 84 31 38; www.fcmanrique.org

Double doors from the road lead on to a small courtyard where the top of a palm tree can be seen appearing out of one of the bubbles. At the bottom of the volcanic staircase, a fountain murmurs quietly in the background. Here, César's skilful use of water, light and evergreen plants gives the room an almost Zen-like tranquillity and peace. Other rooms are painted in statement colours – red, yellow, and black and white – and have minimalist furnishings, some including examples of the artist's metallic sculptures. Before he moved from the house in 1988, César turned the upper storey into a gallery and museum.

The balcony and staircase overhang the sunken garden, where there is a barbecue and seating area and a dazzlingly turquoise swimming pool spanned by a bridge made from lava slabs. A formally planted garden with cacti and other indigenous plants is bordered on one side by a large, naive-style mural created of broken tiles and depicting several bulls. A brilliant scarlet bougainvillea cascades over another wall, and an unusual climbing cactus covers a further section.

RECYCLED ART

César had a passion for creating works of art from scrap metal and other junk. A majestic example of his work is the huge logo sculpture at the entrance to the property, and there are many more on and around the island, ornamenting the seven tourist centres he designed.

CACTUS GARDEN

One of these tourist centres, the Cactus Garden, established near Costa Teguise in 1991, is announced by a massive 8m- (27ft-) high green metallic cactus sculpture, complete with spike. César designed this as a tourist attraction that would be completely in harmony with the landscape. Situated in a disused quarry in the heart of the island's indigenous cactus-growing area, the garden has a collection of 10,000 cacti and succulents of more than 1,100 different varieties. The plants, selected with the advice of eminent botanist Estanislao Gonzáles Ferrer, are shown against a background of steep, curving stone terraces, like a Roman amphitheatre, emphasizing the visual harmony of natural stone and the cacti growing wild in the surrounding fields.

BIOSPHERE RESERVE

Shortly after César's death in 1992, UNESCO declared Lanzarote a Biosphere Reserve and cited César's work as being one of the major factors behind the granting of the award.

WHAT'S IN A NAME?

César Manrique's house was called Taro de Tahiche. 'Taro' is the island word for a construction of 'dry' stones piled on top of each other without any bonding material. An impressively large stone pile in front of the house is constructed in this way. The property is now known as the César Manrique Foundation.

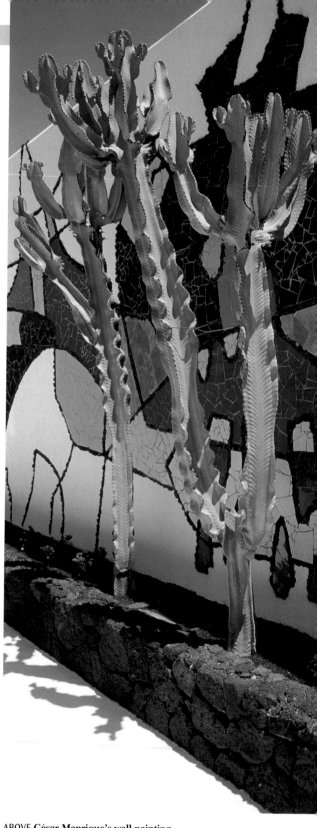

ABOVE **César Manrique's wall painting**

49

HENSTEAD EXOTIC GARDEN

NATIVE PLANTS FROM FAR-AWAY PLACES CREATE A SURPRISING EAST ANGLIAN OASIS

Bananas, palms and tree ferns – this Suffolk garden takes them all gloriously in its stride.

For centuries, Andrew Brogan's 400-year-old cottage has been sheltering between a 3m- (10ft-) high yew hedge on the country lane and a 15-acre ancient wood beyond the garden at the back. And so, in 2000, when he moved from London to this Suffolk idyll, a favourable microclimate was already established.

What was not established was the groundwork for his planned exotic garden. The volume of rocks, stones and hardcore needed to create the foundation was calculated in terms of tons – as many as 50. The volume of plants that Andrew has established since then is in high numbers, too: ten large tree ferns (*Dicksonia antarctica*), which grow 30cm (12in) every ten years; 15 large Japanese banana plants; 50 large palms, including six different types, all growing in the

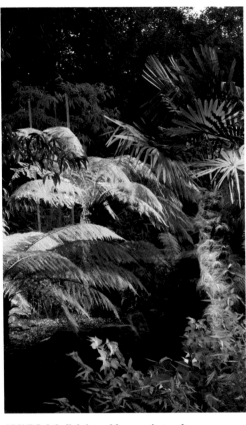

ABOVE **Subtle lighting adds a magic touch**

ground unprotected; over 100 bamboos and countless yuccas, puyas and ferns.

MOVABLE FEAST

With tiers of rocks, low stone walls and curved paths in place to give the garden the look he wanted, Andrew bought some large, well-established plants to get it off to a good start, moving the containerized plants around and changing their positions until he was satisfied with the overall effect of their relative heights and forms.

PROPAGATING NEW STOCK

After this initial luxury of buying mature plants, Andrew has taken a pride in propagating from his stock. Twelve large clumps of the giant reed *Arundo donax*, which produce 3cm- (1in-) thick canes, spikelets of yellow flowers in summer, and grow to a height of 4m (12ft), started as one section of a plant he lifted from his London garden. Offshoots taken from

WHAT'S THERE:	Almost an acre of tropical and sub-tropical plants in a cottage garden
WHERE:	Yew Cottage, Church Lane, Henstead, near Beccles, Suffolk NR34 7LD
GETTING THERE:	8km (5 miles) SE of Beccles, 1.6m (1 mile) W of A12
WHEN TO VISIT:	Open for National Gardens Scheme and other charities; other times by appointment. Andrew also runs morning courses on exotic plants for small groups
CONTACT DETAILS:	01502 743006

FAR RIGHT **A convincingly 'natural' cascade**

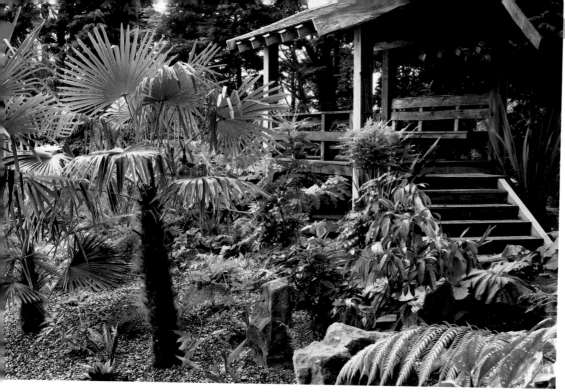

ABOVE **Designed for reflection**

GARDEN STRUCTURES

Two garden buildings, invaded on all sides by gunnera and bamboo, have already lost the appearance of being relative newcomers. One Andrew describes as being like a gingerbread house; the other, on stilts, is a Thai-style shelter with a scooped roof and long benches, a perfect viewing pavilion, especially when the garden is softly lit in the evening.

EXOTIC FEATURES

Three large ponds, one stocked with koi carp and golden orf, attract dragonflies – on a good day (or evening), they fly around the garden in droves. Pheasants strut through the garden as if it were their own, their red, green and blue plumage a camouflage against the colourful foliage. Bananas ripen, if slowly, and plants from as far away as New Zealand, the Himalayas and Japan flourish. It is the Suffolk country cottage, with its Gothic-style door and windows, that seems to belong to a far-off land.

his original Japanese banana plant have resulted in the 15 plants now developing in different parts of the garden. Others are given as presents to friends or sold on the plant stall on charity open days.

WORKING WITH NATURE

Andrew notices that, even in a relatively small garden such as this, the microclimate changes from one area to another, and so he is careful to plant accordingly. He is also aware that certain plants affect others in various ways. For example, a massive evergreen oak creates shade and a dry environment that is favourable to echiums and cordylines.

The poor soil in some parts of the garden can be a positive advantage. A small *Lomatia* tree would die if he fed it or replanted it in richer soil. He does not have a greenhouse and does not mollycoddle his plants, even by covering them with fleece. The resilience of so many plants has surprised him, and he says that most look equally good in baking sunshine or a light covering of snow.

GOOD NEIGHBOURS

Not all the plants in the garden would be termed exotic. Andrew's philosophy is that if a shrub or other flowering plant survives and looks good, then it should be given a chance. Thus there are clumps of pink and crimson bergenias growing beneath tree ferns. A waterfall that tumbles over jagged rocks is flanked by an eclectic mix of moisture-loving ferns and giant gunnera, canna lilies, foxgloves, kniphofia and large fan-shaped palms, which display their leaves as if they were peacock tails.

JARDÍN CANARIO

A BOTANIC GARDEN ON AN ISLAND THAT IS A PLANT-LOVER'S PARADISE

At Jardín Canario, the wonders of the Canary Islands' flora can be seen in a variety of habitats. Embracing the widely different habitats found on the islands, the botanic garden is a natural showplace, especially for the native flora.

If one cannot roam the seven Canary Islands to track down the 2,000 different plant species that make the archipelago such a plant-lover's paradise, then the botanic garden is the place to see them. Here, in a natural setting of rocks and arid terrain, waterfalls and pools, one can appreciate the scale and diversity of the islands' flora, of which 700 species are endemic.

Most of the botanic garden is on the side of the Guiniguada ravine, with wooden bridges linking the different areas that are each devoted to a particular plant group. Trails lead through the gardens to caves and waterfalls beyond; they are recommended only for the sure-footed.

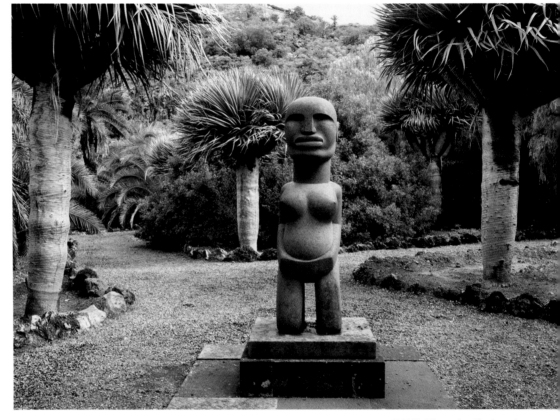

ABOVE **A primitive figure encircled by dragon trees**

BELOW **A jagged wall of cacti**

WHAT'S THERE:	27-acre botanic garden for the conservation of, mainly, the native flora of the islands. Owned by Cabildo de Gran Canaria
WHERE:	Tafira, near Las Palmas, Gran Canaria, Canary Islands
GETTING THERE:	9km (5½ miles) SW of Las Palmas
WHEN TO VISIT:	Open daily
CONTACT DETAILS:	(0034) 928 35 36 04; www.jardincanario.org

PALM COURT

The entrance to the gardens, through the Camino de los Dragos, leads to the Plaza de las Palmeras, where, together, a variety of palm species of the island with their high, dense foliage cover are an awe-inspiring sight. One of the tallest, the Canary Island date palm (*Phoenix canariensis*), which has edible fruit, reaches a height of 18m (60ft) and has leaves 5m (15ft) long.

PLANT DIVERSITY

Palm trees that grow in shrubland and semi-desert regions; dragon trees (*Dracaena draco*) that develop a new tufted branch only every ten years; hummocky yellow barrel cactus juxtaposed with as-different-as-can-be tall, slender pillar cactus; balsamic spurge thriving in the semi-desert region; 10,000 succulents basking in the sun and vibrant with exuberant flowers; and pink, red and purple bougainvillea arching and draping, and creating dappled shade over walkways – these plants and many, many more compose a rich and varied botanical landscape.

Moisture-loving plants are nurtured in the Hidden Garden, where, in a large greenhouse, there is a cave and a fast-running stream to display bamboos, ferns, rushes and papyrus.

BOTANICAL HERITAGE

To turn back the clock and give an impression of how the islands looked in pre-Hispanic times, there is an area of Laurissilva (laurel forest). These trees formed the original dense afforestation,

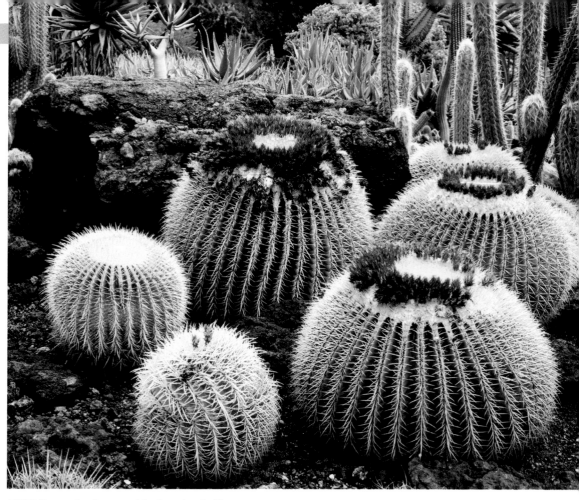

ABOVE **Contrasting forms: golden barrel and pillar cactus**

and they also feature in Garden Island, where there is a central meadow displaying clusters of endemic wild flower species.

The garden was developed in 1959 by a Swedish botanist, Eric Ragnor Sventenius (1910–1973), to display and conserve the botanical richness of the archipelago. An alternative name for the gardens, José Viera y Clavijo, recognizes the pioneering work of an 18th-century botanist of that name who wrote the first natural history dictionary of the islands.

There are many species here from the Macaronesian region – Madeira, the Canary Islands, the Azores and Cape Verde

islands – and, reaching out far beyond the native flora of the archipelago, the Gardens of the World area consists of five different zones featuring plants that are representative of each of the five continents.

PLANT CONSERVATION

The primary purpose of the garden, however, is in the conservation of the 600 threatened or endangered species of the islands and the presentation of the region's rich botanical heritage. At Jardín Canario, there are research laboratories, a herbarium, library and plant nursery.

LE POTAGER EXTRAORDINAIRE

GOURDS HANGING LIKE LANTERNS, FLOWERS IN WAYWARD PROFUSION: IT'S EXCITING!

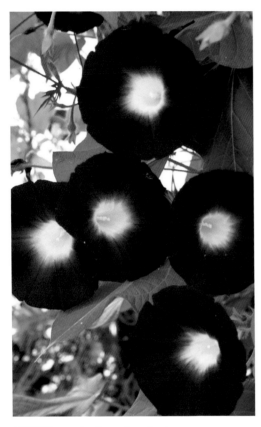

ABOVE **Trumpets of morning glory**

Gourds are grown in amazing and amusing variety in this ambition-come-true garden.

Wander through a light-filtering tunnel with gourds growing above your head, swinging beside you and in some places almost blocking your path. Discover little-known plants that smell of tar, are said to have the flavour of oysters, that recoil when touched or – in the case of a gherkin – have the propensity to explode. Learn the history and multiple uses of gourds from around the world. Become bemused in the maize maze, and be amused by the child-friendly presentation of many of the attractions.

All this and more is part of the Le Potager Extraordinaire experience. The existence of this amazing garden seems like a fairy tale. Now run as an association, the garden was a dream come true for Michel Railland who, since early childhood, had been passionately interested in squash –

ABOVE **Knobbly gourd** BELOW **Tomato plants**

WHAT'S THERE:	½ acre of mainly squashes in arbours and beds; trails, walks, demonstrations; greenhouses, picnic site
WHERE:	La Grange des Mares, La Mothe-Achard 85150, Vendée, France
GETTING THERE:	Between St Gilles-Croix-de-Vie and Les Sables d'Olonne
WHEN TO VISIT:	Mid-Jun to mid-Oct; times vary. Guided tours daily, Jul to mid-Oct
CONTACT DETAILS:	(0033) 251 466783; www.potagerextraordinaire.com

RIGHT **The gourd tunnel**

the cucurbit family that includes marrows, melons and pumpkins – and wanted to discover these treasures of nature through some of the forgotten varieties.

This passion for the plants, most of which are annuals, prompted the Botanical Garden of Nantes to give him a collection of 300 seed varieties. In 1995, his local authority in the Vendée region of France offered him a plot where he could grow the seeds and a barn where he could stage demonstrations and exhibitions. And so in that year this ambitious venture was born.

WIDE VARIETY

The garden is a wonderland of over 1,000 plants, including 300 varieties of cucurbits that produce fruits of all shapes and sizes: globular, pear-shaped, elongated like long, slender pillars or flattened like thin cushions. Some squash have smooth shiny or matt skin, while the skin of other types is heavily warted, ribbed or furrowed. And as for colours, cucurbits span almost the entire spectrum – variously, green, blue-grey, white, yellow, orange or red, striped or blotched, bi- or multi-coloured. One of the most vivid is *Cucurbita maxima* 'Turk's Turban', a squat round squash with red, green and yellow stripes that is almost too decorative to eat!

Le Potager is made up of 13 gardens, each with a different theme. One displays fibre plants, including that familiar bathroom accessory, the loofah (*Luffa cylindrica*), which, when ripe, is soaked in water (a process known as retting) to remove the skin and pulp before the fibrous skeleton is dried. Others feature

textile and dye plants, medicinal and 'magic' plants, everlasting flowers and exotic plants.

BIG AND BEAUTIFUL

The Garden of Giant Plants always astonishes, and it is where you will see many different pumpkins, which are among the largest fruits of the vegetable world. The ones most often used to carve Hallowe'en jack-o'-lanterns are from the *Cucurbita pepo* family. Within this group, there is enough variety of size and shape to carve both grotesque creatures and intricate works of abstract art. Nearly all the weighty prizewinners (see box) are the 'Atlantic Giant' variety. Also look out for the 'Rouge Vif d'Etampes' variety, which was used as the model for Cinderella's fairy-tale midnight carriage.

GOURD HISTORY

The history of gourds and their myriad uses are well represented and add an intriguing element when visiting the gardens. Many gourds have a background or legendary story, and at some events there is a storyteller to fire the imagination of both children and adults.

Butternut squash, a familiar ingredient in the Western world, derives from *Cucurbita moschata*, thought to be the first species of the genus to be cultivated over 7,500 years ago in southern Mexico and Peru. The mature fruits of the wax gourd (*Benincasa hispada*), cultivated in Asia for over 2,300 years, have a waxy layer that is used to make candles. The practical use of bottle gourds (*Lagenaria siceraria*), which

ABOVE **A cheerful complexion!**

originate from Africa and Madagascar, dates back to ancient Egypt. These gourds in their many shapes and sizes have long been dried and used as water bottles, ladles, cups, rafts, fishnet floats, toys, musical instruments and lamps. Many of them grow as vigorous vines in the tunnel of gourds. Duck your head!

ON THE PLATE

If the sight of so many delicious-looking squash excites the palate, the barn at Le Potager Extraordinaire is the place to head for in search of ideas and recipes and, from time to time, talks and demonstrations.

The Malabar gourd (*Cucurbita ficifolia*), for example, looks like a large, oblong watermelon and has black edible seeds. The greenish-white flesh of this summer squash is candied with sugar as a sweetmeat in Latin America, while the fibrous, strand-like flesh of spaghetti squash, one of the *C. pepo* series, can be eaten like pasta with an accompanying sauce.

You will find recipes for savoury dishes, including soups, casseroles and risottos, and also for sweet dishes, which are just as delicious and perhaps less well known than the traditional US Thanksgiving Day pumpkin pie.

ABOVE **Colourful companions**

WHAT'S IN A NAME?

'Squash' comes from 'askutasquash', the word used by the Narraganset (a Native American tribe), meaning 'to be eaten green'.

SUMMER AND WINTER SQUASH

Summer squash include marrows and courgettes (zucchini) and the saucer-shaped pattypan squash, which have a relatively soft skin. Winter squash, which are left longer on the plant and develop a hard skin, include acorn, dumpling, butternut and spaghetti squash, and pumpkins.

PUMPKIN FESTIVAL

A pumpkin festival and feast is held at Le Potager Extraordinaire each year on 1 October, when the pumpkins are at their best – and biggest – and there is a competition for the heaviest one. The winning variety is almost always 'Atlantic Giant', the strain grown by a competitor on Rhode Island in the US, who is believed to hold the world record. At a competition in 2006, his entry weighed in at 681.3kg (1,502lb).

OTHER ELEMENTS

Although the original *raison d'être* of the garden was to grow, display and further knowledge of squash, there are many other elements. One section is devoted to companion planting, displaying, for example, the benefit of planting nasturtiums with tomatoes and beans to avoid attacks of aphids. Another has a collection of *Solanum*, a large genus of plants that includes potatoes and aubergines (eggplants). One species of this genus, nightshade, is included among the poisonous plants in the see but do not touch section. There is a kitchen garden, an aromatic garden and a breathtakingly beautiful area devoted to growing the creeping vine morning glory in all its vivacious colours, from midnight-blue through purple to magenta.

The art of willow weaving is gloriously exhibited in a 32m- (98ft-) long boundary fence composed of 25 different varieties of willow, rippling and dipping and randomly undulating, the range of colours and textures interwoven like an intricate piece of tapestry. This fence is a wonderful example of outdoor art and craftsmanship and almost too beautiful to be invaded by plants. Even morning glory or squash.

LES QUATRE VENTS

THIS WATERSIDE GARDEN CROSSES CONTINENTS YET RETAINS ITS SENSE OF PLACE

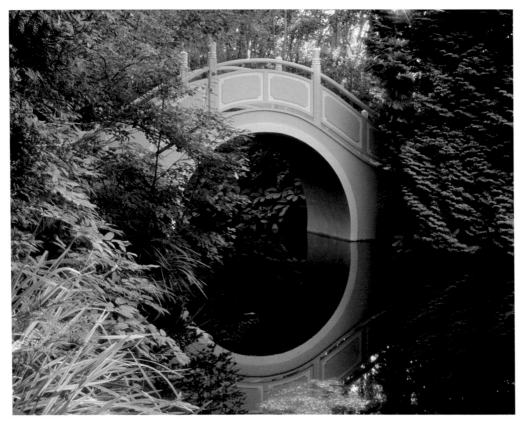

ABOVE **Dramatic reflection of a blue moon bridge**

'Borrowed scenery' contributes to a garden of outstanding beauty and in complete harmony with Nature at Canada's Les Quatre Vents.

Still or running water, a variety of means of crossing it and, everywhere, doubling-the-impact reflections of buildings and vegetation compose some of the most vivid impressions of this so-impressive garden. As if that were not enough, there are sublime views of the St Lawrence River and the Laurentian Mountains.

And there's not just water, but stone, rocks and timber, too. Large boulders seem to have slipped completely naturally into the edges of pools and are now engulfed by vegetation. Shallow stone steps make their way precipitously down steep, lushly planted slopes. Large near-cubic rocks are used to build walls, terraces and sturdy flights of steps. A narrow stone dam leads to a small Japanese bridge with bright red handrail supports, creating a vivid

WHAT'S THERE:	28-acre private garden on N side of St Lawrence River; enclosed gardens, woodland, waterfalls, Asiatic garden
WHERE:	Near La Malbaie, Charlevoix region, Québec, Canada
GETTING THERE:	Off Route 138, 150km (93 miles) N of Québec
WHEN TO VISIT:	Open on Wed and alternate Sat mid-Jun to early Aug by invitation only (see below)
CONTACT DETAILS:	To book, send name and address to F H Cabot, 135 Malcolm Fraser, La Malbaie, QC G5A 1A2 by mid-May. Donation of CAN$30 to CEPAS

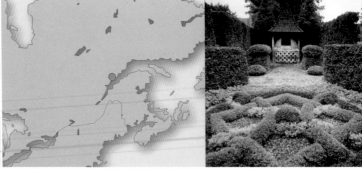

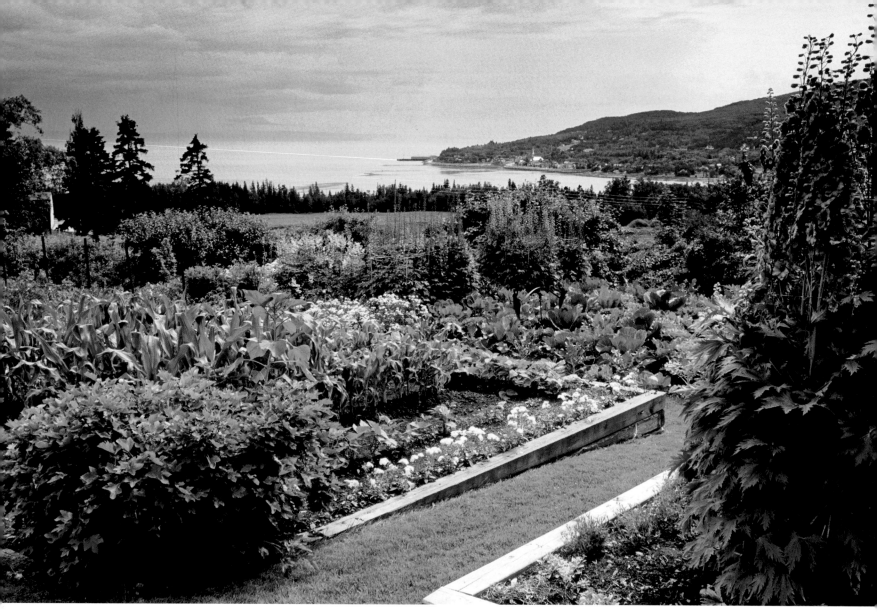

ABOVE **The Provençal-style kitchen garden**

reflection among all the rich greens of the waterside plants. Low walls of square-cut logs edging raised beds of yellow and white flowers create a sense of orderliness in the Provençal-style kitchen garden. Everywhere at Les Quatre Vents, the use of these attractive natural materials creates a feeling of total affinity between the garden and the landscape beyond.

LIVING WINDSHIELD

Francis Cabot's parents built a house on the land in the 1920s, and his mother and an uncle laid out the original garden plans. When the house had been rebuilt after a fire, Francis and his wife Anne took over the property and began reconstructing the gardens. Native trees and shrubs were planted to protect the garden from 'the

four winds', and thuja hedgerows were positioned close to the house to create intimate 'rooms' – of which there are over 20 – and to frame and tantalizingly conceal major features.

VIEWS AND FEATURES

Set among such magnificent mountain and waterside scenery, open views are a strong

ABOVE **Close planting of Stag's horn sumach**

JAZZ SESSION

By now the visitor is probably expecting to come across the unexpected, but not perhaps to be serenaded by a frog quartet. Four human-sized, anodized copper, anthropomorphic frogs on an evergreen stage 'play' Dixieland jazz whenever someone crosses a motion detector. Retrace one's steps and the reward is a chamber music frog quartet rendering excerpts from Mozart's *Flute and Harp Concerto* and Schubert's *Trout Quintet*.

DIVERSE SCHEMES

Sometimes, when the focus is a pool or a waterfall, the enclosed gardens have a cool and calming ambience. Others are exciting explosions of colour and herbaceous planting on a grandiose scale. A border of delphiniums, some plants 40 years old, creates an impenetrable-looking 'forest' of blue, pink, purple and white floral towers, juxtaposed with the glossy greenness of hostas and ornamental grasses. Rare primulas figure in many parts of the garden and in many forms. There are tens and tens of varieties in glorious single and bi-colours, a matter of great pride to Cabot, who hybridizes them.

ASIATIC GARDEN

Cabot's desire to create a garden that was Asiatic in spirit but not an exact Japanese garden lookalike took ten years to achieve. Then, in the 1990s, a Japanese master carpenter, Hiroshi Sakaguchi, constructed a complex of traditional structures and created a framework to

theme of the garden plan, with planting designed to emphasize and enhance perspective and to relate the garden to the surrounding landscape. Radiating allées and pathways link the garden 'rooms' or lead to a viewpoint or a surprise feature, in some cases an amusing one.

One such feature, a three-and-a-half storey pigeonnier modelled on a traditional French building, is at the head of a rectangular pool, framed by high, clipped hedges. The reflection of the building almost perfectly fills the pool and, to Cabot's satisfaction, ducks sometimes fly through the ground floor openings in the structure and land on the water. More neat-as-can-be hedges lead the eye to an outdoor bread oven, still in working order and jovially flanked by clipped thujas, perfect evergreen replicas of *pain à l'eau*, the local bread.

LEFT **The French-style pigeonnier**

house them. A pavilion in the 15th-century classical Irimoya style is set on a gravelled courtyard, overhanging a trout pond, with a smaller pavilion in the Hoogyo style close by. Both are designed for quiet reflection and as viewing havens to 'borrow the scenery', the intensively planted ravine and water cascades on the one hand, and the fields and distant hills on the other.

In 2005, Cabot was awarded honorary membership of the Order of Canada for his 'great services as conservationist, horticulturist and philanthropist… contributing to the common good through his ideas of beauty and his remarkable commitment to growing things'. Here, at Le Jardin des Quatre Vents, one can appreciate how well deserved that honour was.

CREATING THE LOOK YOURSELF

* So much a part of Francis Cabot's garden design, reflections can enhance or even appear to enlarge any garden. Think of a pool as an outdoor mirror. Position a planted urn, a metal sculpture – of a heron or stork, for example – or a graceful shrub where, with the sun or a strategically placed outdoor light behind it, the object will be seen in duplicate.

* Be sure to keep the pool or pond weed-free, and regularly clear any algae from the surface. Cabot periodically uses small quantities of Pylam, a dark brown powder, to achieve a black reflective surface.

ABOVE A regiment of topiary cones

LOTUSLAND

AN ECLECTIC MIX OF BOTANICAL COLLECTIONS AND DELIGHTFUL ECCENTRICITIES

Created by a former opera singer turned devoted gardener, this is a serious plantsman's garden with highly individual overtones.

The grandiose estate now known as Lotusland in the foothills of Montecito, California, reflects many of the characteristics of its former owner, Polish opera singer Madame Ganna Walska. It seems entirely reasonable that this larger-than-life artiste, once the toast of American and European high society, should create a garden that is both luxuriant and eccentric.

Madame Walska bought the estate in 1941 with the encouragement of her sixth husband, Theos Bernard, a scholar of yoga and Tibetan Buddhism. Her plan was to turn the property, originally the home of a 19th-century nurseryman, into a retreat for Tibetan monks. Bureaucracy intervened, her marriage to Bernard broke up and, with advice from leading landscape architects, Lockwood de Forest and Ralph

ABOVE **The floral clock and topiary animals**

BELOW **A carpet of barrel cacti**

WHAT'S THERE:	37-acre, 20th-century botanic garden with unusual features
WHERE:	Montecito, California 93108, USA
GETTING THERE:	Directions will be sent when booking is confirmed
WHEN TO VISIT:	Mid-Feb to mid-Nov; advance reservations required; guided tours by prior arrangement only
CONTACT DETAILS:	(001) 805 969 9990; www.lotusland.org

RIGHT **Aloes around the blue pond**

T Stevens among others, she devoted the rest of her life to creating a non-profit-making botanic garden.

OUTDOOR THEATRE

There are many specialist areas, featuring significant numbers of cacti, bromeliads, succulents and ferns, as well as Madame Walska's well-regarded collection of cycads (some commonly known as sago palms), of which she amassed over 400 specimens and was said to have grown more than half of the known species. And there are her eccentricities: she had an amphitheatre built in the garden, where guests were entertained with short plays, music and song, and grotesque stone figures were brought over from her estate in France to grace the wings of the theatre.

Punctuating the botanical areas of the garden there are bold theatrical statements such as a Mediterranean-blue, kidney-shaped pond edged with abalone shells, and pathways lined with large chunks of translucent green glass. Like a colourful roundabout in a wide brick walkway, a large floral clock in full working order is framed by *Senecio mandraliscae*. The numerals are represented by the 12 signs of the zodiac, and each segment is filled in with a variety of small succulents.

Nearby, there is a boxwood maze and an amusing topiary 'zoological garden', featuring 26 neatly clipped and instantly recognizable animals including a camel, a giraffe, a gorilla and a seal. Other more conventional topiary structures include chess pieces and geometrical shapes.

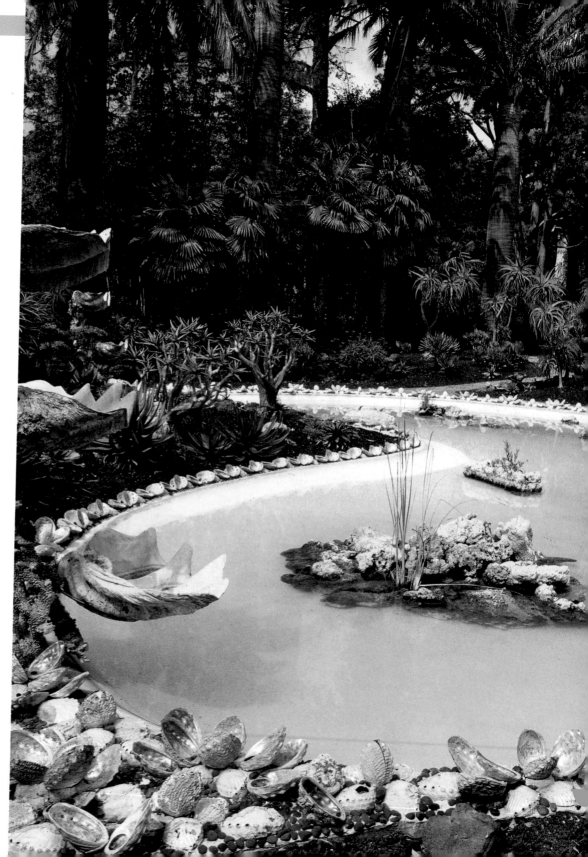

NAMESAKE FLOWER

With the creation of the Japanese garden, Madame Walska especially attained her desire for a calming, meditative ambience. Here, a small Shinto shrine is surrounded by Japanese cedar trees (*Cryptomeria japonica*), coast redwoods and Japanese maples. Pine trees are pruned in the traditional Niwaki style, there is a graceful wisteria arbour, as well as banks of white and stronger colours when the camellias and azaleas come into flower. Several species and cultivars of the property's namesake flower, the Indian and American lotuses (*Nelumbo nucifera* subsp. *nucifera* and *N. nucifera* subsp. *lutea*), make a theatrical appearance in the water garden in late spring and early summer, with many types of water lily playing supporting roles.

Colour and scent, formality and individuality are all enthusiastically expressed at Lotusland. There is a blue garden, which celebrates the blue-grey foliage of trees and shrubs, from Blue Atlas cedars to blue fescue and senecio; a citrus garden, where the exquisite combined perfumes of lemon, lime, grapefruit, kumquat and orange blossoms are a heady experience; a parterre, where brick walkways and formal planting of floribunda roses and walking iris or apostle plant (*Neomarica gracilis*) conform to an Italianate garden style; and everywhere, individual features that are expressions of Madame Walska's own colourful and artistic personality.

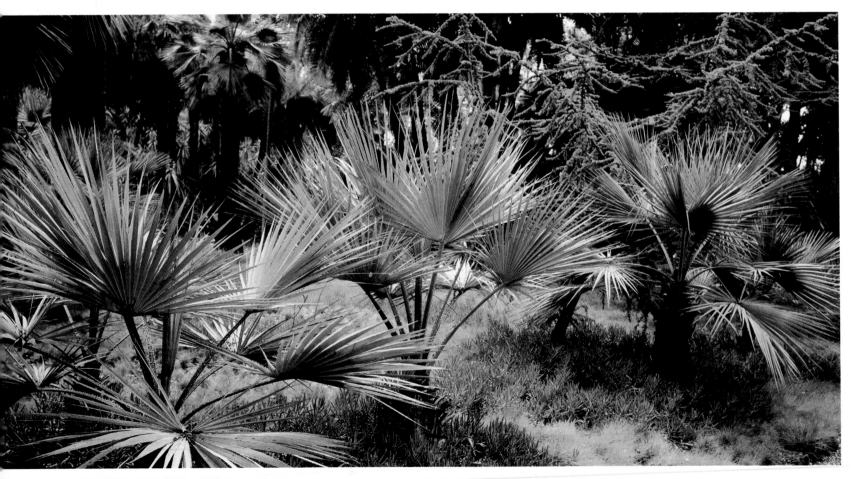

ABOVE **Shimmering foliage in the blue garden**

ABOVE **Madame Walska's amphitheatre**

ABOVE **Wreathed in succulents**

WHAT'S IN A NAME?

When Madame Walska bought the estate in 1941, it was known as Cuesta Linda. She first referred to it as Tibet Land but, ultimately, decided on the name Lotusland, after the lotus flower (*Nelumbo nucifera*), which is held sacred in both Indian and Tibetan religions. The name is defined as 'a place of languid contentment' and 'an idyllic realm of contentment and self-indulgence'. Lotusland was also the name given by author Pierre Burton in 1961 to Vancouver, British Columbia.

WHO WAS MADAME WALSKA?

Madame Ganna Walska (1887–1984) was a six-times-married, Polish opera singer. Her third husband, Howard Fowler McCormick, did much to promote her career and even secured her a leading role in a Hollywood movie (which she did not actually fulfil). Orson Welles maintained that it was McCormick's promotion of his wife's operatic career that was depicted in his classic movie *Citizen Kane*.

LEFT **Intricate mosaic patterns**

WAVE HILL

IT TAKES TIME TO ADMIRE AND APPRECIATE THIS VARIED BOTANIC GARDEN

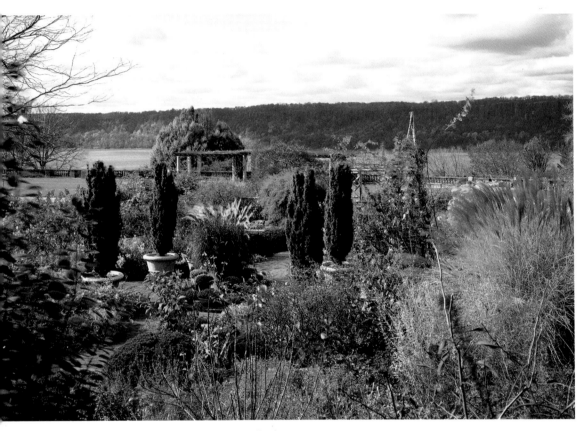

ABOVE **From the Flower Garden to the Palisades**

This series of exquisite gardens has a dream location, with breathtaking views across the Hudson River.

One's first instinct is to stand and stare – stare in amazement at the dramatic views over the river to the New Jersey Palisades, and at the expansiveness yet intimacy of the planting. There are many different types of garden – dry, herb, aquatic, wild and flower – each creating a spectacular display in areas of indigenous or created soil conditions. This is a botanic garden and 'that' is the view. They both deserve time. No hurried itinerary would begin to do them justice.

From the boardwalk entrance, through banks of yews and viburnums, the scene is set for the awe-inspiring vista. At this point, the garden is the auditorium, the Hudson River the stage. Stone pathways invaded by encroaching plants lead to the pergola, an Italianate structure with impressive columns. Tender plants flourish as if

WHAT'S THERE:	Gardens in 28 acres of urban woodland, cafe, shop
WHERE:	675 W 252nd St, The Bronx, New York 10471-2899, USA
GETTING THERE:	19km (12 miles) N of midtown Manhattan; Bx7 or Bx10 bus, walk from 252nd St bus stop. Entrance from Independence Ave on 249th St
WHEN TO VISIT:	All year round, Tue to Sun, times vary
CONTACT DETAILS:	(001) 718 589 3200; www.wavehill.org

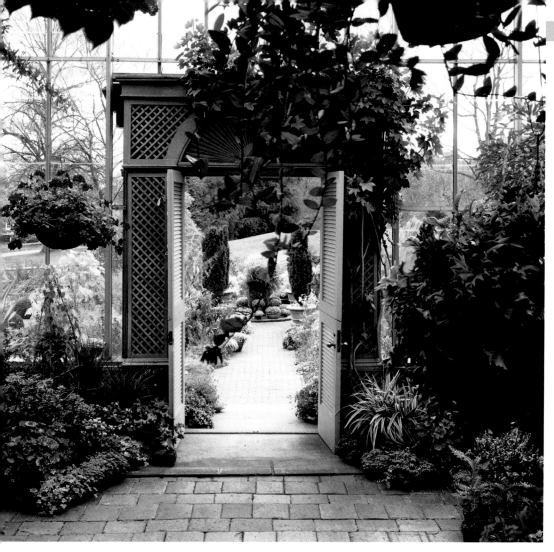

ABOVE **From the conservatory to the Flower Garden**

nurtures plants native to extreme climatic conditions around the world. The Cacti and Succulent House has a collection of plants from arid regions, and the Tropical House displays a wide range of plants from warm and humid environments. In the Palm House, South African bulbs and other tender plants vibrate with colour in winter.

The collection of high-altitude and small rock-garden plants, viewed from outside the Alpine House, provides further winter and early spring colour, when the miniature flowers dazzle like stars and snowflakes among the rocky terrain. Along the terrace, troughs are filled with specimen alpines, while hardy alpines planted in cracks in a retaining wall also create high-level interest.

in a tropical enclosure. Tendrils trail in ribbons from hanging baskets and become entwined with clumps of hydrangeas and groups of planted containers, and above everything, there is an all-enveloping vine.

HOMESTEAD LOOK

Still with dramatic river views in the distance and with inspirational plant associations at one's feet, the Flower Garden has an almost homestead look, with rustic cedar fences, benches and narrow brick pathways that preserve a sense of closeness and intimacy. With evergreen shrubs forming the year-round structure, this garden, above all, rings the seasonal changes with informal combinations of both traditional and modern perennials, annuals, shrubs and bulbs.

WIDE DIVERSITY

The trio of glasshouses, the Marco Polo Stufano Conservatory, named after Wave Hill's first director of horticulture,

FAMOUS RESIDENTS

The family of Theodore Roosevelt rented the house for the summers of 1870 and 1871, when the future President of the United States was 12 and 13 years old. Mark Twain (see over) leased the property between 1901 and 1903, and the conductor Arturo Toscanini lived there from 1942 to 1945. The house was leased to the chief British delegates to the United Nations between 1950 and 1956. The last private owners of the house, the Perkins family, deeded the estate to the City of New York in 1960 and it was opened to the public five years later.

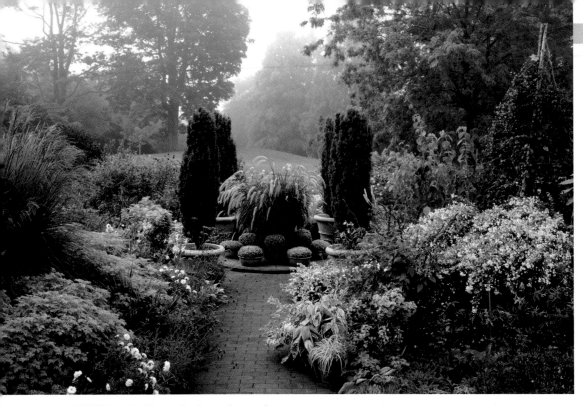

ABOVE **From the Flower Garden to the woods**

HERB AND DRY GARDENS

In an act of practical recycling, the stone foundations of a former greenhouse have been retained and interplanted to form the Herb and Dry Gardens. Ornamental, culinary and medicinal herbs, including mints, standard bay trees, angelica, fennel and bronze fennel, are so skilfully intermingled that this could be a monastery garden. In the adjoining dry garden, salvias, lavender, rosemary and euphorbias bask in the heat given off by the sun-baked paving.

By contrast, the aquatic garden celebrates and nurtures water-loving plants. The formal proportions of a garden pool are submerged beneath tropical and hardy water plants, lotus and water lilies among them, reeds and delicate-looking feathery grasses. In the adjacent Monocot Garden, lilies, cannas and day lilies explode with vibrant colour, challenged only by groups of containers planted at the water's edge.

SPECIAL COLLECTIONS

Throughout the garden, special collections are planned to attract attention throughout the year. Viburnums and other showy shrubs flower prolifically in spring and have a 'second flowering' of vibrant berries in autumn. The Lilac Border holds the spotlight in April and May, with a display of fragrant and colourful flowers. In the hot summer months, the Shade Border offers protection for wild flowers, shade-loving plants and visitors. Taking the form of a traditional parterre, the Elliptical Garden, a masterpiece of geometry, is planted with non-traditional plants native to the north-eastern United States.

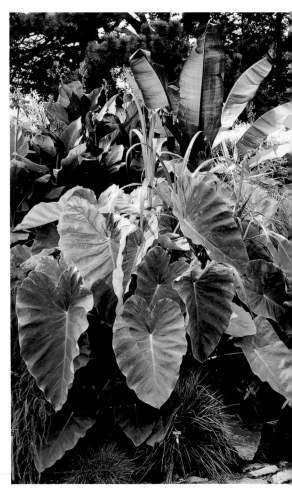

ABOVE **Statement plants in the Monocot Garden**

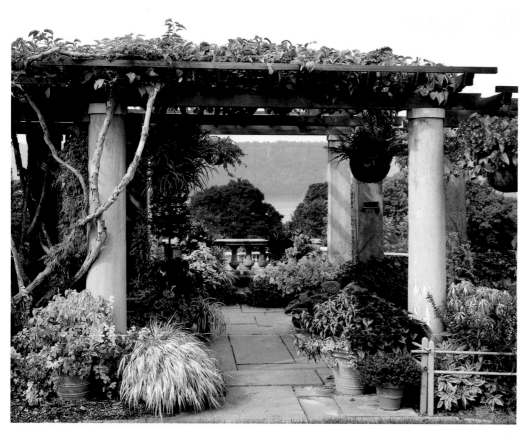

ABOVE **Baskets and pots in the Pergola**

In winter, attention turns to the Conifer Slope, where cone-bearing trees display a range of textures and hues.

TREE COVER

As in so many gardens, trees form the bedrock of the Wave Hill landscape, providing structure and form, shade and shelter, colour and texture. Among the many species to be seen are copper beech (*Fagus sylvatica* f. *purpurea*), American elm (*Ulmus americana*), sugar maple (*Acer saccharum*), cutleaf staghorn sumac (*Rhus typhina* 'Laciniata'), dawn redwood (*Metasequoia glyptostroboides*), dove tree (*Davidia involucrata*) and bigleaf magnolia (*Magnolia macrophylla*).

ON THE WILD SIDE

Perhaps more than any other, the Wild Garden belies its proximity to New York City. A hillside garden and gazebo have existed in this area for almost a century. Since the late 1960s, extensive planting has been so sensitively carried out that it looks as if it just 'happened'. Paths meander, hardscaping varies, stone steps ease out the gradient, plants and colours intermingle, and then, suddenly, beyond the cloud-like yews, there is 'that view' again.

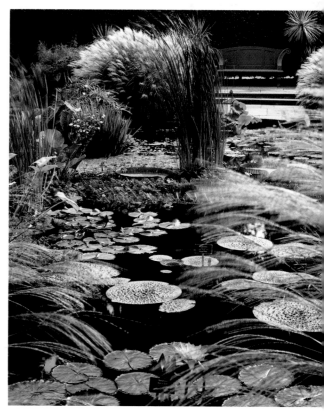

ABOVE **Height and shade in the Aquatic Garden**

69

LE JARDIN MAJORELLE

IN MOROCCO, AN ARTIST'S GARDEN VIBRATES WITH EXCITING COLOUR

Fountains play, reflections dance, the breeze whispers in the palms, and the use of colour is breathtaking – all this in a garden that is a far cry but a short walk from the kasbahs and souks of Marrakech.

This is an artist's garden. Every glimpse of a lily-filled pool, cascade of bougainvillea and daring colour combination should surely be captured on canvas. The creator, French painter Jacques Majorelle (1886–1962), designed it that way. An avid plant collector and – as he described himself – a 'gardenist', he acquired the land in 1924, commissioned the architect Paul Sinoir to build an Art Deco studio, its exterior exuberant with pergolas and cobalt-blue walls, and created a unique botanical experience around it.

Majorelle first went to Morocco for health reasons in 1919 and said that, quite simply, he fell in love with the light of the country. It is his understanding of the quality of that light and the way he used its

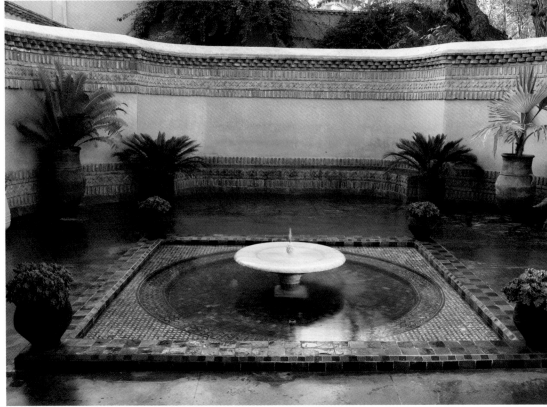

ABOVE **A rare note of symmetry**

WHAT'S THERE:	Exciting garden; art and craft museum; shop
WHERE:	Avenue Yacoub el-Mansour, Marrakech, Morocco
GETTING THERE:	Taxi or 15-min walk from Place Jemaa el Fna
WHEN TO VISIT:	Usually open daily; closed 12–2pm
CONTACT DETAILS:	(00212) 24 30 18 52; www.jardinmajorelle.com

RIGHT **Arches and trees frame a rill**

strength and depth that makes his garden such a dramatic work of art. The garden, but not the Moorish villa, which the artist designed for himself, was first opened to the public in 1955.

TRADEMARK BLUE

Visitors to the garden have a foretaste of the colour treats in store. A wall at the entrance, painted in cobalt-blue, the colour that became known as Majorelle blue, supports a large panel with a fretwork frame, its centre panel painted in the brightest, most contrasting – some would say clashing – shade of orange peel. Colour is used lavishly and just as strikingly on architectural features and accessories throughout the garden. Cubic and rectangular shapes for gate supports, walls and pillars, many painted in Majorelle blue, provide visual stability in strong contrast to the spiky, thrusting, grey-green cactus of which there are, in the garden, over 1,800 species. Rows of terracotta urns lining the paths, painted variously in Majorelle blue, lime-green or sharp lemon yellow, are inspirational containers, the citrus colours especially effective in the haze of the African sun.

A set of steps covered in alternate pale blue and peacock-green glazed tiles is flanked dramatically by a bright pink cubic plinth, which supports a blue urn of tumbling glossy evergreens. It is thrilling!

With such vibrancy of colour highlighting the structural features, Majorelle could be sparing with plant colour, although there is magenta bougainvillea cascading over trees and

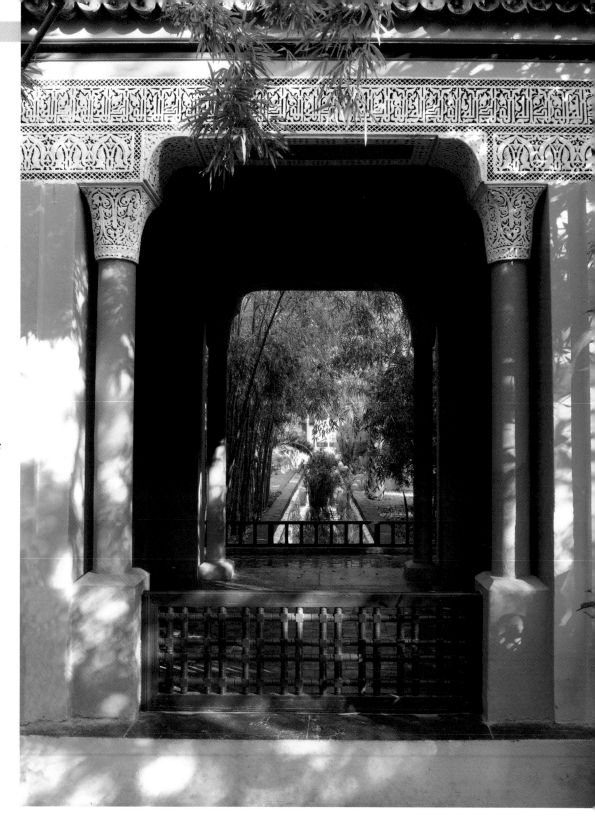

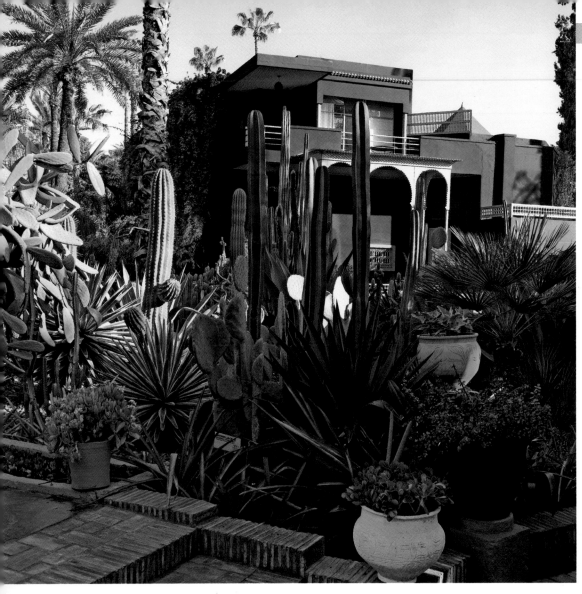

ABOVE **Plant containers in stunning colours**

to contrastingly soft foliage. Imported from all over the world – South African succulents, over 400 varieties of palms mainly from the South Pacific, water lilies and lotus from Asia – they all have the look of indigenous plants that are very much at home in this setting.

COOL, CLEAR WATER

Water has both a practical and a decorative role in the garden. Planted areas are occasionally flooded by water from a square pool fed by long narrow channels and bridged over with walkways. 'Decorative' water is bubbling from fountains and confined in marble pools. Essentially restful and cooling, water also creates intriguing painterly patterns as buildings, flowers and plants are reflected this way and that, the images distorted by any slight movement on the surface. The gardenist designed it that way.

After Majorelle's death, the garden fell into disrepair until, in 1980, it was rescued by the French couturier, the late Yves Saint-Laurent and his companion, the artist Pierre Bergé, who said, 'We came into possession of this jewel, and set about saving it'. In his words, it was, 'A small, mysterious garden painted in all the colours of Henri Matisse, all silence, and secluded in a bamboo forest'. It still is.

The building that was once the artist's studio is now a small museum displaying Moroccan arts and crafts. Here, one can see a changing selection of antique carpets, Fassi ceramics, Berber doors, textiles and Majorelle's evocative engravings of Atlas Mountain villages and kasbahs.

buildings, small parterres filled with scarlet hibiscus and coral geraniums, and flowering cactus and echeveria.

ATTRACTION OF OPPOSITES

The main focus of the planting, however, is in architectural plants, chosen for their contrasting forms and textures, and skilfully displayed in striking juxtaposition. One gravelled area beneath a cobalt-blue wall is planted mainly with cactus, pin-sharp agaves and prickly aloes. Tall, erect torch cactus, some smooth, some covered in spikes, rise up beside large, near-spherical agaves as prickly as giant hedgehogs; urn-shaped cactus, ridged green and gold, are half-buried in gravel like shipwrecked pithoi; and balls of spike-full, yellow-flowering cactus are all the more eye-catching as they grow next

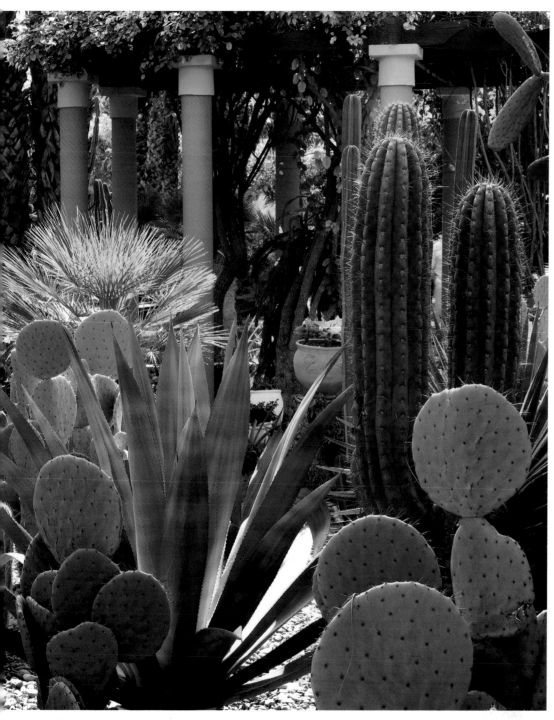

CREATING THE LOOK YOURSELF

✳ It is colour, exciting, vibrant colour, that gives the Majorelle garden the immediate wow factor – a design idea that is simple to emulate. There is no need to go to the extent of painting structural walls, although you might choose to do this. Paint three or five urn-shaped plant containers or those in the near-cylindrical 'long Tom' shape, group them together or arrange them in a row, and your garden or patio could soon look artist-inspired.

✳ If the Marrakech combination of Majorelle blue, lime and lemon seems too vivid in a less exotic climate, consider bright orange, shocking pink and sky-blue, or purple, buttercup-yellow and lavender. Choose a weatherproof paint, and select and reselect colour swatches until you find the combination that looks right in your surroundings.

ABOVE **Vertical take-off of cactus and columns**

RIGHT **Fretwork panel at the entrance**

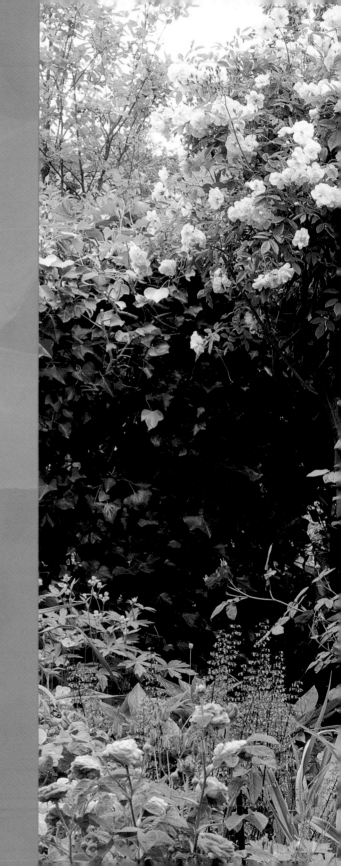

CHAPTER 3

COTTAGE GARDENS

Perhaps the most romantic of all garden styles,
where vegetables and fragrant herbs mingle
with traditional country flowers – foxgloves,
hollyhocks, sweet peas, nasturtiums –
and there might be roses round the door.

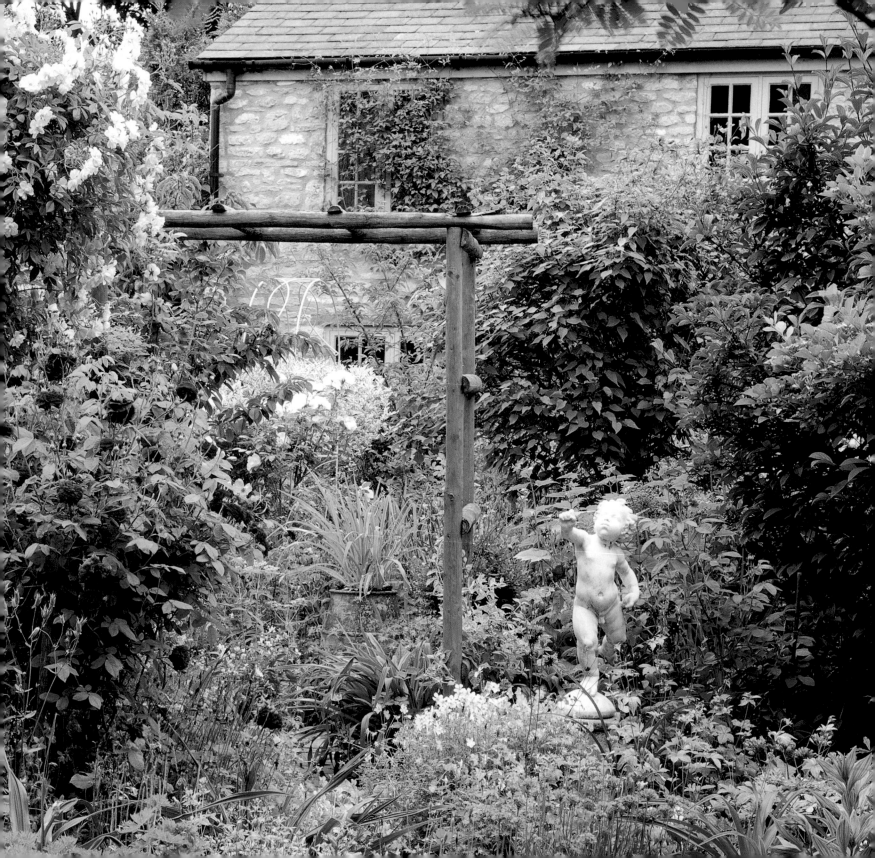

BAYLEAF FARMSTEAD

AN AUTHENTIC RECREATION OF A MEDIEVAL COTTAGE GARDEN

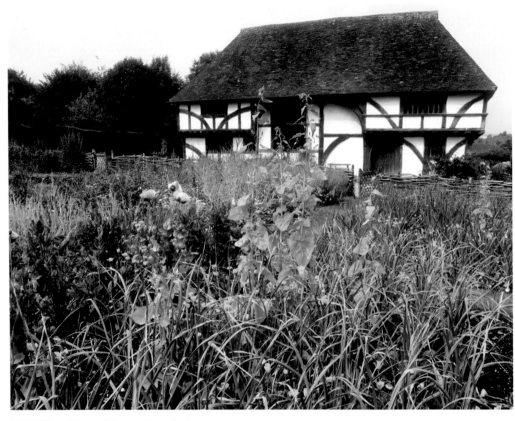

ABOVE **Vegetables and flowers in profusion**

Mingling fruit and vegetables, herbs and weeds, this garden is planted as it might have been centuries ago.

Peas and beans, pot marigolds and poppies, winter savory and thyme, woven wattle fences and a well for water – the garden around the Bayleaf homestead is a nostalgic and authentic look back in time to cottage gardens over four centuries ago, when vegetables, edible flowers and weeds grew higgledy-piggledy together, creating unintentional drifts of colour.

The 15th-century Kentish house, rescued from the site of a new reservoir, has been re-erected in West Sussex as part of the Weald and Downland Open Air Museum, where regular events held throughout the year give a further insight into the daily lives of our ancestors.

GARDEN PLANNING

Cottage gardens were originally devoted to the intensive cultivation of fruit, vegetables

WHAT'S THERE:	Re-erected 15th-century house with small traditional cottage garden; cafe, bookshop, gift shop, museum, over 40 other historic buildings
WHERE:	Singleton, Chichester, West Sussex PO18 0EU
GETTING THERE:	11.25km (7 miles) N of Chichester off A286 at Singleton
WHEN TO VISIT:	Open daily throughout the year; times vary
CONTACT DETAILS:	01243 811348; www.wealddown.co.uk

and herbs, as well as some flowers for both kitchen and medicinal use. Space was not spared for decorative pathways and terraces, and structural features such as fences, shelters and plant supports were made from wood cut from copses and hedgerows.

This is how the Bayleaf garden has been planned. Fences and low edging panels have been woven from wattle. Slender branches are tied together as plant supports for peas and beans, and an open shelter storing tools, implements and beehives is reinforced with thin branches. Hedgerow roses clambering over the front are merely decorative. Beside the shelter and a short distance from the house, there is a brick well of the kind that would have been used to draw water for the house and garden.

ABOVE **Beehives stored in a rustic shed**

PRACTICAL USES

The main vegetables traditionally grown in cottage gardens were brassicas, such as cabbages and kale, and roots, including turnips and skirret, which tasted like watery parsnips, together with leeks, onions, spinach beet, peas, beans, poor man's celery (alexanders) and lettuce. Many of the greens would have been boiled to make a 'pottage' or soup. Herbs, such as parsley and sage, and flowers, including pot marigolds and feverfew, were used for flavouring and for tisanes (teas) and ointments. Tansy and wormwood were grown as strewing herbs for the house, to help deter insects.

From time to time, there are cookery demonstrations at the Weald and Downland Open Air Museum, showing how the garden produce would have been cooked, and occasional 'herb days', demonstrating, for example, how to make calendula ointment from marigolds.

HARVEST TIME

In summer, the Bayleaf garden seems to invite the romanticized medieval housewife to wander out with a flat basket to pick peas growing among flowers and edible weeds, or to gather herbs for the kitchen, and also rosemary, sage, thyme and marigolds to make into fragrant tussie-mussies (small posies) for scenting the rooms in the homestead. She would supplement gooseberries, raspberries and wild strawberries from the garden with blackberries and bullace (wild plums) from the hedgerows and, later, with apples and pears from the orchard, for making jams, jellies and chutneys and for storing for the coming winter.

NEW WOODLAND

There were many shaws (small woodlands) growing around Bayleaf in its original Weald of Kent location, and three with similar trees and shrubs have now been planted at the Museum. Oak and ash are the main timber trees planted with other species, including hazel, hawthorn and field maple. As these shaws develop, they will not only create an authentic landscape but – notionally, at least – be able to provide timber and saplings for structural work around the farmstead.

CREUX BAILLOT COTTAGE

INFORMED PLANTING, COLOUR AND ORIGINALITY IN A SUN-BATHED JERSEY GARDEN

Take Jersey's sun-bathed, temperate climate, Judith Quérée's instinct for what will grow where and her quest to build up her many plant collections, and you have a garden buzzing with interest.

This is a great little garden. It would be easy to be lost here – lost in admiration, that is, that Judith and Nigel Quérée have managed to pack so much colour, interest and originality into their quarter-acre Jersey plot. Approaching the 300-year-old, ivy-round-the-door granite cottage along a narrow country lane – the only access – gives no hint of the dedicated and informed planting that comprises a woodland, a bog area and a dry garden, nor of the unaccountable sense of space.

COLLECTIBLES

Judith is, first and foremost, a plant collector. She has a collection of over 200 clematis, her favourite plants, but even that is not enough. There are many

ABOVE **The 300-year-old Jersey cottage**

WHAT'S THERE:	¼-acre garden packed with over 2,000 plants from all over the world
WHERE:	Creux Baillot Cottage, Le Chemin des Garennes, Leoville, St Ouen, Jersey JE3 2FE, Channel Islands
GETTING THERE:	Off B65
WHEN TO VISIT:	Visitors are always welcome, but make contact first
CONTACT DETAILS:	01534 482191; www.judithqueree.com

RIGHT **Nigel Quérée's boardwalk over the bog garden**

more, she says, still to find. It seems that almost every vertical structure is host to these spectacular flowers in shades from sea-foam white through sky-blue, pink, lavender and magenta to deepest purple, and Judith is proud that on every day of the year there is likely to be at least one clematis in flower. It is high-rise gardening on a glorious scale.

In the bog garden, kept constantly moist by natural springs even in the driest of summers, there are over 160 moisture-loving irises – another of Judith's collections. This enthralling display includes the dramatic beardless Japanese flag *Iris ensata*, the Siberian flag *I. sibirica* 'Lady Vanessa', another beardless form displaying the richest of purple petals blotched with lavender and flashed with white, and the hybrid *I.* 'Hatsuho', its creamy-white, curled-back petals gilded with golden half-moons.

ROPE WALK

Nigel constructed a long, curving, planked boardwalk through the bog garden. Not much more than 45cm (18in) off the ground and with sturdy manila rope supports, it nevertheless introduces a spirit of adventure, of discovery, and allows the plants around the walk to grow unhindered, as they would be by a path. In late spring this area, which seems illogically remote from other parts of the garden, is vibrant with some 35 pink, golden and orange candelabra primulas. Almost concurrently the clouds settle, clouds of minute snowy-white umbels of *Anthriscus sylvestris*, variously known as wild chervil

ABOVE **Tree ferns love the Jersey climate**

and cow parsley, which contrast strikingly with the sword-like iris leaves. At other times there is split-level interest, the long spikes of purple loosestrife towering above terrestrial orchids, ornamental grasses and dense, lush foliage plants. Still later, a sunshine-yellow carpet of rudbeckias appears to switch on the garden lights.

GOOD NEIGHBOURS

The woodland area of this Channel Island garden has yet another ambience, bringing together species from China, Japan and North America. Familiar garden plants such as the sky-blue 'Bill Wallace' geranium, the mauvy-white *Primula sieboldii* and the perhaps less well-known blue-flowered *Omphalodes cappadocica* 'Cherry Ingram' have somewhat unusual neighbours: Judith's collection of around 40 *Arisaema* plants. These tuberous perennials, with their large, weird-looking, hooded spathes, some speckled, some blotched, some dramatically striped, are outstanding feature plants that have fleshy red fruits in autumn. Growing among this collection there are herb Paris (*Paris polyphylla*), a summer-flowering rhizome, and *Podophyllum peltatum*, which has brown, mottled light green leaves and white, cup-shaped flowers in spring.

In the dry garden, where geraniums and sun-loving salvias including many tender species from Central America flourish, there is a sculpture of a young girl, *The Dreamer*, by Kate Denton, affectionately

nicknamed Dilly Day-Dream by the Quérées. Two wire sculptures, a rooster and hen by Rupert Till, perch on the Welsh slate roof of the cottage, and two well-dressed scarecrows re-create a delightful rural encounter at one of the garden fences. A life-sized figure of a gardener clutching a bundle of straw looks completely at ease leaning on the fence, while his scarecrow wife, dressed in a frock and pinny and with arms akimbo, is clearly encouraging him to return to his task.

BEING ORGANIC

For the last four years Judith and Nigel Quérée have been managing three meadows around their property using, as they do in their garden, totally organic principles. Their stewardship is paying dividends. They have revived an old cider apple tree, increased the biodiversity of the land and reduced the noxious weeds that had taken hold. But here as in the garden, as always, Judith says, there is still much work to be done.

TALKING POINTS

Judith takes her gardening skills way beyond the boundaries of her own property. At the RHS Hampton Court Palace Flower Show in 2002 she won a Bronze Medal for her garden 'A Fisherman's Cottage'. With its lavender-edged shingle path, and a box of Jersey Royal potatoes and other vegetables for sale on the wall, it was, Judith says, a faithful representation of a cottage at L'Etacq, St Ouen, close to Creux Baillot. She had another success in 2000 at the

BBC Gardener of the Year competition held in Harrogate, Yorkshire, coming second with her 'Fish Out of Water' creation. Having lived most of her life within walking distance of the sea and understanding how plants struggle to survive in such conditions, Judith chose to create a shingle garden with gentle contours, as if the shingle had been sculpted by the tide, and with driftwood and glass washed up as the flotsam.

CREATING THE LOOK YOURSELF

* One of the most notable of Judith Quérée's collections is that of the unusual and curiously-shaped *Arisaema* plants, which flourish so dramatically in her bog garden. Among them are *A. nepenthoides*, which has speckled spathes, and *A. concinnum* and *A. ciliatum*, both of which have striped spathes.

* The plants are tuberous perennials, which do best in moist but well-drained soil that is rich in humus. They like sun or partial shade, and are fully to half-hardy. Plant the tubers 15cm (6in) deep in spring, and propagate by pulling off and setting the offsets in spring, or by planting seed. Many of the plants produce spikes of fleshy red fruits in autumn and have beautiful umbrella-like leaves, creating further interest.

RIGHT **Every scarecrow tells a story**

EASTGROVE COTTAGE GARDEN

A PROFUSION OF TUMBLING VIBRANT PLANTS WITHOUT A STRAIGHT LINE IN SIGHT

ABOVE **Clusters of tulips accentuate the borders**

Complementing perfectly an old yeoman's farmhouse, this must-see garden has romantically pretty and thrillingly vibrant borders as well as peaceful, away-from-it-all areas.

One could visit this exquisite garden two, three or even four times a year and not capture, even then, every subtle transition in the planting schemes. Cottage garden plants flourish in delightful profusion, merging into each other, tumbling over winding brick paths and scrambling up trees. The garden wraps around the 17th-century, half-timbered farmhouse as if it has always done so, and then meanders off to surround the beautiful brick and timber barn in a more sophisticated way.

The garden is the creation, the dream come true, of Malcolm and Carol Skinner who gave up city life in 1975 to establish first a garden and then a small plant nursery in this rural setting.

WHAT'S THERE:	1-acre flower garden plus meadow, glade and arboretum; nursery selling only home-propagated plants
WHERE:	Sankyn's Green, near Shrawley, Little Witley, Worcestershire, England WR6 6LQ
GETTING THERE:	13km (8 miles) NW of Worcester between Shrawley on B4196 and Great Witley on A443
WHEN TO VISIT:	Usually open 3 afternoons a week in spring and summer, 1 afternoon a week mid-Sep to mid-Oct
CONTACT DETAILS:	01299 896389 (after dark); www.eastgrove.co.uk

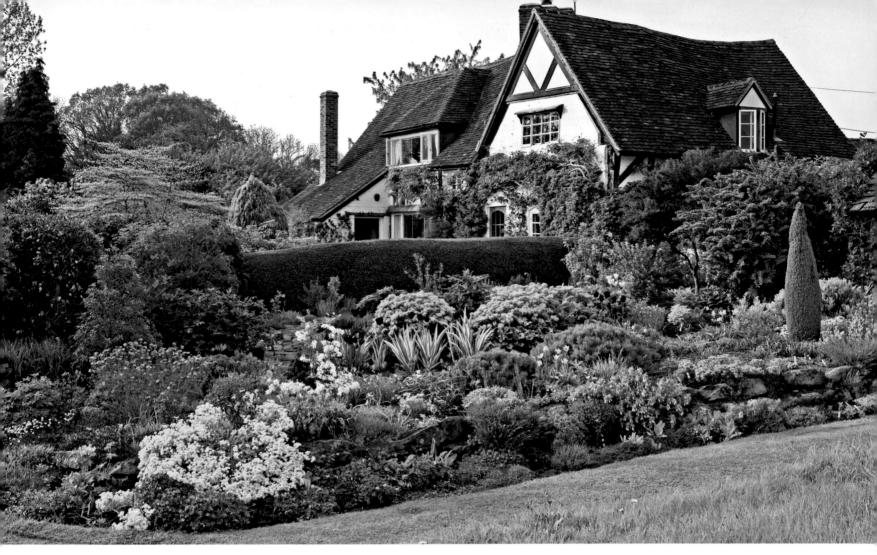

ABOVE **A tapestry of evergreens and rich colours**

WAVY LINES

None of the pathways at Eastgrove Cottage
Garden are straight, no hedges square and
nothing exactly lines up. That is just as it
should be, Carol insists, if the garden is
to complement – as it does so well – the
higgledy-piggledy roofline of the house.
In accordance with this naturalistic
approach,a mixed hedge at least 250
years old and dense with intermingled
hawthorn, holly and privet is always cut
with suitably wavy contours.

USING COLOUR

The Secret Garden, 'trapped' in a recess
in a closely clipped hedge of honeysuckle
(*Lonicera nitida*) and copper beech, is
where Carol most effectively demonstrates
her passion for romantic colourings.
Pretty groupings of pink and burgundy are
created with pink lavender, dark sedum,
burgundy day lilies, heuchera, the crimson-
going-on-purple *Rosa* 'Tuscany Superb',
the single pink and white *R.* 'Eglantine',
and *R.* 'Pink Bells'. Drifts of pale blue are

introduced with *Ruta graveolens* 'Jackman's
Blue' and *Allium sphaerocephalon*.

An exception to her romantic colour
pairings is the area that Carol refers to
as the 'Lloydian hot spot' (after the late
horticulturist and writer Christopher
Lloyd), where the colour progresses from
red through bronze to gold and maintains
the wow factor well into the autumn. In
spring, this hot spot is fiery with tulips
from scarlet to almost brown, with 'Queen
of Sheba' dramatically complemented by

83

ABOVE **Poppies and everlasting pea, a duet of pinks**

variegated comfrey (*Symphytum*) and bronze heuchera. Then 'Red Velvet' roses, salvias and red lobelia merge with bronze fennel and the bronze-leaved *Miscanthus sinensis* 'Yakushima Dwarf'. Late-season flowering is taken over by old hardy chrysanthemums, Kaffir lilies and tiny asters, 'to cool the scheme just a little', as Carol Skinner is happy to explain.

A second hot spot, fully south-facing and jokingly referred to as the Great Wall of China because of its 40cm (16in) sandstone wall, nurtures delicate alpines such as pasque flowers (*Pulsatilla vulgaris*), species tulips, dianthus, sempervivum, sedum and dwarf iris. Adequate drainage is essential, so grit is incorporated when planting.

The 15m (50ft) south-facing 'morning border' is a mixed palette of blue, white, purple and lemon flowers, achieved in spring with tulips and wallflowers, then later with delphiniums, nepeta, salvias, *Achillea* 'Moonshine' and *Dahlia* 'Glory of Heemstede'. This refreshingly 'blue sky and golden sunshine' scheme is viewed against a rich curtain of roses and *Clematis* 'Jackmanii', 'Etoile Violette' and 'Perle d'Azur' reaching skywards on old apple tree trunks.

MAKING STATEMENTS

Planting around the barn is on a larger scale, as befits the size of the building. Statement planting on the south-east side includes *Magnolia grandiflora* 'Exmouth', *Buddleja* 'Crispa', lilac abutilon, double-flowered jasmine and mimosa. The west-facing side is predominantly planted

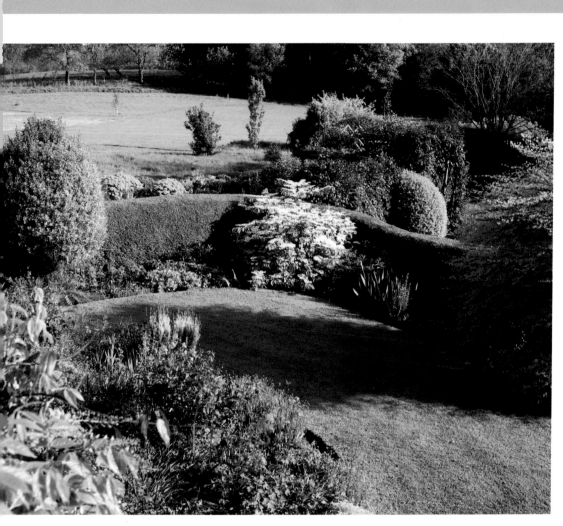

ABOVE **Not a straight line in sight**

ABOVE **The 'thinking stool'**

with camellias, hydrangeas, hostas and rodgersias.

In 1984, with the garden jam-packed with flowers, the Skinners extended the site outwards and planted first a glade and then a grove, which envelops the garden like a protective shawl. More recently, they planted a two-acre arboretum, leaving wide 'rides' and open views. There, they created a grass labyrinth, now mature, in the hope that visitors will wander around it in the way of medieval monks, and find peace.

Seating, musing and creative thinking areas are everywhere at Eastgrove: there are two- and three-seater benches in the flower garden; a 'thinking stool', designed to look like a throne and made from an old Nepalese cartwheel, in the silver birch glade; and a Seat of Hope near the labyrinth. This reflective resting place, planted with betulas and many-coloured dogwoods, was created the day after the disastrous South-East Asia tsunami, in memory of the victims.

CREATING THE LOOK YOURSELF

✳ The Eastgrove Cottage Garden has taken years to plan, modify and mature. To create one with a similar feel, it is a good idea to visit as many open gardens as possible, jotting down any plant combinations that particularly appeal to you. Plan your garden or a garden bed on paper, using long drifts of planting to achieve the maximum effect. Allow an occasional statement plant to stand alone, to give the garden variety and a more natural look. When your garden has matured in summer, make a note of any areas that are not quite as you had hoped, so that you can make adjustments in the spring.

LITTLE LARFORD COTTAGE

BOLD AND SKILFUL USE OF COLOUR CHARACTERIZES THIS ENCHANTING GARDEN

Planted with an artist's eye for perfection, shimmering tulips enhance this country cottage garden wonderfully.

It is not surprising that springtime visitors to this Wyre Forest property nickname it Tulip Cottage. A curving drive to the thatched cottage is lined with wide arcs of tulips; a raised bed is like an artist's palette, colourwashed with groups of tulips, narcissi and primroses composing a subtle blue, pink and white scheme; camellias and other shrubs have a dense underplanting of the glossy blooms; and pots of flowering bulbs are grouped in beds and around the porch. It is a truly breathtaking sight as swathes, drifts and clusters of 20,000 tulips (some 110 varieties) and 2,000 narcissi (some 30 varieties) illuminate the garden through most of April and early May.

The number of bulbs that Lin and Derek Walker plant each year does not faze them. When they moved to the cottage in 2002, they had just retired from their

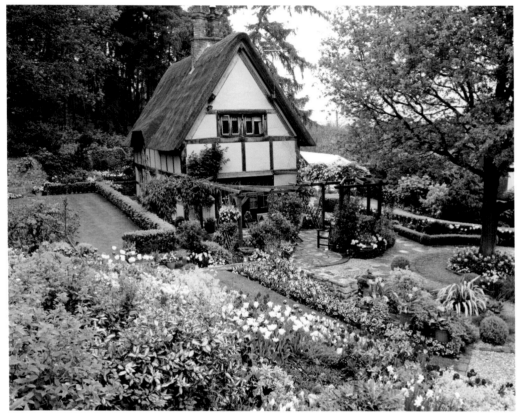

ABOVE **Drifts of tulips against a backdrop of greens**

BELOW *Tulipa viridiflora* **'Green Wave'**

WHAT'S THERE:	½-acre garden, 3-acre woodland and bird sanctuary, meadow; teas on open days; plants for sale
WHERE:	Scots Lane, Astley Burf, Stourport-on-Severn, Worcs DY13 0SB. Access from Larford Lane or Seedgreen Lane
GETTING THERE:	4.8km (3 miles) W of Stourport-on-Severn. A451 from Stourport, then off B4196
WHEN TO VISIT:	Open for National Gardens Scheme and other charities and groups. Private visits by appointment
CONTACT DETAILS:	01299 823270; www.littlelarfordcottage.org.uk

garden centre business and were used to dealing in large quantities, even supplying public parks. Planning for maximum impact, they plant in groups of a minimum of 50 bulbs, more often 75 or 100.

COLOUR SWATCHES

Planning the colour schemes is mainly Lin's task and takes as much time as the actual planting. (Derek says that one person can plant up to 2,000 bulbs a day.) Lin has large colour plates from the suppliers of each named bulb and moves the photographs around, comparing mauve and purple, pink and peach, lemon and yellow, making sure that the tints and shades of each colour are complementary and the relative heights uniform. The underplanting, principally primulas, polyanthus, pansies, violets and forget-me-nots (*Myosotis*), is planned with just as much care and precision, so that the 'ground-cover' plants allow the bulbs to be the show-offs.

When the bulbs have finished flowering and died down, they are all removed (most are given to charities and garden clubs) and the ground and a great number of pots are planted with 45 varieties of lilies (some 1,500 blooms) including oriental, apollo, madonna, pixie and regal types, in preparation for the explosion of colour and scent in July.

BIRD SANCTUARY

Beyond the half-acre planted garden, there is a bird sanctuary in three acres of woodland on the hillside. There are insect boxes, bird boxes and feeding stations,

TULIP PARADE

Lin and Derek Walker lift all the tulip bulbs at the end of the flowering season and make a new selection for the next year, repeating some that have been especially effective and bringing in new varieties. These are among their favourites:
'Angélique': Multiple pink-on-pink long-lasting and scented double flowers resembling peonies; 45cm (18in) tall.
'Blue Parrot': Violet-blue flowers flushed bronze-purple inside and attractively fringed; 45cm (18in) tall.
'Claudia': Pale lavender and deep mauve lily-flowering tulip; 45cm (18in) tall.
'Golden Artist': Golden-orange flowers with broad green stripes; 30cm (12in) tall.
'Happy Generation': Ivory-white flowers with prominent red flames up the centre of petals; deep blue-green foliage edged with silvery-white; 50cm (20in) tall.
'Texas Flame': Parrot tulips, buttercup-yellow flamed with red; 55cm (22in) tall.

and visitors are given a plan and a bird-spotting form to list how many they can spot of the 40-something species that nest there.

SURROUNDING SCENERY

From all around the garden, there are magnificent views towards some of Worcestershire's most magnificent scenery, the Severn Valley. But in tulip time and, later, when the lilies are in bloom, attention is focussed inwards, on the garden at Little Larford Cottage.

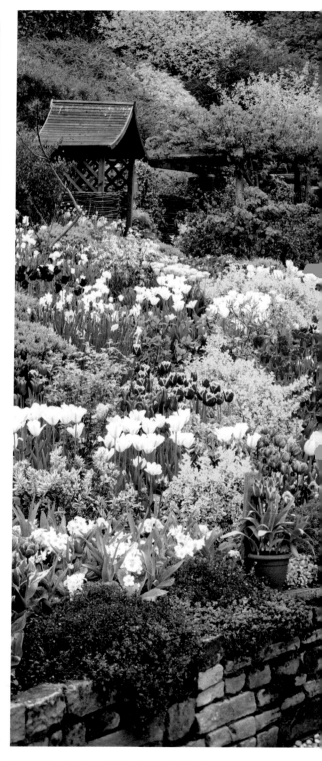

ABOVE **Edge-to-edge planting in a raised bed**

87

WOODCHIPPINGS

BE PREPARED TO FALL IN LOVE WITH THIS IMAGINATIVE GARDEN

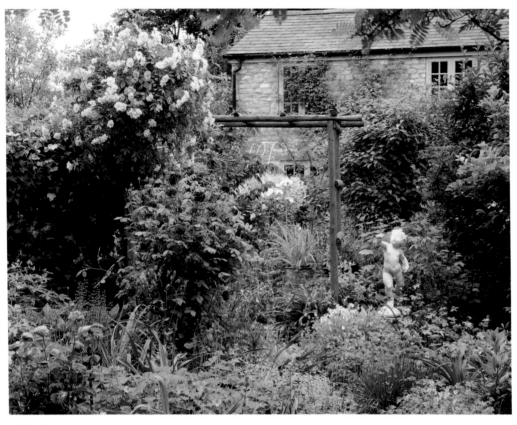

ABOVE **Old roses spread an aura of romance**

In a hamlet with nostalgic literary links, the owners of Woodchippings have created a dream of a country garden.

This is a garden for all seasons, from January and February, when the woodland is carpeted with the showy dark carmine flowers of *Cyclamen coum*, and snowdrops and hellebores, prettiest of all when they are spattered with snow – through springtime, when cherry trees scatter their pink blossom over grape hyacinths and the pink, near-trumpet-shaped flowers of corydalis. Then, in summer, when the beds and borders are packed with grasses and bright perennials, there are visiting plant-lovers scribbling down names, colours and planting schemes.

LITERARY ASSOCIATION

Woodchippings is a plantsman's garden, owned and cared for by Valerie Bexley and Richard Bashford. It has been created on the site of an old orchard, one

WHAT'S THERE:	Third of acre informal garden with year-round interest
WHERE:	Juniper Hill, Brackley, Northants NN13 5RH
GETTING THERE:	4.8km (3 miles) S of Brackley off A43, just after junction with B4031
WHEN TO VISIT:	Open by appointment; very narrow paths not suitable for pushchairs
CONTACT DETAILS:	01869 810170

ABOVE *Meconopsis cambrica* '**Double Orange**'

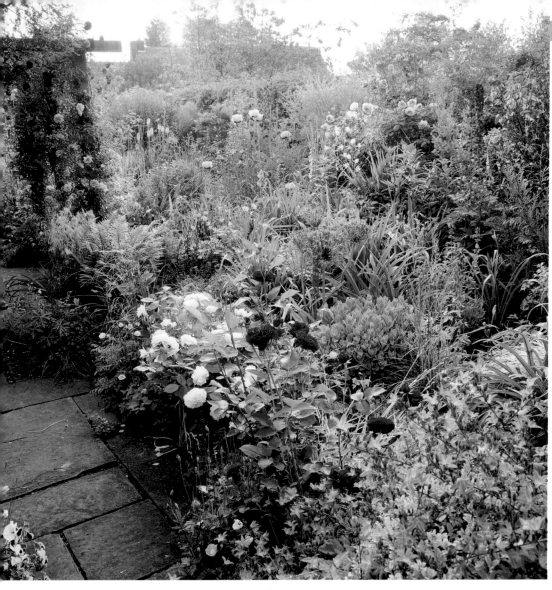

ABOVE **Gloriously uninhibited colour in the flower borders**

DELIGHTFUL INFORMALITY

For all the skilful planting and expert handling, this is a casual garden, clearly labour-intensive yet delightfully lacking in formality. Both the woodland and the intensely planted borders closer to the cottage look so natural that they might just have 'happened'.

Statues are positioned here and there throughout the garden in an informal way, too, with no attempt at classical placement, even though one does resemble a Roman god. Some of the statues – a stone figure of a girl carrying a sheaf of wheat, for example – appear almost as if they have paused for thought for a moment, then became frozen in time wherever they happened to be.

A boy piper nestling against an ivy-covered hedge might have chosen the perfect place to stop – he is the focal point at the end of a pathway. A stone urn giving height and form to a densely planted flower bed is swathed in cascading branches of the English rose 'Teasing Georgia'. Over time it has become so enwrapped in the profusion of soft yellow flowers that they seem to be growing not in the ground but actually in the container.

Metal arches, wooden pergolas and some tree trunks are shrouded in the gorgeous soft blooms of clematis and climbing roses, vertical planting that takes colour and interest in the garden to eye level and above. *Clematis* 'Rhapsody', one of the first to bloom, carries large sky-blue flowers skywards, and a cabin/studio is all but concealed behind a strong pinky-red clematis and the glorious *Rosa gallica* 'Belle Sans Flatterie'.

surely known to the characters in Flora Thompson's *Lark Rise to Candleford*, which was set in the hamlet of Juniper Hill. Some of the old plum trees survive to provide springtime colour, shade and, occasionally, fruit. The essence of a true cottage garden lives on, the beds and borders a-tumble with densely planted species grown for their colour and scent, as well as attracting beneficial insects.

HELLEBORES

Hellebores are one of Richard Bashford's passions, and the garden at Woodchippings is enhanced by many hybrid forms that have been grown from the seed strains he develops. Spanning colours from primrose-yellow through softest pink to duskiest purple, they are all named *Helleborus* x *hybridus* 'Juniper Hill', in tribute to the famous hamlet.

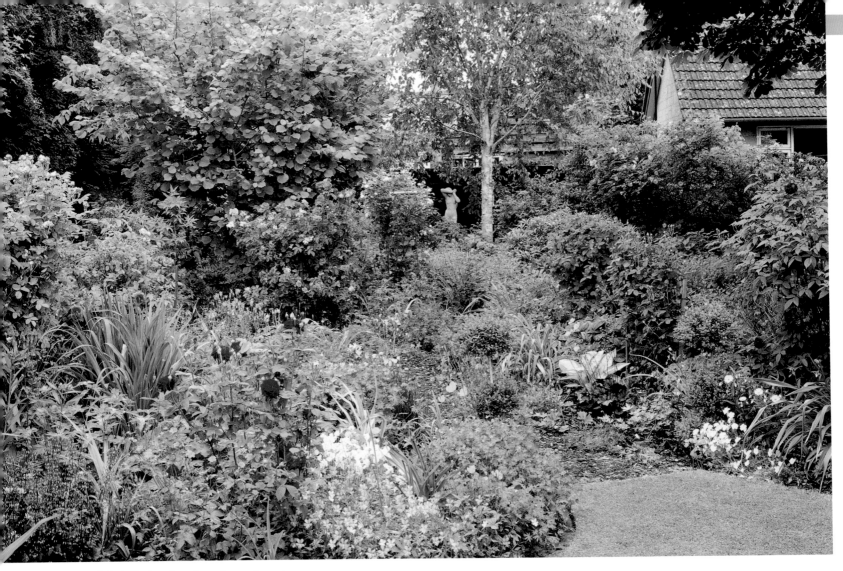

ABOVE **Valerie Bexley plants for colour and scent**

COLOUR PALETTE

The wide borders around the cottage are painterly, irresistible in their gloriously uninhibited use of colour. Tall spikes of terracotta mullein (*Verbascum*), red hot pokers (*Kniphofia*) and blue and white delphiniums tower above purple alliums and pink-frilled oriental poppies. Large clusters of day lilies, another of Richard's passions, have a long flowering season and give continuity to beds where other species come and go. A pathway through the orchard is delightfully encroached in summer by delicate, wild-looking single and double meconopsis, their yellow and orange flowers resembling beacons in the dappled light. And in June, the collection of romantic old roses, many of them French, spreads an aura of romance throughout the garden.

Woodchippings is one of several cottages nestling along a country lane, each tantalizingly obscured behind a tall hedge; this one is the farthest from the road. Enter through a small wooden gate and be prepared to fall in love with this delightful cottage garden.

COTTAGE GARDENING

In her book *Lark Rise to Candleford*, Flora Thompson describes the energy and enthusiasm put into gardening at Juniper Hill at the end of the 19th century:

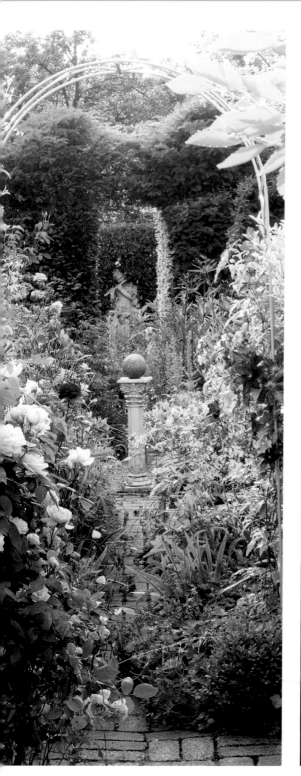

'The energy they brought to their gardening after a hard day's work in the fields was marvellous… Often, on moonlight nights in spring, the solitary fork of some one who had not been able to tear himself away would be heard and the scent of his twitch fire smoke would float in at the windows. It was pleasant, too, in summer twilight, perhaps in hot weather when water was scarce, to hear the swish of water on parched earth in a garden – water which had been fetched from the brook a quarter of a mile distant. "It's no good stintin' th' land," they would say. "If you wants anything out you've got to put summat in, if 'tis only elbow-grease." '

CREATING THE LOOK YOURSELF

* Richard Bashford's displays of sun-loving day lilies (*Hemerocallis*) in this Northamptonshire garden are inspirational. Among his sensational collection there are *H.* 'Coburg Frightwig', a delectable shade of apricot going on peach; *H.* 'Spanish Harlem', a vibrant shade of magenta with golden spots; *H.* 'Janice Brown', with pale to deep pink petals; and *H.* 'Lilting Lavender' (below, near left), its outward-curling mauve petals flashed gold at the centres. They all go to show that there are day lilies for any garden scheme.

* Given favourable conditions, day lilies should flower until late summer. They thrive in a warm position in the garden, preferably in full sun or, at least, in semi-shade. They like a moisture-retentive but not waterlogged soil. You can divide the rhizomes at any time, but it is best to plant them between early and late spring. If they are planted later in the year, they must be well watered throughout the summer.

FAR LEFT **A boy piper nestles against the hedge**

LEFT **Day lily** *Hemerocallis* **'Lilting Lavender'**

CHAPTER 4

COASTAL GARDENS

Lashed by off-shore breezes and drenched in
salty sea-spray or created on the fringe of a balmy
tropical paradise, coastal gardens take their cue
from the environment and are private havens
at one with the prevailing conditions.

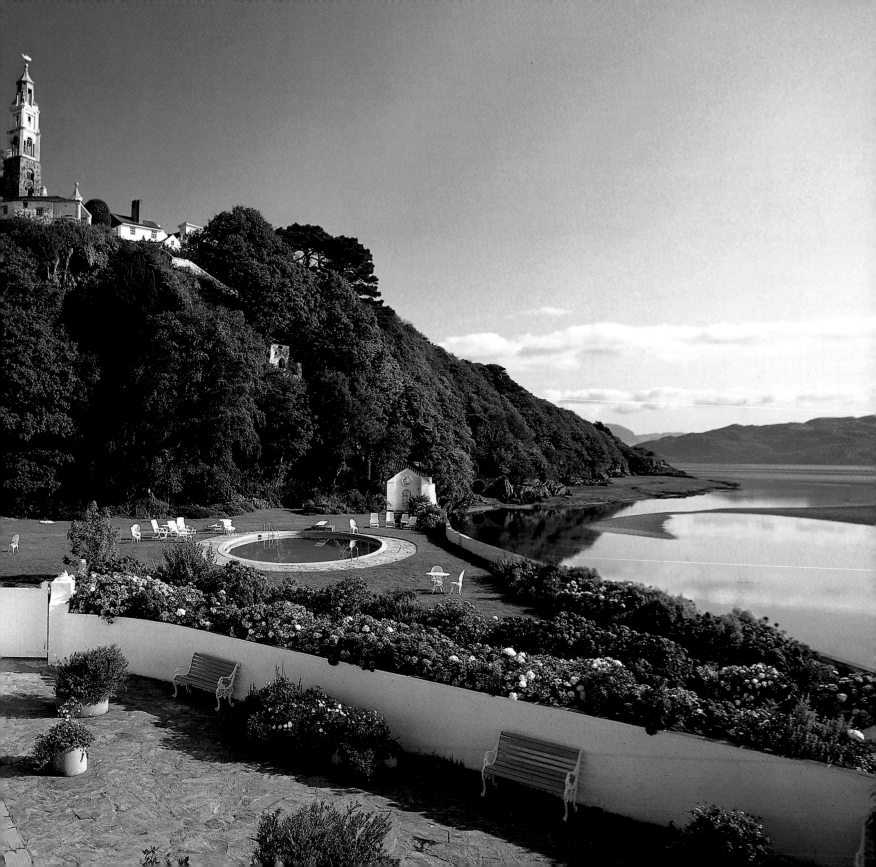

EAST RUSTON GARDENS

THIS GARDEN REACHES OUT TO THE LANDSCAPE AND 'BORROWS' THE LANDMARKS

ABOVE **Porthole view of the lighthouse**

Exquisite and complex, this coastal garden rises elegantly out of acres of unbroken arable land.

Just 2.5km (1½ miles) from the Norfolk coast, there is a garden that, defying the infamous east wind, takes one on an improbable horticultural tour. Protected now by belts of trees and cosseted by dense hedges, there are gardens with the ambience of the Mediterranean, the luxuriance of the tropics, the aridity of the Arizona desert and, in a field spattered with cornflowers and poppies, the nostalgia of childhood. This exhilarating complex of gardens is all the more wondrous because it rises out of an area given over to large-scale cereal farming, where there is no longer any economical place for hedges, ditches and ponds.

Alan Gray and Graham Robeson bought the property in 1973, when the former vicarage had a look of desolation and the surrounding two acres were waist high

WHAT'S THERE:	Outstanding variety of Mediterranean, formal, arid, sunken and woodland gardens, colour-themed borders, meadows and pools; tea-garden; sales of plants propagated by the owners
WHERE:	East Ruston, Norwich, Norfolk NR12 9HN
GETTING THERE:	Off A149, then B1159, near Happisburgh
WHEN TO VISIT:	Usually from Easter until late Oct
CONTACT DETAILS:	01692 650432; www.eastrustonoldvicarage.co.uk

RIGHT **Topiary plays a variety of roles**

in weeds. They saw this as a chance for ambition and imagination to have free rein; a blank canvas on which to create an oasis-like cordon around the Arts and Crafts brick and tile house. At first, they were commuter gardeners, living and working in London, until, in the mid-1980s, they moved in pick, spade and shovel. Within a few years, they were able to buy first one parcel and then another of the adjoining glebe land until now – they say this is the end – the garden and woodlands extend over 32 acres.

WIND PROTECTION

To protect the tender, rare and unusual plants that they grow and propagate, Alan and Graham planted large shelter belts of Monterey pine (*Pinus radiata*), Italian alder (*Alnus cordata*) and many eucalypts, which, as they developed, significantly fostered the microclimate. More protection comes from mixed hedgerows planted for their changing colours and textures and as habitats for birds and other wildlife.

Evergreen hedges, obelisks, blocks, balls and other decorative structures – even a pair of hornbeam 'houses' with pointed roofs and an archway – play a large part in the overall structure of the garden. Decorative they certainly are, but these hedges are wind-defying, too. In a further attempt to cheat the wind, the owners dug into a slope to create a deep, sun-trapping sunken garden with a square, water-filled basin displaying and reflecting a glass and stainless steel sculpture. Large blocks of yew add formality to an area almost hidden from view.

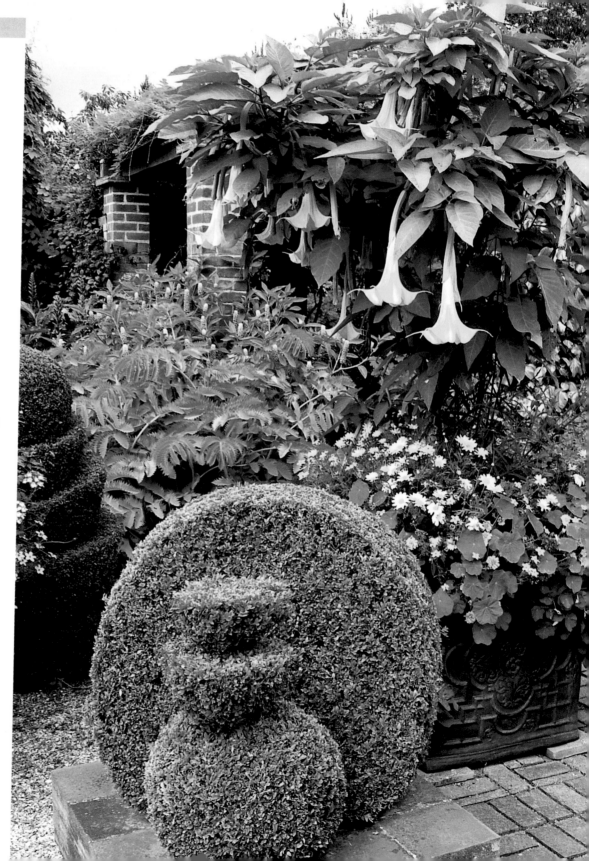

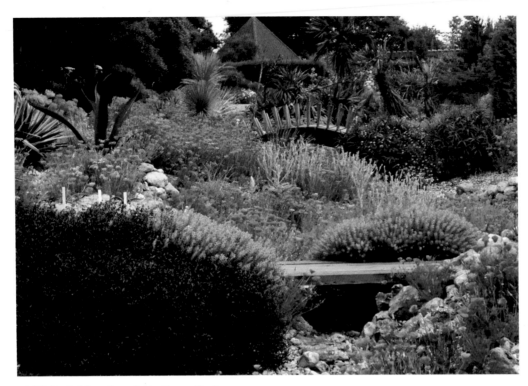

ABOVE **Sun-bright colours in the Desert Garden**

A SENSE OF PLACE

Part of Alan and Graham's vision was to maintain a high level of colour and interest for as long as possible, and to give the garden a sense of place by harnessing nearby landmarks. A porthole in a Monterey pine hedge neatly frames the Happisburgh lighthouse, and the parting between tall poplars at the end of the apple walk seems to enclose Happisburgh church, which is over a mile away, within the confines of the garden.

SCENE CHANGES

The extended season of colour is nowhere better exemplified than in the field and woodland garden, which, criss-crossed by meandering paths, has a naturalistic feel. Several thousand bulbs are planted each year to reinforce the already glorious display of snowdrops and aconites in February. The scene shifts markedly through the changing colours and textures of a collection of hydrangeas in summer, before the golden gleam of autumn takes over with magnificently colourful trees, including liquidambars and black gums (*Nyssa sylvatica*). It is a similar story in the fern garden, where a dense canopy of tree ferns has an understorey that progresses from pink and white hellebores and narcissi through pink hardy begonias to the rich blues of aconitum.

Perhaps the summer belongs chiefly to the (usually) red and purple border, where, in a wooden summerhouse in the centre of a long ribbon of flowering plants, visitors can sit among a profusion of roses, alliums and dahlias. Or perhaps it belongs

DESERT ZONE

It took excavation on an equally arduous scale to create the arid conditions needed to replicate the rapid drainage of the Arizona desert after its occasional rainfall. Layers and layers of gravel, the top one mixed with soil, and hundreds of tons of pebbles went into the preparation of the garden where now, in this East Anglian climate, agaves, aloes, puyas, beschorneria, bear grass (*Dasylirion*) and many varieties of cactus flourish.

MEDITERRANEAN STYLE

Brick walls that retain and reflect the heat cosset a series of south-facing terraces in the Mediterranean garden, where palms, grasses, agapanthus and kniphofia are almost put in the shade, metaphorically speaking, by the 1.8m- (6ft-) long shrimp-pink curving stems of the Mexican *Beschorneria yuccoides* and the 3.6m- (12ft-) high pink- and white-flowering columns of *Echium pininana* from the Canary Islands.

ENCOURAGING WILDLIFE

Ponds and pools have encouraged the return of wildlife, which had long lost its local habitat. Minnows ripple the surface of one of the formal pools; newts, toads and frogs enliven the boundaries of a large natural-looking pond; and fairy-like dragonflies and damselflies flutter and hover. Presenting the gardeners with the greatest compliment of all, a pair of kingfishers has taken up residence.

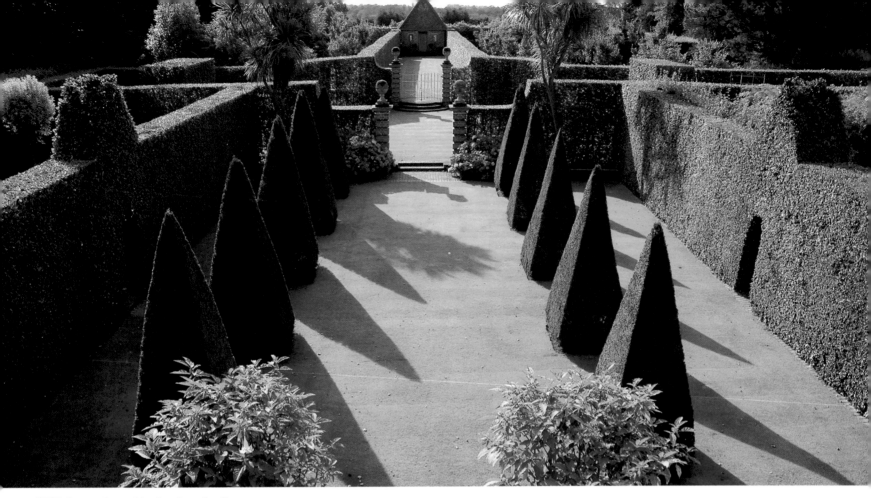

ABOVE **Geometric precision in a formal walk**

to outlying fields-in-miniature planted with rows and rows of sun-worshipping sunflowers and shoulder-high sweetcorn. Forget Norfolk. This could be the south of France.

COLOUR IN WINTER

The Winter Garden at East Ruston Old Vicarage has lessons every gardener can learn. Alan and Graham advise that when planning for winter colour and interest, think leaf, bark and berry, and you can't go far wrong.

These innovative gardeners have planned their winter wonderland by planting birches for their white, cream or rusty red stems; dogwoods and willows for their red, gold and yellow stems; hollies with leaves from deepest green to variegated shades of yellow and cream; and berries from scarlet through orange to gold. The spiky outlines of phormiums in various hues add architectural interest, and grasses that change from green to tan and cream have an ethereal quality. A group of eucalyptus trees, with textural trunks in shades of cream, tan and grey, makes a glistening background of foliage cover, the more so when the garden is touched by frost.

TALKING POINT

The Happisburgh lighthouse, which can be seen through a 'porthole' in the Monterey pine hedge in the East Ruston Old Vicarage garden, was built in 1790 and is the oldest working lighthouse in East Anglia. The tower is 26m (85ft) tall and the lantern 40.8m (135ft) above sea level. The lighthouse is maintained and operated by voluntary contributions.

INCE CASTLE

A GARDEN WITH REFRESHINGLY INFORMAL PLANTING AND ELEGANT SURPRISES

Waves of colour drift through borders, and a flowery meadow seems to merge naturally into the waterside. Spring comes early and winter is soon forgotten in the West Country, where Ince Castle stands on the Ince peninsula, a promontory jutting out into the tidal St Germans River.

The gardens herald this seasonal shift with waves of hellebores, primroses and spring bulbs – purple, mauve and blue, pink, yellow and white – covering glades and woodlands, and lining paths and driveways. And then, in summer, there is a seasonal drift, too, when borders are a luxuriant tapestry of mixed colours, and wild flower meadows lead the eye to the inlet where sailing boats bob on the water.

When Lord and Lady Boyd – Simon Boyd is the second Viscount – moved into the property in 1994, Alice Boyd 'inherited' a garden laid out and tended for over three decades by her mother-in-law. The protecting belt of trees, a

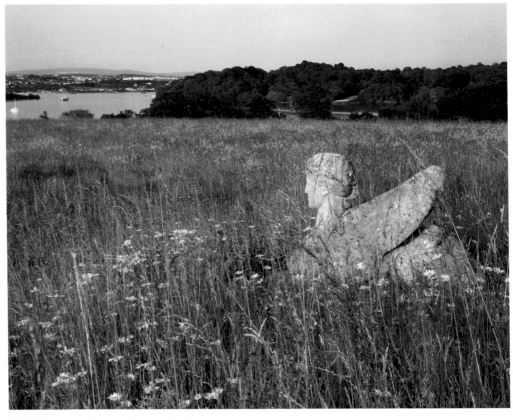

ABOVE **A stone sphinx watches over the flower meadow**

WHAT'S THERE:	9 acres of gardens, ornamental woodlands, wild flower meadow, shell-lined tower, river views; teas on charity open days
WHERE:	Saltash, Cornwall PL12 4QZ
GETTING THERE:	3km (2 miles) from Saltash. From A38 W of Saltash to Trematon and then to Elm Gate
WHEN TO VISIT:	Open for National Gardens Scheme and other charities; groups by appointment; dogs on leads only
CONTACT DETAILS:	01752 842672

RIGHT **The gloriously colourful tea tree**

necessary precaution on this wind- and salt-lashed site, was already in place, with some trees probably dating back to the early 19th century. Many of the outer rims consisted primarily of *leylandii* cypress, which have recently been removed, as other species have now developed enough to take over the protection role. A recent addition of two rows of evergreen oaks will eventually form a cool and shady tunnel beside the summer garden.

MILD CLIMATE

The shortness and relative warmth of the Cornish winters mean that this is not ideal territory for herbaceous plants – they do not have a long enough period of dormancy. For this reason, Alice plants borders with a dense foundation of evergreen shrubs and then adds annuals, half-hardy annuals, bulbs and some perennials. The effect is of profusion, luxuriance and a gloriously harmonious colour mix in the English country garden tradition.

Borders throughout the garden are at their peak from July until October and, because of Alice's clever plant selection, usually continue until well into November. In one border there are recurring clusters of foliage plants such as the variegated *Salvia officinalis* 'Icterina', its pale green and yellow leaves providing a light background for more showy salvias including the bright blue *Salvia patens*, and the gloriously rich and fragrant chocolate cosmos (*Cosmos atrosanguineus*), which flowers late into the autumn.

ABOVE **The terrace at the back of the house**

SELF-SEEDING PLANTS

A terrace around the house is gradually becoming less well defined as self-seeding plants are welcome to stay. These include fat, round hummocks of the white, pink and purple daisy-like flowers of *Erigeron karvinskianus* and the tall, swaying stems of purple-violet *Verbena bonariensis*. A once-straight inlaid pebble path leading past a sundial is similarly invaded, now encroached on both sides by a dense planting of shrub roses, cistus, nicotiana and geraniums. The focal point of the terrace is an 18th-century fountain and, to one side of it, a magnificent Australian tea tree (*Leptospermum*), which is covered in early summer with flowers the colour of ripe watermelon (see previous page).

GARDEN SURPRISES

Throughout the garden there are elegant and intriguing surprises. A beautiful stone seat nestles in a border beside a wide grass path, and an old stone wall running parallel with the river would not look out of place in a cottage garden, as orange eschscholzia, pink ivy and lilac mallow form clumps over and around it. In the midst of a grass and wild flower meadow, where the garden appears to merge into the shoreline, the head of a stone sphinx rises gracefully from a sea of ox-eye daisies, knapweed and bird's-foot trefoil.

Most intriguing of all is the small, tower-like folly that stands at one end of a narrow rectangular pool. The interior walls are completely covered with intricate panels of shells, stones, cross-sections of minerals and other *objets trouvés*, a glowing,

RIGHT **Iridescent murals line the Shell Tower**

AUTUMN TINTS

The deep red and russet tones of autumn foliage are a recurring theme in the late-flowering borders. The arching stems of dark orange crocosmia, scarlet and ruby-red dahlias and yellow and orange kniphofia mingle with annual sunflowers in colours from deep rust to bright gold. Punctuating this abundance of flower colour, there are clumps of the castor oil plant (*Ricinus communis*), whose large glossy leaves give solidity and structure to the planting.

SUMMER SPLENDOUR

The walled garden at Ince Castle is still part kitchen garden, part orchard. Here, there are more borders that become particularly resplendent in the summer months, when a spectacular purple, magenta and lime-green colour scheme is effected with the use of deep mauve buddleia, catmint (*Nepeta* x *faassenii*), the dark-flowered *Geranium psilostemon* and the refreshingly yellowy-green *Euphorbia schillingii* and lady's mantle (*Alchemilla mollis*).

iridescent mural of items collected by Simon's father, Alan Lennox-Boyd, who was Secretary of State for the Colonies in the 1950s and the first Viscount Boyd.

BREATHTAKING VIEWS

Viscount Boyd and his wife Lady Patricia Boyd bought Ince Castle in 1960 but it was not until 1995, when Simon and Alice Boyd lowered the ground to the east of the property, that the spectacular shoreline could be seen from the house. Now on the horizon in one direction it is possible to see Plymouth, and in the other direction, over the water, there is a pastoral scene of patchwork fields, pine woods and cottages watched over by two sphinxes.

THE TEA TREE

The glorious red-flowering tea tree growing close to the terrace at Ince Castle is one of the *Leptospermum* genus, which is native to south-east Australia and New Zealand. It is said that Captain Cook infused the small evergreen leaves to make a tea-like drink. The tea tree can grow to a height of 15m (50ft) and is able to withstand strong winds, although it needs the protection of other trees from maritime exposure.

INCE CASTLE

A castellated manor house rather than a true castle, Ince Castle, with its four three-storey towers, battlements and 1.2m- (4ft-) thick walls, was built at the beginning of the English Civil War in 1642 for Henry Killigrew, the Royalist Member of Parliament for Looe in Cornwall. The property was later run as a farm but by the late 19th century had fallen into disrepair. Severe fire damage in 1986 necessitated the rebuilding of the roof.

INVEREWE

YEAR-ROUND COLOUR AND INTEREST CHARACTERIZE THIS SPECTACULAR SCOTTISH GARDEN

ABOVE **A shoreside walk through the gardens**

Set amid some of Scotland's most glorious coastal and mountain scenery yet lashed by North Atlantic gales, Inverewe is the triumphant result of a Victorian Highlander's determination to overcome the elements.

Swathes of herbaceous borders, with drifts of magenta flowers merging into blue then orange; woodland walks, with exuberant splashes of rhododendron colour; ponds, bog gardens and leafy glades; a walled garden, with an improbable mix of cottage garden plants and exotic bulbs – all this and more now delights visitors to these gardens that perch on a rocky peninsula above the shores of Loch Ewe.

Inverewe is the result of the rugged determination of one man, Osgood Hanbury Mackenzie, to overcome both probability and practicality. When the 20-year-old Osgood, the younger son of Sir Francis Mackenzie, Laird of Gairloch,

WHAT'S THERE:	50 acres of inspired planting on reclaimed moorland; visitor centre, shop, restaurant (open Easter to Oct)
WHERE:	Poolewe, Ross-shire IV22 2LQ
GETTING THERE:	On A832, 9.6km (6 miles) NE of Gairloch
WHEN TO VISIT:	Usually open daily all year. Rhododendrons: Apr, May, Jun. Free guided walk each weekday at 1.30pm mid-Apr to mid-Sep
CONTACT DETAILS:	01445 781200; www.nts.org.uk/inverewe

acquired the 12,000-acre site in 1862, it was barren moorland and rocky coast. Fierce, salt-laden gales blew in from the Atlantic, burning and shrivelling any tender leafy plants in their path.

More than a century later, Inverewe is considered one of the most spectacular gardens in Scotland. It hosts a national collection of olearias, one of the most comprehensive collections of acid-loving rhododendrons in the United Kingdom (most notably the scarlet, winter-flowering *Rhododendron barbatum*, with its dramatic wine-red trunks) and a significant collection of ourisias – one variety of which is named 'Loch Ewe'. From spring to autumn and even in winter, the garden has both colour and interest.

COLOUR PLAN

In spring, snowdrops and snowflakes, dwarf daffodils, crocus and Californian dog's-tooth violets bloom along path edges and throughout the dappled woodland. In May and June, the blended fragrances of Mexican orange blossom (*Choisya ternata*), deciduous yellow azaleas and the strong honey scent of Madeiran spurge drift across the garden. By summer, in the Walled Garden, the herbaceous borders dazzle with a mingling of flowers, herbs and vegetables. Clematis and climbing roses clamber over pergolas, and a row of *Rosa* 'Silver Jubilee', underplanted with lavender-coloured nepeta, makes a beautiful central feature.

In autumn, banks of predominantly blue and purple hydrangeas create a cloud-like effect, scarlet maples enflame many a vista,

ABOVE **Waves of alpine rhododendrons in 'America'**

and the Tasmanian climber *Billardiera longiflora*, its greenish-yellow flowers long past, hangs with deep blue-purple fruits. Then, in winter, there is more colour on a grand scale, with the rose-red blossoms of frost-hardy *Rhododendron* 'Nobleanum'.

IMPROVING THE SOIL

While still building his Victorian mansion, which faced south towards the Torridon

mountains and his favoured stalking grounds, Osgood set about improving the impoverished soil by adding a mixture of peat, seaweed, manure, plant clippings and, as folk memory has it, loam brought by boat from Ireland. Ever since, in an area with an average annual rainfall of around 2m (78in), tons of mulch are needed each year to replace the leached soil and continue to nurture the plants.

HERBACEOUS BORDERS

High walls of the local pink-coloured sandstone were built to shelter Osgood's first venture, a south-facing, one-acre walled garden constructed on a former glacial raised beach. Conceived on almost cottage garden lines, yet using plants from around the globe, this area has scarcely changed today. Huge decorative cabbages and aromatic herbs grow in harmony with delphiniums and geraniums, Chatham Island (New Zealand) giant forget-me-nots and American cannas. A profusion of red hot pokers, blue Himalayan poppies, iris and agapanthus, purple alliums, orange crocosmia, day lilies and tall, feathery bronze fennel composes a thrilling palette.

A further luxuriant herbaceous border runs along the front of the current Inverewe House (the original mansion burnt down in 1914). Osgood's daughter Mairi, who inherited his estate when he died in 1922 and also his passion for gardening, created a courtyard garden in the ruins. Closer still to the shore and often lapped by the tide, there is a rock garden that experiences the full force of salty storms.

TREE CANOPY

In an area with a latitude of 58°N, more northerly than Moscow and only 965km (600 miles) from the Arctic Circle, a substantial windbreak was essential. Osgood planted over 100 acres of mainly salt-tolerant Scots and Corsican pines with, further inland, copses of alder, beech, birch and oak. It took over 20 years to establish the tree canopy. Only then could clearings be cut to create dense clusters of brilliant colour. Osgood loved the large-leaved rhododendrons newly introduced from China and the Himalayas. Some specimens of his 19th-century planting still flourish, notably *Rhododendron hodgsonii*, which reaches a height of 10m (30ft) and bears rose-magenta flowers through April and early May. Next to a rare rhododendron from Sri Lanka, in the area curiously named Bamboosalem, Osgood dedicated the only inscribed stone in the garden to the peace achieved at the end of World War I.

LEFT **A study in contrasting forms and textures**

ABOVE **Candelabra primulas and irises in a bog garden**

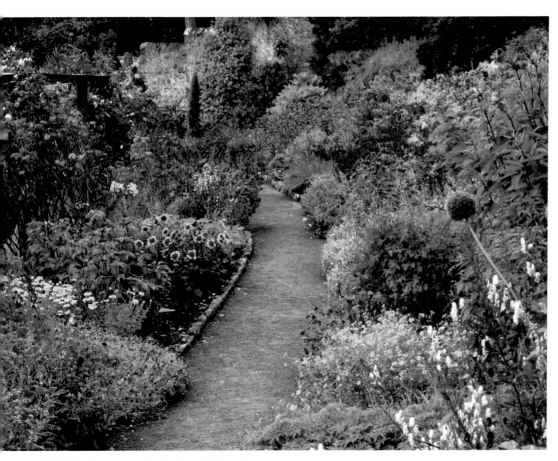

ABOVE **Herbaceous borders in the walled garden**

SHOWPLACE

Over a period of 90 years and with, it must be said, a little assistance from the warm currents of the North Atlantic Drift, father and daughter created a magnificent showplace that defied the elements. In 1952, a year before her death, Mrs Mairi Sawyer handed over the garden and part of the estate to The National Trust for Scotland to ensure that it would continue to welcome and delight visitors all year round.

CREATING THE LOOK YOURSELF

* Rhododendrons, such a magnificent feature of the Inverewe gardens, make a wonderful late winter or springtime display, whether planted in a border or a container. They are, variously, evergreen, semi-evergreen or deciduous shrubs - these last are popularly called azaleas - and range from dwarf to almost tree-like proportions like the ones in the Inverewe woodland clearings. All rhododendrons need a soil that is neutral-to-acid, preferably rich in humus, and well drained; they cannot tolerate lime. Most prefer dappled shade but some will thrive in full sun, especially in cooler climates.
The flowers may be double, semi-double or single and colours vary from deep magenta through bright red and orange to pale pink, cream and white. To encourage plant growth, remove dead flower heads.

From the outset of the project, Osgood realized the importance of height in a garden of this size and dramatic scale and, in holes that were hewn out of the bedrock, he set about planting the mighty Tasmanian and Australian eucalyptus, now reputed to be some of the largest-growing trees in the world.

He also carefully sited a number of rare and tender palms in order to maximize and enhance the drama of their jagged silhouettes, while edging the bog garden with giant gunnera, contributing their own dramatic outlines.

TRANSATLANTIC FEATURE

Once thought to have been planted by Osgood's daughter Mairi in honour of US servicemen stationed in the area during World War II, an area called 'America' is now known to have been planted by Osgood in 1898 as a home for a range of American plants. Its crowning glory is a massive turkey oak (*Quercus cerris*), which might now have reached its full potential height of 30m (100ft). Other plants in this most sunny and sheltered area include alpine rhododendrons, Japanese and other maples and South American bromeliads.

JARDINS DE MÉTIS

PLANTS FROM ALL OVER THE WORLD INHABIT THIS CANADIAN GARDEN OF CONTRASTS

ABOVE **The stream garden**

A desire to enjoy exotic and tender plants from around the world and an appreciation of native species prompted a determined Canadian gardener to create a unique shoreside haven.

Tantalizing glimpses of the St Lawrence River; a glorious profusion of many-hued spring bulbs as soon as the snows melt; rare heavenly blue Himalayan poppies carpeting a glade; blowsy peonies from a decades-old collection and, everywhere, refreshingly modern garden art – that is the legacy of an historic garden on the scenic Gaspé Peninsula.

The property, on the confluence of the St Lawrence and Métis rivers, came into the hands of Elsie Reford, a passionate gardener, in 1918, and it has since become a showplace for over 3,000 species and varieties of native, exotic and tender plants, many shipped from all parts of the world. Winding paths link separate gardens, each designed to show a selected group of plants to best advantage. Plants from Burma, China, Tibet and the Himalayas grow side by side with indigenous species.

EMERGING FROM WINTER

The garden comes alive when the first snows melt in May. Then there are palettes of daffodils, tulips, grape hyacinths, basket-of-gold (*Aurinia saxatilis*) and rockcress (*Arabis caucasica*). An azalea walk thickly planted with rhododendrons imported from England displays these bright-flowering bushes in almost miniature form – the heavy snows inhibit their growth to little above 2m (6ft) but do not diminish their flowering.

HIGH-ALTITUDE PLANTS

One of the rarest imports, the Himalayan blue poppy (*Meconopsis betonicifolia*) has a long history of success in the garden. The offspring of plants that Elsie grew from seed in the 1930s, they bloom from mid-

WHAT'S THERE:	Recreated 40-acre historical garden with contemporary art; cafe, shop
WHERE:	Grand-Métis, Québec, Canada G0J 1Z0
GETTING THERE:	On Route 132 on S shore of St Lawrence River
WHEN TO VISIT:	Open daily from end May to early Oct. International Garden Festival end Jun to early Oct
CONTACT DETAILS:	(001) 418 775 2222; www.jardinsmetis.com

ABOVE **Himalayan blue poppy** RIGHT **Allée Royale**

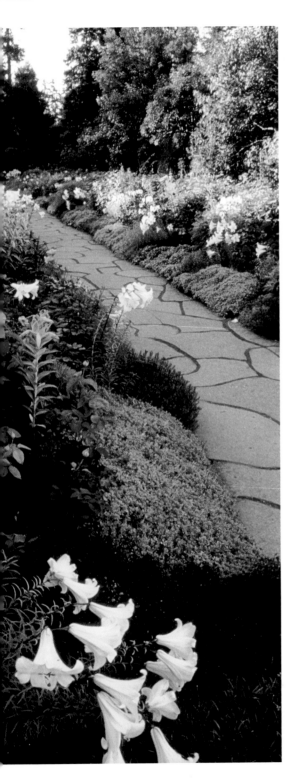

June to the end of July between martagon lilies (*Lilium martagon*) and maidenhair ferns (*Adiantum pedatum*). Native to the high altitudes of Tibetan mountains, their success here is attributed to the combination of humidity and cold night air.

A rock garden, or scree, is planted with more high-altitude plants. Of particular interest is a collection of dwarf alpines including lilies and gentians, among them the glorious trumpet-shaped, rich blue flowers of *Gentiana sino-ornata*, *G. septemfida* and *G. cruciata*.

ROMANTIC CAMEO

This is a garden of contrasts in which both alpine flowers and those regarded as country garden species are equally acclimatized. A Long Walk, which promises a tree-framed view of the St Lawrence at its conclusion, is bordered on either side with sloping beds of perennials. Lilac, delphinium, lilies, peonies, phlox and roses compose a romantic cameo, planted in a style that has more than a hint of renowned garden designer Gertrude Jekyll's influence.

ACCOUNT BOOK

Elsie kept a detailed diary of her plant and seed purchases, their flowering times, successes and any failures, a record that has enabled the present stewards of the garden, Les Amis des Jardins de Métis, to catalogue the present-day planting and, where necessary, to restore the garden with complete authenticity. For example, her notes on the 42 different peonies in the garden are enabling specialists to identify

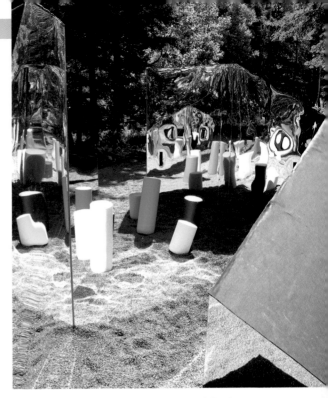

ABOVE **Works of art, en route to the Festival Garden**

those that remain, including the double 'Festiva Maxima' with its white-blotched-with-crimson blooms and the arrestingly beautiful 'Sarah Bernhardt', which has fully double rose-pink flowers.

PRACTICAL ART

As part of efforts to conserve and restore the shoreline below the gardens on the river, five mammoth boulders have been put in place, each engraved by artist Bill Vazan with botanical hieroglyphics and looking more like works of art than articles of practical necessity. Pieces of garden art by leading artists and sculptors add to this garden's unique quality, and since the year 2000 designers from around the world have converged at Grand-Métis to create temporary gardens as part of the three-month-long International Garden Festival.

LE BOIS DES MOUTIERS

RHODODENDRONS AND OTHER ACID-LOVING SPECIES ON AN ARTS AND CRAFTS ESTATE

Created on the favourably acid soil of the region, this exciting Arts and Crafts garden in Normandy has become widely known for its stunning display of magnificent rhododendrons.

It is small wonder that Guillaume Mallet, an amateur botanist from a Protestant banking family, fell in love with this estate at the end of the 19th century. With its commanding position high up on the magnificent Normandy coastline, established woodland, mild maritime climate and, most of all, vertiginous views across the English Channel, it proved irresistible – especially to a man who, having spent part of his childhood on the Isle of Wight, was fascinated by the geological structure of cliffscapes.

Mallet commissioned Edwin Lutyens, then only 29 years old, to design an Arts and Crafts house and to plan the structure of the park and gardens – the layout of the paths, the pergolas and pavilions.

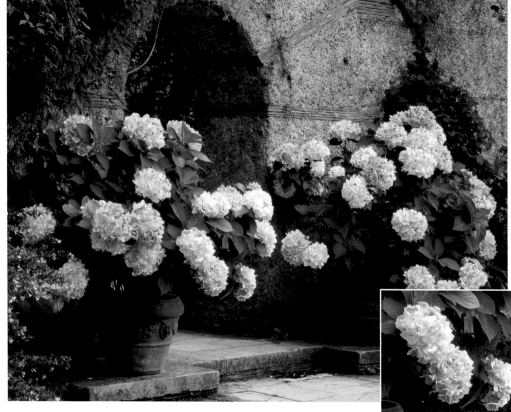

ABOVE 'Mme Emile Moullière' hydrangeas adorn the arch

WHAT'S THERE:	24-acre Arts and Crafts gardens and park overlooking the English Channel
WHERE:	Route de l'Eglise, 76119 Varengeville-sur-Mer, Normandy, France
GETTING THERE:	7km (4¼ miles) SW of Dieppe, 1km (¾ mile) from Varengeville-sur-Mer railway station
WHEN TO VISIT:	Usually open daily mid-Mar to mid-Nov
CONTACT DETAILS:	(0033) 2 35 85 10 02; www.boisdesmoutiers.com

The 'icing on the cake', the vivacious planting scheme, was created by Lutyens's design partner Gertrude Jekyll.

TREE SCULPTURE

The boundaries of the park were defined, decorated and sculpted by a mixture of mature plantings that Mallet himself brought together: evergreens to provide year-round colour, structure and form, and deciduous trees, many of them rare species from around the world, selected for their leaf shape and autumn glory. A succession of valleys dipping down to the coast is similarly planted, with rare trees, shrubs and perennials, flowering dogwoods and fragrant-flowered eucryphias among them – truly an arborist's walk.

GARDEN ROOMS

The gardens are divided into a series of intimate rooms defined by neat walls and meticulously well-clipped hedges, some with cut-out, porthole-like windows and with deeply dished tops – all the better to admire the views. A clipped yew 'lookout post' on one side of the house, described by Guillaume Mallet as a fairy cage, was designed to give a bird's-eye view of lower plantings.

FLORAL FIREWORKS

Jekyll introduced ferns, a whole spectrum of perennials, wisterias – and rhododendrons. Made possible by the naturally acid subsoil of the Pays de Caux region, the garden is, a century later, widely known for the magnificence of its rhododendrons and other acid-loving

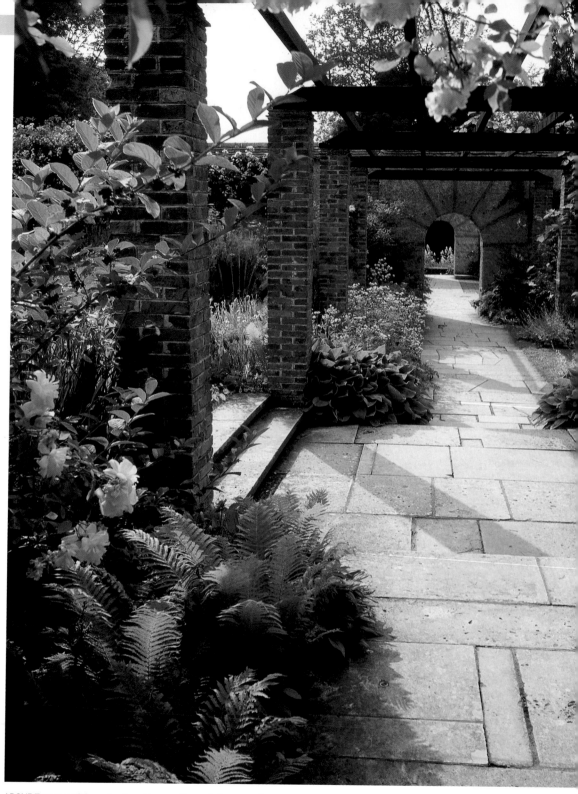

ABOVE **Roses and ferns beckon the way through the pergola**

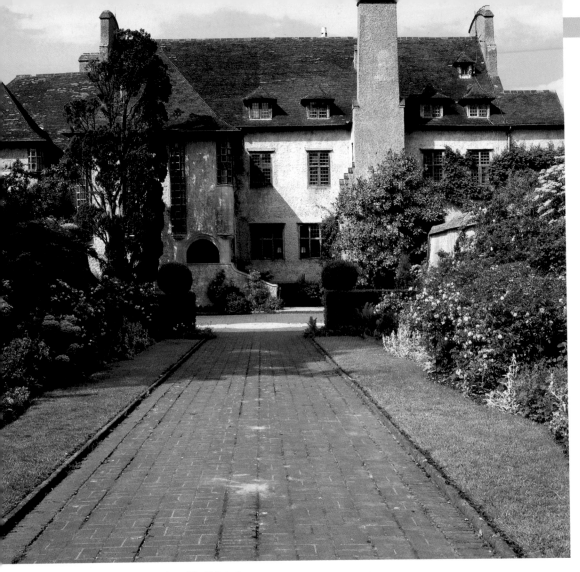

ABOVE **The house, designed by Edwin Lutyens**

species. One rhododendron bank, densely planted with the most glorious flowering bushes, measures 80m (87 yards) long and 15m (17 yards) high – an explosion of thrilling colours that has the breathtaking impact of a floral fireworks display. An individual shrub so densely covered with flowers that the leaves are almost invisible has been described variously as being the size of a house and of a double-decker bus – impressive.

DIARY DATES

The calendar at Le Bois des Moutiers is irrevocably marked by the flowering seasons: camellias come into flower in this mild climate from as early as February and have an exceptionally long flowering time; magnolias burst into bloom in March and April; and the rhododendrons and azaleas, many from the Himalayas and from China respectively, explode into flower in May and June. June is also the month for the

riot of roses – many selected by Jekyll for her original planting scheme – and for hydrangeas that colour-wash the woodland walks with their subtle hues.

A circular walk through the gardens and park takes in one planting scheme after another. On gently sloping paths, wander down through a sweep of meadow and wooded glades to the bog garden where, in summer, astilbes flourish and Japanese iris blaze against the giant umbrella-like leaves of gunnera. Climb up through a pink-, blue- and white-spattered wild flower meadow, and walk through avenues of hydrangeas and, eventually, you find yourself back at the house, looking across the parkland and admiring the misty English Channel seascape. No wonder Mallet found this place irresistible.

Since it was first bought by this visionary botanist, the property has undergone a number of vicissitudes but it is now as elegant as ever. During World War II, the house and grounds were forcibly occupied and the park mined, necessitating many years of restoration work by generations of the Mallet family. And during the great storm of October 1987, many of the treasured trees were felled and parts of the woodlands devastated. Mallet's great-grandson Antoine, now in charge of Le Parc du Bois des Moutiers, has undertaken a thorough restoration programme, replacing many of the pines and other species. Surely it is irresistible to the prospective visitor, too.

RIGHT **Shrubs paint the woodland pink**

ABOVE *Hydrangea macrophylla* 'Grayswood'

CREATING THE LOOK YOURSELF

* Hydrangeas, which make such an impact in wooded areas of this Normandy garden, present something of a challenge since they naturally change flower colour – between pink, red and blue – according to the pH of the soil. Given favourable conditions, and when growing in the wild, they mutate naturally.

* They are happiest in moist, well-drained and humus-rich soil. Plant them in full sun and they might flower for three or four weeks; plant them in light shade, particularly in the microclimate created by light tree cover, and they might flower for three months.

* Hydrangeas benefit from a mulch of finely chopped pine bark and should ideally be fed with well-rotted manure or an acidic fertilizer.

MILLE FLEURS

A POTPOURRI OF COTTAGE GARDEN FLOWERS AND SUB-TROPICAL PLANTS

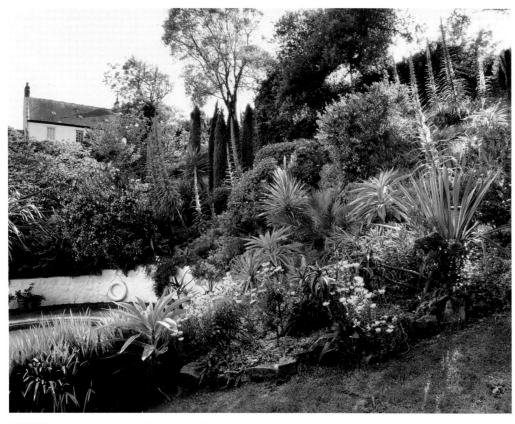

ABOVE **Vibrant colours surround the swimming pool**

Taking advantage of a favourably balmy climate, this Channel Island garden moves effortlessly from conventional cottage planting to sub-tropical exotics.

The name of the traditional Guernsey farmhouse, Mille Fleurs, is defined as 'a pattern of many different colourful flowers, leaves and vines' or 'a perfume distilled from several different kinds of flowers'. The garden that Jane and David Russell have created there lives up to both definitions. Their two-and-a-half-acre garden is a blissful potpourri of cottage garden flowers and sub-tropical plants, many inspired by their travels to Thailand and South Africa, and all equally at home in this benevolently mild climate.

The farmhouse is settled on top of a steeply wooded conservation valley and has views across a reservoir, which attracts many different bird species, to a nature reserve beyond. When the Russells moved to the property in 1985, their first task was

WHAT'S THERE:	2½-acre traditional and sub-tropical planting
WHERE:	Rue du Bordage, St Pierre du Bois, Guernsey GY7 9DW, Channel Islands
GETTING THERE:	From St Pierre du Bois village, take road signed to Rocquaine Bay, then 3rd road on right, La Rue de Quanteraine; fork right at The Granary
WHEN TO VISIT:	Open for charities, or by appointment
CONTACT DETAILS:	01481 263911; www.millefleurs.co.uk

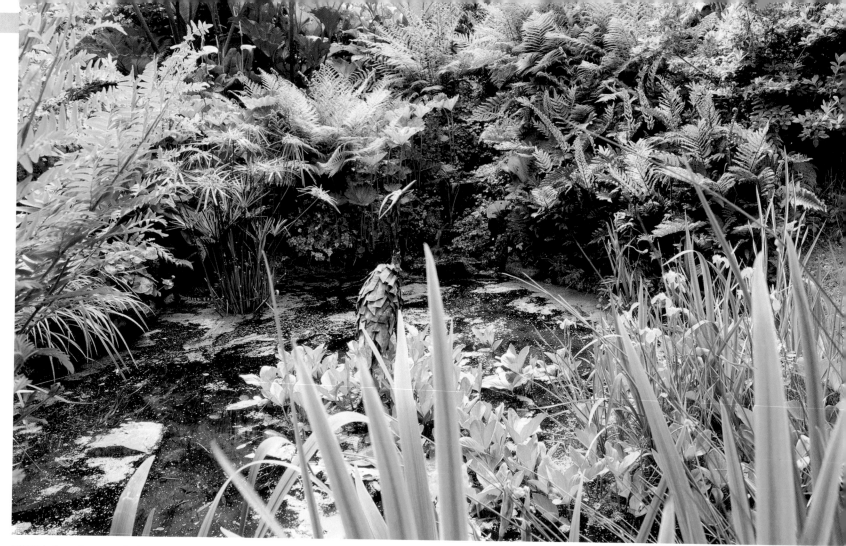

ABOVE **A decoy heron wades into the pool!**

to clear away the thicket of uncontrolled undergrowth and expose the existing network of paths and terraces. Their second was to begin planting a strong framework of native trees such as oak and ash to give form and structure to the garden and provide a habitat for birds and other wildlife. With those elements established, they created a garden that is in parts as romantically pretty as any cottage garden, and in parts excitingly, uncharacteristically lush.

FLORAL BOUQUETS

Around the farmhouse and the three holiday cottages neatly tucked away in a corner nearby, the planting becomes unashamedly conventional – the traditional roses-around-the-door kind. *Convolvulus sabatius* throws its enveloping purple and green cloak so effectively over the wall of the house that the windows seem like peepholes, and roses, honeysuckle and jasmine give veracity to the 'distilled perfume' definition.

PLANTING CONTRASTS

A series of paths zig-zags down the side of the valley, levelling out at first one terrace and then another, each offering a breathtaking view. At the bottom of the valley, an area that the owners have dubbed the jungle, tender and sub-tropical plants flourish in a sheltered microclimate, with palms, cannas, gingers and bananas creating a density of lush foliage. Here, a 100-year-old Tasmanian blackboy or grass tree (*Xanthorrhoea*) was the main attraction

until one of Jane's newest acquisitions, a blue hesper palm, replaced it and took on the starring role. In another corner of the garden, in complete contrast to this showcase of exotics, there is a bluebell and wild flower copse, a hazy sea of blue in spring and, when the foxgloves are in flower, a mixed colour-washed palette in early summer.

CHANGE OF ENVIRONMENT

Three small ponds fed by natural springs are the focus for a tree fernery and bog garden, inspired by a visit to the Lost Gardens of Heligan in Cornwall. Mature tree ferns stand tall, casting the shade of their giant umbrellas over astilbes, bog primulas, hostas, gunnera and other moisture- and shade-loving plants. Cut into a sloping, sun-filled lawn, the South African border, too, is planted with species far from their natural milieu, with peach-coloured diascias, restios and protea among them all looking perfectly at home. In this sun-trapping area of the garden, a swimming pool glistens beside a bank of dry, arid soil that has been intensely planted with more sun-loving plants, creating a gold, orange and yellow curtain. Gazanias and crocosmia spatter the bank with colour, while phormium and aloes give shape, and a large mature fig tree presides. Terracotta pots around the pool, planted with brilliant red pelargoniums, seem to turn up the heat. There is nothing random about Jane's choice of colours, and nowhere is there a jarring note. Colours progress seamlessly from this riot of fiery hues back through a series of colour-themed areas before returning to the comparative calm of the plants enveloping the house.

BACK TO BASICS

The ground around the farmhouse was once a cider orchard. During World War II, it was given over to intensive fruit and vegetable production until, like the rest of the garden, it became overgrown. A part of it is productive again. The Russells have recently extended a fruit, vegetable and cutting garden to provide produce and flowers for the house and their self-catering guests, as well as, they say wryly, for the birds and rabbits. Apart from the island's famous 'Guernsey Tom' tomatoes, which are a 'must', they experiment with less everyday crops such as melons, sweet potatoes, Thai chillies, Chinese artichokes, custard squash and borlotti beans. In the vegetable garden, as in the rest of the acreage, there is a successful marriage of the familiar and the exotic.

LEFT **The peeling bark of** *Luma apiculata*

ABOVE **The fan-shaped fern** *Todea barbara*

ABOVE **Tall spires of fastigiate conifers**

CREATING THE LOOK YOURSELF

❋ After Jane and David Russell had
cleared the tangle of brambles, they
waited a year before creating their
garden to 'see what came up'. Even
the most unpropitious plot might have
hidden treasures that will emerge
months later and so, they advise, it
pays to be patient. Their patience
was rewarded by the discovery of
many path-edging 'true' Guernsey
lilies (*Nerine* 'Corusca Major'), a large
fruitful fig tree, a beautifully positioned
and sweetly scented myrtle (*Luma
apiculata*) and, among the evergreens,
trachycarpus, summer-flowering palms
and many fastigiate junipers.

RIGHT **Roses round the cottage door**

YEWBARROW HOUSE

YEAR-ROUND COLOUR AND INNOVATIVE FEATURES ADD UP TO A COASTAL HAVEN

ABOVE **A lizard sculpted against a rock**

RIGHT **Dahlias make a brilliant swathe of colour**

So very much at home in its northern landscape, the garden at Yewbarrow House has some truly exciting areas of exotic planting.

The sand and sea merging with the far horizon over Morecambe Bay seem to compose a blank canvas against which Jonathan Denby has painted his vibrant and ever-changing garden. The use of local slate and limestone to create snaking paths, dividing walls and structural features gives the four-and-a-half-acre garden of Yewbarrow House a fitting sense of place, a carefully planned space entirely at one with its surroundings.

In only eight years, the area that previously saw its heyday in Victorian times has been transformed from a near-wilderness of brambles and unkempt trees and shrubs to a garden and woodland with real purpose. The purpose – the owner's vision – was to create a coastal haven with year-round colour, a variety of moods and,

WHAT'S THERE:	Themed gardens, including Italianate and Japanese; fernery
WHERE:	Hampsfell Road, Grange-over-Sands, Cumbria LA11 6BE
GETTING THERE:	Just off the B5277
WHEN TO VISIT:	Open under National Gardens Scheme, usually first Sun in Jun, Jul, Aug, Sep, or by appointment
CONTACT DETAILS:	01539 532469 www.yewbarrowhouse.co.uk

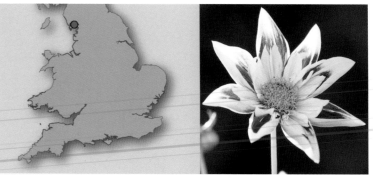

ABOVE **'Fashion Monger' dahlia**

to the delight of visitors, a number of lovely surprises.

On an exposed, sloping site on England's northwest coast, one might not expect to see exotic plants native to far warmer climes. And yet here at Yewbarrow, where frost rarely penetrates the ground, there are olive trees that bear fruitful if modest crops; mimosa that sparkles like sunlight against the neutral background of a ruined stone bridge; and myriad exciting plants native to Mexico, Hawaii, Africa, Australia and New Zealand.

Local materials have been used to construct paths and architectural features that look as if they might have played host to naturalizing plants for centuries, and evergreen plants have been amassed to create a verdant background, which, attractive in its own right, serves to highlight the colour and form of both modest and showy flowers. A new round tower above a steep bank and a realistic lizard sculpture shaped from cement are surprise elements.

STEEP SLOPES

Gradient is a significant factor. The garden at the front of the house, which has the steepest of slopes, around 45 degrees, has been planted with hundreds of large evergreens to minimize maintenance and create a looking-down-on-the-clouds effect. Only the formal lawn in the sunken garden is on the level. This grassy patch, defined by slate paths and high banks, has a striking central feature, a tall, straight-as-can-be New Zealand cabbage palm (*Cordyline australis*), its frondy umbrella far too elevated to offer shade. At one end of the lawn, a curved

stone seat supported by three lion figures is veiled throughout the summer with white daisy-like marguerites, a triumph of contrasting textures. Like a balcony overlooking the stage, a high bank of *Hebe parviflora* var. *angustifolia*, with cloud-like clusters of snow-white flowers and decorative evergreen foliage, forms a thick hummock year round, while on the other side is a curtain of cardoons and dense evergreens.

ITALIAN TERRACE

Move onto the Italian terrace, and the mood of the garden changes from restrained to exuberant, and the planting might change from year to year. Where once there was a dense planting of cannas, there might now be dahlias, displayed to superb effect in alternating rows of burnt orange and lemon-yellow flowers. Dahlias have become a speciality at Yewbarrow; shows and competitions are held there, space is given to a trial ground, and the head gardener prides himself on his success with saving and growing the seed.

Juxtaposed with familiar garden plants, there are notable rarities such as uhdeas, native Mexican plants known as tree daisies, which were popular in Victorian times but have been little known for decades; the so-called false banana (*Ensete ventricosum* 'Maurelii'), an African native whose burgundy-washed-with-green leaves form a distinctive vase shape, and the succulent *Aeonium* 'Zwartkop', which has rosettes of narrow purple leaves and, it is hoped, will eventually be crowned in spring by pyramids of golden flowers.

LEFT Towering above a 'hot' border

ORIENTAL THEME

The Japanese garden, perhaps the most surprising feature in this Cumbrian environment, was created around a hot spring that doubles as a heated swimming pool. The boiler and filter are concealed in the ornamental teahouse; stone pagoda-like ornaments reinforce the oriental theme and the area is enlivened by a deep bank of yellow and orange azaleas.

THE FERNERY

Ferns self-seed wherever the spores are carried in the garden and are allowed to grow there only until they are ready to be transplanted to the fern garden, where they provide dense ground-cover beneath the feature plants. These include several species of tree ferns (all of which need to be watered freely in a dry summer) such

ABOVE **Mixed planting on the Italian terrace**

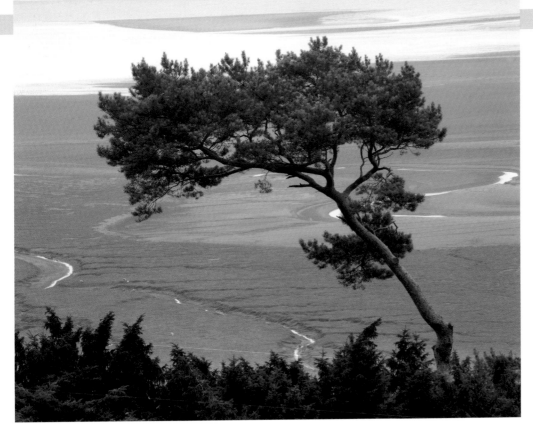

ABOVE **Morecambe Bay: a silhouette**

as the frost-tender cyatheas, the palm-like *Dicksonia squarrosa* and the Australian tree fern (*D. antarctica*), which can reach a height of 6m (20ft).

CREATING THE LOOK YOURSELF

* A small patio or gravel garden can be given the 'Yewbarrow House look' with one or more Mexican beschorneria plants, which, being almost stemless, form a fan shape close to the ground. The plants are half-hardy, need full sun and well-drained soil. Propagate by dividing the leaf rosettes at the base in spring or summer.

GRAVEL GARDEN

Height is a feature in the gravel garden, too. An exercise in restraint, this area is formalized with rows of circular beds mulched with gravel and edged with stones. Most display a single plant to full advantage: here, the Mexican beschorneria, a clump-forming succulent with greyish-green, sword-shaped leaves up to 90cm (3ft) long and, in spring, spikes of tubular flowers twice that length; there, specimens of tree echium, or pride of Tenerife (*Echium pininana*), which were planted as seeds and, in only three years, attained a height of 3.5m (14ft). This is a plant that enjoys a maritime situation, attracts bees and hoverflies, and, in summer, is covered with thousands of small, blue, bell-shaped flowers. Among these almost other-worldly plants, there is a gazebo and, seated on a stone wall, a life-size bronze of Jonathan and Margaret Denby's eldest daughter Joanna.

KITCHEN GARDEN

Whereas the rest of the Yewbarrow House garden is decorative, restful, inspirational, the Victorian kitchen garden has work to do: provide fruit, vegetables and herbs not just 'for the house', as in days gone by, but also for the owners' three neighbouring hotels. The kitchen garden is entirely organic – no chemicals at all are used – and worked on the crop rotation system. Some plots are laid out in a knot-garden design, with salad leaves and herbs planted in distinctive patterns, colour contrasted with colour within each geometric area, while other plants are in soldierly rows. Visitors, please make a note of a construction not to be missed: the potting shed. This powerhouse of the vegetable garden was recently built around two beautiful pre-Raphaelite stained glass windows.

YEAR-ROUND COLOUR

At the top of the Yewbarrow site, there is a large cutting garden with row upon row of flowers that, like the produce, will be sent to the hotels. From one season to the next, this area is perhaps the most painterly of all, a palette of colour etched against the sometimes grey, sometimes blue vista of Morecambe Bay.

PORTMEIRION

PAINTERLY COLOURS, CASTLE RUINS, COASTAL VIEWS – A WINNING COMBINATION

ABOVE **Mature trees surround the holiday village**

A fanciful holiday village, known for its association with the 1960s cult TV series, *The Prisoner*, is enhanced by glades of specimen trees and spectacular flowering shrubs.

The holiday village that Sir Clough Williams-Ellis built combines the nostalgia of terraced fishermen's cottages – here painted in Neapolitan ice-cream colours – with formal Italianate architecture. High on the hillside and with only a swathe of trees to separate the two vastly different architectural styles, the cottages look down on an impressive stone colonnade decorated with domes and finials and with a flight of semi-circular stone steps leading down to a formal lawn.

When Sir Clough acquired the village, the few existing houses were almost overshadowed by a substantial number of specimen trees planted in the 1850s by the then owner Henry Seymour Westmacott. Large coast redwoods, firs (Wellingtonia,

WHAT'S THERE:	Italianate-style village incorporating formal gardens; woodland; shops, plants for sale, cafe
WHERE:	Minffordd, Penrhyndeudraeth, Gwynedd LL48 6ET
GETTING THERE:	3.2km (2 miles) E of Porthmadog at entrance to Lleyn peninsula; 1.6km (1 mile) from Minffordd station serving Ffestiniog narrow-gauge railway
WHEN TO VISIT:	Daily, except 25 Dec
CONTACT DETAILS:	01766 770000; www.portmeirion-village.com

Douglas, noble and Himalayan), and pines, including a distinctive Scots pine (*Pinus sylvestris*), had all proved their survivability on the windswept site.

THE WILD PLACE

Sir Clough acquired the adjoining woodlands known as Y Gwyllt – 'the wild place' – in 1940 from George Caton Haigh, a leading authority on Himalayan flowering trees and shrubs, who set the scene for a remarkable display of springtime colour through a seemingly magical wilderness.

Paths meander through a painterly glade of closely planted rhododendrons, a glorious vision in June when huge clusters of red, white, purple and pink flowers mingle. Azaleas, camellias, liriodendrons, magnolias and fragrant eucryphias are all evidence of Caton Haigh's confidence in their suitability to the mild, almost frost-free, though windswept, climate of the peninsula. A spectacular sight not to be missed: the broad-leaved dancing tree (*Griselinia littoralis*), said to be the largest in Britain.

FAMILY CONNECTION

Nearby, there are two structures spanning several centuries, each with a family connection. The ruins of Castell Deudraeth, built by one of Clough Williams-Ellis's ancestors in 1188, are curtained in spring by pink cherry blossom, and rise from a sea of red, orange and yellow tulips. Over 800 years later, in 1983, a gazebo was erected to commemorate the centenary of Sir Clough's birth.

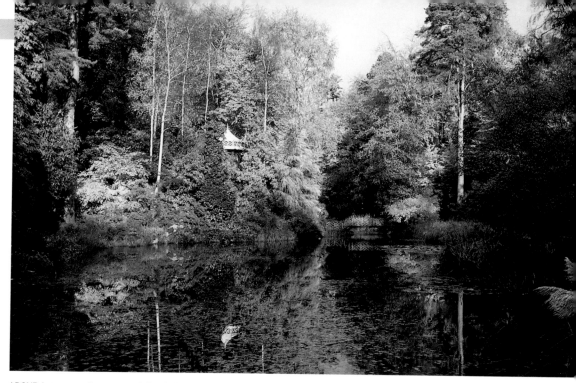

ABOVE **Autumn colour around the Oriental lake**

ON THE WATER

The ponds in the gardens have recently been restored and reshaped. One, the Temple Pond, originally formed in 1963, is surrounded by gunnera, a collection of tree ferns and the signature plants of the estate – mature rhododendrons. A stone temple was built in 1993 to complement it.

The Oriental Lake provides one of the most beautiful autumn vistas. It is crossed by an elegant red Chinese bridge, surrounded by acers and overlooked by a charming red chinoiserie pavilion capped by a turquoise dome. The three elements of bridge, pavilion and trees create an unforgettable mirror image.

The way to the shore leads through Tangle Wood – more rhododendrons – and the Ghost Garden, so called because of the insistent whispering of the wind through the silver-grey eucalyptus. And there on the beach is Sir Clough's folly lighthouse. This fanciful structure appears to secure the link between the architecture of his holiday resort and its natural environment, the Welsh coastline.

SIR CLOUGH WILLIAMS-ELLIS

Clough Williams-Ellis was a Welsh architect with a practice in London. His ambition to build a holiday village that would be in harmony with its environment led him to search southern Europe for a suitable location. Eventually, he decided that his own Snowdonia peninsula was the perfect place to realize his dream, and he began building the village in the Italianate style in 1925. He was knighted in 1972 at the age of 89. He died in 1978.

CHAPTER 5

ORIENTAL GARDENS

Teahouses where a centuries-old ritual is performed;
areas of gravel swept into meaningful curves;
trees laden with springtime blossom; flowers and
shrubs each with religious significance –
these are all attributes of an oriental garden.

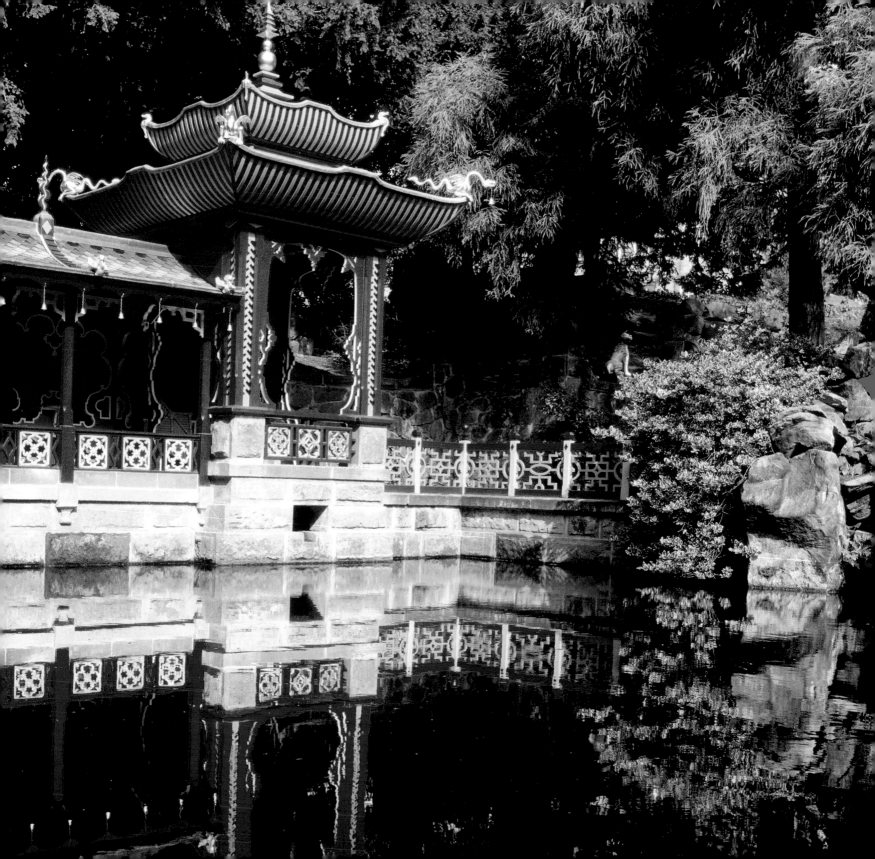

BIDDULPH GRANGE GARDEN

BE PREPARED TO TAKE AN INTRIGUING AND INSTRUCTIVE VOYAGE OF DISCOVERY

Tunnels, passages and paths lead you on a fantasy world tour in this amazing Victorian garden.

It is advisable to approach the gardens with a sense of unreality, prepared to embrace the illusion of taking a journey not just back in time but around the world – on a magic carpet, perhaps. Within an area of only 15 acres, a Victorian gardener created eclectic areas seemingly remote from each other, featuring plants, buildings and statuary representative of countries as far apart as Egypt and China, Italy and Scotland.

The gardens were designed in the mid-19th century by James Bateman, a landowner and accomplished horticulturist, to 'amaze and delight' visitors and to display his extensive and wide-ranging plant collection. His wife Maria, also passionate about plants, especially fuchsias and lilies, brought her own significant collections. Bateman built

ABOVE **A topiary pyramid marks the entrance to 'Egypt'**

WHAT'S THERE:	15-acre garden with themed areas including Chinese, Egyptian, Italian and Scottish; tearoom, shop
WHERE:	Grange Road, Biddulph, Staffordshire ST8 7SD
GETTING THERE:	0.8km (½ mile) N of Biddulph, 5.6km (3½ miles) SE of Congleton, 11km (7 miles) N of Stoke-on-Trent
WHEN TO VISIT:	Wed to Sun and BH Mon, mid-Mar to late Oct; Sat and Sun, early Nov to mid-Dec; tours for 10+ Wed, Thu, Fri
CONTACT DETAILS:	01782 517999; www.nationaltrust.org.uk

new conservatories to house Maria's tender plants and his own orchids – in which he was becoming a recognized expert – as well as ferns and camellias, and extended the house, a former vicarage, in the Italianate style. But his greatest joy must surely have been in the planning and construction of his round-the-world horticultural adventure.

The timing was propitious. Bateman was constructing his gardens at a time when plant collectors were bringing back exotic and unfamiliar species from their voyages of discovery in the Far East, the Americas and South Africa, which could all contribute to his horticultural Disneyland.

SENSE OF WONDERMENT

With the help of his friend Edward William Cooke, a famous seascape painter, he created a series of microclimates and, artfully, devised ways of separating each 'national' compartment to maintain the sense of wonderment. This was achieved in a variety of ways, using heaps of rocks, thick swathes of shrubs, banks, dense hedges and even tunnels.

One such tunnel figures in the entrance to the Egyptian garden, for which Bateman used the shorthand term 'Egypt', an area enclosed within tall clipped yew hedges. Two sphinxes guard the mastaba-like entrance flanked on either side by topiary obelisks and topped by a cut yew pyramid. The tunnel leads to a murky chamber lit only through a hidden window of blood-red-coloured glass. This is not for the faint-hearted! In an inner chamber, there is a semi-comic, semi-spooky figure of the

ABOVE **Focussing on a vista in 'China'**

Ape of Thoth (Thoth was the assistant to the God of Botany). Bateman was a stickler for authenticity.

NO-MAN'S-LAND

A path from 'Egypt' winds down to a stumpery, overgrown with ivy and wild plants and, perhaps, designed to be a no-man's-land between the national compartments. It is, however, fascinating in its own right, the twisted and gnarled tree stumps forming weird and wonderful shapes.

EASTERN PROMISE

The stumpery leads to a small Chinese garden, richly furnished with a variety of statues. The garden is announced by an

ABOVE **A smiling stone sphinx**

impressive golden bull that amply fills an alcove overlooking the Dragon Parterre and Bridge. Through a stone gateway, a lion stands guard, while a small temple is watched over by the stone image of a crouching frog.

'China' – the perfect setting for Bateman to display part of his collection of rare azaleas and rhododendrons, his particular passion – was partially modelled on the design of Willow Pattern pottery. There is an ornate wooden footbridge over a stream, and in early spring the garden is bedecked in delicate blossom. Maples burst into leaf, and the scene is reflected in a large pool rippling with golden fish. A temple is ornamented with gilded dragons, sea horses, grebes and hanging bells, and a large sculpture of a gilded water buffalo overlooks the garden. Subsidence caused the representational Great Wall of China to fall into disrepair but it has since been partially rebuilt.

LEFT **Gateway to the Chinese Garden**

Take the tunnel route from the Chinese Garden and you come to the Ice House, a natural stone grotto that served the family at Biddulph Grange in the pre-refrigeration era.

DIVERSE APPEAL

There are many other sections that take the visitor on a grand tour of other parts of the world – a formal Italianate garden of symmetrical topiary features and a replica of a Scottish glen among them. The Dahlia Walk is at its most spectacular in late summer, when the borders dazzle with competing colours. There is also a Woodland Terrace, rock garden, fernery, pinetum and a Wellingtonia Walk of spectacular conifers with rich red-brown bark that enlivens winter.

CHANGING FORTUNES

After his financial situation changed for the worse, causing Bateman to leave the property in 1861, it underwent a series of vicissitudes. It was sold to a new owner in 1871. The house was burnt down five years later and rebuilt by an architect. Eventually, the house was turned into a hospital – it remained so until 1991 – and various outbuildings were constructed in the grounds. Shamefully, Bateman's fanciful gardens were completely neglected and, in parts, vandalized to the point of being obliterated.

The National Trust took over the gardens (but not the house) in 1988, and major restoration and reconstruction work began, in some areas to archaeological levels. Features that had been submerged

ABOVE **A path between national borders**

for decades were revealed, annotated, charted, restored or replaced until, now, authentically reconstructed and replanted according to the original plans, the gardens are one of the most exciting and challenging survivals of the great era of Victorian gardening.

Over 150 years ago, James Bateman created the gardens to 'amaze and delight visitors with a continuing journey through different types of gardens inspired by exploring the world'. Now, in the 21st century, the meticulously restored gardens at Biddulph Grange do so again.

DAITOKUJI TEMPLE GARDENS

GARDENS IN THE ZEN BUDDHISM TRADITION WITH SYMBOLIC AND HARMONIOUS IMAGES

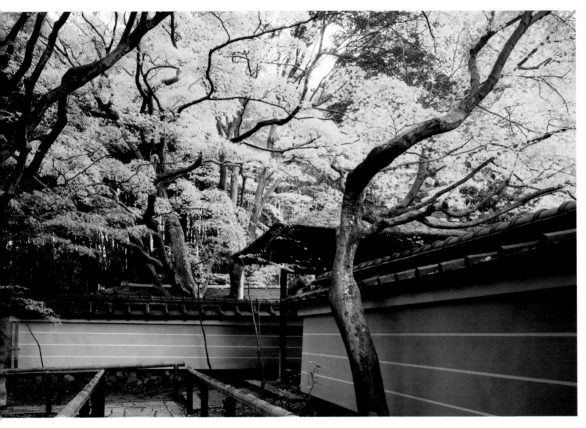

ABOVE **A colourful walk in the Koto-in garden**

The stones, rocks and gravel representing mountains and flowing water at this beautiful garden have deep religious symbolism.

The Japanese Zen Buddhist Daitokuji Temple Complex, which resembles a walled city, is made up of several sub-temples, each displaying a different aspect of the art and symbolism of Japanese garden design. Usually only four of these temples are open to the public.

The gardens epitomize the karesansui (dry landscape) convention, where stones, rocks and gravel are used to signify flowing or tidal waters. Each garden is seen as a canvas on which natural materials are placed to express the philosophy of Zen Buddhism, which was imported from China, through Japanese aesthetics.

DAITOKUJI TEMPLE

Founded around 1320 by Shoho Myocho (1282–1337), the Temple of Great Virtue

WHAT'S THERE:	A complex of temples and gardens displaying Chinese philosophy through Japanese aesthetics
WHERE:	53 Murasakino-Daitokuji-cho, Kita-ku, Kyoto 603-8231, Japan
GETTING THERE:	From Kyoto station, 50min by bus 206 or 101; alight at Daitokuji-mae stop; 5min walk from there
WHEN TO VISIT:	Open most days; best in spring and autumn
CONTACT DETAILS:	(0081) 75 493 0019

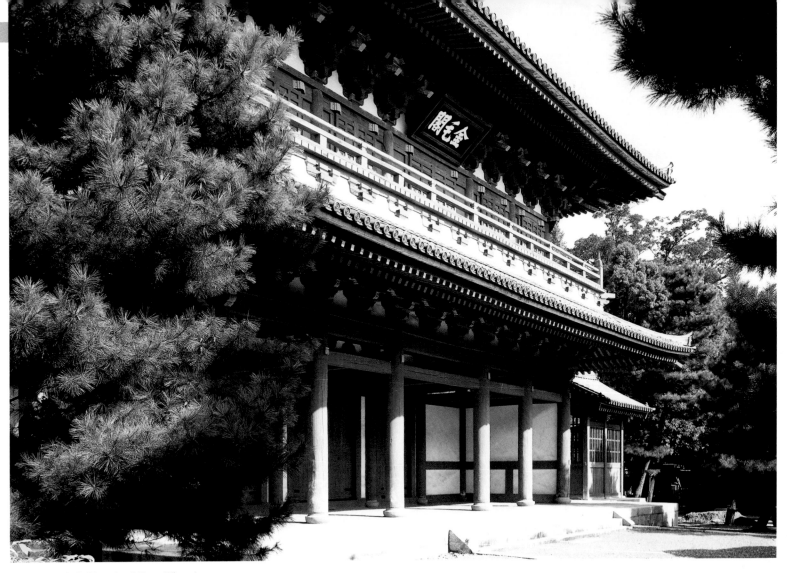

ABOVE **Daitokuji (Temple of Great Virtue)**

was the centre of Rinzai Zen culture, especially associated with the tea ceremony, and frequented by the Japanese Emperor Go-Daigo, one of its sponsors. With its focus on Buddhist teaching through Zen practices, the temple garden has a dry waterfall of raked gravel that swirls over and around rocks. Other large natural rocks are selected and positioned to have special significance. The mountain of the temple, which is also called Ryoho-zan,

meaning Dragon Treasure Mountain, was counted as one of the five sacred mountains of China until the Ashikago shogunate was established, and it was removed from the list.

The Daitokuji Temple has the classical Zen monastic layout, with a Sanmon (Mountain Gate), Butsuden (Buddha Hall), Hatto (Dharma Hall), Hojo (Abbot's Quarters), which are designated as a National Treasure, Yokushitsu (Bath

House) and Kyozo (Sutra Library). The Karamon (Chinese Gate) was moved from the military leader Toyotomi Hideyoshi's castle in Fushimi, south of Kyoto, while the Chokoshimon (Imperial Messenger Gate) was originally in the imperial palace grounds.

A legend surrounding the second storey of the Mountain Gate relates that, in 1589, it was renovated by Sen no Rikyu, a hugely influential master of the Japanese tea

ABOVE **Planters decorating stone graves – Koto-in temple**

To the eastern side of the temple, a garden composed of black stones and white gravel represents legendary mountains, islands and waterfalls in China, conjuring up a harmonious image and aiding contemplation. In another area, large stones are arranged to represent the course of waterfalls, with white gravel representing water flowing into an expanse of swirled gravel, which is the sea.

KOTO-IN TEMPLE

This garden is noted for the beauty of its maples, whose leaves turn scarlet in autumn. The ground is completely covered in moss to blur the boundary between the garden and nature. A stone lantern stands in the centre, and sunlight filters through a line of bamboos outside the garden.

RYOGEN-IN TEMPLE

Built in 1503, this temple, whose name means Source of the Dragon, was once an abbot's residence. There is a moss garden and, enclosed by hallways, a gravel garden, said to be the smallest Zen garden in Japan. Only white gravel and a few stones are used to represent a drop of water falling into a pool, with concentric rings of raked gravel representing the ripples it causes. This is an example of a minuscule world magnified and, through contemplation, one that leads to a larger world, and then from the real world to the imaginary one in our hearts.

POINT OF VIEW

It is thought that by viewing a Zen garden close-up one absorbs too much detail. It is

ceremony. He placed a statue of himself on the top of the gate, but Hideyoshi realized that whenever he or anyone else passed through it, Sen no Rikyu would be looking down on them. This so angered him that, according to the legend, he ordered Sen no Rikyu to commit ritual suicide (seppuku), which he did.

The Daitokuji Temple and several of the sub-temples were burnt down during the Onin War and later restored by rich merchants. The outer gate and main hall are the oldest structures, designated by the national government as Important Cultural Properties.

DAISEN-IN TEMPLE

The main sub-temple of the Daitokuji complex, Daisen-in is one of the oldest remaining examples of the Hojo style of Zen-Buddhist architecture and recognized as a national treasure. Completed in 1513 and fully restored in 1961, the tiny garden, one of the most beautiful and famous Zen gardens in the world, is an outstanding example of karesansui from the Muromachi period (1336–1573).

The garden brings together in three-dimensional form all the traditional elements of a classic Sung-dynasty Chinese landscape painting.

therefore considered best to view a temple garden from the back of a pavilion. From there, the door structure and any columns will compose a frame, enabling the viewer to see the garden as a picture. In that way, the distance will filter out details, and in one's mind the garden will become abstract rather than representational.

An Ode to the Dry Landscape
by Muso Soseki (1275–1351)
Without a speck of dust being raised, the
mountains tower up, without a single drop falling,
the streams plunge into the valley

SPIRITUAL MEANING

Existing Japanese Zen gardens resemble ancient rock arrangements dating from the 5th century. Circular arrangements of flat or upright rocks found in Akita and Hokkaido were used for spiritual rituals and as objects of worship and prayer. Between the 7th and 10th centuries, Buddhism and new cults brought to Japan from China and Korea played significant roles in the development of garden art.

Dry river landscape represents the journey of life, from the narrow rapids of youth to the mature stream of adult life. Rocks can symbolize difficulties along the way. Eventually, the river empties into a flat void of white gravel, representing death. In some gardens, a single bodhi tree beyond gravel cones represents obstacles to the attainment of enlightenment.

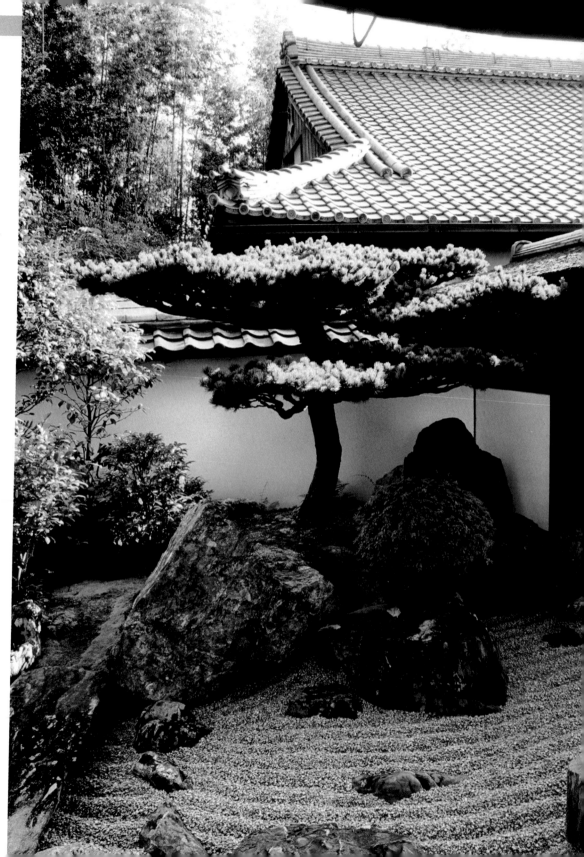

RIGHT **Daisen-in temple garden**

HUNTINGTON LIBRARY

BOTANICAL GARDENS FEATURE CLASSICAL CHINESE AND JAPANESE GARDENS

Two contemplative gardens invoke the aura of the Orient. The Huntington Library, Art Collections and Botanical Gardens was founded in the early 20th century by Henry Edwards Huntington, a railroad tycoon, on his estate near Pasadena, California. Set on 120 acres of undulating landscape, with established trees, long vistas and sweeping lawns, there are now 15 themed or specialized areas, with several botanical collections consisting of around 15,000 plants from all over the world – there is far too great a diversity of interest to appreciate in a single visit.

THE CHINESE GARDEN

The newest landscape at The Huntington is Liu Fang Yuan, or the Garden of Flowing Fragrance, a classical Chinese garden that opened in February 2008. The garden's first phase covers 3½ acres of a planned 12-acre site, and was designed to respect and integrate with the existing landscape.

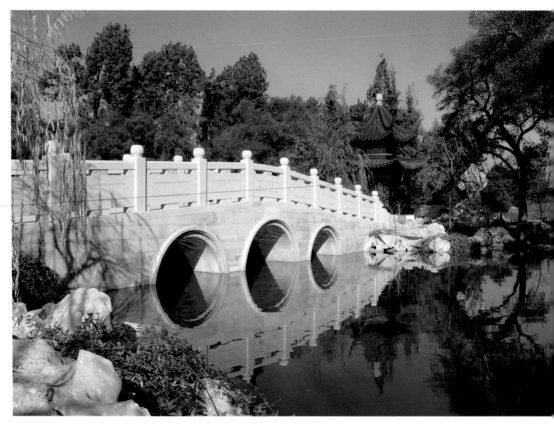

ABOVE **Jade Ribbon Bridge**

BELOW **Asian magnolia**

WHAT'S THERE:	120-acre botanic garden with 15 areas, including Chinese, Japanese, desert, Australian, rose, camellia and palm gardens; tea room, cafe, shop, plant sales
WHERE:	1151 Oxford Road, San Marino, California 91108, USA
GETTING THERE:	19.3km (12 miles) NW of downtown Los Angeles. Entrances on Oxford Rd and Allen Ave
WHEN TO VISIT:	Daily except Tue. Tours available
CONTACT DETAILS:	(001) 626 405 2100; www.huntington.org

Mature pine trees and California oaks are balanced with Chinese architecture and native plants. A 1½-acre man-made lake was formed in a deep hollow where water naturally collected after heavy rains.

The garden is planned so that a stroll along the walkways and shoreline and over the five stone bridges presents new vistas and scenes at every turn, giving the visitor a sense of walking through a Chinese scroll painting as it is slowly unrolled.

Weathered limestone rocks from Lake Tai in China were placed around the water's edge, evoking the craggy mountains of a Chinese landscape painting. Further celebrating the importance of real or evoked mountain scenery in the creation of Chinese gardens, a view of the distant San Gabriel Mountains is drawn into the garden landscape, where it can be enjoyed from the 'Terrace that Invites the Mountains'. The round gates in the 'Terrace of the Jade Mirror' are shaped to represent the full moon, a concept inspired by Chinese literature, which compares the moon to a round mirror of highly prized white jade.

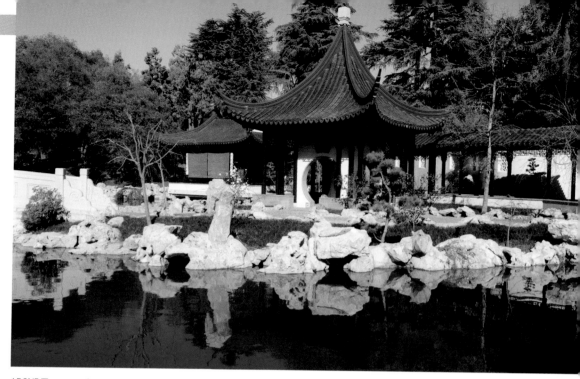

ABOVE **Terrace of the Jade Mirror**

BALANCE OF NATURE

Water in Chinese gardens symbolizes the ever-changing, whereas rocks are considered eternal – the balance of Yin and Yang. The lake in the Liu Fang Yuan garden not only reflects the elegant pavilions and teahouses, blossoming trees and flowering plants, but the ever-changing light and varying moods of the sky and clouds.

This is a garden that invites changing perceptions. Bridges lead to small islands, from which pavilions and other structures on the shore are seen from a different viewpoint. Lattice windows in the pavilions and teahouse are designed to frame the view and focus attention on a harmonious group, and all the buildings, covered walkways and bridges, beautiful in their own right, are positioned so that they offer carefully considered views.

SYMBOLIC MEANINGS

There are many allusions to Chinese literature and art throughout the garden, and many beautiful calligraphic texts. On the ceiling of the 'Pavilion of the Three Friends', there are carvings of bamboo, pine, and plum blossom, which, in Chinese

LEFT **Carving in Love for the Lotus Pavilion**

133

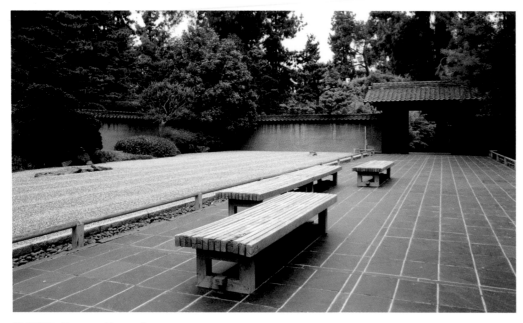

ABOVE **The Japanese Zen garden**

THE JAPANESE GARDEN

A failed tea-garden operation in Pasadena provided many of the buildings, ornaments and plants that compose the Japanese garden (there were so many components that it took a workforce of 70 men working daily for five months in 1912 to move and establish them on The Huntington site). Later, a Japanese craftsman built the delightful moon bridge and gong tower. In 1968, two further additions were opened to the public: the Zen Court, which is a dry gravel garden, and the Bonsai Court, where there are fine examples of potted trees dwarfed by pruning to look like miniature versions of old, weathered ones.

The landscaping throughout the garden is superb. The seemingly naturalistic combination of indigenous trees and shrubs and Asian species, together with grassy knolls and hillocks, form lush backgrounds for a Japanese house, bridges, stone lanterns and other ornaments. Streams and pools have been so carefully engineered that they, too, seem to be part of the original landscape.

literature, represent perseverance, courage and endurance (bamboo and pine stay evergreen in winter, and the plum trees blossom in early spring when there is still snow on the ground). Among other plants in the garden with symbolic meanings are peach, symbolizing spring, and lotus, the flower representing purity.

The camellia, valued as a source of leaves from which to make tea, is celebrated in the Liu Fang Yuan garden by elaborate wood carvings in the 'Hall of the Jade Camellia'. Separate from the Chinese garden, the extensive camellia collection at The Huntington features many hundreds of camellias, including 1,200 cultivars, in a formal design along avenues decorated with 17th- and 18th-century statues of mythological figures.

RIGHT **A simple bamboo water feature**

SNAPSHOT SCENES

Carefully composed still-life groupings and snapshot scenes are designed to be viewed and considered from a distance. A decorative moon bridge spans a small pool edged with Japanese black pine, weeping willows and Japanese maples. A bamboo fence, a gravel path with arranged rocks and a bamboo fountain trickling water into a massive stone urn compose a tranquil 'still-life' group. A stream is crossed by a simple stone bridge without handrails, its

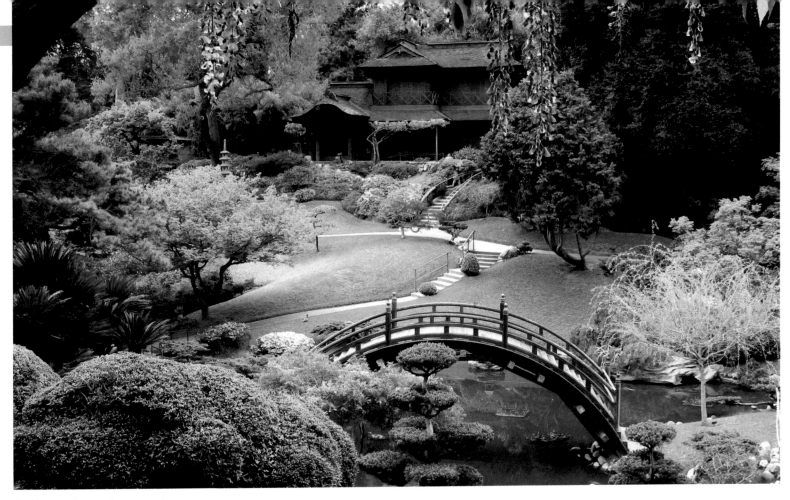

ABOVE **Wisteria over the moon bridge**

uncompromising outline accentuating the intricacy of the gnarled and twisted trunks of a Japanese black pine beside it. Another stream, crossed by a wooden bridge with a lantern at one end, is seen against a clump of evergreens clipped into thick cloud shapes.

In late winter, the pink and white blossoms of the flowering fruit trees bring a new dimension to the garden, with the 'confetti-laden' branches either hanging low over a pool or scattering petals on the pathways. Japanese peach, with its deep pink blossoms, along with the Japanese cherry, plum and apricot, all create glorious swathes of colour reminiscent of Japanese art.

'VIEWING STONES'

In the Zen garden, which is a representation of karesansui (dry landscape), large stones are placed in a long, rectangular area of gravel raked in fluid, horizontal lines. Beside it, there is a slate courtyard with a few simple benches for contemplation and meditation, inviting the viewer to interpret the scene. Throughout the garden, there are 'viewing stones', suiseki, representing mountains, animals or human figures. These stones, such beautiful natural works of art, are never carved or changed in any way; it is the way they are placed that changes their symbolic meanings.

At the heart of the Japanese garden is a house that formed part of the original Pasadena purchase. This upper-middle-class home from the 1800s was built in the shoin style, using natural materials and unpainted surfaces to celebrate the beauty of Nature. The rooms are beautifully decorated, with flowers arranged by members of an ikebana league who meet at The Huntington once a week for instruction in the art of Japanese flower arranging.

TATTON PARK JAPANESE GARDEN

THE 'BORROWED LANDSCAPE' OF THIS CHESHIRE ESTATE ADAPTED ADMIRABLY

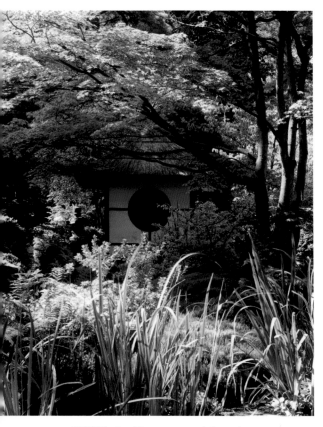

ABOVE **Spring blossom around the teahouse**

Created a century ago on a large Cheshire estate, this garden symbolizes peace, harmony and welcome.

A natural stream and a snaking waterway, spanned by elegant bridges; trees pruned to create shapes conveying ancient symbolism; rocks selected to represent mountains; and a Shinto shrine and artefacts brought from Japan – the Japanese garden at Tatton Park, originally constructed in 1910, is said to be one of the finest examples of its kind in Europe.

The garden was created as a consequence of Alan de Tatton's visit to the Anglo-Japanese Exhibition held at the White City in London. There, the 'shakkei' – the borrowed landscape, comprising mountains, trees and water, essential to a Japanese garden – was represented by a painted canvas backdrop. At Tatton Park, there was already a stream running through the property and many large specimen trees that could be pruned to symbolize peace, harmony and welcome, important tenets of Japanese Buddhist philosophy.

SYMBOLIC IMAGES

Inspired by what he had seen and in keeping with what became a fashionable trend, de Tatton commissioned a team of Japanese gardeners to create an authentic teahouse garden. The stream was diverted to create snaking waterways, which are spanned by elegant bridges and widen to create reflective pools. The garden and its reflection in the pools portray a variety of scenes, some mythical and others factual but all harmonious with Nature. Thus planting around the pools is carefully planned so that each one mirrors a group of components – it might be a specimen tree, an azalea and a small pavilion – that together compose a symbolic image.

Mountains, the third essential element represented in Japanese gardens, are

WHAT'S THERE:	Immaculately restored Japanese tea garden in 2,000-acre estate; deer park, Italian garden, walled garden, fernery; shops, restaurant
WHERE:	Knutsford, Cheshire WA16 6QN
GETTING THERE:	16km (10 miles) W of Macclesfield, off A537
WHEN TO VISIT:	Tue to Sun and Bank Holiday Mon; times vary
CONTACT DETAILS:	01625 374435; www.tattonpark.org.uk

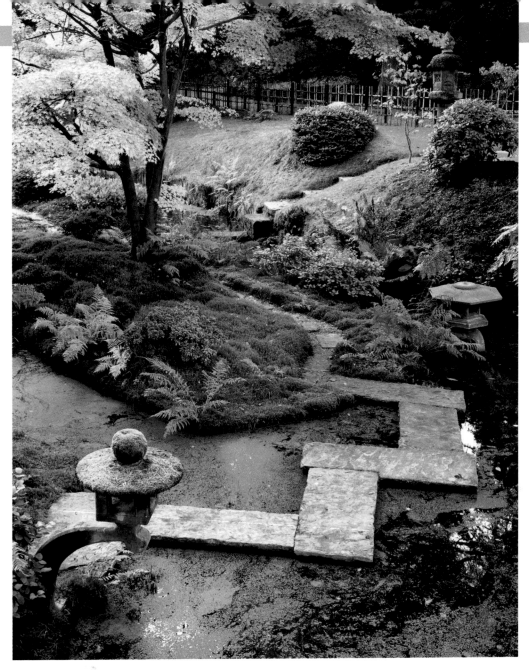

ABOVE **The Flying Goose Bridge and lanterns**

The Shinto shrine and the teahouse, which both have deep significance, are sited so that, according to the season, they are framed by sweeping arches of blossom or the brilliant autumn foliage of Japanese maples.

CHANGES OVER TIME

The Japanese garden underwent a major reconstruction in 2000, when another Japanese team was brought in to work with head gardener Sam Youd. He had joined the estate team in the late 1970s, having visited China and Japan and studied the Eastern philosophy relating to gardens. He is responsible for the authenticity, colour and harmony that is experienced in the Tatton Park garden today.

The Egerton family had owned the Tatton Park for almost 400 years when, in 1958, the last Lord Egerton died. The estate was bequeathed to the National Trust and is now managed by Cheshire County Council.

HIGHLY RECOMMENDED

Sam Youd, the head gardener at Tatton Park, has found the following plants to be the most satisfying in the Japanese garden.
Best acers: *Acer japonicum* 'Senkaki', *A. japonicum* Aconitifolium, *A. carpinifolium*
Best evergreens: *Cryptomeria japonica, Ilex crenata, Pinus parviflora*
Best colour: *Osmunda regalis, Euonymus alatus, Skimmia japonica, Azalea* 'Palestrina'
Most impact: *Cercidiphyllum japonicum* f. *pendulum*

symbolized here by carefully selected rocks, positioned to produce a natural balance in relation to other components. One rock is topped by white stones to represent the snow on top of Mount Fuji, the most important mountain in Japan.

The many lanterns in the garden, of varying shapes and sizes, have differing functions and meanings. One is especially chosen for its shape so that it will capture and hold the most snow and add to the beauty of the garden in winter.

MOGUL GARDENS OF SRINAGAR

DESIGNED WITH THE THREE ESSENTIAL ELEMENTS OF ISLAMIC GARDENS

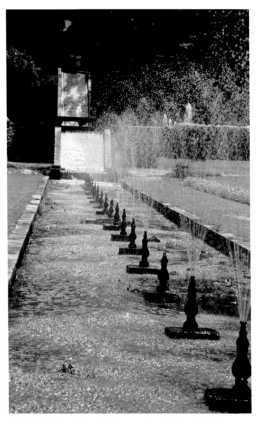

ABOVE **Arches of sparkling water at Nishat Bagh**

These fragrant and romantic gardens represented the Islamic concept of paradise on earth.

At the heart of the Kashmir Valley and at 1,730m (5,650ft) above sea level, Srinagar was the location selected by 17th-century Mogul emperors for their summer retreats – luxurious pavilions surrounded by luxuriant gardens.

The roots of the garden designs lay in Persia (now Iran) and, like all Islamic gardens, represented the concept of paradise as described in the Koran. The first important element, water, symbolic of the rivers of paradise, was featured in the form of cascades, rills, pools and fountains. Shade was essential for practical reasons and, in these gardens it is gloriously provided by the indigenous chinar, a form of plane tree. Perfume was the third essential element, provided by the sweet scent of roses and lilies, and the fresher perfumes of magnolia and citrus blossom.

NISHAT BAGH

The largest of the Kashmiri Mogul gardens, measuring 44 acres, Nishat Bagh ('bagh' means garden) was created in 1633 by Asaf Khan, brother of Empress Nur Jahan for whom Shalimar Bagh was designed (see over). Both gardens are situated on the banks of the picturesque Dal Lake, with a backdrop of the Zabarwan Mountains and russet-gold chinar trees that explode with colour in the foreground.

The garden originally had 12 terraces (the lowest one has now been cut off by a road), each representing a sign of the zodiac. Viewed from the top, the terraces are seen to descend gradually until the lowest of them appears to merge with the lake.

A spring at the top of the garden, known as Gopi Tirth and augmented by snow melt, gushes with crystal-clear water that supplies the fountains and cascades. A row of elegant black marble fountains runs

WHAT'S THERE:	3 Mogul gardens with formal pools, fountains, springs, terraces, fragrant flowers and indigenous chinar trees
WHERE:	In Srinagar District, Kashmir, India, 11–15km (7–9 miles) from District Headquarters
GETTING THERE:	Airport, Badgam, connected with Delhi, Mumbai and Jammu; bus or taxi from there. Nearest railway station, Jammu. The National Highway 1A from Jammu connects with Kashmiri Valley, 300km (186 miles)
WHEN TO VISIT:	All gardens are open daily from sunrise to sunset

ABOVE **Poppies** RIGHT **Chashma Shahi Bagh**

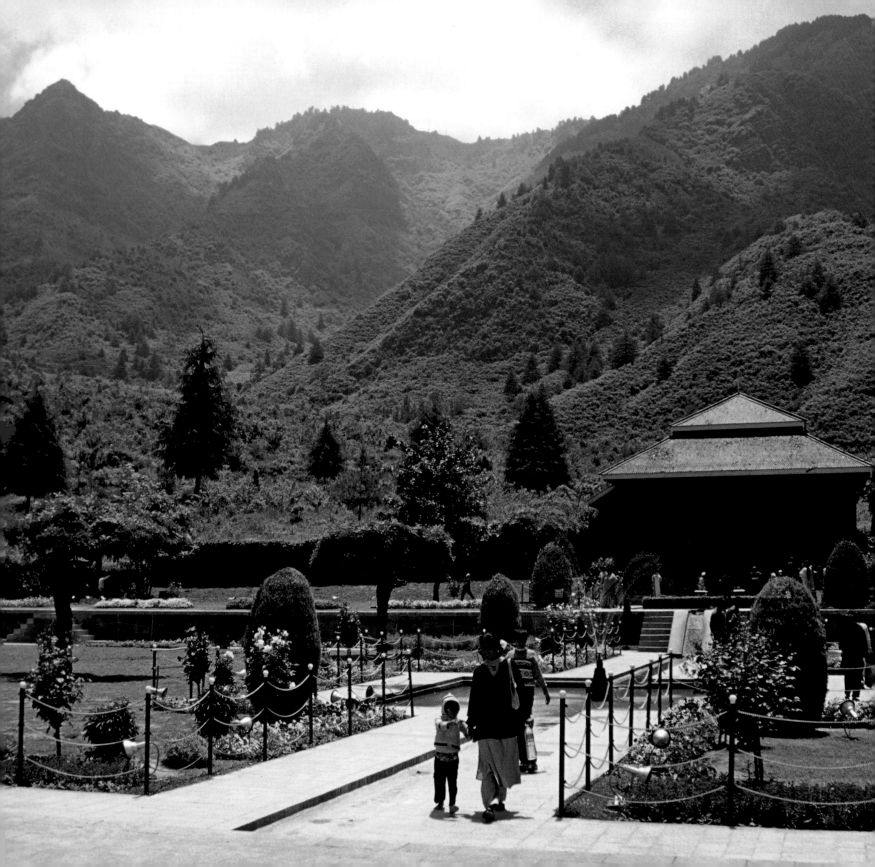

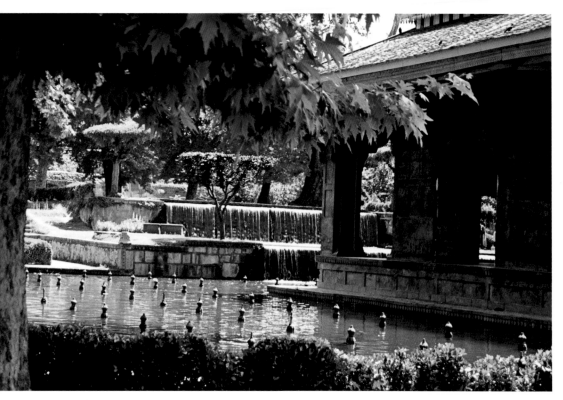

ABOVE **Cascades and fountains at Shalimar Bagh**

CHINAR TREES

From the plane tree family, the chinar trees (*Platanus orientalis*) that so spectacularly paint the Kashmir Valley in autumn can reach enormous proportions and, because of this, have been the subject of folk history. They have greyish-white bark that peels off in sections, palmate leaves and pendulous, burr-like fruits. The trees can live for 400 years.

Known in Kashmir as bouin, from Bhawani, the goddess of shrines, chinar trees can grow to a height of 25m (82ft) and have a girth of 15m (50ft). Hollow trunks, which may be used for meditation, are thus considered sacred, and the trees are often planted at Hindu shrines. It is said that 34 people once sheltered in a hollow chinar tree trunk, and there would have been room for more!

Due to their religious significance, chinar leaves are represented in wood carvings, embroidery and other forms of needlework, and it is said that walking over the leaves makes the sound of music.

along the entire length of a central pool that bisects the main part of the garden. The water erupts into a series of tall arches, which, catching the light this way and that, sparkle like jewels.

Nishat Bagh is also known as the 'garden of bliss', not least because of its glorious profusion of flowers in mainly sun-bright colours. Among clipped evergreens there are sweetly scented roses and lilies, poppies and pansies, clarkias and cosmos – a regal collection.

SHALIMAR BAGH

Like Nishat Bagh, this garden has breathtaking views over the lake and a backdrop of the snow-capped Zabarwan

Mountains. It was created by Emperor Jehangir in 1616 for his wife, Mehrunissa, the Empress Nur Jahan. The emperor loved flowers, scented blooms especially, and had a different variety planted on each of the terrace gardens. The walkways are perfumed, too, lined with fragrant, many-petalled magnolias and standard rose trees.

The 24-acre garden has a central axis – a series of pools lined with sparkling polished stones and flanked on either side by flower beds and standard roses.

Four terraces ranged one above the other are separated by cascades. The uppermost terrace, which cannot be seen from below, has uninterrupted views over the royal gardens and the lake.

It was formerly reserved for the pleasure of the emperor and empress and the ladies of the royal court. A black stone pavilion, once a lavish banqueting hall, is supported by engraved and fluted black marble pillars.

Originally named the Farah Bakhsh, 'delightful garden', and also known as the 'garden of love', Shalimar Bagh is secluded and tranquil, the rows of fountains, flowers and shade-giving chinar trees gradually

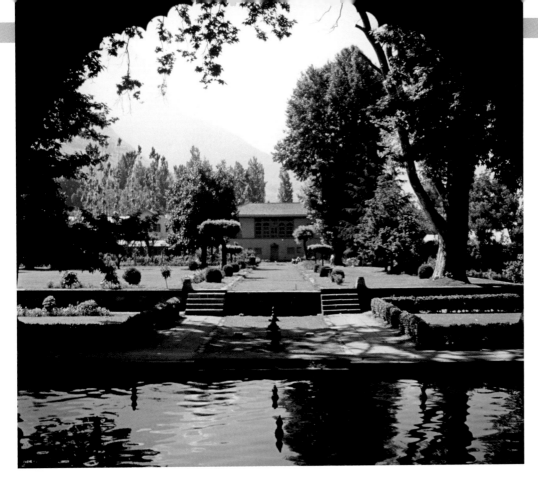

ABOVE **Shalimar Bagh**

receding into the misty mountain foothills. The beauty of this garden has inspired the creation of many other Islamic gardens, notably the Shalimar Gardens in Lahore, Pakistan.

PARADISE ON EARTH

It is said that when Shalimar Bagh was completed, the Emperor recited the famous Persian saying: 'If there is a paradise on earth, it is this, it is this, it is this.'

A romantic *son et lumière* show takes place in the gardens every evening from May to October.

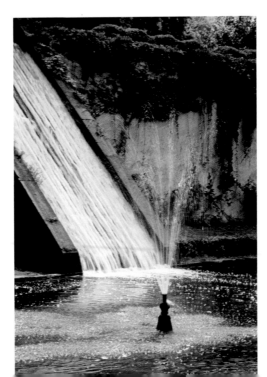

RIGHT **Water thunders down a black stone chute**

CHASHMA SHAHI BAGH

This is the smallest of the three Mogul gardens at Srinagar. The dramatic highlight of this garden, whose name means Royal Spring, on the hillside above Nehru Memorial Park is a thundering 5m- (17ft-) cascade of water plunging down a polished black stone chute. The spring water supplies the many fountains in the gardens, runs through the floor of the pavilion and falls to the lower terrace in a carefully managed way.

The gardens were laid out in 1632 by Ali Mardan Khan and became a favourite retreat of the fourth Mogul Emperor, Shah Jahan, who reigned from 1627 to 1658. It is said that his wife, Empress Mumtaj Mahal, recovered from a long illness after drinking the spring water, held to have beneficial digestive properties. Because of its believed restorative and enervating qualities, the water was taken to the royal households at Agra for the benefit of the royal princesses and court members. A small shrine near the gardens, Chashma Sahibi, also has fresh spring water.

With its glorious fruit trees, beds of paintbox-bright and fragrant flowers, impressive cypresses and many-coloured chinar trees, Chashma Shahi Bagh invites the visitor to linger and, like the former Mogul rulers, feel refreshed.

FOOTNOTE

Emperor Shah Jahan later built the Taj Mahal in Agra as a memorial to his beloved wife.

PURELAND JAPANESE GARDEN

WITH HIS OWN HANDS BUDDHA MAITREYA HAS CREATED A HAVEN FOR MEDITATION

In rural England, a Japanese monk has created a garden that inspires, delights and invites reflection.

In his Japanese-style garden at North Clifton, Buddha Maitreya has captured the essence of his homeland, recreating in miniature the characteristic hills, pools, running water and lush planting. It is an oasis in what was almost a desert. Small pools are skirted by mossy paths, embellished with glossy waterside plants and overhanging with yellowy larch and elegant wisteria. A charming pavilion emerges from a cluster of pink asters, and azaleas in fire-flame orange glow among a profusion of foliage shrubs. Stone lanterns and small pagodas focus attention at almost every twist and turn. Across a bridge there is a traditional teahouse and, best of all, there is a Zen garden.

Buddha Maitreya, a Japanese monk and son of a potter, came to England in the 1970s, intending to stay for two years to

ABOVE **A bench invites contemplation**

WHAT'S THERE:	2-acre garden of lush planting, pools, streams, rocks, teahouse
WHERE:	North Clifton, near Newark, Notts NG23 7AT
GETTING THERE:	19km (12 miles) N of Newark-on-Trent, 19km (12 miles) S of Gainsborough, off A57 and A1113
WHEN TO VISIT:	Open end Mar to end Oct; lantern-lit viewing Fri to Sun evenings, Aug and Sep; groups by appointment
CONTACT DETAILS:	01777 228567; www.buddhamaitreya.co.uk

continue his studies. Instead, he bought a two-acre plot of flat wasteland, the site of an old farmhouse, and created a garden that fulfilled his vision. With his own hands (and hired machinery), he dug out pools and ponds, and used the soil to create representational mountains. He had rocks, some massive ones, carted from a Derbyshire quarry and used them to form paths, bridges, walls, benches and rockpiles that look like ages-old geological features.

CALMING INFLUENCE

Curving paths link separate but related outdoor rooms, each symbolic in its own way. Some paths are composed of large, round, flat stones like stepping stones set in pebbles, and some paths are circular, to confuse ancient bad spirits. A small stone bridge, a viaduct, crosses over a low-level walkway, while most of the paths lead to a resting place where there will be a wooden seat or stone bench, inviting

contemplation and a sense of calm that comes from the sounds of rippling water and the rustling breeze.

POOLS OF WATER

Water is an important element here, as it is in Japan. Pools filled with koi carp are enhanced and fed by sparkling waterfalls, creating ripples on the surface. Clumps of bamboo combine ramrod-straight golden stems with light green, translucent leaves. Huge, rough stepping stones march across some pools, contrasting strikingly with the seeming frailty of arching pond grasses. Waterside and overhanging trees are selected for their reflective qualities – golden laburnum looks particularly pretty – and many have overhanging lanterns to give the garden a special magical quality at nightfall.

SETTING THE STANDARD

The use of colour, particularly green, in this garden is striking. The way in which trees and shrubs are planted one against the other celebrates the glorious variety of shades, from greeny-yellow through lime to the deepest hues. And the way trees and shrubs are shaped, pruned, trimmed and clipped celebrates the design versatility of many familiar species. Variegated holly and other evergreens, *leylandii* cypress included, are formed into standard trees, the lower branches removed to expose the trunks, and the foliage clipped to create high-level globe or hummocky cushion shapes. Taller tree trunks are used as natural pillars, some with stripped bark, others selected for the beauty of it; some

143

ABOVE **Lush bamboo edges a carp pool**

trunks are gnarled, others twisted, and
some multiple trunks look as if they have
been neatly hand-plaited.

ZEN GARDEN

The Zen garden, created with circular
stones set in pebbles, is a study in the use
of form and texture – a shining greyish-
white, there is no need for the further
addition of colour. With its own symbolism
and significance, the teahouse has a view
over the representational mountains and
valleys, rockpools and streams beyond
and a sense of tranquillity within. And
this is in Nottinghamshire.

by the water lily
swimming serenely
koi carp

Kōji
26.9.03

睡蓮のわき
中、泳ぐ
鯉の群

平成十五年九月二十九日

耕司

ABOVE **A poem by Buddha Maitreya**

ABOVE **Stepping stones in a pebble path**

CREATING THE LOOK YOURSELF

* A secluded area, a garden room within
 a garden, or a corner of a patio can
 be designed to reflect the Japanese
 approach to gardening. Use natural
 materials for hardscaping – pebbles,
 stones, gravel and stepping stones – and
 create paths that twist and curve, not
 ones with corners and hard edges. Use
 green plants lavishly and other colours
 sparingly. A patch of purple irises or
 orange azaleas, so effective at Pureland,
 will create the look. A small pool or the
 smallest of water features and the sound
 of trickling water is a must. With a seat
 beside it, irresistible.

RIGHT **Asters reach out to the pavilion**

JIM THOMPSON'S HOUSE

AMID URBAN SPRAWL, A JUNGLE-LIKE GARDEN CELEBRATES THE NATIVE FLORA

ABOVE **Comfort, colour and exotic plants**

Planted with the passion of a man who had fallen in love with Thailand, this garden is a tropical haven among Bangkok's urban sprawl.

The traditional Thai house painted a dark pinky-red rises exotically from the lushly planted garden that seems almost to have the building in its grip. The house is now a museum, preserved as its American owner Jim Thompson left it, while the garden is a fair copy of a jungle, restored to how he planted it.

Jim, an architect, had served in the US Office of Strategic Studies (the forerunner of the CIA) in Thailand during World War II and, after his military discharge, decided to return and settle there. He scoured the country for six of the finest Thai homes and had them put together in the local tradition – without nails – to construct one beautiful and still traditional residence. He officially took possession of the house in April 1959 on a date chosen after consultation with Thai astrologers.

TROPICAL PARADISE

A passionate gardener and in love with all things Thai, including native plants, Jim surrounded the house with a virtual jungle – which is how he described it. Dense and seemingly impenetrable planting creates an illusion of a space far larger than it actually is; a notable ploy. Shaded by a 100-year-old rain tree (*Samanea saman*), the garden comes alive with henna trees, scarlet-flowering flame trees (*Delonix regia*), hibiscus and gardenias. Overhanging branches mingle, almost knit, with rampant ferns and palms; lotus pools seem to be scattered with a confetti of vibrant flowers; and lorikeets and cockatoos flounce and flutter.

Jim Thompson's aim had been to transform a block of land on the edge of a busy canal into a natural, wild-looking

WHAT'S THERE:	House maintained as museum; 1-acre, lushly planted tropical garden beside canal; restaurant, bar, gift shop
WHERE:	6 Soi Kasemsan 2, Rama 1 Road, Bangkok, Thailand
GETTING THERE:	Bangkok Skytrain to National Stadium; off Siam Square; 250m (250 yards) from main road
WHEN TO VISIT:	Open daily; English spoken
CONTACT DETAILS:	(0066) 662 216 7368; www.jimthompsonhouse.com

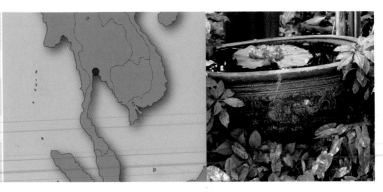

RIGHT **A Buddhist spirit house**

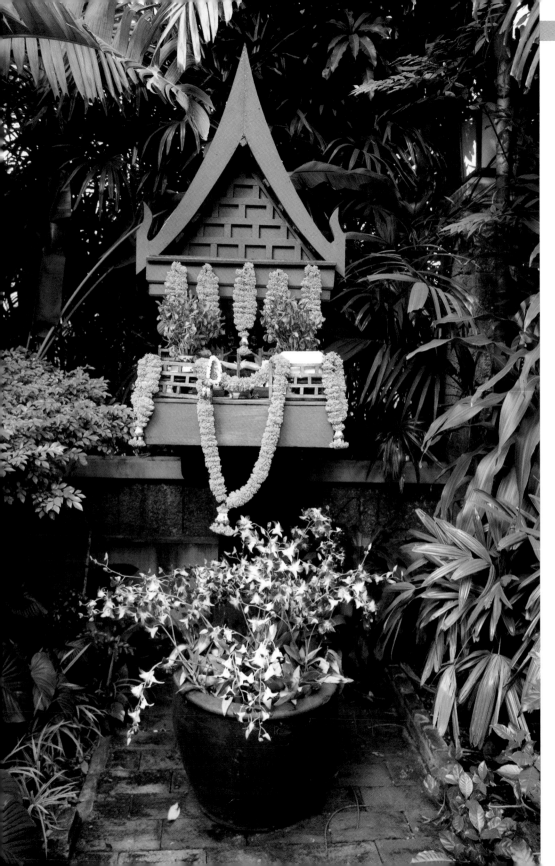

garden that would celebrate the beauty of native flora. He could not have foreseen that, four decades later, the city would sprawl to within yards of his creation, but the denseness of his planting was thoughtful and successful. Even now, it all but obscures the sounds of day-to-day urban life.

After Jim Thompson's disappearance in 1967 (see below), the garden became more wild-looking than ever. It was restored in the mid-1990s, when new paths were laid, antique sculptures put in place, and a planting scheme similar to the original one carried out. Wayward shrubs were cleared from the front of the house to make way for a group of shapely dracaenas, and a red ginger tree (*Alpinia purpurata*) with its elegant flowers atop 1.5m (5ft) stems was another inspired addition. The house and garden are now run by The James H W Thompson Foundation.

JIM THOMPSON, THE LEGEND

Soon after his return to Thailand, Jim Thompson became interested in the country's ailing silk industry, learned about the manufacturing process and took samples of woven silk to be sold in North America. It is widely recognized that Thompson was responsible for regenerating the failing industry and for promoting international demand for Thai silk. In 1967, he set off with friends on a walking trip in the Cameron Highlands in Malaysia. He was never heard of again. There are many conspiracy theories about his disappearance but there has never been a satisfactory explanation.

WANG SHI YUAN GARDEN

A HISTORIC RETREAT KNOWN AS THE MASTER OF THE FISHING NETS GARDEN

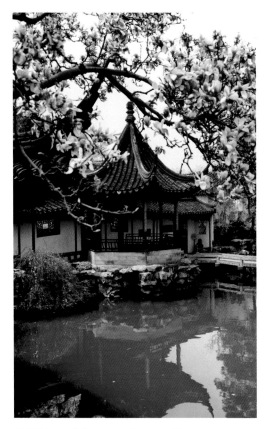

ABOVE **A carefully managed composition**

This small residential garden in bustling Suzhou is considered the most beautiful in China.

Designed in the mid-12th century as a contemplative retreat and now hemmed in by city blocks, this courtyard garden with its pavilions still maintains the air of peace, tranquillity and harmony that was its original *raison d'être*. The smallest of the many residential gardens in Suzhou, it is considered the most beautiful and was granted World Heritage status in 1997.

The pavilions and gardens were built for Shi Zhengzhi, a retired government official of the Song dynasty. He named the property 'Fisherman's Retreat' because, he said, he would rather be a fisherman than a bureaucrat. The garden changed hands many times until, in 1795, it was bought by a merchant prince, Qu Yuancun, who built many of the pavilions that so characterize it today. Wang Shi Yuan Garden later fell into disrepair but

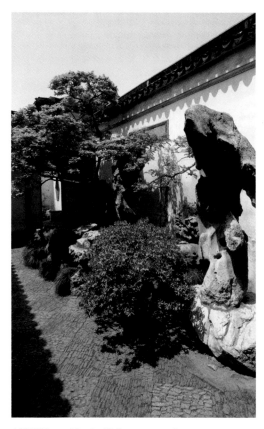

ABOVE **Bonsai in the Taihu stone rockery**

WHAT'S THERE:	1-acre garden with central lagoon, pavilions, terraces
WHERE:	11 Koujiatou Lane, Daichengqiao Road, Suzhou City, Jiangsu 215006, China. SE area of Suzhou old city
GETTING THERE:	Bus 2, 4, 14 or 31 from Shanghai bus station, adjacent to railway station, takes 1½ hours
WHEN TO VISIT:	Open daily
CONTACT DETAILS:	(0086) 512 65 293190; www.szwsy.com

was restored in the mid-19th century. It became a government property in 1958. A cypress tree planted by the first owner and still flourishing today has survived many centuries and many vicissitudes.

ELEGANT PAVILIONS

The garden faces inward onto a central lagoon. Pavilions, corridors and rockeries are arranged around the shoreline, which is encircled by a walkway. The elegant pavilions, which together comprised the original residence, are interspersed by pierced walls, like trellises, acting as windows on the space beyond, to give glimpses of carefully managed compositions of sky and water, flowers, trees and structures. As is customary, there is a small pavilion in the lagoon, reached by the narrowest of bridges.

As is also customary, the pavilions have delightfully evocative names. Around the lagoon, there are the 'Where the Moon Meets the Wind' and the 'Washing My Ribbon' pavilions. At a particularly fine vantage point, there is the 'Belvedere of Magnificent and Bright Water', and on the north side, a 'Viewing Porch for Looking at Pines and Paintings'. To the north-

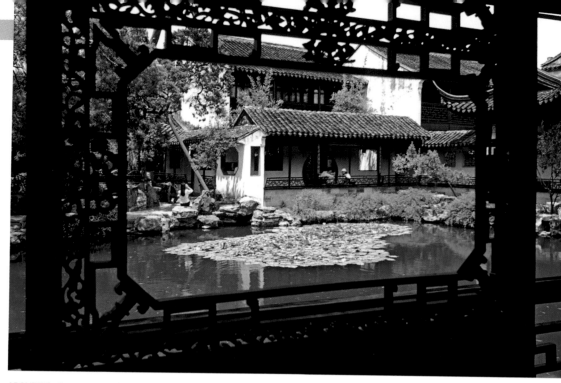

ABOVE **Windows are used to frame views**

west, there are courtyards and buildings designed for studying, painting, taking tea or sharing meals. The courtyard and cottage on the west side of the lake, now used as study rooms, was the model for Astor Court at the Metropolitan Museum of Art in New York City.

THE CITY OF SUZHOU

Suzhou is situated on the lower reaches of the Yangtze River and the shores of Lake Taihu in the province of Jiangsu. It is noted for its waterside architecture, beautiful stone bridges and pagodas, and delightful gardens. The city has been important in the silk trade since the Song dynasty (960–1279), and is one of the oldest towns in the Yangtze basin, having been inhabited by tribes 2,500 years ago.

ROCK SOLID

Complementing the elegant and delicate-looking structures, there is a massive rock-built tunnel and arches – rugged, jagged, imposing – some of which are edged contrastingly with rows of purple and yellow pansies and mauve alyssum. Throughout the garden, complex pebble mosaic paving composes curvilinear patterns and representations of animals and fish.

THE ROLE OF TREES

Trees are planted for maximum effect, so springtime blossom will arch gracefully over a pavilion or pool, shaped bonsai are seen to advantage against a plain wall, and clusters of pines frame a pavilion. The main plant species used are green maple, laurel, white bark pine, black pine, wisteria, magnolia and peony.

HUMES JAPANESE STROLL GARDEN

EAST MEETS WEST IN THIS AMERICAN GARDEN OF RELIGIOUS SYMBOLISM

Close to the bustle of Manhattan, Humes Japanese Stroll Garden is designed to slow down the pace of life and aid contemplation.

An idealized landscape portraying a coastal mountain setting, this stroll garden was created on a wooded hillside on the north shore of Long Island in the 1960s. The design reflects a natural approach to garden design in its sympathetic response to the topography and existing vegetation. The winding gravel paths suggest mountain streams that form pools at different levels before cascading downwards over symbolic waterfalls and eventually flowing into the ocean, represented by the pond. The symbolic representation of a rocky coastline at the east end of the pond is known as 'Ariso'.

This American adaptation of a Japanese stroll garden follows a style that originated during the Edo period (1603–1867), of which there are three

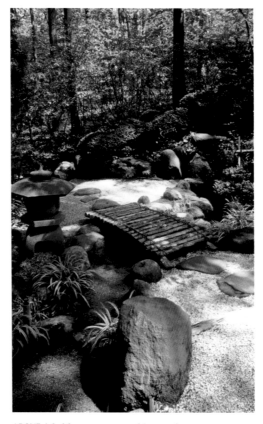

ABOVE **A bridge over a gravel 'stream'**

fine examples at former imperial villas in Kyoto. The placement of the large stepping stones in the gravel paths is of great significance, designed to slow down the pace of movement around the garden – and therefore the pace of life – and to encourage the visitor to pause and contemplate. The layout of the paths is of equal significance. They never follow a straight line but instead weave this way and that, revealing first one scenic view and then another, and never giving a long vista of the garden. These design principles are known as 'hide and reveal' and 'movement along the diagonal'.

The garden was the inspiration of Ambassador and Mrs Humes who, on their return from a visit to Japan, commissioned a Japanese garden designer and his wife to create a stroll garden appropriate to the American environment. It is interesting to note that many familiar North American flora featured in the garden, including

WHAT'S THERE:	4-acre Japanese garden with teahouse, woodland, wild flowers, bamboo groves, ikebana and bonsai displays
WHERE:	Oyster Bay Road and Dogwood Lane, Locust Valley, Mill Neck, New York 11560, USA
GETTING THERE:	42km (26 miles) from Manhattan, 1.6km (1 mile) from Planting Fields Arboretum, off Route 25A/Nrn Blvd
WHEN TO VISIT:	Sat and Sun, Apr to Oct; tours with tea ceremony
CONTACT DETAILS:	(001) 516 676 4486; www.humesjapanesestrollgarden.org

jack-in-the-pulpit (*Arisaema triphyllum*), blue flag iris (*Iris versicolor*), black snakeroot (*Cimicifuga racemosa*) and red maple (*Acer rubrum*) have identical counterparts in East Asia, thus facilitating the East-West transition.

TEA-GARDEN

The teahouse, characteristic of the shoin-zukuri style from the Ashikaga period in the 14th century, was bought by Ambassador Humes in Japan. Recessed among evergreens in the tea-garden, it is a quiet retreat designed to evoke the tranquil atmosphere necessary for the full appreciation of the tea ceremony.

The tea-garden is laid out with various symbolic arrangements of plants and stones, one of which is the tortoise island near the pond. A moss mound forms the shell of the tortoise, a creature that symbolizes longevity, while its head, feet and tail are represented by stones. Above a moss path opposite a 'female stone', there is an arrangement on three levels of three large stones representing Heaven, Man and Earth.

STONE LANTERNS

Two types of stone lanterns used throughout the garden as architectural ornaments contrast with the natural features, form part of several carefully managed scenic views and provide subtle illumination at nightfall. These are the standard pagoda-style lanterns and the 'snow-viewing' ones, with their wide, umbrella-like tops shaped to collect snow, the flower of winter.

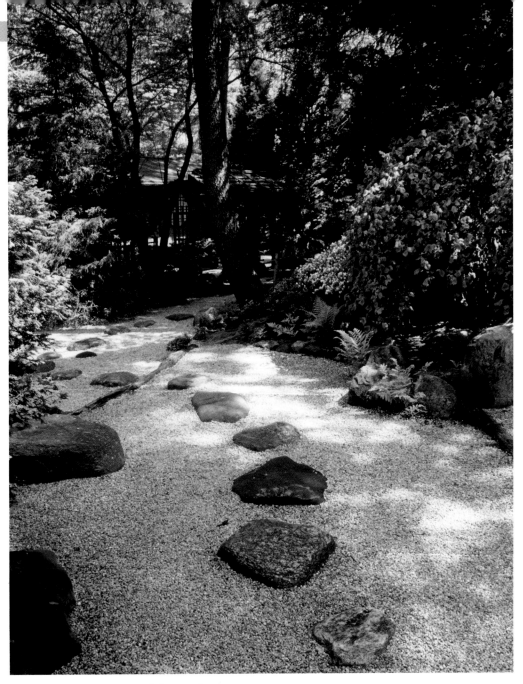

ABOVE **Stepping stones are carefully spaced**

RECENT CHANGES

Two further acres have been added to the garden, allowing space for a collection of Japanese maples and Asian and native wild flowers. There is a beautiful wisteria arbour, bamboo groves and a display hut for ikebana and bonsai. The garden is now managed by the Garden Conservancy, which is responsible for its maintenance and long-term preservation.

CLASSICAL GARDENS

A raised temple; a folly by the lakeside; an avenue
of classical pillars; an imposing geometric parterre
or a pair of elegant statues – these and other elements
reminiscent of the 18th century or displaying an
Italian influence characterize so many great
classical gardens around the world.

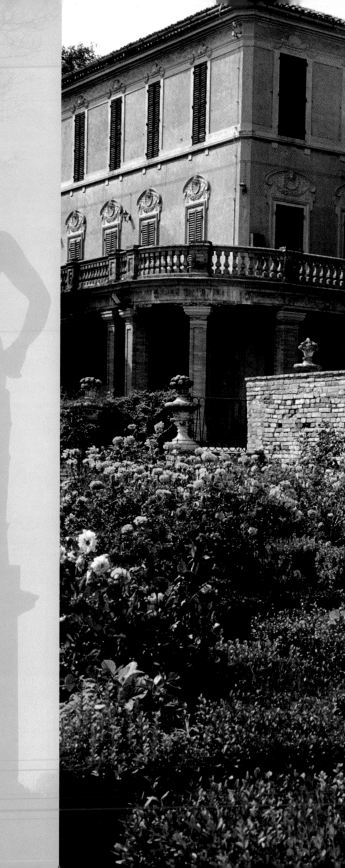

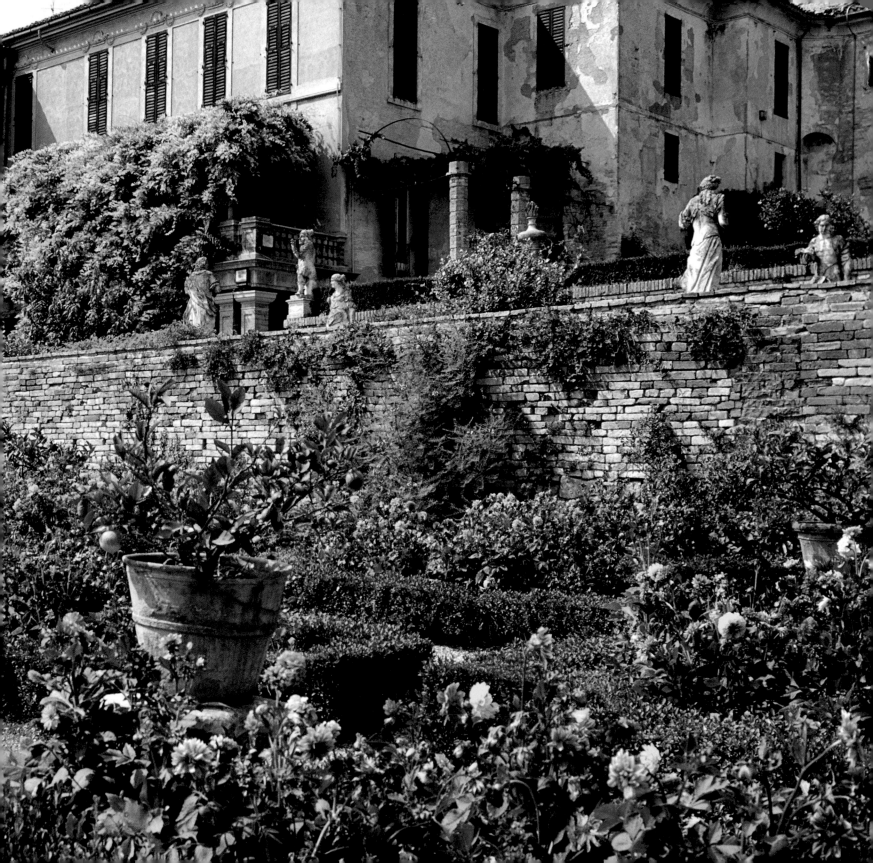

BRODSWORTH HALL

SENSITIVE RESTORATION HAS RETURNED THE GARDENS TO THEIR FORMER GLORY

Designed in Victorian times, this garden epitomizes the elegant formality of the Italianate style.

When, in the 1860s, Charles Thellusson built a mansion on his 13,000-acre South Yorkshire estate, the gardens were laid out in the 'high Victorian' style, following formal Italianate design. Clipped box, yew and holly were established to create domed, pyramidal and cubic shapes, hedges and edges. A marble fountain and a wealth of statues were shipped from Italy. One of the most romantic of these is a statue of Psyche holding a butterfly, the symbol of the soul.

Flights of steps leading from the terrace down to the extensive lawn were designed with extreme formality, with shallow urns at the head, and marble greyhounds at the foot – even though it was for horse racing and yachting that the wealthy Thellusson family was best known.

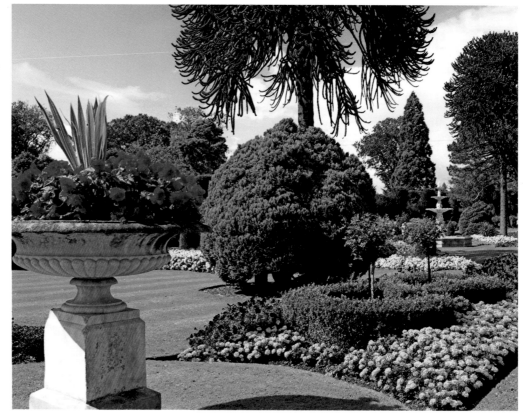

ABOVE **Evergreens balance the brilliant colour**

What's there:	15-acre restored Victorian gardens with rose garden, fern dell, woodland; shop, restaurant
Where:	Brodsworth, Doncaster, S Yorkshire DN5 7XJ
Getting there:	8km (5 miles) NW of Doncaster off A635; from junction 37 off A1(M)
When to visit:	Usually open daily throughout the year
Contact details:	01302 722598; www.english-heritage.org.uk

ABOVE **12th-century** *Rosa mundi*

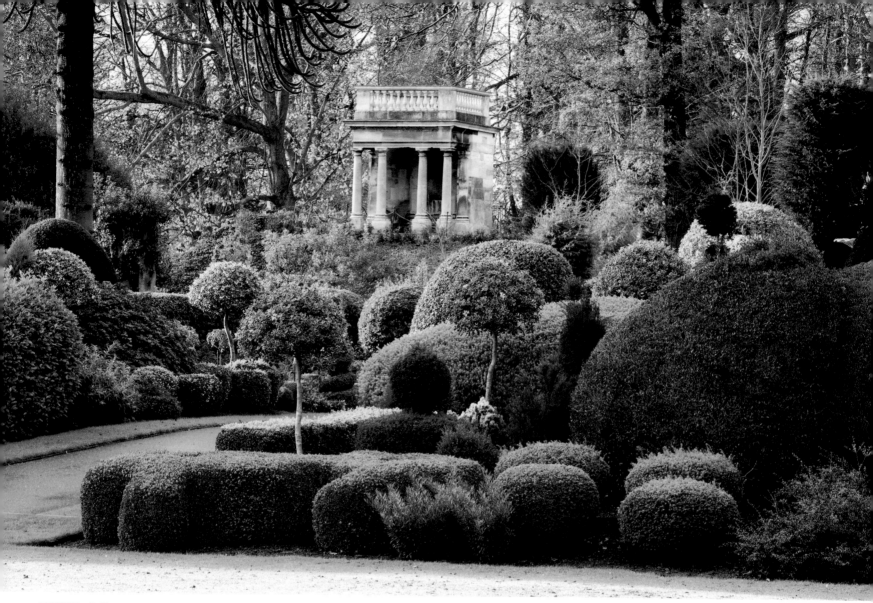

ABOVE **The Italianate summerhouse**

ROSES ALL THE WAY

Separate areas of the garden are linked by walks that formed part of the original concept. Lined with clipped and shaped hedges, they appear all the more formal because of the statuary displayed in arched niches. A box hedge outlines the rose garden, where there are over one hundred historic rose varieties, many of them 19th-century Portland roses, and where, in May and June, the air is heady with their perfume (see box, over). A recently restored iron pergola provides a romantic walkway through the garden, the stylized design of which was based on the shape of a rose leaf. Close to this original rose enclosure, a new collection of species roses has been planted, presenting a tapestry of vivid colour.

FERN DELL

The rock garden, established in a quarry and benefiting from its own microclimate, has been replanted as a fern dell, with some 350 varieties of fern, reflecting the Victorian passion for these plants, known as pteridomania. The outstanding feature in this lush, verdant area is a giant tree fern (*Dicksonia antarctica*).

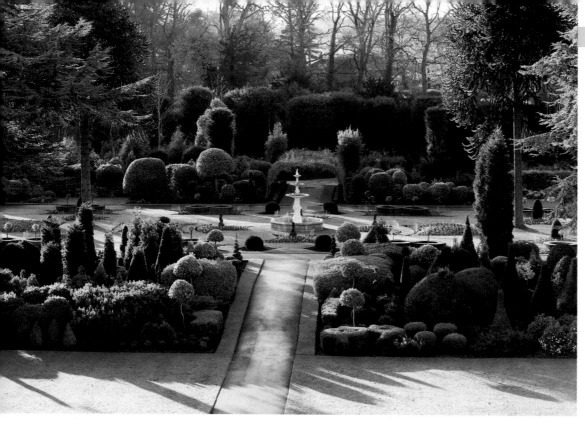

ABOVE **Intriguingly random topiary shapes**

ARCHITECTURAL FEATURES

Symmetrical flowerbeds, in keeping with the overall geometry of the design, are cut out of the turf and, in one of these, a striking central feature – a three-tier Italian marble dolphin fountain – has been expertly restored to working order after years of inactivity.

Architectural structures figure prominently in the original garden design. An Italianate summerhouse was sited where it would make the most of the romantic views across the estate. The Target House, where once the family practised archery, now contains a small garden exhibition, while the original game larder and the unusually ornamental privy are still intact and on the viewing itinerary. The garden has a further unique feature, a mischievous piece of deception in the shape of an 'eye-catcher', or folly: the façade of a building like a small brick cottage is improbably sited half-way up a cliff and now heavily cloaked in ivy.

RESTORATION PROGRAMME

Members of the Thellusson family continued to live on the estate until 1990. When English Heritage took over the property, both the house and gardens were in need of restoration, and an extensive and sensitive programme of work was begun. With the help of family photographs taken of the gardens in the late 19th and early 20th centuries, it has been possible to turn back the clock and restore them with almost complete authenticity. So successfully has this been achieved that it is scarcely possible for the visitor to distinguish between original and recent features. The gardens and parkland now merit Grade II* English Heritage status.

FLORAL TAPESTRY

With the Italianate topiary now back in shape and making up the formal structure of so much of the garden, more swathes and banks of colour have been added to ensure that the property has something new to offer month by month. In February and March, there is the breathtaking sight of some 180,000 snowdrops and over 30 varieties of daffodils, many of them growing naturally in long grass. In April, the floral tapestry changes as at least 5,000 tulips take over, while, in May and June,

the fragrant rose garden and the colourful wild flower meadows naturally attract the most attention.

Grassy areas around the property are neither close-cut nor treated with herbicides, so wild flowers, including orchids, restharrow, milkwort and cowslips, flourish in this natural environment, a remnant of magnesium limestone grassland. Just as they were in former times, the summer bedding plants in beds, borders and urns are at their peak in late June and July, when the ferns, too, are at their best.

VIBRANT WOODLAND

The woodland walks, beautiful throughout the year, become more and more vibrant as autumn progresses, and then in winter, the original garden design, structured as it is with myriad sculpture-like topiary shapes, becomes all important.

ARCHAEOLOGICAL FINDS

The Brodsworth estate, situated on a limestone ridge that runs across South Yorkshire, was developed on a site where there were known to have been medieval villages and a medieval nunnery. Now, archaeologists have discovered that there were Iron Age and Roman enclosures and field systems and, on neighbouring property, the sites of several Neolithic longbarrows. An extensive investigation, using the latest equipment and techniques, and including a geophysical survey, is now being undertaken. It is hoped that it will establish who were the earliest inhabitants of this site where, a century and a half ago, Charles Thellusson built his country home.

ABOVE **The improbable 'eye-catcher' folly**

CREATING THE LOOK YOURSELF

Clipped evergreens, a major feature of classical gardens, are effective in mixed borders, where they can bring form and definition among spreading or unruly plants. Box is one of the simplest to shape, particularly for small-scale topiary. *Buxus microphylla* is a compact, dense, dwarf shrub with small, oval dark green leaves. It has insignificant white flowers in late spring or early summer. Garden centres and nurseries sell already-shaped shrubs in containers, allowing you to make an immediate impact on your garden. Box is frost-hardy and does best in sun or semi-shade and in any reasonably well-drained soil. Clip the shrubs in summer and trim them lightly as and when your topiary loses its distinctive outline.

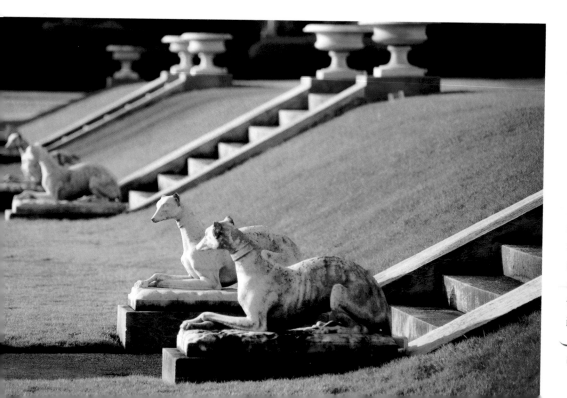

LEFT **Marble greyhounds guard the steps**

FORDE ABBEY GARDENS

THEY EVOKE A CENTURIES-OLD LEGACY OF TRANQUILLITY AND CALM

Changes of ownership, fashion and taste are evident in these magnificent gardens where Cistercian monks once worked, but the sense of history remains completely undiminished.

In a moment of quiet reflection, perhaps beside the Great Pond, which once powered the monastery grain mill, one might call to mind the work of the Cistercian monks who tended this land around the 12th-century monastic building. In the intervening centuries, the gardens have several times fallen into disrepair and consequently undergone several major redevelopments and refurbishments, but the legacy of tranquillity and sense of calm remain.

The principal landscaping was set out in the early 18th century when the property was owned by Sir Francis Gwyn and, it is thought, he called on Guillaume Beaumont, a pupil of André Le Nôtre, the famous French landscape architect,

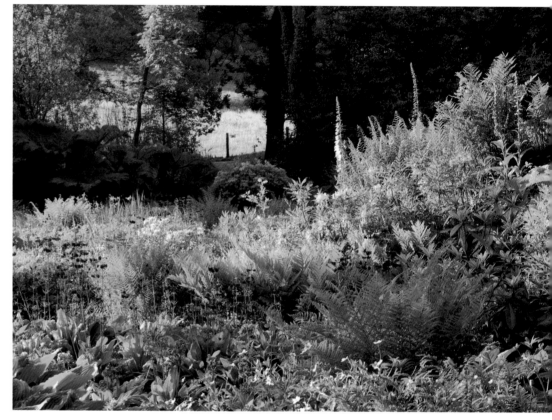

ABOVE **Mixed planting in the bog garden**

WHAT'S THERE:	30-acre garden on banks of River Axe; shop, restaurant, plant centre
WHERE:	Chard, Somerset TA20 4LU
GETTING THERE:	2.5km (4 miles) SE of Chard; brown tourist signs from A30, A358, B3165
WHEN TO VISIT:	Usually open daily
CONTACT DETAILS:	01460 221290, 01460 220231; www.fordeabbey.co.uk

ABOVE **Sunlight dapples the cloisters**

intricate wrought iron dome that casts intriguing reflections.

SPRING IN THE AIR

A bog garden created in the early 1900s is presided over by the structural forms of giant gunnera, royal ferns and hostas. In spring, tall white and yellow glossy spathes of lysichiton precede the large fresh green leaves of the plants that can reach 90cm (3ft) in height, and colour is reinforced by irises, meconopsis and waterside-loving forms of lobelia.

In other parts of the gardens, spring is heralded in spectacular ways. At a time when the front of the house is cloaked in pale mauve wisteria, thick borders of wallflowers seem to spray the air with their perfume, and carpets of Dutch crocus (*Crocus vernus*) cover ten acres of lawns. In order to ensure their continuity, the plants are left to die down in the long grass, which is not cut until the end of June. A woodland spring garden, structured with camellias, magnolias, azaleas and rhododendrons, has a confetti-like spattering of dog's-tooth violets (*Erythronium dens-canis*) with their pretty pink, purple and white flowers and mottled leaves.

SUMMER COLOUR

The herbaceous borders, which are reflected in the long canal, become an explosion of colour from midsummer onwards, when dahlias, asters, delphiniums and aconitums combine to create a floral tapestry, while in the facing border, protected by a high wall, there are

to assist with the layout. Strong elements of this design remain: the extensive lawns, the giant yews, the walls, the cascades and three lower pools that augment the original monastic one, now home to a pair of swans. A change of ownership in the mid-19th century saw the creation of a typically Victorian garden with dense shrubberies and an overemphasis on dark foliage and flowers.

BIG SPLASH

In 2005, the present owners, the Roper family, celebrated 100 years at Forde Abbey by the installation of the Centenary Fountain in the Mermaid Pond. With a 48.7m (160ft) flow, this is the highest powered fountain in England. The Long Pond has its focal point, too. At its head there is the Ionic Tempietto, a small circular temple capped by an

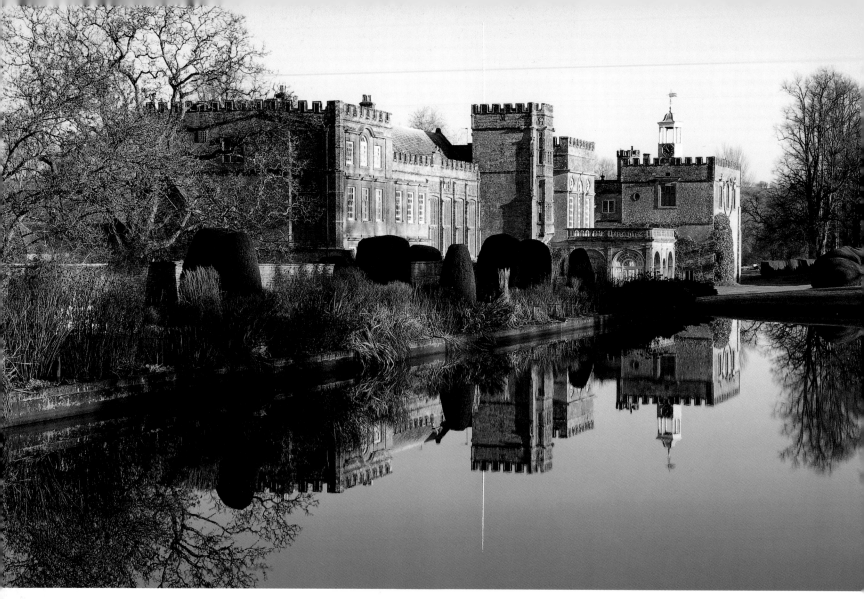

ABOVE **Autumn colours enrich the house**

carpenteria, lace-cap hydrangeas and the yellow-flowering evergreen shrubs, azaras.

USING TREES

Trees have a significant role at Forde Abbey. Geoffrey Roper, father of the present owner, Mark, planted an arboretum and increased other areas of woodland in the 1940s. The Mount is dominated by giant redwoods, incense cedars (*Calocedrus decurrens*) and oriental plane trees. Large Douglas firs (*Pseudotsuga menziesii*) are a legacy from the previous owners.

The Beech House, planted with saplings of pleached beech in the 1930s as a hide for bird-watching, is now seen as a delightful, living folly, one that is complete with a roof and small windows – an alternative version of a treehouse.

KITCHEN GARDEN

The walled kitchen garden, restored in the 19th century with extensive greenhouses and now producing an abundance of fruit, vegetables and flowers for cutting, is perhaps the closest link with the gardens as they were during their monastic period, over 800 years ago.

RIGHT **The Centenary Fountain**

CREATING THE LOOK YOURSELF

* The pale mauve wisteria that clambers over the mellow stonework of Forde Abbey adds immensely to the grace and charm of the building. With its clinging tendrils and graceful flowers, this voracious climber will flatter house walls, fences and trellises. It is fully- to frost-hardy and does best in fertile, well-drained soil.

* Choose a position in full sun. Fix a trellis or wire support frame 30cm (12in) above the soil and 5cm (2in) from the wall. Dig a hole 45cm (18in) from the wall and add compost. Before planting, thoroughly soak the root ball of a containerized plant, then position it to slant towards the wall at an angle of 45 degrees. Spread out the roots away from the wall, fill in the hole with soil and stamp it down to remove any air pockets. Separate the stems and tie them to the frame with plant ties. Water the plant well and cover the soil with a mulch such as chopped bark to aid moisture retention.

* Tie the stems to the plant supports as they grow. Prune after flowering and again in late winter.

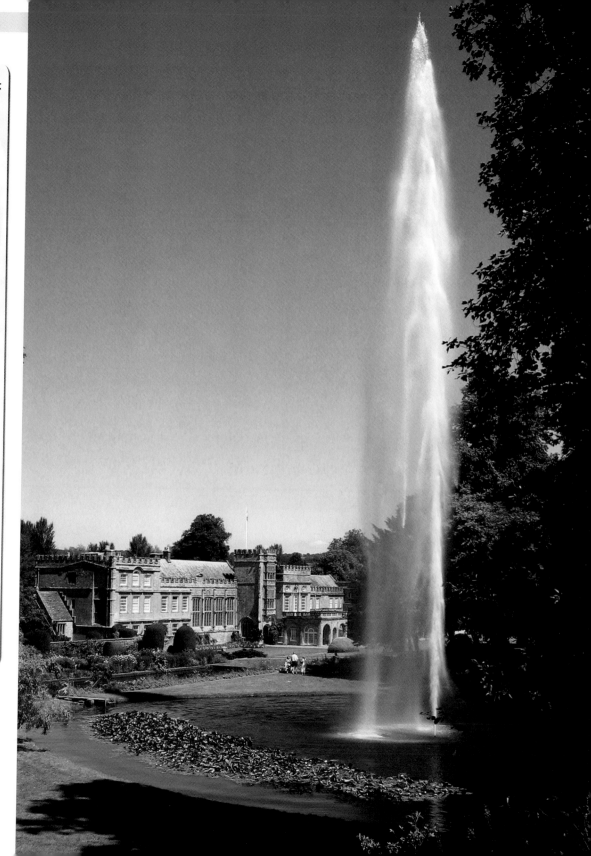

GIARDINO BUONACCORSI

DESIGNED IN THE ITALIANATE STYLE, YET WITH DELIGHTFUL ECCENTRICITIES

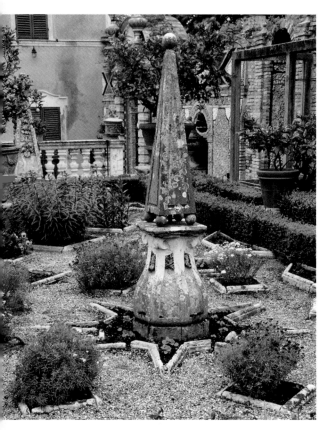

ABOVE **Obelisk in the Secret Garden**

These late-baroque gardens became an enchanting playground for a nobleman's many children.

If one set out to design a garden with the magical quality that appeals to children, one could scarcely improve on the whimsical features that were so much a part of the Giardino Buonaccorsi design. A puppet theatre, a grotto with caricatured figures, amusing statuary and so much more must have made this garden an irresistible playground to the young members of the Buonaccorsi family.

Here is a garden that has survived with its 18th-century persona almost completely intact, matching detail for detail a painting that is believed to record the design in its infancy. Orientated towards the sun and protected from the prevailing winds, this south-facing hanging garden is laid out as five terraces from which, on a clear day, one can see over green hills and valleys to the Adriatic in the distance.

ATTRACTION OF OPPOSITES

There is formality in the star and diamond shapes of stone-edged flowerbeds and the obelisks in a secret garden, and of neatly clipped box hedges that form a parterre. And there is romanticism in the terraces perfumed by lemon trees, and in the abundance of flowers and scents, and drifts of soft, subtle colours that balance the geometric shapes; there is perhaps more romanticism here than in any other classical Italian garden.

WEALTH OF STATUARY

There are over one hundred statues in the garden, covering a wide range of subjects, and all the work of Orazio Marinali, a sculptor from the northern Italian city of Vicenza. One of the terraces is known as the Avenue of the Emperors because of the number of ancient Roman likenesses arranged there, and in a niche there is a statue of the goddess Flora. Elsewhere,

WHAT'S THERE:	Mid-18th-century formal garden design with over 100 specially commissioned statues
WHERE:	Near Potenza Picena, Marche, Italy
GETTING THERE:	30km (19 miles) S of Ancona, between Macerata and the coast
WHEN TO VISIT:	By appointment, Apr to Sep
CONTACT DETAILS:	(0039) 0733 688189; Signor Marcellari, Società Agripicena, Via Giardino 9, Potenza Picena, Macerata, Marche, Italy

ORAZIO MARINALI

The sculptor who carved 105 pieces for Giardino Buonaccorsi trained in Venice with Josse de Corte, a leading sculptor in the city at that time. Marinali (1643–1720) executed many famous religious works, including *Virgin and Child with Saints,* and *Angels and Putti,* both for the cathedral in Bassano del Grappa. He also sculpted many figures and bas reliefs for the interior and exterior of the church at the Shrine of the Madonna of Mount Berico, in Vicenza, an important site of Marian worship. Marinali founded a school in Vicenza, and, with his brothers Francesco and Angelo, produced an enormous number of statues for fountains, for palazzi, and for other churches in the city and far beyond. Marinali usually signed his work 'O.M.'

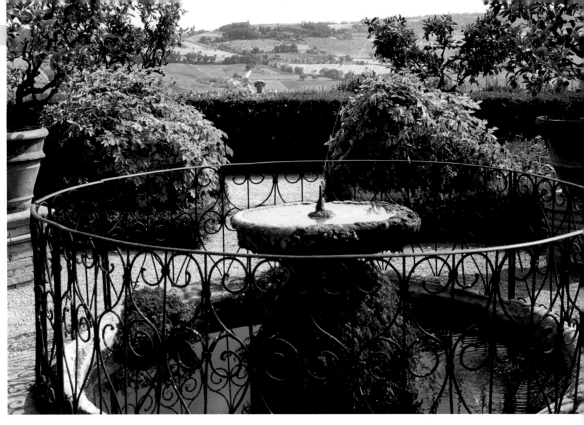

ABOVE **Citrus trees frame the view**

there are statues of mythological gods, of carved figures with a variety of musical instruments, of commedia dell'arte characters, including Harlequin and Pulcinella, captured with humour and puckishness, and affectionate likenesses of many of the family's dogs.

NOBLE FAMILY

When the Buonaccorsi family was ennobled by Pope Clemente XI in 1701, the head of the family, Count Simone, called in the architect Giovanni Battista Contini to beautify both his city palace and the 17th-century hilltop villa and gardens surrounding his country estate at Potenza Picena. The Count died seven years later,

and his son Raimondo took over the estate and the task of overseeing the design of the gardens, which eventually became a pleasure ground for his 18 children.

AMUSING FEATURES

Prominence was given to a statue of Pan displayed in a niche on top of one of the terraces. He was said to be the guardian of the garden, and played his pipes whenever anyone came within his line of sight. There was an aviary of singing canaries, no doubt enchanting to children, and a number of water ambushes that must have caused great delight when set to surprise their elders with a drenching. The children had their own outdoor stage – an automated puppet theatre in which a huntsman blew his horn, a blacksmith smote his

forge and Harlequin banged his drum. More controversially, in one of the several grottoes, there were two figures of praying monks being mocked by a devil, who popped out of a recess and poked out his tongue.

For all its amusing features, this was and is a garden of late-baroque charm, conforming in many ways to the formality and precision of the era. The jokes and games were just fun additions.

FOOTNOTE

The Buonaccorsi estate had been in the family since 1582 and, when the last Contessa died in 1970, the family sold the villa. A group of friends formed a company to preserve the gardens, which are now owned by Società Agripicena.

LEVENS HALL

FANCIFUL DESIGNS CREATED OVER 300 YEARS AGO ARE JUST AWE-INSPIRING

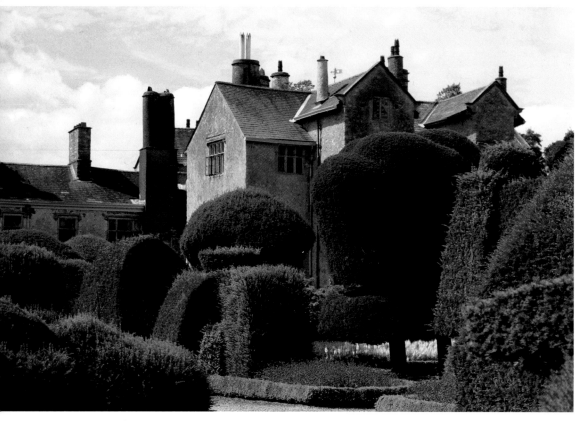

ABOVE **Majestic silhouettes against the Hall**

World famous for its magnificent topiary sculptures, said to be the oldest in the world, the gardens at Levens Hall are truly inspirational.

What do 'Queen Elizabeth and her Maids of Honour', 'The Judge's Wig', 'The Bellingham Lion', and 'The Jugs of "Morocco"' have in common? They are the affectionate and fanciful names given to some of the 90 topiary structures that adorn and dominate the gardens at Levens Hall. These living sculptures, some of the oldest in the world, have survived true to the original designs for over 300 years and make the gardens a place of horticultural pilgrimage for a great many garden lovers.

FORTIFIED TOWER

The property originally consisted of only a square, fortified (pele) tower built on the lower reaches of the River Kent in 1350 by the de Redman family as a defence against the threat of Scottish raiders from over

WHAT'S THERE:	Grade I listed garden with over 90 magnificent topiary sculptures, orchard, nuttery, herb garden, herbaceous borders; deer park; restaurant, shop, plant centre. Steam engine collection Sun and Bank Holiday Mon only. Fine Elizabethan house
WHERE:	Kendal, Cumbria LA8 0PD
GETTING THERE:	8km (5 miles) S of Kendal off A590/A6
WHEN TO VISIT:	Sun to Thu, late Mar to early Oct
CONTACT DETAILS:	01539 560321; www.levenshall.co.uk

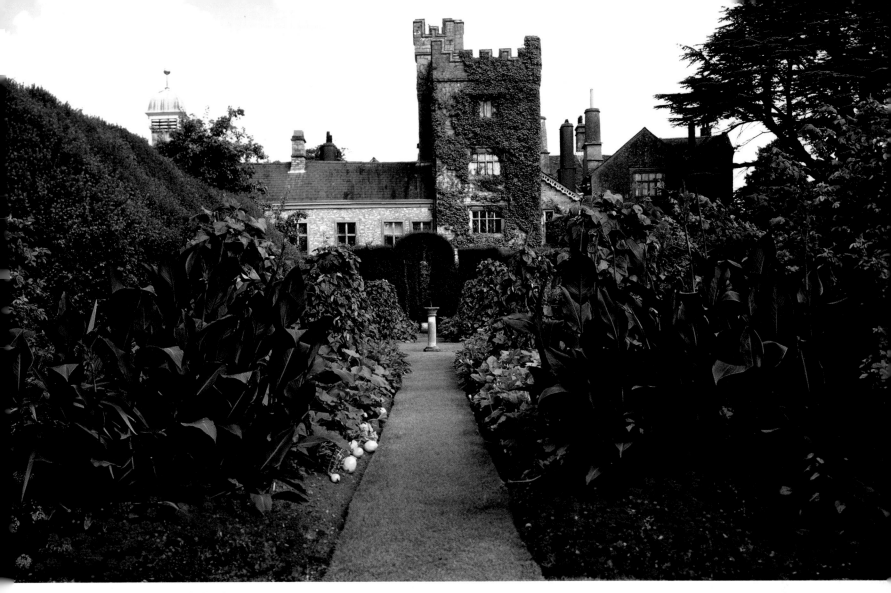

ABOVE **Cannas predominate in the borders**

the border. In the mid-16th century, their descendants, the Bellingham family, built an Elizabethan house around the tower and, in 1688, it passed into the hands of Colonel James Grahme, a cousin of Alan Bellingham, who added the east and south wings. It passed from Colonel Grahme to his daughter Catherine, who became Countess of Suffolk, and later to the Bagot family.

GUILLAUME BEAUMONT

The history of the Levens Hall gardens begins with Colonel Grahme's ownership. Grahme, a Jacobean nobleman who held the office of Keeper of the Privy Purse to King James ll, brought with him a young French gardener, Guillaume Beaumont, who had been a pupil of André Le Nôtre in the gardens of the Palace of Versailles, Paris. Beaumont, who had recently finished

laying out the Hampton Court Palace gardens, spent the last 40 years of his life working at Levens Hall. A portrait of him that hangs in the Hall has the inscription: 'Gardener to King James ll and Colonel James Grahme'.

Beaumont began work on the gardens in 1694, and 300 years later, to celebrate the partnership of Colonel Grahme and his gardener and their enduring inspiration,

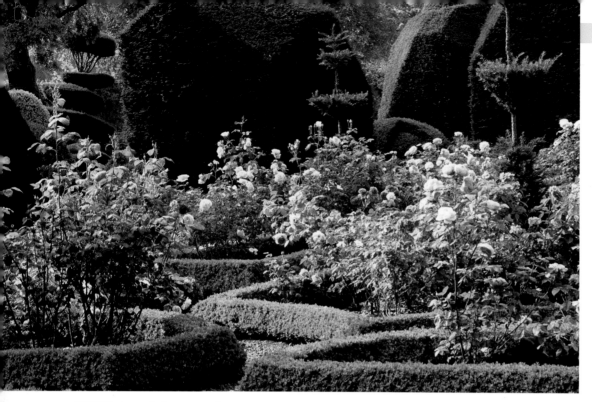

ABOVE **Parterres in the rose garden**

a fountain garden bordered by pleached limes was created.

HEIGHT OF FASHION

The fashion for gardens featuring precisely clipped evergreens began in Holland, travelled through France and arrived in England in the late 17th century, coinciding with Colonel Grahme's arrival at Levens Hall. Beaumont's imagination knew no limits. He created designs, some now over 6m (20ft) high, representing graceful birds, elegant beasts, chess pieces – some quaintly reminiscent of the Duchess in *Alice in Wonderland* – cones, spirals, pyramids, giant rings, arches and even teacups and saucers.

Over the years, successive gardeners, charged with maintaining these sculptural masterpieces, have added tails to birds, curlicues to wigs, handles to teacups and other refinements without altering the spirit of the original designs.

Beaumont's design for the garden consisted of more than the yew and box sculptures. He created a series of garden walks and planted extensive beech hedging, which in summer is seen as a 5m (16ft) high crisp green wall, and in winter displays its superstructure of massive, gnarled and twisted trunks: a sculpture of a different kind. This innovative gardener is also credited with creating the first known example of a 'ha-ha', a sunken ditch designed to keep cattle out of the gardens without a fence interrupting the view.

KEEPING IN SHAPE

Visitors to the garden are always incredulous at the formidable amount of maintenance needed to keep the topiary masterpieces in shape. Work begins in August, when a team of five gardeners starts trimming the beech hedge. Then in October, when the garden is closed to visitors, they start clipping the topiary structures, which have to be clad in scaffolding and trimmed with petrol clippers, a task that can often last well into the following year.

These ancient sculptures are now so firmly established at Levens Hall that they are able to recover from seasonal damage. Heavy snow, which weighs down the branches, can play havoc with the intricate shapes so that they take a while to regain their crisp outlines. Two of the sculptures took a year to recover from damage caused when a tree felled by a storm crashed on top of them. Some of the oldest structures now lean drunkenly in ways that were not intended, but perhaps that only adds to their charm.

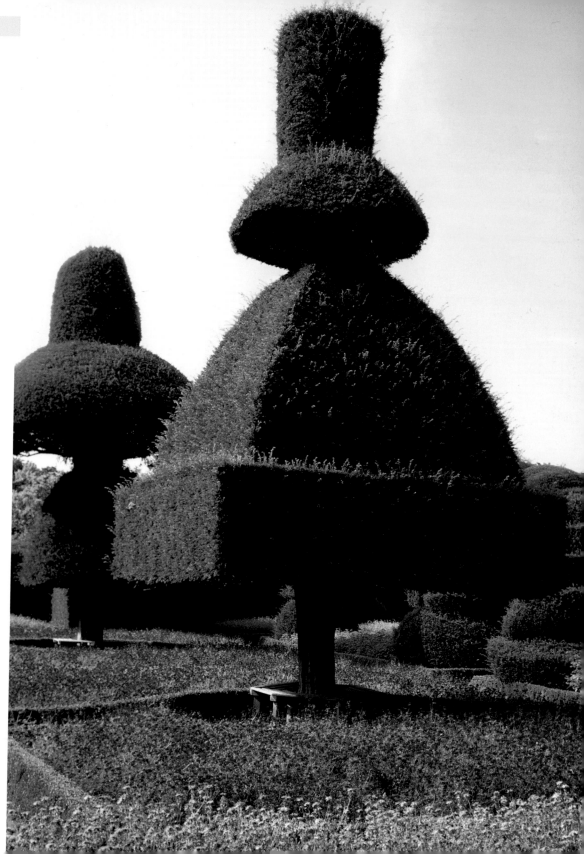

SEASONAL COLOUR

The topiary structures and a parterre with beds edged with low box hedges – more work for the shearers – are planted twice a year with some 15,000 seasonal bedding plants, a glorious sight in both early summer and autumn. In spring, large carpets of naturalized snakeskin lilies (*Fritillaria meleagris*) punctuated by thick ribbons of cream narcissus enliven the ground down to the river.

When visitors have marvelled enough at the topiary eccentricities, the Levens Hall garden has yet more to offer. There is a small orchard, a nuttery and a herb garden. The rose garden is a delight in summer, and the long herbaceous borders are planted to maintain colour and interest over many months. An undulating avenue of oaks leads to the parkland where a herd of black fallow deer and the famous Bagot goats – a rare breed with long, curved horns – roam. Levens Park was also laid out by Guillaume Beaumont.

GHOST STORIES

Not surprisingly, Levens Hall, which dates back over so many centuries, has a number of ghost stories attached to it. It is said that a Grey Lady appears in front of cars on the driveway, that a friendly woman wearing a print dress and cap appears only to children, and that a small black dog wanders the Hall.

RIGHT **Chess pieces or the Duchess in** *Alice* ?

ROUSHAM HOUSE

A SENSE OF CONTINUITY IN A BEAUTIFULLY PROPORTIONED WILLIAM KENT GARDEN

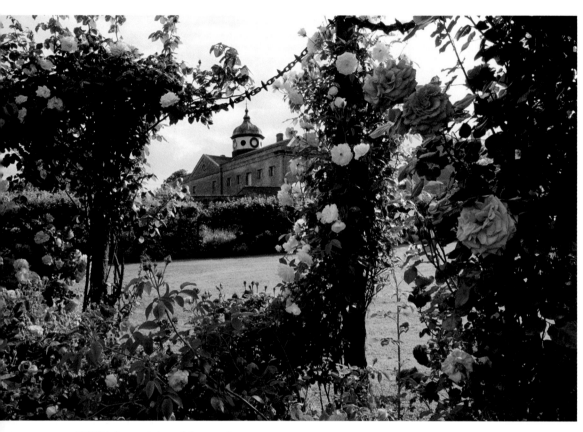

ABOVE **A fragrant view of the mansion**

This Oxfordshire garden is the only one of landscape artist William Kent's designs to survive virtually unchanged.

One has a sense of continuity at Rousham House. The imposing, almost fortress-like Jacobean mansion, built on a curve on the River Cherwell, has been owned by members of the same family since Sir Robert Dormer, a staunch royalist, acquired the land in the 1630s. And the garden, designed to complement the house and blend effortlessly into the Oxfordshire countryside, has been maintained true to the design laid out by William Kent a century later. In addition, it has acquired a unique place in the history of horticultural design, being the only example of a classical landscape garden surviving almost exactly as Kent intended.

LANDSCAPE PAINTING

The plan for the garden was originally laid down in the 1720s by Charles Bridgman,

WHAT'S THERE:	30 acres with woodland walk, statues, temples, walled garden. Children under 15 not admitted
WHERE:	Near Steeple Aston, Bicester, Oxfordshire OX25 4QX
GETTING THERE:	19km (12 miles) N of Oxford, 11km (7 miles) W of Bicester, off A4260 and B4030
WHEN TO VISIT:	Open daily all year
CONTACT DETAILS:	01869 347110; www.rousham.org

RIGHT **The dovecote and parterre**

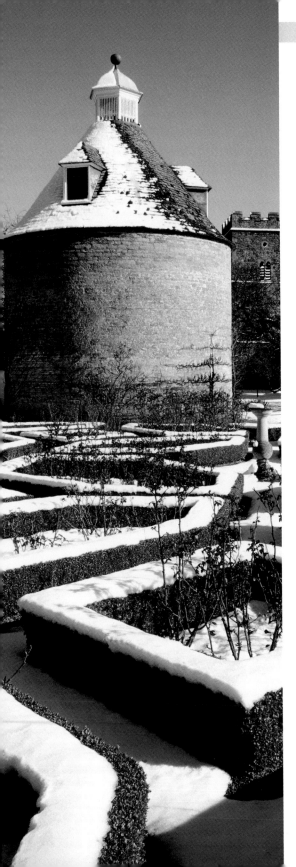

a royal gardener, but it was Kent who created an Augustan landscape with features that evoke not only the glories of Renaissance Italy but also of ancient Rome. A Yorkshireman who studied art in London and moved to Italy, where for ten years he painted frescoes, Kent envisaged this garden as a landscape painting, and designed it to use shape and form, light and shade to maximum effect.

He used water from springs in the hill above to create cascades, rills and ornamental pools, simple features that formed romantic cameos within the classical framework. One curvaceous rill runs through a stone channel linking the Cold Bath and the so-called Venus Vale. Other rills, sparkling and light-catching, feed into ornamental pools, and a white-water cascade tumbles into a grotto. One large pond, surrounded by lawns and

overlooked by an old stone bridge, is carpeted from side to side with water lily leaves of stepping-stone proportions and spotlighted at times with their white, waxy flowers.

CRITICAL APPROACH

Woodland trees serve as a stage backdrop to beautifully proportioned temples, statues and follies, sited at intervals along a meandering path. This is a walk to be taken slowly and reflectively, allowing time to appreciate and assess the structures and statuary, each one given centre-stage prominence in its own glade or clearing. Some statues are fanciful or mythological, others recall Imperial Rome. There are images of Pan, a leaping fawn and Venus. A lion savagely attacks a horse, and a gladiator, an impressive figure on an impressive plinth, is depicted in his dying moments. A small classical temple is almost overshadowed by the arms of a large cedar of Lebanon tree, dating from Kent's time, and unplanted urns are positioned to be appreciated as the pieces of classical sculpture they are.

NOT TO BE MISSED

William Kent's most outstanding contribution to the Rousham House garden is the Praeneste, modelled on the arcaded temple at Palestrina, outside Rome, a 'must see' building on the itinerary of travellers on their Grand Tour of Europe. With its seven magnificent stone arches, each framing the view beyond the sloping lawns and down to the riverside, it is not to be missed here, either.

ABOVE **A snowy outlook**

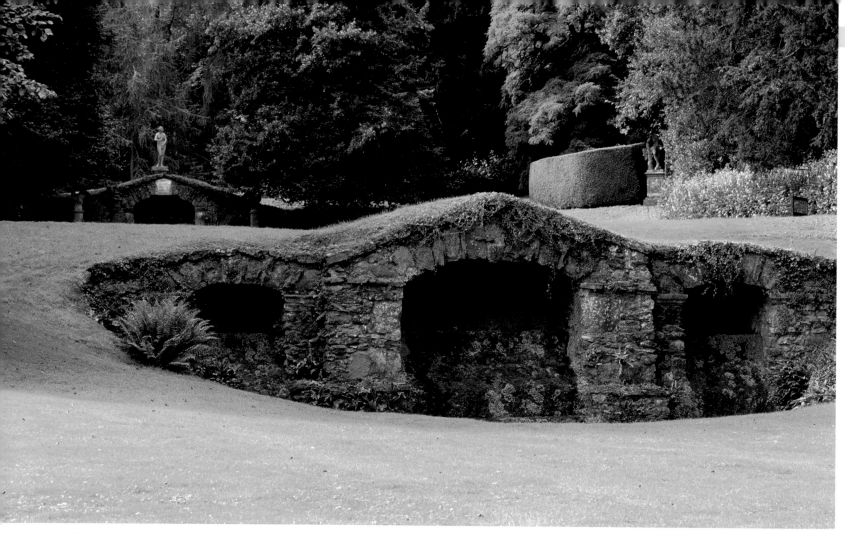

ABOVE **Graceful statues decorate the walks**

LIVING MOSAIC

Part of the garden predates Kent's time. There is a 17th-century walled garden, productive still, with espaliered fruit trees, their branches outstretched and clinging to the walls, and a circular dovecote with the original revolving ladder. Around the dovecote, like pieces of a deep green mosaic floor, is a series of hexagonal box parterres dating from Tudor times, each division now closely planted with rose bushes.

LATER ADDITIONS

There are later additions close to the house, which in no way detract from the original design concept.

In Victorian times, a fernery was added, together with a conservatory, to nurture frost-tender plants, while in the 20th century, two long herbaceous borders were planted. These bring a joyful note of informality and a palette of summer colour to the garden, as well as providing cut flowers for the house.

PRAISE INDEED

William Kent, whose nickname was 'Kentino', was fond of emphasizing his classical connections by dropping Italian phrases into his conversation. When Horace Walpole (1717–1797), the politician, writer, and cousin of Lord Nelson, visited the estate, he expressed his appreciation succinctly. Stating that he considered the Rousham House garden the finest of all Kent's achievements, he summed it up in one word, 'Kentissimo!'

RIGHT **Seven stone arches of the Praeneste**

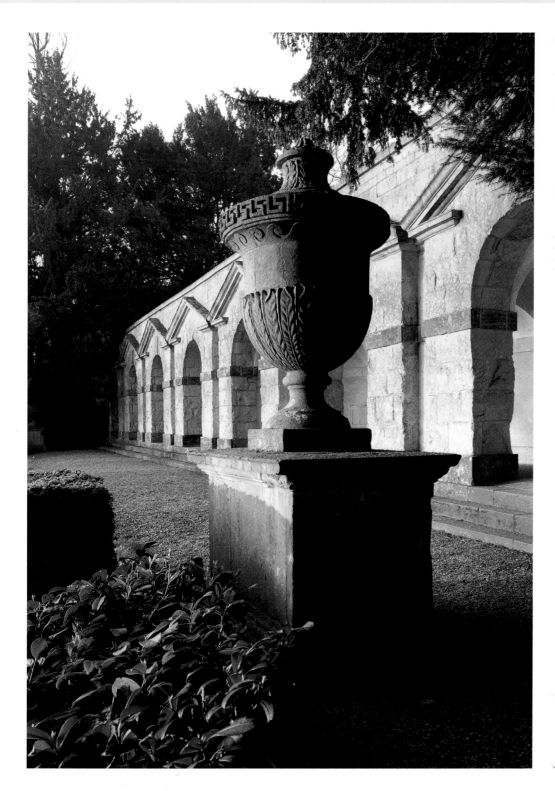

CREATING THE LOOK YOURSELF

✳ Learn from the effect that landscape designer William Kent achieved with his use of statuary at Rousham House. A piece of fine sculpture, depicting a human or mythological figure or an animal, or a sundial or an elegant plant container can become an eye-catching focal point in your garden and create as much impact as any flowering shrub or tree.

✳ Consider the position of your chosen piece: in a niche or arch clipped from a dense hedge; at the end of the garden where two paths or hedges meet; between two trees or other features – anywhere that will draw the eye. Illogically, placing a sculpture in such a position has the effect of making a garden seem longer. A delightful way to create an element of surprise is to place a sculptural piece 'round the corner' in an outside garden room where it cannot be seen from the main garden. Then stand back and wait for the oohs and aahs of visitors! Alternatively, in another interpretation of classical garden design, position a pair of matching sculptures on either side of a door, flight of steps, pathway or gateway.

✳ Garden centres and garden specialist shops sell good reproductions of classical statues and other attractive garden ornaments. It is also worth looking in antiques shops and demolition yards.

THE MOUNT

SENSITIVE PLANTING AND A STRONG ITALIAN INFLUENCE HAVE LEFT A FINE LEGACY

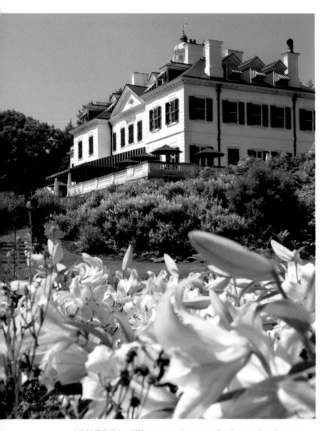

ABOVE **White lilies complement the imposing house**

A novelist's statement on the relationship between a house and its landscaping is evident at The Mount.

When Edith Wharton and her husband Edward moved to The Mount in 1902, she considered it her first real home. Here, with help from her niece Beatrix Farrand, she created a garden that was in every way an architectural extension of the house, designed in the formal Colonial Revival style by Francis Hoppin.

A passionate gardener who had travelled widely and become an authority on European landscape design, Edith Wharton (1862–1937) believed that a garden should 'possess a charm independent of seasons'. Using trees, shrubs and perennials from around the world, together with many native ferns that she collected from the Berkshires in Massachusetts, she created an elegant series of outdoor rooms, most of which had year-round appeal.

ITALIANATE GARDEN

One of the keynote gardens, reached across a wide sloping lawn at the back of the house, shows a strong Italian Renaissance influence. This green-and-white garden, created on a gentle slope that runs parallel to the house, has a pathway with wide grass borders on either side. To take account of the incline, the pathway has sequences of widely spaced flights of stone steps. Each flight of steps is marked by a pair of low, clipped evergreen pillars.

Unusually, the borders have deep steps cut into the grass. A small circular pool is ringed around with a ground-covering of fresh green and white planting, which is repeated as an edging to four surrounding grass parterres. In the centre of each parterre there is an evergreen pillar, and in the centre of the pool, a rough rockpile fountain that strikes a strangely rustic note in this formal setting.

WHAT'S THERE:	3-acre garden designed by writer Edith Wharton in early 1900s and now managed by Edith Wharton Restoration Inc; gift shop
WHERE:	2 Plunkett St, Lenox, Massachusetts 01240-0974, USA
GETTING THERE:	8km (5 miles) N of Lee, 1.6km (1 mile) W of Routes 7 and 20
WHEN TO VISIT:	Open May to Dec
CONTACT DETAILS:	(001) 413 551 5111 www.edithwharton.org

CROWN JEWEL

Another of Wharton's flower gardens is about as different as can be from this cool, calm and restrained creation. Described as the 'crown jewel' of her planting, it explodes with an unrestrained exuberance of colour in 4m- (12ft-) wide borders around a rectangular pool. Pinks and reds, blues and purples, crimsons and violets create a thrilling palette.

HISTORIC LANDMARK

After the Whartons moved from The Mount in 1911, the property went through several changes of ownership, and both the house and gardens fell into disrepair. However, because this garden represented the only example of Edith Wharton's theories on landscape and garden design, and was a National Historic Landmark, a trust was formed to ensure its complete and authoritative restoration. In June 2005, over 3,000 annuals and perennials were planted to restore the flower garden to its former glory. The hardscaping, including the 1km- (½-mile-) long drive, has been repaired or restored to its original state, and over 5,000 trees, shrubs and herbaceous plants have been set out.

Now, once again, it is possible to see this remarkable garden, designed by a Pulitzer prize winner who was, as is evident, a passionate gardener.

EDITH WHARTON, NOVELIST

When her novel *The Age of Innocence* won the 1921 Pulitzer Prize for Literature, Edith Wharton became the first woman to win the award.

CREATING THE LOOK YOURSELF

* The green-and-white planting scheme chosen by Edith Wharton for her Italianate garden gives a delightful air of elegant sophistication. It is also cool-looking.

* To achieve something similar in spring, you could combine flowering bulbs such as *Fritillaria verticillata*, which grows to a height of 90cm (3ft) and has graceful, bell-shaped flower heads, with *Erythronium californicum* 'White Beauty', which has attractive green-and-cream mottled leaves and white flowers, and grows to about 30cm (12in). To intensify the impact, you could plant the delightful *Tulipa* 'Spring Green', whose white flowers are feathered with green.

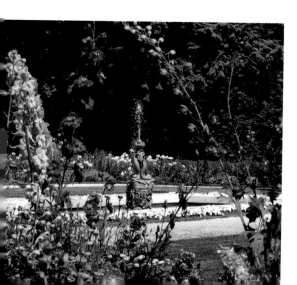

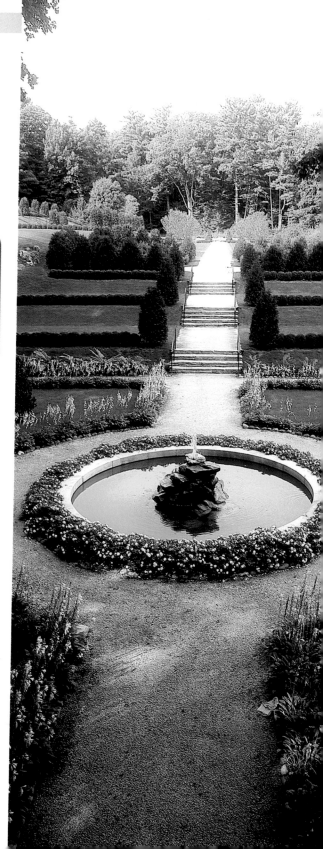

RIGHT **The Italianate garden**

VILLA D'ESTE

ONCE A MAGNET FOR HIGH SOCIETY AND NOW A WORLD HERITAGE SITE

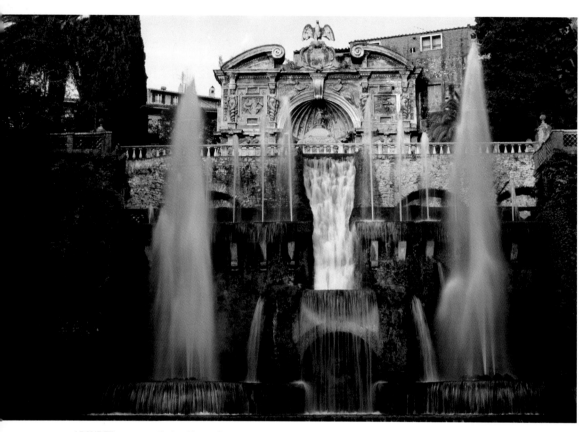

ABOVE **The ornate Organ Fountain**

The gardens that inspired composer Franz Liszt in the 19th century have magic and mystery still.

Fountains that cascade, and fountains that trickle, ornate statues of bathers in sun-dappled water; romantic and mythical figures guarding or enhancing mysterious grottoes; haunting music by Liszt in the background, and the sound of birdsong. That is the essence of the gardens at Villa d'Este, created in the 16th century to satisfy the vanity of the wealthiest cardinal in Rome, and destined to become a magnet for the highest of society.

Son of the infamous Lucretia Borgia and Alfonso d'Este, Cardinal Ippolito d'Este, a patron of the arts who had been frustrated in his bid for the papacy, established a grandiose Renaissance villa, built in the 1550s, and commissioned cascading gardens in the Renaissance style.

WHAT'S THERE:	Garden of many spectacular water features reached by steep paths; restaurant
WHERE:	Tivoli, near Rome, Italy
GETTING THERE:	Bus from Rome to Tivoli, 2min walk from bus stop
WHEN TO VISIT:	Usually open Tue to Sun
CONTACT DETAILS:	From Italy: 199 766 166; from abroad: (0039) 0424 600460; www.villadestetivoli.info

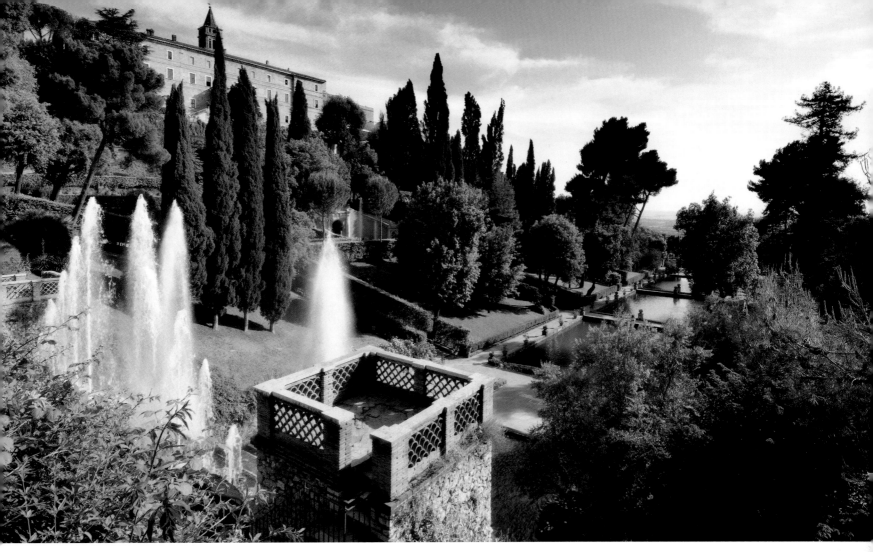

ABOVE **There are long views over the city**

HANGING GARDENS

His garden architect – the archaeologist and painter Pirro Ligorio – achieved what might have seemed the impossible, given the gradient. This garden, created with terrace upon terrace cut into the steep hillside below Tivoli, seems to be precariously hanging on to the side of the cliffs of the Valle Gaudente. Little wonder that Villa d'Este sometimes draws comparison with the biblical Hanging Gardens of Babylon.

WATERY ELEMENTS

Water and fountains are the main elements used in the creation of the garden, with decorative features and statuary, allegorical allusions and evocations of ancient Rome its attractions. Entrance to the garden is now through ornate but unfurnished chambers of the villa. Even that display of former glories does not prepare the visitor for the astonishing showpiece of fantasy and whimsy, and, on a less romantic level, the engineering skill of the craftsmen.

GRADUAL DESCENT

A central alley, known as the Avenue of Perspectives and criss-crossed with axial paths, snakes its way from the villa all the way down to the garden's lowest level. However, the visitor is unlikely to keep to the Avenue and make the descent in one take but, instead, allow themselves to be drawn off at a tangent down the many paths to wonder at the ingenuity and diversity of up to 500 different water feature designs.

ABOVE **The sculpture of Diana**

DESIGN FANTASY

Centre stage in this design fantasy is the entertaining Organ Fountain (see right), which, like so many of the water features, fell into disrepair. It has now been restored to its melodic splendour by British and Italian craftsmen and organ specialists. Similarly, the Fountain of the Owl (see right) once again warbles with the simulated sound of birdsong.

SOUND OF MUSIC

The long path of the Hundred Fountains displays a remarkable marriage of water and decorative stonework, with individual fountains separated by slightly shaggy cypress pillars and other trees. The three water levels symbolize the rivers Albuneo, Erculaneo and Aniene, which converge and flow through the Roman landscape and into the Tiber. Franz Liszt, a frequent guest at the villa in the 19th century when

LEFT **Shade is always welcome**
RIGHT **Path of the Hundred Fountains**

FOUNTAIN HIGHLIGHTS

The gardens rely little on vegetation for their appeal. Although there are cypress trees, flowering shrubs and wayward wild flowers thrusting up between the paths and stairways, this garden is almost entirely about the magnificence of its water features.

* **The Organ Fountain** This elaborate fountain, decorated with reliefs of Orpheus and Apollo playing musical instruments, has a water-operated organ hidden within the complex architecture. The mechanical-sounding music is played every two hours each day. The sculpture of Diana, with water spouting from her many breasts, once stood in the central niche of the organ structure. In the 17th century, the statue was held to have pagan associations and removed to a less prominent part of the garden.

* **The Fountain of the Owl** In this fountain, too, water pressure activates an organ that plays tunes similar to the sound of birds. Small birds sing until the appearance of the owl.

* **The Rometta Fountain** A tribute to ancient Rome, this fountain included recreations of many of the city's monuments, including a ship symbolizing the Isola Tiberina.

* **The Fountain of the Dragon** Four dragonheads compose a glorious piece of statuary in a cave-like recess between steep stairways. The dragons spout water into a pool in the direction of two dolphins on each side of the dragons.

* **The Ovato** This oval-shaped fountain is backed by a nymphaeum. It was possible to walk behind the fountain along a corridor linking several caves.

it was in the possession of the Austrian Emperor, was inspired by the musical sounds of the multiple cascades and composed a piece for the piano, *Les Jeux d'Eau à la Villa d'Este*.

MYTHOLOGY

A fork in a stairway leading to some of the many grottoes was said to have Herculean symbolism, with one path leading to the goddess Diana, the other to Venus. Visitors to the gardens make a choice at every crossing. Each one leads to a magical, mythical structure, and each one is entrancing, with spectacular views across the plain to Rome, the city that inspired so much of the architectural design.

WORLD SIGNIFICANCE

The gardens of the Villa d'Este, sometimes known as 'the gardens of miracles', have been given World Heritage status by UNESCO because of their significance in the history of garden design.

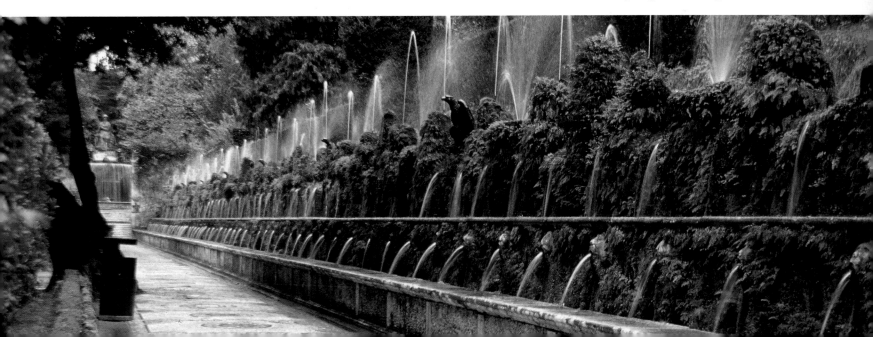

PETO GARDEN, IFORD MANOR

ONE OF THE FINEST OF THIS GARDEN ARCHITECT'S ITALIANATE DESIGNS

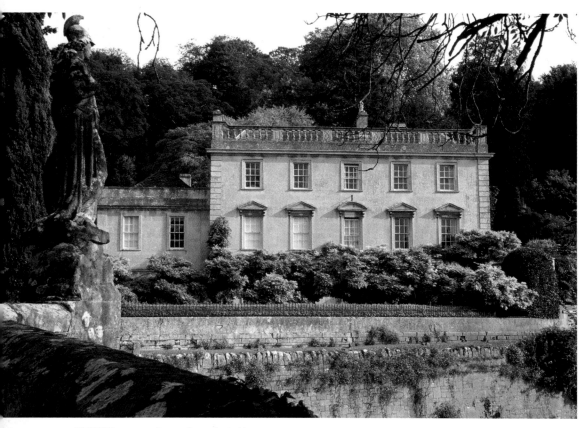

ABOVE **The manor house from the bridge**

The hillside garden overlooking the Frome valley that Edwardian garden architect Harold Peto designed for himself is considered one of the finest of all his Italianate designs.

Cross the beautiful old stone bridge over the river and there is the medieval manor house with its honey-gold, 18th-century facade, nestling at the foot of the steep, wooded slopes of the Frome valley and viewed sometimes through folds of pale mauve wisteria. This initial view gives a clue to the chief elements of the garden design. Beside the house and on banks high above it are layer upon layer of trees in every shade of green, and of yellow, bronze and purple, too, partially obscuring walls and subsidiary buildings.

The garden design and layout was the work of architect-turned-landscape gardener Harold Peto, who designed so many magnificent gardens in the classical manner. This, however, was his own

WHAT'S THERE:	Romantic Italianate-cum-Arts and Crafts garden
WHERE:	Bradford-on-Avon, Wiltshire BA15 2BA
GETTING THERE:	11.25km (7 miles) SE of Bath via A36; 3.2km (2m) S of Bradford-on-Avon
WHEN TO VISIT:	Apr and Oct: Sun and Bank Holiday Mon; May to Sep: Sun, Tues, Wed, Thu and Sat; groups by appointment. Children under 10, weekdays only
CONTACT DETAILS:	01225 863146; www.ifordmanor.co.uk

ABOVE **Stone columns of cathedral-like proportions**

garden, where he lived for the first three decades of the 20th century and where he created a theatrical setting for his collection of Italian Renaissance statuary and artefacts. He used the steep slope of the site to spectacular advantage, marrying structural plants and stone, and creating a series of terraces linked by flights of

steps and standard Chinese wisteria shrubs (*Wisteria sinensis*). Each terrace is completely different from the last, and each one is furnished with a distinctive architectural feature, such as a pavilion, loggia, pool or patio, setting the stage for classical fountains, lavishly planted urns and statues.

ECCLESIASTICAL OVERTONES

One of these structures, on the Great Terrace, is of cathedral-like proportions and follows ecclesiastical lines. The terrace is edged with stone columns representing the nave. At the north-west end, a large semi-circular stone seat represents the apse and, continuing the ecclesiastical

theme, there are two small enclosures like side chapels, one of which displays topiary emblems of the Chigi family, to whom one of the present owners, Elizabeth Cartwright-Hignett, is related.

Another architectural structure that also has its roots in ecclesiastical building design is the Romanesque-style cloisters that Peto built in 1914 and which came to be called a 'Haunt of Ancient Peace'. Constructed of local Westwood stone, this gloriously spiritual structure, with its arched windows and spectacular views

LEFT **Flights of stone steps link terraces**

across the valley, became a sanctuary for many of the designer's most precious treasures. The small inner courtyard has as the central feature an octagonal wellhead from a convent in the northern Italian town of Aquileia, and clematis hangs in elegant ribbons from the roof. A chapel in the cloisters was dedicated in 1916 'To the Glory of God and The Blessed Virgin Mary'.

COMPATIBILITY

Throughout the Grade I listed garden, now restored and tended by the present owners to Peto's design, flowers are subordinate to both architectural and clipped evergreen features. These structural plant elements are mainly designed with cypress, juniper and *Buxus sempervirens*, which grows wild in the woods above the house. There are exceptions. Banks of scented day lilies (*Hemerocallis citrina*) and naturalized martagon lilies make a glorious summer display. It is, however, the elegance of the permanent structures and the masterful use of compatible natural materials that make this garden seem aloof from the changing seasons.

BATS IN THE BARN

The roof space at Iford Mill Barn is the summer breeding roost for great horseshoe bats, one of only 14 known roosts for this species in England. With over 250 individual great horseshoe bats recorded in the barn each summer, the buildings and a small area of land surrounding them were, in 1996, designated Sites of Special Scientific Interest (SSSI).

HAROLD A PETO, LANDSCAPE GARDENER

The garden he created for his own home at Iford Manor is considered one of Peto's finest Italianate gardens. A son of Sir Samuel Morton Peto, a contractor who built the Houses of Parliament and Nelson's Column in London, Harold Ainsworth Peto (1854–1933) became a partner in an architectural practice in London in 1876, where for one year in 1880 Edwin Lutyens was a pupil. Peto, by then a collector and connoisseur of Italian landscape and art and an exact contemporary of Gertrude Jekyll, the eminent garden designer, left the partnership in the 1890s and himself became one of the foremost landscape gardeners of his time.

ABOVE **The chapel in the cloisters**

ALHAMBRA AND GENERALIFE

ONCE THE PALACES AND LEISURE GARDENS OF KINGS, AND MAJESTIC STILL

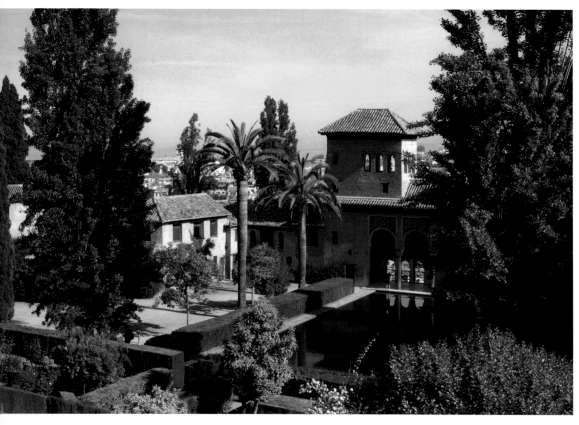

ABOVE **The Partal gardens, on the site of a Nasrid palace**

Medieval Moorish palaces and exquisite gardens convey an aura of glamour and romance.

Arcades decorated with intricate plaster fretwork; ornate marble fountains and reflective pools; the entrancing sound of running water and sometimes of nightingales; the fragrance of roses and myrtle; the formality of evergreen parterres; and, beyond, a park bejewelled with wild flowers – the palace complex of Alhambra and the neighbouring former summer palace of Generalife have all these enticing elements and more.

At the foothills of the Sierra Nevada mountains and overlooking the once-powerful Moorish city of Granada, Alhambra was built as a fortress and palace for the Moorish rulers of southern Spain. The first Nasrid king, Mohammed ben Nasar (1238–1273), began work on the site by restoring an existing fortress. Many of the luxuriant palaces that followed

WHAT'S THERE:	Small city and summer palace on the SE border of Granada; palaces with courtyards, fountains and gardens
WHERE:	Granada, Andalucia, Spain
GETTING THERE:	Bus 2 from Granada
WHEN TO VISIT:	Open daily all year from 9.30am until dusk. Night visits: summer, 10-11.30pm, Tue to Sat; winter, 8-9.30pm, Fri and Sat. It is advisable to book tickets
CONTACT DETAILS:	To book: (0034) 93 49 23 750; www.alhambratickets. com; for information: www.alhambra.org.es

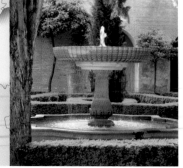

had been completed by the reign of Mohammed V (1353–1391), by which time the complex was a citadel of power. This magnificent historic treasure largely escaped the destruction wrought on other Moorish cities by the Spanish Christians.

THE ALHAMBRA PALACE

The majority of the palace buildings, many added by successive Muslim rulers, consist of quadrangles opening onto a central court or patio and enclosing romantic and private gardens.

The abundance of water cascading from fountains, tumbling down steps and along handrails, harnessed in elegant pools and flowing through channels in marble floors was a display of power and extreme wealth. It was also a display of engineering ingenuity, since the water was carried along conduits from the hill above the Generalife (see over).

The layout of the gardens, with precise clipped evergreen hedges outlining pools or enclosing fragrant shrubs and flowers, established a tradition of garden design that is still echoed in European gardens today.

Access to Alhambra is through Puerta de las Granadas (Gate of the Pomegranates), a triumphal 15th-century arch, then up the Cuesta de Gomerez hill to the main entrance, Puerta Judiciara (Gate of Judgment), a huge horseshoe-shaped archway at one time used by the Moors as an informal court of justice. Once inside the complex, there are many large and small palaces, arcades and courtyards, some edged with myrtle or cypress hedges taking the place of demolished walls.

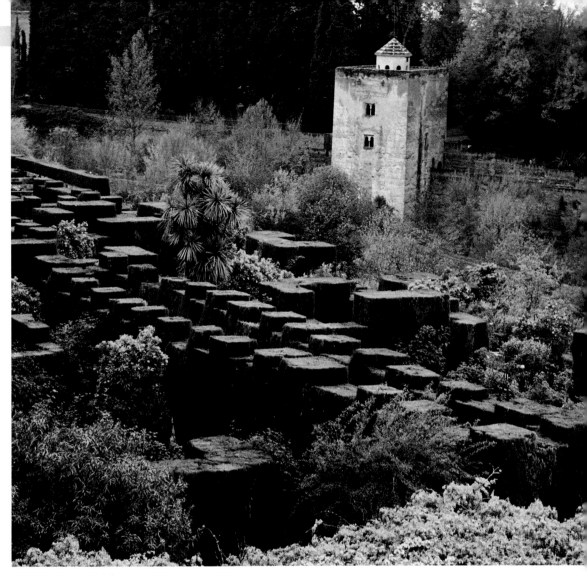

ABOVE **Looking towards Generalife from Alhambra**

THE COURTYARDS

The following courtyards are among the most significant in the Alhambra Palace.

PATIO DE LOS LEONES

The most spectacular courtyard of the Alhambra complex, the Court of the Lions, was built by Mohammed V. It is lined with arcades supported by 124 slender columns, which have been likened to a grove of palm trees, and is planted with aromatic herbs.

At the centre of the courtyard, a marble fountain is supported on the backs of 12 lions, an unusual feature in Moorish architecture and decoration because the portrayal of animals was not permitted by Islam. An ode by the poet Aben Zemrek is carved around the rim of the basin. Water spills from the mouths of the lions into the fountain basin, and is then distributed throughout the courtyard.

PALACIO DEL PARTAL

A tower and a pavilion are all that remain of Alhambra's oldest palace, built on the site of the demolished Nasrid Palace and largely replicating its layout. One side of the pavilion overlooks Granada and the other, with five elegant arches, is fully reflected in a large rectangular pool. This is edged with low, thick hedges backed by myrtles, cypress and palm trees. The water is fed through a series of rills running through the elaborate mosaic paths and down steps to trickle gently into the pool, always maintaining the water level to compensate for loss through evaporation.

PATIO DE ARRAYANES

The Court of the Myrtles, also known as Patio de la Alberca (Court of the Pond), and created in the mid-14th century for the Moorish ruler Yusef l, displays a striking simplicity and lack of adornment. The central feature, set in a marble pavement, is a pool that reflects light into the surrounding arcades and open halls. The design is emphasized by fragrant myrtle hedges and trees.

PATIO DE COMARES

The courtyard of the Comares Palace is one of the simplest yet most dramatic. The water in the long central canal appears as black, creating reflections that appear as negative images of the surrounding arcades, with their intricate, lace-like plasterwork. The drama is heightened by the vivid contrast of the light-reflecting white marble paving.

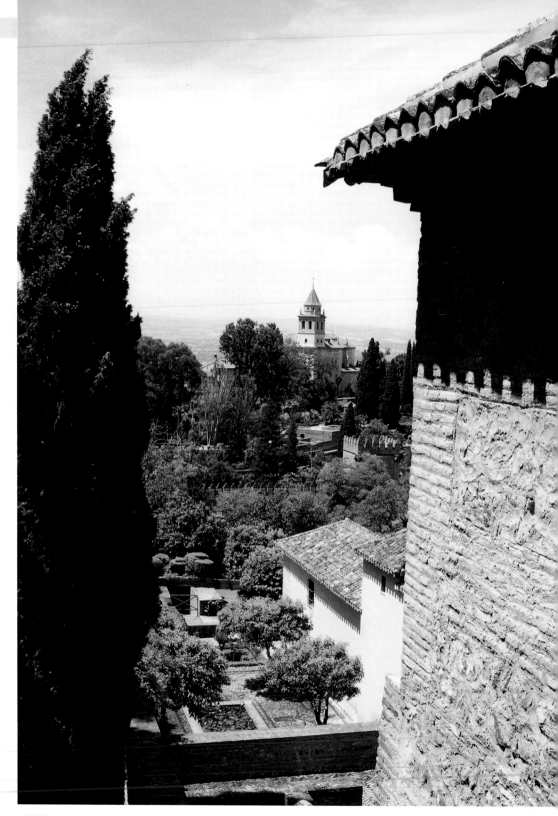

ABOVE **Looking towards Alhambra from Generalife**

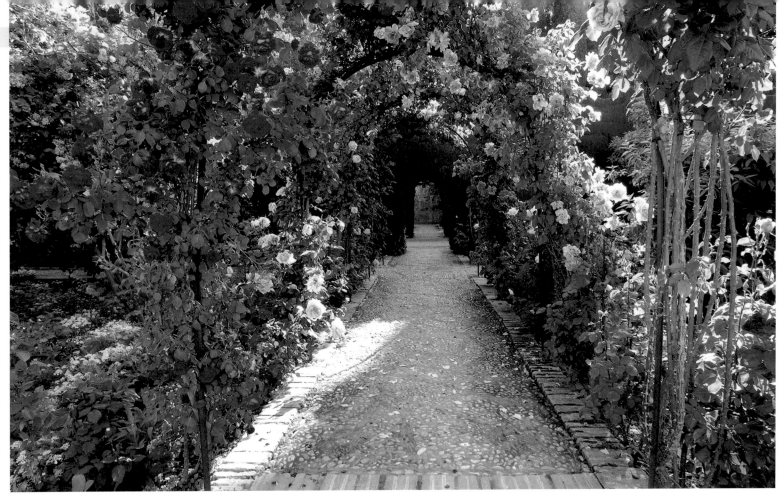

ABOVE **Was there ever a more romantic walkway?**

As in other courtyards, the pool is outlined by Alhambra's now signature myrtle hedges, low, dense and wider than they are tall. At one time, according to a 15th-century account, the courtyard was adorned with orange trees, which would have been grown for the delicacy of their blossom and the sweetness of their perfume.

THE GENERALIFE

Located on the north side of Alhambra and originally linked to it by a covered walkway over the ravine, the Generalife (or Gennat Alarif, Arabic for 'garden of the architect') was built as the country estate and hunting lodge of the Nasrid rulers. Here, a little closer to heaven and in the cooler mountain air, they could escape the intrigues and pressures of palace life.

The concept was to build a 'garden of paradise' as defined in the Koran, with running water, shade-giving trees and beautiful plants. The gardens were begun in the 13th century and, in spite of many subsequent modifications, are considered to be the oldest surviving examples of Moorish garden design.

Where once there were olive groves and orchards, there are now fountains and Italianate gardens showing the Renaissance influence. Parts of the original kitchen garden for the palace remain and are still productive, although they seem somewhat out of place surrounded by such splendour. Further additions to the gardens were created in the classical style between 1931 and 1951, and now a musical auditorium, or concert bowl, has been added – tastefully.

At the heart of the gardens is the Patio de la Acequia (Water Courtyard), which has a long, narrow rectangular pool framed by flower beds, with rows of water jets making noisily splashing arches above it.

It is unlikely that this exuberant feature is original because such an invasive sound of running water would not have been music to the ears of the Moors. They preferred silence to be broken only by the soft strains of music and gently bubbling water.

A portico from the water garden leads to the Patio de los Cipreses (Courtyard of the Cypresses), a blend of Moorish and Renaissance design, with two parallel pools known as 'conjuring mirrors'. This courtyard is also known as the Patio de la Sultana because it was the secret meeting place of Soraya, wife of the Sultan of Granada, Abu I-Hasan Ali, and her lover, the head of the influential Abencerrajes family. A romantic meeting place it must have been but secret it was probably not. The courtyard is overlooked by a two-storey arched gallery, which would have afforded little privacy.

One of the most intriguing features in the Generalife garden is the 14th-century Escalera del Agua (Water Staircase), a steep staircase with water tumbling down the banisters as if they were rills outlining the long flight of steps. Apart from its cooling and soothing effect, the water had a spiritual purpose. It could be used to cleanse the hands and face before prayer.

Impressive mosaic walkways threading through the 300-acre Generalife site also give an impression of coolness. They were created in the traditional Granadian style of symmetrical curlicue patterns and made with white pebbles from the River Darro and black ones from the River Genil, a colour scheme that well complements the evergreen corridors.

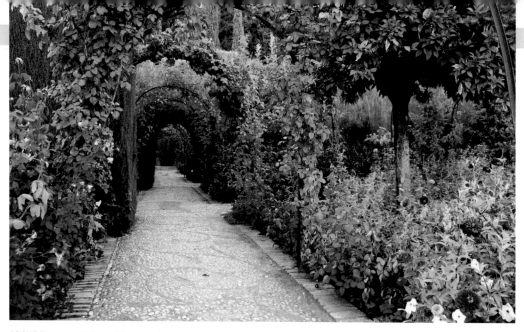

ABOVE **Roses and citrus blossom, favourites of the Moors**

Tall clipped hedges of cypress (*Cupressus sempervirens*), which often follow the outlines of long-demolished walls, form narrow, shade-giving corridors. Some lower hedges, as wide as they are tall, enclose beds of roses and other scented flowers in the romantic Moorish tradition. Tall spires of cypress define the perimeter of some courtyards and the outer reaches of the gardens.

To the east of the Patio de los Cipreses are the Jardines Altos (Upper Gardens), laid out geometrically as a series of evergreen blocks: squares and diamonds, triangles and hexagons, some separated by fountains. The Jardines Bajos (Lower Gardens) form an overture to the Patio del Generalife, where a floral-shaped fountain pool is framed by low, dense hedges. On the hillside below, in an undefined area of about an acre, there is a box nursery where plants have been left to grow untamed, in inspired contrast to the grandeur and formality of the courtyards and gardens.

TALKING POINT

The Salón de los Embajodores (Hall of the Ambassadors) was built between 1334 and 1354. At 12m (37ft) long, it is the largest hall in Alhambra, with a central dome 23m (75ft) high. The ceiling is sumptuously adorned with blue, white and gold stars and crowns representing the seven heavens of the Muslim cosmos.

When the palace was occupied by the Moors, the sultan's throne was placed opposite the entrance. When the palace came under Catholic rule in 1492, King Ferdinand and Queen Isabella presided, and it was in this hall that Christopher Columbus asked for royal support for his quest to sail to India, the voyage that led to his discovery of the New World.

Alhambra and Generalife have been granted World Heritage status by UNESCO.

RIGHT **The enclosed Patio de la Acequia**

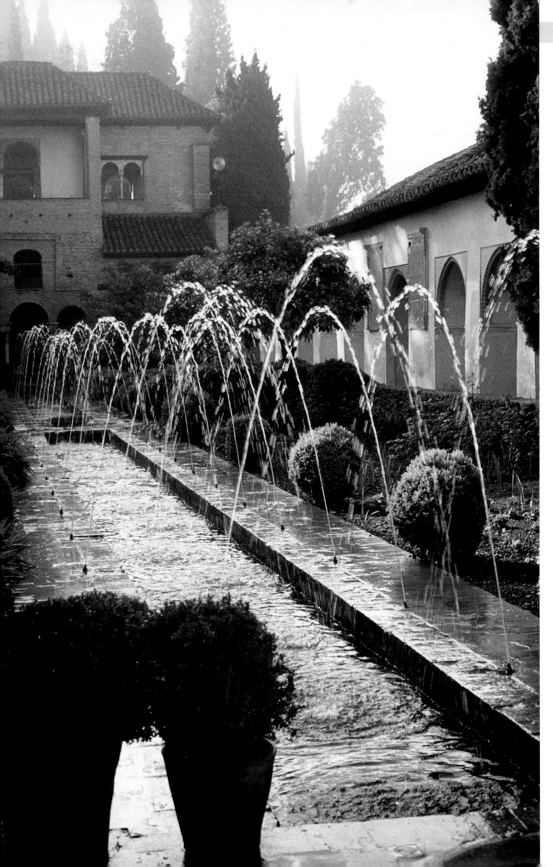

THE WAY IT WAS

In 1526, Navagero, a Venetian nobleman, visited Generalife and found the castles and grounds in ruins, but still enchanting. He wrote this account:

'One leaves the encompassing walls of the Alhambra by a door at the back, and walks into the lovely garden of a pleasure-house that stands a little higher. This... is a striking building with wonderful gardens and waterworks, the finest I have seen in Spain. It has many courts, all abundantly supplied with water, but one in particular with a canal running through the middle, and full of fine orange trees and myrtles. One gets a view outside from a loggia, and below it the myrtles grow so high that they almost reach to the balcony. The foliage is very thick, and the height so nearly the same that it all looks just like a green floor. There is water running through the whole palace, and even at will in the rooms, some of which are joined on to a grand summerhouse.'

ABOVE **Orange trees in a Generalife courtyard**

ENGLISH-STYLE GARDENS

Immaculately mown lawns; herbaceous borders dazzling
with colour; fruit trees trained against mellow walls;
shapely features from statuary to topiary –
this is a garden style with myriad international adaptations.

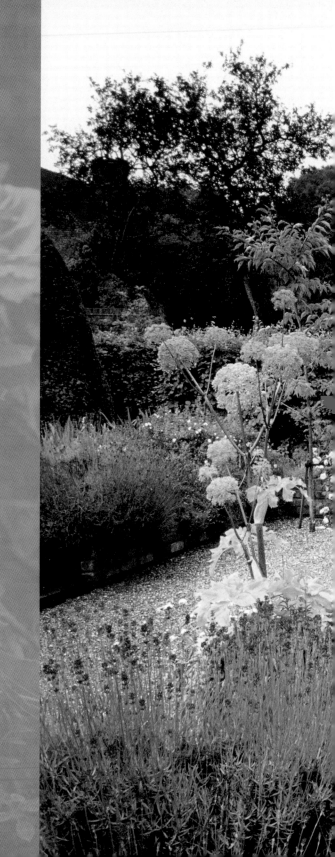

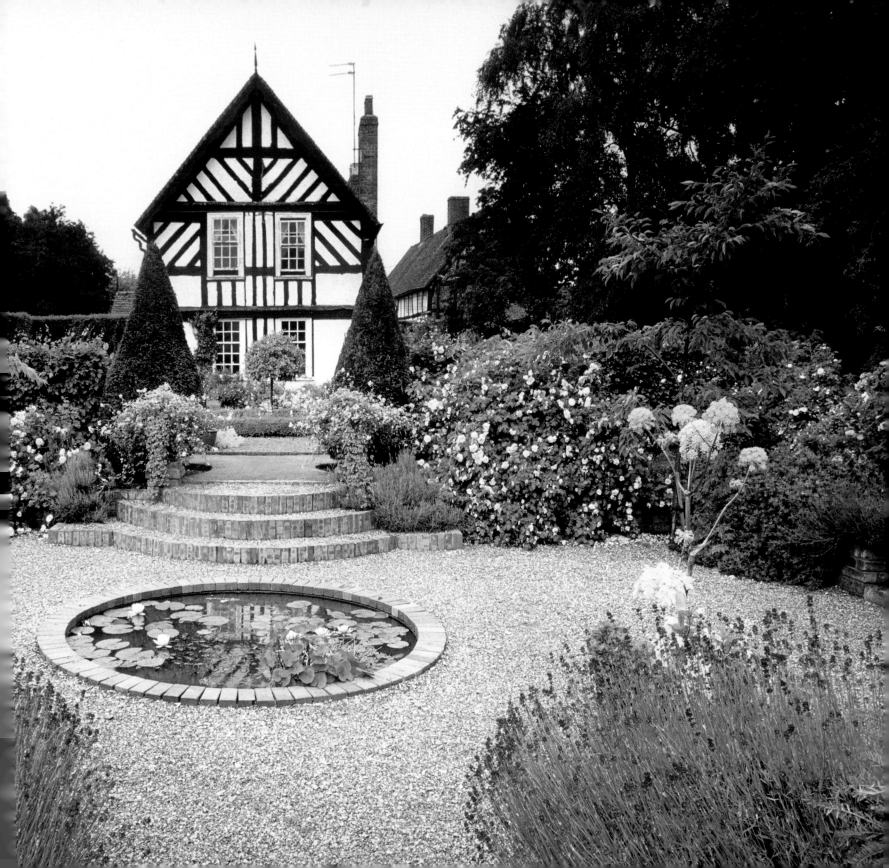

CHENIES MANOR GARDEN

PERFECT PARTNERS – A MEDIEVAL MANOR AND A MODERN APPROACH TO PLANTING

A garden very much of today, this is a place where colour is used with both subtlety and drama to complement a medieval manor house.

Chenies Manor has a long and noble history. The magnificent brick manor house was built in 1460 for Sir John Cheyne and enlarged in 1526 by Sir John Russell, later to become the first Earl of Bedford. The gardens that complement the Tudor house so exquisitely are the design and creation of the present owners, Alistair and Elizabeth MacLeod Matthews.

Every one of the garden compartments – including the Rose Garden, the Sunken Garden and the South Border – display Elizabeth's brilliantly artistic use of colour and texture. She has permanent plantings of shrubs and foliage plants as a year-round canvas against which to ring the plant changes season by season.

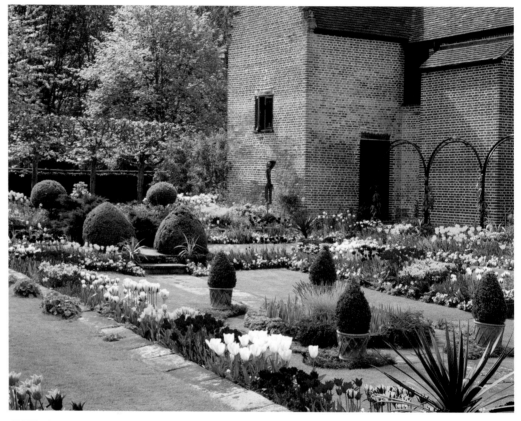

ABOVE **Mixed colouring in the Sunken Garden**

BELOW **'Foxtrot' tulip**

WHAT'S THERE:	English Heritage Grade II* garden with rose garden, physic garden, maze, speciality tulip plantings; shop, tea room, plant stall
WHERE:	Chenies, near Amersham, Buckinghamshire WD3 6ER
GETTING THERE:	4km (2½ miles) from junction 18 of M25 off A404
WHEN TO VISIT:	Open Wed, Thu and Bank Holiday Mon afternoons beg Apr to end Oct; groups by appointment
CONTACT DETAILS:	01494 762888; www.cheniesmanorhouse.co.uk

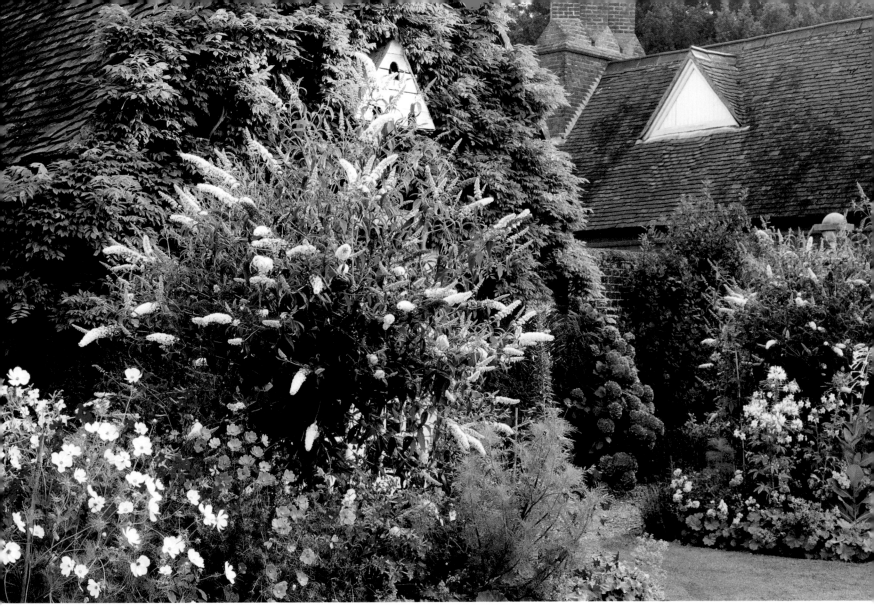

ABOVE **White buddleia erupts over the cosmos**

TULIP FIESTA

Tulips are Elizabeth's speciality, and in the Chenies Manor garden she has shown how versatile, elegant yet flamboyant they can be. The peak of the spring season is when some 7,000 tulips are composed throughout the gardens in impact-making blocks of single colours. The White Garden sparkles with only white and the palest yellow. The colours strengthen considerably to buttercup-yellow and red through to orange in the South Border while, in the Rose Garden close to the house, pinks and mauves paint a romantically pretty picture. It is left to the Sunken Garden to illustrate the plant's flamboyance; here they are displayed in a mixed colour palette. And wherever there are tulips, there is an understorey of, as appropriate, pink and white bellis daisies, pale and deep blue forget-me-nots and many-hued wallflowers.

SEASONAL COLOUR

Before the fiesta of tulips, the gardens come alive in a number of ways. A 45m (150ft) arched walkway is bordered by

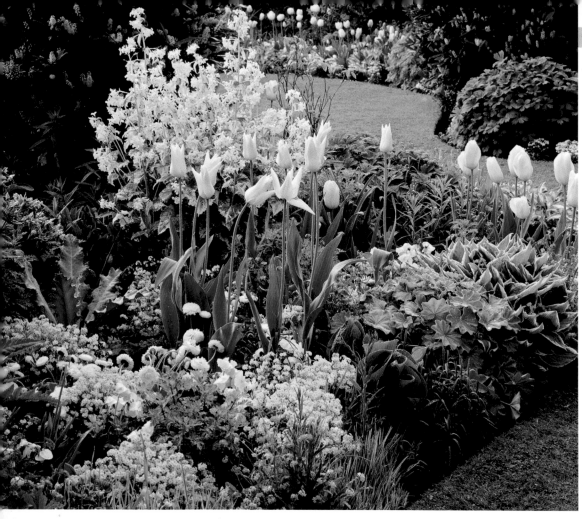

ABOVE **Clusters of tulips in the White Garden**

narcissi and many-coloured hellebores, to be followed by the stately globes of mauve and white alliums. The arches are wreathed in sweetly scented *Clematis armandii.*

At a time when the tender greenhouse-grown perennials are ready to be planted out, late spring beds and borders put on a gentle blue, mauve and pink cloak, some speckled with blue and white campanulas, iris and sisyrinchium blended with the intensely pretty lime-green lady's mantle (*Alchemilla mollis*).

In summer, the gardens take on, variously, the mantle of a brilliantly sunny day or one casting dappled shade. The bright blue-sky ambience is matched with dahlias in pinks and reds mixed with inky-blue and purple petunias, blue salvias and the ermine-crimson *Lobelia cardinalis.* Self-sown *Eryngium* 'Miss Willmott's Ghost' serves to dilute and separate the jazzy colours.

PURE ROMANCE

By contrast, the Rose Garden casts a romantic spell. Surely, royal visitors centuries ago would have been delighted to wander here. There are many historic roses, some with a lineage almost as old as the manor house itself: Bourbon and musk roses, hybrid perpetuals and repeat-flowering English roses. A between-planting of pink, white and mauve daisy-like cosmos casts a delightful veil over the rose beds, while towering *Onopordum* thistles make a strong architectural statement.

SENSE OF HISTORY

The Physic Garden, too, has its roots in medieval times. Planted around a centuries-old wall, there are apothecary roses (*Rosa gallica*) and hundreds of plants grouped according to their medicinal and other uses, as they would have been in monastery gardens. There are groups of plants for dyeing, such as woad, elecampane, camomile and alkanet, for antiseptic use and for perfumes, and plants that, in Shakespeare's time, were used to make poisons.

'Queen Elizabeth's oak tree' (see Talking point, right) commands pride of place in the parterre, where a yew maze is based on an intriguing pattern of interlocking icosahedrons (shapes with 20 sides). Dramatic bands of catmint *Nepeta* 'Six Hills Giant' border a path leading to the orchard, the cutting garden and the kitchen garden, which has a medieval-style turf maze. Laid out in a formal potager style, this 'edible' garden is as productive as ever – perhaps because of the vigilance of a scarecrow.

RIGHT **Evergreen topiary fence**

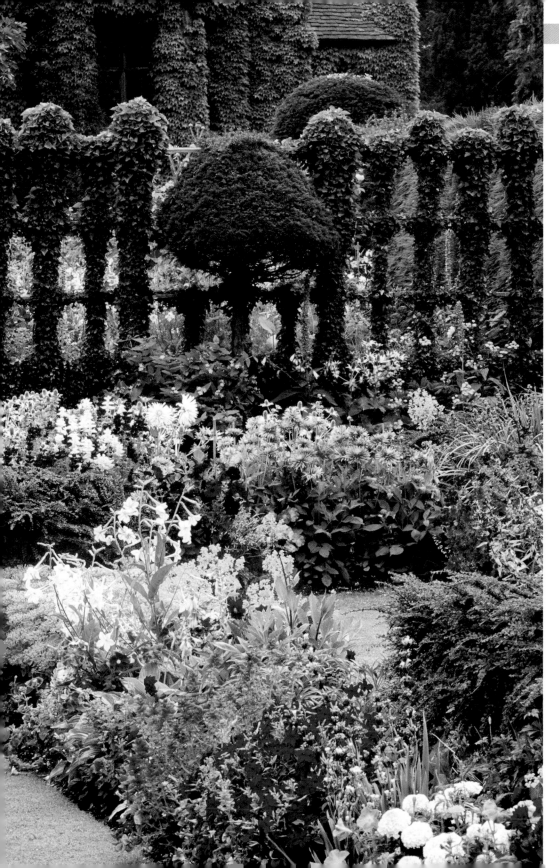

TALKING POINT

Visit the gardens at Chenies Manor and you could be walking in the footsteps of royalty. The Court of Queen Elizabeth I stayed there many times, and the Queen frequently sat in the shade of a magnificent oak tree that still graces the parterre today. Henry VIII stayed there, too, with his bride Catherine Howard. It is even fancied that on some nights his footsteps can be heard crossing the gallery in the centre of the house!

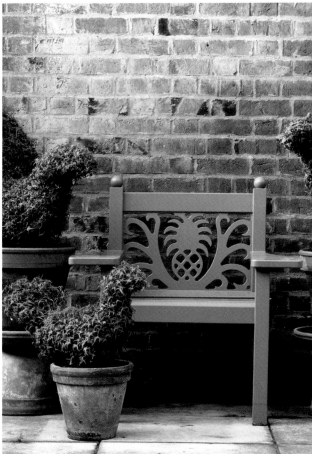

ABOVE **A flock of shapely birds**

DOCWRA'S MANOR

A GLORIOUSLY INSPIRATIONAL GARDEN CREATED FOR MEANDERING AND LINGERING

ABOVE *Rosa glauca* clambering over the gazebo

There is more than a hint of Impressionism in this wonderfully understated garden.

The planting in Docwra's Manor Garden is inspired. The borders are a tapestry of mixed colours, but not too mixed. Flower colours are principally blue, mauve, white and pink with significant additions of grey-leaved plants. There are flashes of scarlet and spatterings of orange, eye-catching exceptions to the rule. Faith Raven's instinct has been to plant what she likes where she likes – and the result is delightful.

She and her late husband John bought the property in 1954, when the one-and-a-half-acre garden contained little of consequence except for a few fine trees. They began working on the garden from the house outwards, so that the earliest plantings enhanced the views from the windows.

IMPRESSIONISM

A strong framework of existing walls and planted hedges encloses or semi-encloses courtyards and themed gardens, each with an individual character. Each corner of a rectangular pond on a patio is marked by a clipped rosemary cone in a terracotta container – the closest this garden ever gets to geometric formality. Other box cones of varying heights and sizes punctuate borders without ever dominating or detracting from the Impressionist look.

MEDITERRANEAN PLANTS

The climate and soil at Shepreth proved ideal for Mediterranean plants. As each new area of the garden was taken into cultivation – a further one acre of land has since been added – so the need for more plants grew. Faith increased her plant collection in those early days with cuttings, seedlings and established plants procured with 'magpie inquisitiveness' from friends

WHAT'S THERE:	2½ acres with walled garden, wild garden, informal cottage-style planting
WHERE:	2 Meldreth Road, Shepreth, Royston, Hertfordshire SG8 6PS
GETTING THERE:	Off A10, about 13km (8 miles) SW of Cambridge and 8km (5 miles) N of Royston
WHEN TO VISIT:	All year Wed to Fri; first Sun, Feb to Nov; times vary
CONTACT DETAILS:	01763 260677; www.docwrasmanorgarden.co.uk

ABOVE *Paeonia mlokosewitschii*

and family, nursery gardens and plant-seeking expeditions abroad.

COTTAGE GARDEN LOOK

Her preference for species over hybrids and old-fashioned varieties over 'modern novelties', and the way that she allows plants to intermingle give all the borders a natural look. Seedlings grow wherever they sow themselves; bulbs and herbs thrust through cracks in paving; and roses are planted among herbaceous species and fruit trees, which they use as climbing frames.

TOWERING SPIRES

Faith uses tall, stately perennials with inspirational effect – a striking contrast to her use of *Crambe cordifolia*, with its clouds of minute, fragrant white flowers drifting above ground-covering mounds of crinkled dark green foliage.

In a pair of borders bisected by a wide grass path, delphiniums are grown side by side with Scotch thistles (*Onopordum acanthium*). The silver-grey foliage makes a perfect foil for the pinkish-purple blooms of *Gladiolus italicus*, and the huge, purple heads are echoed at a lower level by the round globes of *Allium cristophii*. Mingled with these statement plants, there are clouds of feathery fennel and bronze fennel, and a dense underplanting of *Geranium* 'Johnson's Blue'.

PEONY COLLECTION

Lining the path leading to the greenhouse, camassia and fennel play supporting roles to some of Faith's enviable collection of

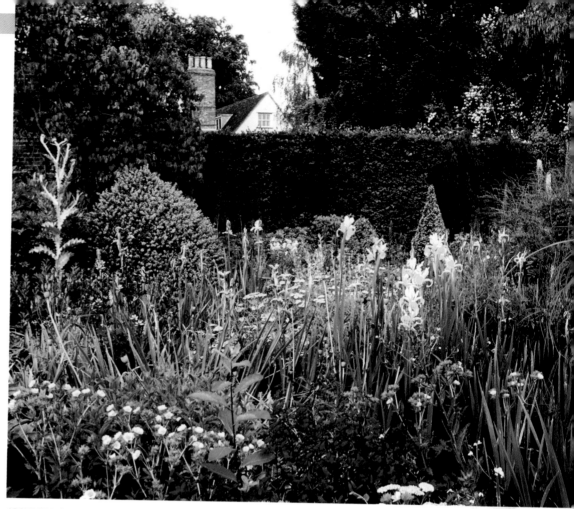

ABOVE **Height is an advantage in a border**

long-established tree peonies and *Paeonia mascula*. In a raised bed by the long greenhouse is *Paeonia cambessedesii*, with its deep mauvy-pink flowers and purple-veined leaves, while beyond is a group of yellow *Paeonia mlokosewitschii*, its beautiful bowl-shaped flowers echoing the colour of *Euphorbia polychroma* and *Helleborus argutifolius*.

ROSE HIGHLIGHT

The highlight of the Temple Garden is an elegant gazebo with a brilliant turquoise dome, almost veiled in midsummer with

Rosa glauca. The small, cerise-pink flowers have the 'innocent' look of wild roses growing in the hedgerows.

TAKE NOTE

This is a garden created for meandering and lingering. Take a notebook. Faith's instinctive planting has good ideas for gardeners everywhere.

FOOTNOTE

The house and some outbuildings are Grade II* and are under covenant to The National Trust.

GRESGARTH HALL

THE ITALIAN SENSE OF THEATRE EMBRACES THE ENGLISH ROMANTIC STYLE

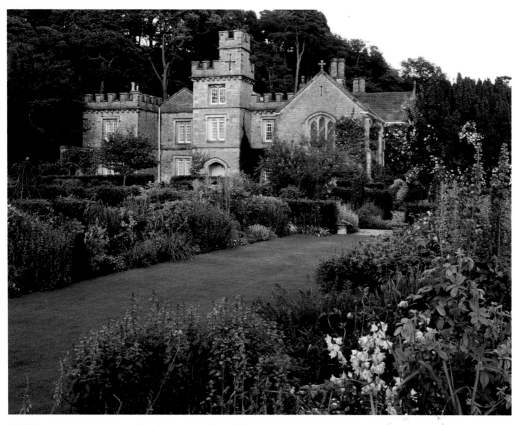

ABOVE **Luxuriant herbaceous borders around the Hall**

Garden designer Arabella Lennox-Boyd displays a fine versatility of styles in her own Lancashire garden.

The gloriously productive kitchen garden at Gresgarth Hall might be considered a microcosm of the garden design as a whole, made up, as it is, of separate beds – small squares and larger ones, rectangles, triangles and curves, each with its own ingredients, colour scheme and intricate patterns, coming together like pieces of a horticultural jigsaw to make a complete picture.

The garden surrounding the honey-gold, castellated house is composed in a similar way with a variety of elements – colour-themed gardens, luxuriant herbaceous borders, a serpentine walk, bog and lakeside garden, wild garden, orchard and nuttery – that combine to display a versatility of moods and styles and yet compose an integrated design.

WHAT'S THERE:	Colour-themed rooms, woodland, stream; refreshments and garden products available on open days
WHERE:	Caton, Lancashire LA2 9NB
GETTING THERE:	From junction 34 on M6 take A683 towards Kirkby Lonsdale; turn right at Caton
WHEN TO VISIT:	Second Sun of the month Apr to Oct, or by appointment
CONTACT DETAILS:	www.arabellalennoxboyd.com

RIGHT **The olive tree mosaic by Maggy Howarth**

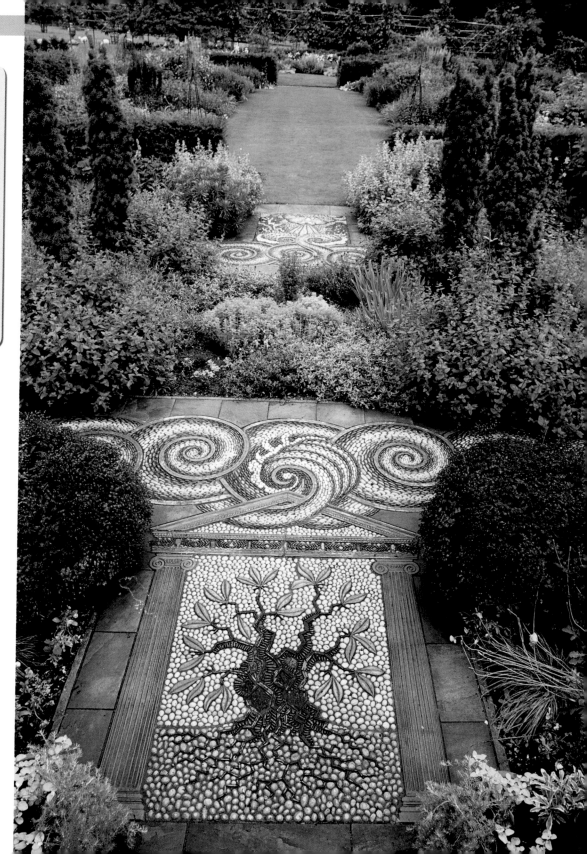

ARABELLA LENNOX-BOYD

During the 1990s, Lennox-Boyd designed five Gold Medal-winning gardens at the RHS Chelsea Flower Show, one of which won the Best in Show award. Displaying the design versatility that is evident in her garden at Gresgarth Hall, her entries ranged from a slate rill and a series of bubble fountains celebrating the centenary of the National Trust, through a formal terrace and topiary garden, to a romantic ruin inspired by the Italian gardens at Ninfa. She won Gold again at Chelsea in 2008.

ITALIAN INFLUENCE

The Gresgarth Hall garden is the vision of Arabella Lennox-Boyd, a renowned garden designer, who moved there with her husband Sir Mark in 1978, when he became Member of Parliament for a Lancashire constituency. Italian-born and raised in Rome, Lady Lennox-Boyd brought with her the Italian sense of formality and theatre, but had already fallen in love with the English romantic style of soft, gentle colour drifts and understatement.

MARRIAGE OF STYLES

At Gresgarth, she has achieved a delightful marriage of the two styles. The centre of the design, remarkable for its lack of detail, is a circular, closely mown lawn, its restraint seeming to accentuate the ambitious and varied planting radiating from it. In front of the house, herbaceous borders

ABOVE **A friendly lion topiary**

facing the house, and is all the more striking for the underplanting of white daffodils.

Pleached limes separate a series of garden rooms from the surrounding parkland and act as a windbreak from the vicious westerly winds. Arabella has always eschewed the kind of design that encloses a garden within restrictive boundary walls or fences, preferring to create the impression that the garden melts – fades – into its surroundings. Here at Gresgarth Hall, where the Artle Beck, a tributary of the Lune, defines one border and trees merge into the distant parkland beyond, it certainly does.

protected by yew hedges are a watercolour palette in summer of blues, pinks and magentas with delphinium, campanula, lavender, old roses, pelargoniums and peonies tumbling together in a romantically pretty way. By autumn, stronger hues are introduced with fiery dahlias and rudbeckias sharing the limelight with purple foliage plants.

Throughout the garden, there is a marriage of classical and modern statuary and ornaments. A cobble mosaic of an olive tree has unmistakable Italian overtones. Formal steps and terraces encroached by cascades of fragrant roses lead down from the house to a lake where, as in the bog garden, there is a cacophony of ferns and other moisture-loving plants, as well as abundant wildlife.

TREE CURTAINS

Trees are an important and dominant feature of the landscape and garden at Gresgarth. The house is at the head of a small valley with a river running through it, and is surrounded on three sides by hills covered with majestic oaks and beech. These comprise an arboretum, where there are also magnolias, styrax, halesia, stewartias, acers, sorbus and cornus. Ferns and hellebores flourish under the leaf cover of rhododendrons and other interesting shrubs. A moss-and-fern-covered *metasudans* – a tall, narrow pyramid down which water trickles – contributes both height and formality, and is at the centre of a thicket of birch trees (*Betula utilis*). A massed planting of white cherries throws a veil of blossom over the slope

ABOVE **'Gloriously productive kitchen garden'**

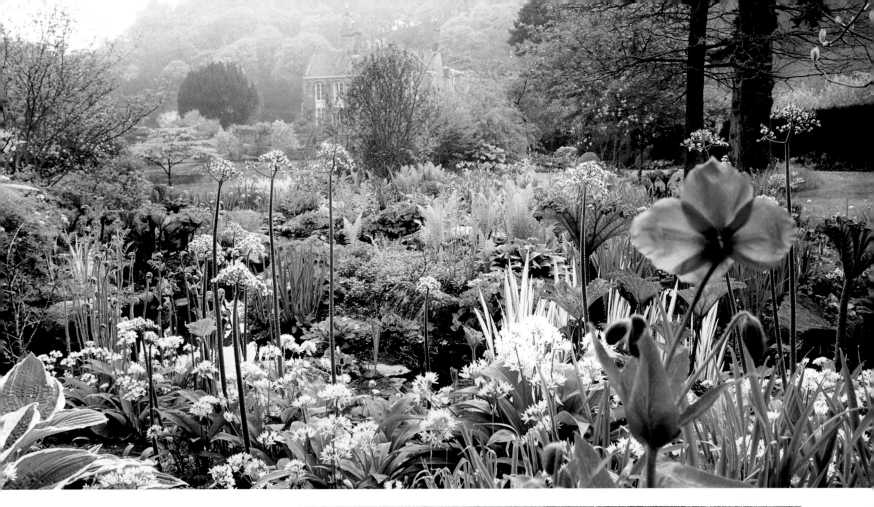

WHAT'S IN A NAME?

'Gresgarth' is a Norse word, meaning 'boar yard'. A garth is an enclosure, but it does not necessarily signify that there is also a dwelling. Gresgarth Hall was first known as Grassyard Hall. The original pele tower is thought to have been erected on the site before 1400. The oldest surviving portions consist of a two-storey building 14.6m (48ft) long and 8.2m (27ft) wide. There is a tunnel vault on the ground floor and, visible from the road, a Gothic Revival tower. The house was largely remodelled in the early 19th century.

TOP **Soft colours fade into the mist**

ABOVE **Serpentine-effect tree planting**

HEALE GARDEN

DESIGNED BY HAROLD PETO, A RIVER GARDEN SPARKLING WITH EXUBERANT PLANTING

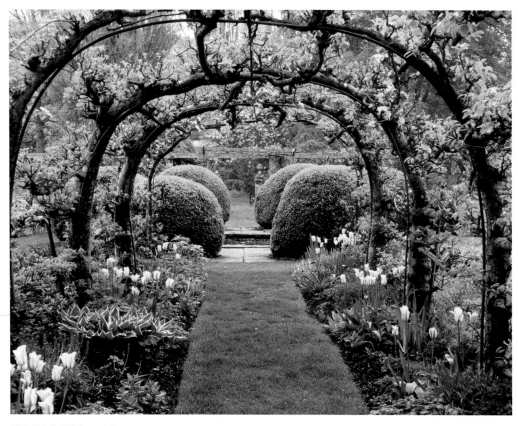

ABOVE **A fruitful pergola**

This waterside garden with trout streams, a Japanese teahouse and an eclectic blend of formal and romantic plantings has year-round appeal.

Ask four garden lovers to nominate their favourite season to visit Heale House garden and one might receive four different and equally valid replies. Open to visitors from the beginning of February until the end of October, the garden does not have a between-seasons period when one exuberant explosion of flowering is over and the next is yet to come – it has colour and interest all year round.

The garden is not only situated on the banks of the River Avon but tributaries of the river meander through it, with sparkling trout streams and quiet backwaters creating perfect conditions for shade-loving species and colourful cascades of trailing plants.

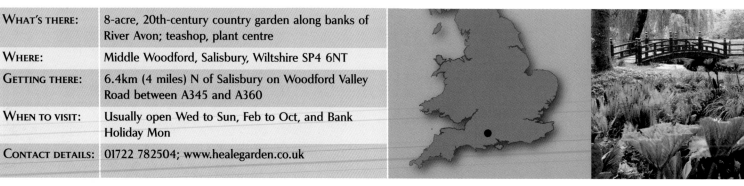

WHAT'S THERE:	8-acre, 20th-century country garden along banks of River Avon; teashop, plant centre
WHERE:	Middle Woodford, Salisbury, Wiltshire SP4 6NT
GETTING THERE:	6.4km (4 miles) N of Salisbury on Woodford Valley Road between A345 and A360
WHEN TO VISIT:	Usually open Wed to Sun, Feb to Oct, and Bank Holiday Mon
CONTACT DETAILS:	01722 782504; www.healegarden.co.uk

HISTORICAL PERSPECTIVE

The red brick house built by Sir William Green in the late 16th century took its place in the history books when King Charles II took refuge there for several nights in October 1651 before fleeing to France; later the King reported his experience to Samuel Pepys (*see* Talking Point, below). After several changes of ownership, the property was bought in 1894 by the Honourable Louis Greville, great-uncle of the present owner, Guy Rasch. The foundations of the garden were laid shortly afterwards when Greville commissioned the architect and gardener Harold Peto.

Many of the early 20th-century structural features and formal plantings remain. To the west of the house, a stone slab drive cushioned with hummocks of lady's mantle (*Alchemilla mollis*) leads to a terrace with formal beds planted with clipped yews and tall perennials, and decorated with rose-entwined obelisks. A working kitchen garden blends a formal layout – a beautiful potager – with wide, densely fruitful tunnels of apples and pears.

ENCHANTED ISLAND

A large lawn to the south leads to the trout stream and, where it divides, to Louis Greville's Japanese garden, situated on an island. Greville brought back the thatched teahouse and the brilliant scarlet Niko bridge when he left the British Embassy in Tokyo, where he was a diplomat. Overhung by weeping willows and close to light-dappled woodland, it is a delightful feature.

HERALDS OF SPRING

Along the river banks, carpets of spring bulbs colour-wash the woodlands and meadows. Early in February, parts of the garden are inches deep in snowdrops, so many that, following an old country-garden tradition, there are usually two dedicated Snowdrop Sundays when soup and snacks are served. Rivalling the snowdrops in number, aconites add more than a touch of gold. Tiny pink and white cyclamen, wine-dark hellebores and fragrant daphne bushes are other heralds of spring that might give these early winter-going-on-spring months the connoisseur's vote for best season of the year.

TALKING POINT

In the account of his visit, which he dictated to Samuel Pepys, King Charles II reported that, on the advice of his companion Robin Philips, he rode with him to Heale House where Mrs Hyde, whom he described as a widow gentlewoman, 'being a discreet woman, took no notice of me at the time', there being other guests present. Mrs Hyde advised the King to ride away and 'make as if I quitted the house' and return again secretly, which the King did. Mrs Hyde, the King continues, 'told me she had a very safe place to hide me in till we knew whether our ship was ready or no... I went up into the hiding hole that was very convenient and safe, and staid there all alone... some four or five days.'

RIGHT **A cottage on stilts straddles the stream**

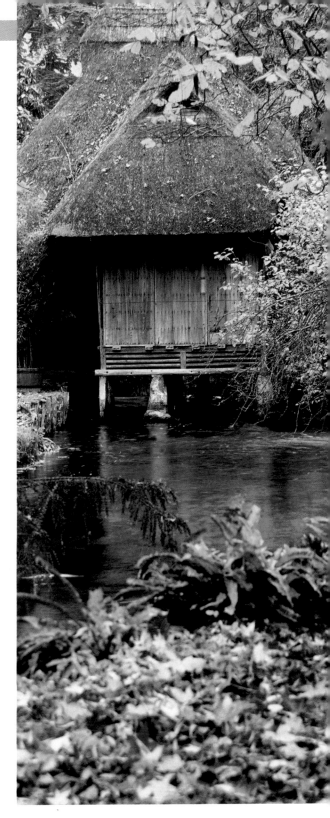

HIDCOTE MANOR GARDEN

DRAMA, ROMANCE, SUSPENSE, NOSTALGIA – THIS GLORIOUS GARDEN HAS IT ALL

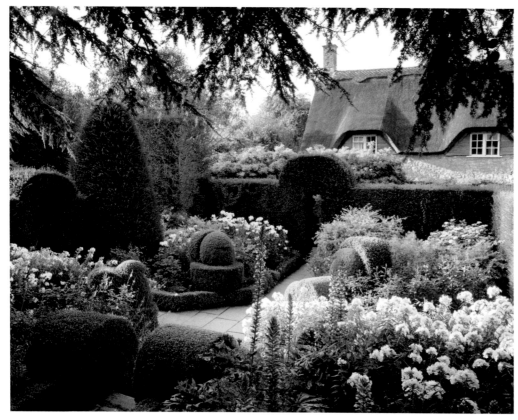

ABOVE **Topiary contrast in the White Garden**

BELOW RIGHT **Tree poppy**

One of the most influential gardens in Britain reveals its secrets in a series of themed 'rooms'.

Hidcote Manor Garden combines elegance with ebullience, and restraint with an expression of *joie de vivre*. In keeping with the Arts and Crafts style, which the garden exemplifies, there is a well-defined ground plan marked by dramatic paths, hedges in strong, straight lines and strict – though sometimes fanciful – topiary shapes. The planting is exuberant, exciting, expressive and the garden has surprises at every turn.

Lawrence Johnston and his mother Gertrude Winthrop bought the property in 1907 when the house was surrounded by nothing but fields and a few mature trees. Johnston read extensively, studying the work of leading garden designers, especially Thomas Mawson, and himself became a recognized horticulturist and plantsman. He sponsored and took part

WHAT'S THERE:	10-acre Arts and Crafts garden with themed 'rooms', formal topiary; shop, cafe, restaurant, plant sales
WHERE:	Hidcote Bartrim, near Chipping Campden, Gloucestershire GL55 6LR
GETTING THERE:	6.5km (4 miles) NE of Chipping Campden, 1.6km (1 mile) E of B4632, off B4081
WHEN TO VISIT:	Mon, Tue, Wed, Sat, Sun, mid-Mar to end Oct; also Fri, Jul and Aug. Private evening tours by appointment
CONTACT DETAILS:	01386 438333; www.nationaltrust.org.uk

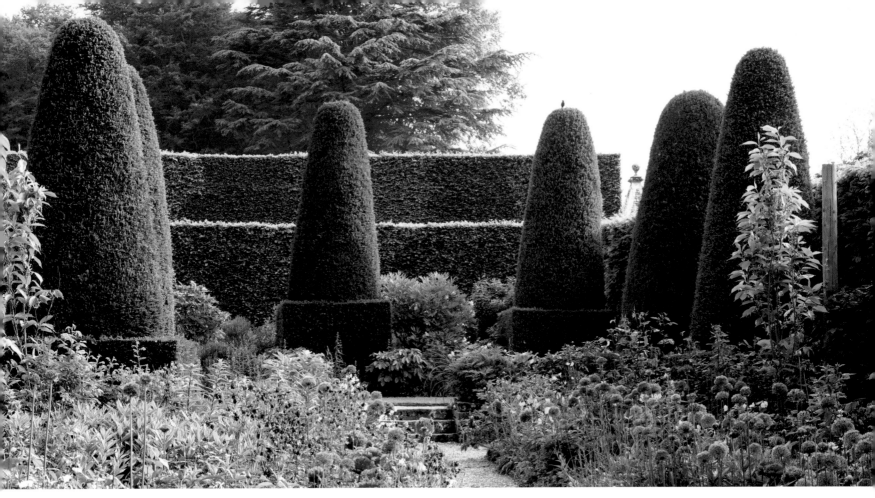

ABOVE **The dramatic Pillar Garden**

in many plant-hunting expeditions to
the Alps, Kenya, South Africa and China,
and also built up a network of fellow
plantsmen around the world with whom
he exchanged specimen plants. As a result
of these expeditions, over 40 new species
were cultivated in the UK, many of which
bear his name, and he was awarded three
Awards of Merit by the Royal Horticultural
Society for his plant-hunting achievements.

Johnston is particularly associated with
two garden plants. One, the South African
Verbena peruviana, which he especially
admired for its cherry-red flowers, always
features in the Hidcote Red Borders.

The other, a yellow climbing rose, which
he bought as an unnamed seedling from
the breeder, was first called 'Hidcote
Yellow' but later renamed 'Lawrence
Johnston'. It now garlands the north wall
of the Old Garden.

GROUND PLAN

Clipped hedges of holly, beech, hornbeam
and yew divide the garden into separate
compartments – Johnston called it a
'garden of rooms' – each with a distinctive
characteristic and colour theme. The use
of tapestry hedging in the Lilac Circle was
innovative in garden design at the time,

though mixed planting was commonplace
in ancient hedgerows. Here, the blend
of different species such as yew, beech
and holly has an intriguingly mottled
appearance, which, unlike evergreen
hedging, varies in colour and characteristic
season by season.

To reinforce the ground plan further,
two axes run uncompromisingly North-
South and East-West, with a gazebo at their
intersection.

SECRET GARDEN 'ROOMS'

Hedges separating the garden 'rooms'
are tall and so there is no peering over

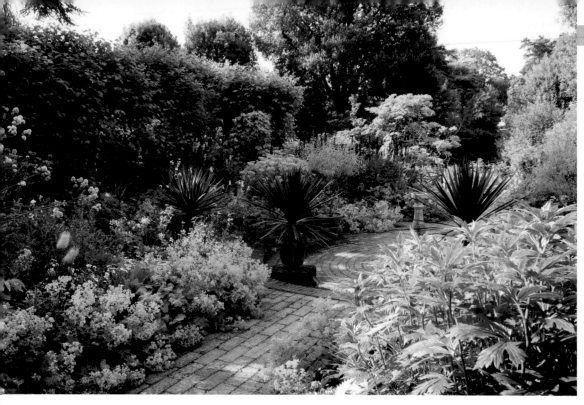

ABOVE **'Mrs Winthrop's Garden'**

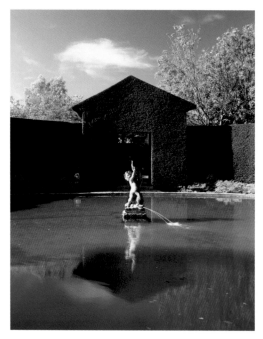

ABOVE **The Bathing Pool Garden**

them – one has to enter each 'room' to experience the riotous explosion of colour, the sensuous planting and the compatible marriage of formal topiary shapes and blowsy old-fashioned roses, rare shrubs and perennials.

In some cases, the sense of occasion and anticipation is heightened by the style of the entrance. One of the most formal areas, the Bathing Pool garden, has a massive topiary hedge shaped in the centre to form a truly triumphal arch with a steeply pitched, overhanging roof. Its reflection in the rectangular pool increases the impact.

The Red Border is reached by a wide flight of stone steps, flanked by a pair of tall, narrow brick pavilions with incurved roofs topped by ball-shaped finials. Pots

of red geraniums and agaves on the stone walls hint at the exciting colour profusion to come.

COLOUR COMBINATIONS

The Red Border is a flamboyant coming-together of red, purple, orange and bronze. The groundwork is laid with the purple-bronze foliage of *Heuchera* 'Palace Purple', which perfectly complements the 1940s blood-red floribunda *Rosa* 'Frensham', the blazing reds of *Lobelia* 'Will Scarlet' and 'Queen Victoria', *Canna indica* 'Le Roi Humbert' and, as always, the cherry-red verbena.

A bright star in this border is the striking day lily *Hemerocallis fulva* 'Flore Pleno', with its orange-going-on-red petals the colours of leaping flames.

In strikingly similar vein to the garden of Vita Sackville-West (see panel) at Sissinghurst Castle in Kent, the White Garden at Hidcote has a billowing profusion of silver-leaved and white-flowering plants, their contrasting forms and textures linked by their uniformity of colour. The beds are bordered with low clipped hedges topped by topiary peacocks. Tall erect spires of white acanthus tower above common wormwood (*Artemisia absinthium* 'Lambrook Silver'), a glorious snow-white cistus, mop-headed phlox and shrub roses. Later in the season, huge clumps of white dahlias hold centre stage.

MIDSUMMER ROSES
One of the glories of summer at Hidcote is the flourish of old roses in the Rose Walk.

RIGHT **Views are scrupulously managed**

Johnston gradually built up a collection of 18th- and 19th-century damask, gallica and moss roses, many of which were bred in France, and planted them in two long borders. These romantic and sweetly scented roses bloom in one short-lived but exquisite midsummer burst. It is dream-time.

NAMESAKE GARDEN

'Mrs Winthrop's Garden', named after Johnston's mother, has a Mediterranean ambience and a largely blue, yellow and lime-green colour theme. The edges of brick paths and a circular brick terrace are blurred by billowy hummocks of yellowy-green lady's mantle (*Alchemilla mollis*) and blue geraniums. Clusters of blue aconitums give the scheme height and structure, and terracotta pots of bronze cordylines and aloe vera produce a dramatic contrast of shape.

CLOSE TO THE EDGE

In some areas closer to the garden boundaries, Johnston's planting became more cottagey, some would say jungle-like, with such delightful combinations as poppies, marigolds and ferns. In others, azaleas, rhododendrons and rare trees are evidence of his worldwide quests for plants.

FRAMING THE VIEWS

Long views in the garden are scrupulously managed to enhance the wow factor of its situation in the beautiful Vale of Evesham. At the end of the Long Walk, the tall iron gates are left open to frame the distant view, while another grass walk slopes up to the Stilt Garden, a wide avenue bordered by tall hornbeams on stilt-like trunks, surely evidence of a French influence.

END OF AN ERA

The garden had reached its peak by the 1930s. In 1948, Johnston retired to Serre de la Madone, his property in the south of France, and The National Trust took over Hidcote Manor, the first gift they accepted solely because of the garden.

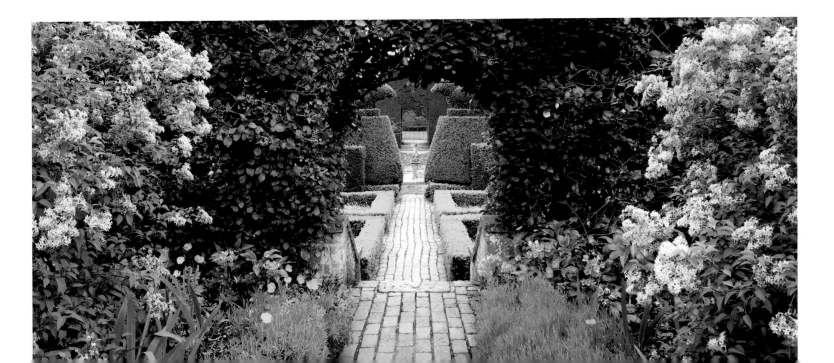

SCAMPSTON HALL

AN EXCITINGLY MODERN DESIGN TRANSFORMS AN OLD WALLED GARDEN

Set in 'Capability' Brown parkland, the walled garden is a courageous and thrilling patchwork of innovative planting.

An avenue of limes curtaining a vivacious spring-flowering border; a wild flower meadow displaying naturalistic planting at its very best; a grove of trees with leaves that turn from bronze through yellow to purple; a 'silent' garden of evergreen columns around a reflective pool – all these elements and more have been created within the walls of the former kitchen garden that once kept the household at Scampston Hall self-sufficient in fruit, vegetables and herbs and, more recently, grew Christmas trees for sale.

Sir Charles and Lady Legard, who came to the property in 1987, first turned their attention to the 17th-century house and the surrounding 'Capability' Brown-modelled parkland. Then, in 1998, they called in Dutch designer Piet Oudolf to remodel the kitchen garden and create an excitingly

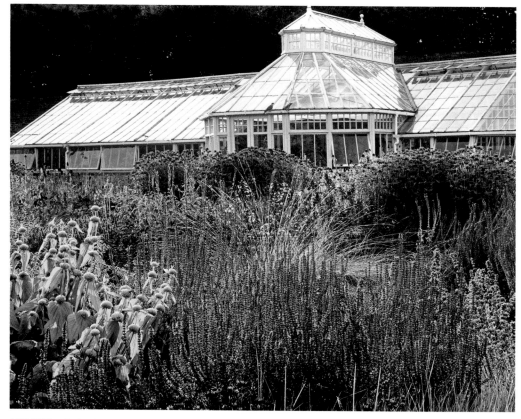

ABOVE **Mixed planting in the perennial meadow**

BELOW **Bee-attracting bergamot**

WHAT'S THERE:	4½-acre walled garden within a 'Capability' Brown park; shop, restaurant
WHERE:	Malton, Ryedale, N Yorks YO17 8NG
GETTING THERE:	8km (5 miles) E of Malton off A64
WHEN TO VISIT:	Walled garden and park usually open 6 days a week Easter to end Oct
CONTACT DETAILS:	01944 759111; www.scampston.co.uk

modern design within its walls. When the
dilapidated glasshouses and gardeners'
quarters were demolished, leaving only
the listed greenhouse, the fig house and a
pool, Oudolf had an almost blank canvas
on which to sketch a patchwork of garden
'rooms' with widely varying characteristics,
yet with a feeling of oneness.

SCENTS OF SPRING

The result is thrilling. Entrance to
the garden leads immediately to the
plantsman's walk, which runs along three
sides of the original wall and is marked by
an avenue of 200 lime trees. In the 3m-
(10ft-) perimeter bed, spring-flowering
shrubs, all underplanted with bulbs,
include tree peonies (*Paeonia rockii*), their
large, waxy, white-petalled flowers blotched
with maroon, and *Edgeworthia chrysantha*,
noted for its rounded heads of fragrant
yellow flowers in winter and early spring.

SEASONAL COLOUR

In autumn, colour in the borders is
achieved with flowering hydrangeas and
the rice paper plant (*Tetrapanax papyrifer*),
whose bold sprays of creamy-yellow
summer and autumn flowers are replaced
by black berries in winter.

A naturalistic, perennial meadow in
front of the conservatory is a keynote
feature of Oudolf's work. Planted around
a circular dipping pond, it is spattered
with flower colour from early spring until
late autumn. First, there is a kaleidoscopic
pattern of red and yellow, purple and
orange. Shake the kaleidoscope a little
and, later in the year, the colour pattern

ABOVE **Co-ordinated colours, contrasting forms**

ABOVE **The sum of the squares…**

is dominated by green and brown, yellow and black foliage, seedheads and grasses, which, by then, can be appreciated almost individually for their shape and form.

WOODLAND IN MINIATURE

Planted as a backdrop to the perennial meadow, the katsura grove is a woodland in miniature, dramatically highlighted by the inclusion of *Cercidiphyllum japonicum*, whose leaves from spring to autumn turn through almost all the colours of the rainbow. Yew hedges, sober by comparison, are not yet fully formed. When they are, they will have

straight edges and sides but serpentine tops, the undulations lending an air of informality to this dense evergreen shrub.

IN GOOD SHAPE

Clipped and shaped yew and box feature prominently throughout the walled garden, and are used in many different ways to convey a variety of ideas. In both the spring and summer box gardens, each of which has a seasonal herbaceous border, widely spaced 1m- (3ft-) cubes of box will in time have, respectively, domed and dished tops. In the 'silent' garden, rows of

clipped yew columns, each one standing on a square, clipped base, are doubly effective as they are reflected in the square, black-water pool. And in the serpentine garden, six rows of clipped yew hedges, all with undulating tops, encourage visitors to weave between the lines and discover the concealed herbaceous beds beyond.

DRIFTS OF GRASS

There are no formal lawns in this excitingly unorthodox walled garden. Instead, there is an infinitely more original feature – an area that the owners call 'drifts of grass'.

CREATING THE LOOK YOURSELF

* One of the most delightful elements of the walled garden at Scampston Hall is the 'drifts of grass' area, with its curving swathes of molinia grass planted among the mown areas. The grass is not difficult to grow, and multiplies prodigiously – the 650 plants now forming the swathes began as a planting of only 50.

* Some of the molinia grasses grow to great heights – *M. altissima* can reach 2.5m (8ft). The variegated form, known as variegated purple moor grass, which has yellow and green striped leaves and, in late summer, purple spikelets, grows to 60cm (2ft). These grasses prefer acid soil and need a dry, sunny position.

* Many other grasses and sedges would create a similar effect when planted in mown grass in strips, swathes or clumps. Bowles' golden sedge (*Carex elata* 'Aurea') which has golden-yellow leaves and blackish-brown flower spikes in autumn, reaches a height of 40cm (16in). For a more feather-like effect, you could plant squirrel tail grass (*Hordeum jubatum*), which can grow to 60cm (24in) and has arches of silky, creamy-golden plumes.

ABOVE **The 'drifts of grass'**

Divided by a path and inset with bench seats, patches of mown grass are alternated with thick, curving swathes of tufty molinia grass, attractive for its light-as-a-feather movement in the slightest breeze, and for the long purple spikelets it produces in late summer.

OVERALL APPEAL

Climb a flight of steps to the top of the Mount, a decapitated grassed pyramid in the centre of the garden, and all becomes clear: how the pieces of the patchwork fit neatly together, and how this former kitchen garden has been transformed with ingenuity, flair and, situated within a park laid out by 'Capability' Brown, with genuine courage.

Brown's scheme for the 80-acre parkland had so pleased Sir William St Quintin, the then owner of Scampston Hall and an ancestor of the present owner, that he wrote to Brown saying that the design 'answers prodigiously well' to his requirements. Visitors to the remodelled walled garden would surely echo those sentiments today, with reference to Piet Oudolf's design.

WOLLERTON OLD HALL

A PERFECT MARRIAGE OF EXUBERANT PLANTING AROUND A BLACK AND WHITE HALL HOUSE

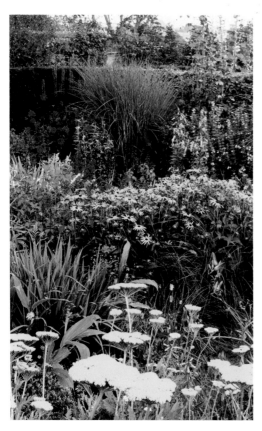

ABOVE **Primary colours in a 'hot' border**

The garden achieves a skilful blend of formal and informal, restrained and, most of all, flamboyant planting.

At times, the colour in this four-acre garden is breathtaking – at most times, in fact. Here is a relatively newly planted garden on a site where there has probably been one since 1450. It is designed in the classical English Arts and Crafts style, and uses colour in a way that seems oddly familiar. Could it be that it resembles the decoration on some of Clarice Cliff's more flamboyant pieces of pottery?

The garden surrounds a 16th-century, black-and-white, half-timbered hall house, which was Lesley Jenkins's childhood home. When she and her husband John moved to the property in 1983, Lesley set about redesigning the garden, with an emphasis on colour and form, integrating indigenous and rare plant species and embracing both hot and cool themes.

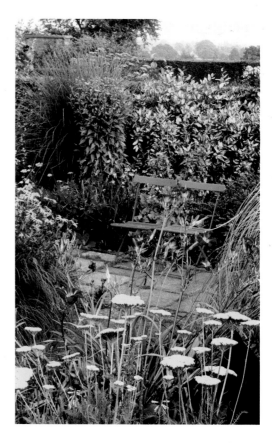

WHAT'S THERE:	4-acre Arts and Crafts garden with 'rooms' of different styles
WHERE:	Wollerton, Market Drayton, Shropshire TF9 3NA
GETTING THERE:	0.8km (½ mile) NE of Hodnet on A53
WHEN TO VISIT:	Usually open Fri, Sun and public holidays
CONTACT DETAILS:	01630 685760; www.wollertonoldhallgarden.com

ABOVE **Elegant oriental poppies**

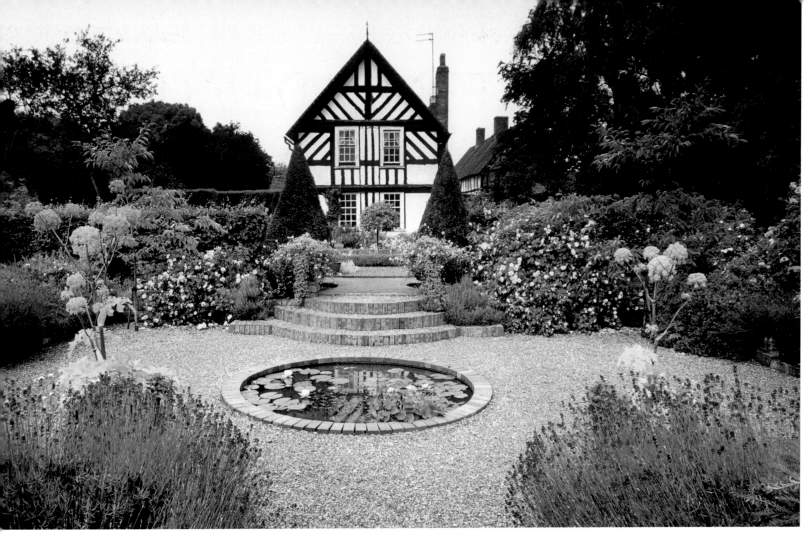

ABOVE **Circular pond in formal garden**

PERFECT SYMMETRY

The geometric lines of the house suggest
a sympathetic symmetry in the garden
design, thus boundaries are defined by
brick walls and long straight hedges,
mainly of beech and yew. On the site of
the original Elizabethan knot garden, the
area now described as the Old Garden has
a crenellated York stone path flanked by
two lines of mophead standards of Portugal
laurel (*Prunus lusitanica*). This is further
enlivened in spring by ground-covering
harebells and camomile.

Giving perspective to the central vista, the
Lime Allée is planted with pleached limes
(*Tilia platyphyllos* 'Rubra'), and delightfully
underplanted with *Viola labradorica* and
Muscari latifolium, which in summer are
followed by the understated *Heliotropium*
'Lord Roberts'.

The entrance to the Yew Walk is
colourfully announced for several weeks of
the year by two oak balustrades curtained
in many-hued clematis, including 'Black
Madonna', 'Romantika' and 'Negritianka'.
The pyramidal yews lining the avenue

are planted in soldierly rows, evergreen
sculptures forming bays planted with drifts
of perennials in white and yellow, with the
odd 'trumpets' coming from splashes of
purple, blue and orange.

COLOUR DRIFTS

Colour is used to dramatic effect in the
main perennial border, which is protected
by an old brick wall and accessed through
a gate cascading with honeysuckle. Here,
the planting is in well-defined diagonal
drifts, colour merging into colour, in

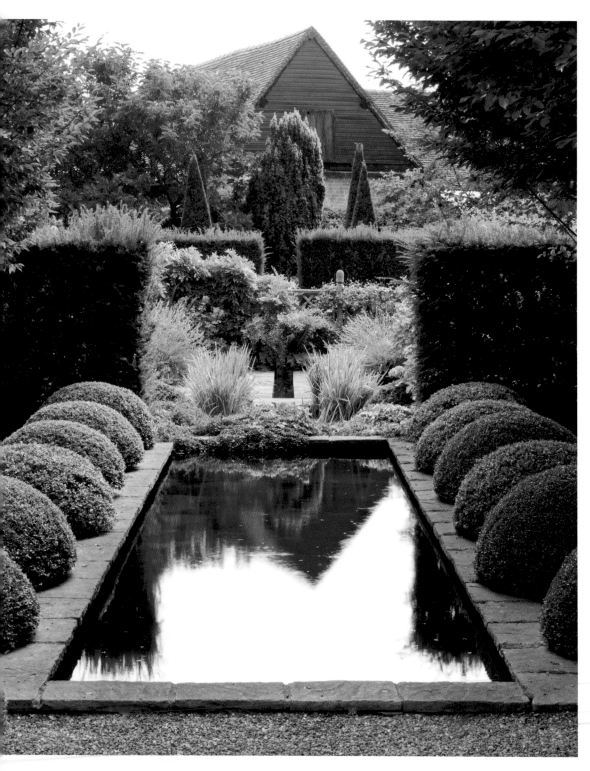

the manner characteristic of the famed garden designer, Gertrude Jekyll. Many species, delphiniums, lupins, mullein among them, are set in clusters of up to 11 plants, making strong statements, not just spatterings of colour. The room known as Daisy Borders, with a sundial set in the centre of a wide grass path and with twin borders packed with aquilegia, delphiniums, hollyhocks and asters, has a look of autonomy. It could be any small and beautiful English garden anywhere.

Colour runs riot in many areas, and never more so than in the Lanhydrock Garden, which explodes into view through a gap in a tall beech screen. Here, it is bold and certainly beautiful. Colour-wise, August is the hottest month, beginning with the opening firework-like display of oriental poppies before fiery dahlias in flame, coral, red and orange take up the theme. Rudbeckias, red-going-on-golden heleniums and, lastly, a significant collection of salvias maintain the wow factor, which, here, is maximized.

WATER COURSE

There are two water gardens at Wollerton Old Hall, each with totally different characteristics. One, approached through an ivy-festooned door, has a central limestone wellhead flanked by more pyramid-shaped yews, as if they are standing formal guard over this ancient water source. Picking up the colour theme from the sparkling effect of sun on clear water, peripheral planting around the well marries white and pale lemon-yellow. In

LEFT **Reflections in a small enclosed pool**

contrast, the sound of more running water leads one to a tranquil area where, in a rectangular sunken garden, there is a rill running over York stone. A newer, upper rill is directed through a canal edged with fat hummocks of clipped box. Giving the opportunity for rest and reflection, there is, nearby, an oak gazebo hooded in *Rosa* 'Champneys' Pink Cluster'.

OAK LOGGIA

A magnificent oak loggia with the look of ages offers similar pause for thought, facing as it does an old stone font rising up, in spring, from surrounding waves of delicate *Fritillaria meleagris*. Once the fritillaries are dormant, they are replaced in early summer by moon daisies (*Leucanthemum vulgare*).

THE WORLD OUTSIDE

After so many intimate, secluded and diverse 'rooms', the garden eventually comes down to earth and mingles with the world outside, the hills and vales of the Shropshire countryside close to Market Drayton, where there was a Saxon settlement. Norwegian maples and mature specimen shrubs including the winter- and early spring-flowering *Stachyurus chinensis*, *Buddleja nivea* var. *yunnanensis* and *Heptacodium miconioides*, known as seven sons flower, finally bring down the curtain on a garden that has so many exciting elements competing for attention.

LEFT **Garlands of vine enflame a hedge**

CREATING THE LOOK YOURSELF

* With so many contrasting elements in the garden at Wollerton Old Hall, one is spoilt for choice when selecting a single 'look'. The blend of formal and informal planting carried out so successfully in, for example, the Yew Walk, could be achieved on a minor scale by planting a clipped box pyramid or globe in an urn and surrounding it with a tumbling cascade of pale to deep pink trailing plants such as pelargonium and impatiens.

* It is possible to replicate the excitement of the spice-coloured Lanhydrock Garden on a smaller scale, too. Even in a tub, windowbox or sink garden, a collection of small or dwarf plants in fiery colours will have impact. For one of many exciting combinations, plant orange and golden marigolds to complement the small, bright red flowers of *Dianthus chinensis* 'Fire Carpet' and the mixed colours of *Phlox drummondii* Button Series.

* In a garden bed, bulb flowers can paint a vivid picture in both spring and summer. The fiery-red arching spikes of *Crocosmia* 'Lucifer', together with summer-flowering lilies in flame, orange and pink, and Peruvian lily (*Alstroemeria aurea*), with its loose heads of orange flowers, will look satisfyingly inspirational.

213

WYKEN HALL

FROM PRECISION TOPIARY TO DREAMY ROSES, A GARDEN TO DELIGHT ALL THE SENSES

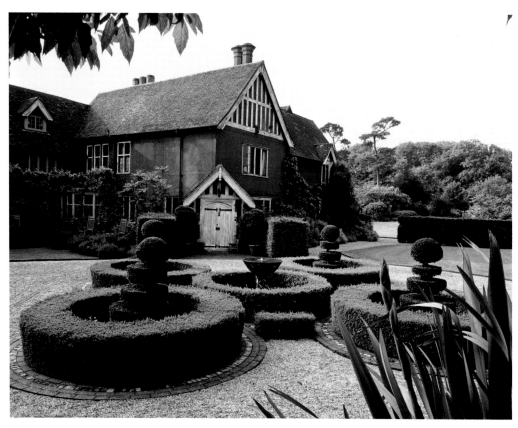

ABOVE **The box topiary quincunx**

BELOW RIGHT **Bearded iris and purple allium**

Contrasting and connecting 'rooms', formal or free, have a wealth of imaginative and inspiring ideas.

On an estate once occupied by the Romans, mentioned in the Domesday Book and now at the heart of a working farm, Wyken Hall is a half-timbered, medieval manor house with multiple gables, banks of octagonal brick chimneys and an almost indefinable roof line. The garden, which was redesigned in the 1980s mainly by the owners, Sir Kenneth and Lady Carlisle, is a plant-lover's cameo framed by the Suffolk countryside. Plant colours vary from verdant to vibrant, and the mood changes from restrained to wild in areas that blend seamlessly into the surrounding meadows and woodland.

The approach to the house strikes a formal note of introduction, with a group of five circular box hedges laid out in the shape of a quincunx. One encloses a sparkling blue and white fountain made

WHAT'S THERE:	Sheltered gardens, woodland walk, vineyard; restaurant, cafe, shop
WHERE:	Stanton, Bury St Edmunds, Suffolk IP31 2DW
GETTING THERE:	13km (8 miles) N of Bury St Edmunds, 1.5km (1 mile) W of A143
WHEN TO VISIT:	Open afternoons, Sun to Fri, Apr to Sep
CONTACT DETAILS:	01359 250287; www.wykenvineyards.co.uk

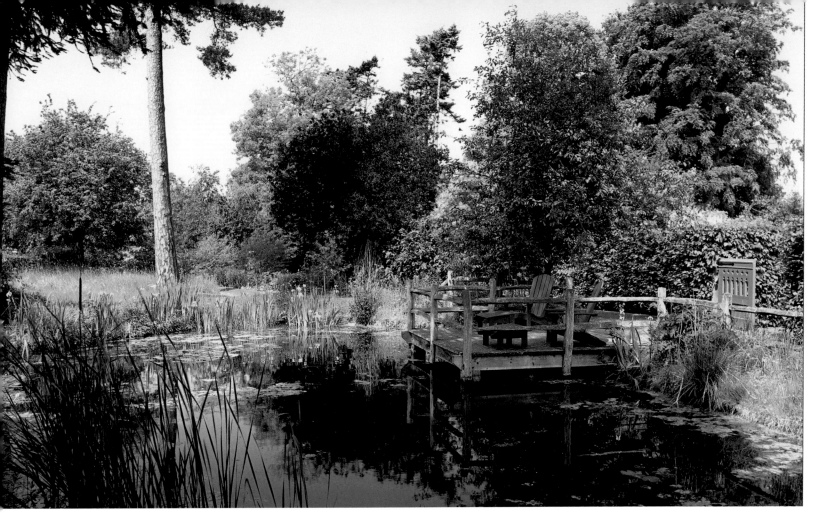

ABOVE **The pond. Please be seated!**

and fired by Clive Davies, a Suffolk potter. Others encircle elegant, tiered topiary sculptures quaintly reminiscent of chess pieces. In spring, the box circles are highlighted by rings of crisp white tulips peeping through deep blue forget-me-nots, while in summer the bulbs give way to flowering herbs.

SECRET GARDENS

The higgledy-piggledy shape of the house, painted in traditional Suffolk pink, has inspired the creation of 'secret' knot gardens that nestle in its sheltering hollows. These outside designer rooms, snugly protected by the walls of the house, are further examples of the versatility of topiary. There are no two alike. Low, clipped, diamond-shaped box hedges corner-touch square parterres, and sculptural pyramids, cubes and spheres are planted as focal points. There are many permutations. A herb garden designed by Arabella Lennox-Boyd integrates beautifully with the knot garden, bringing together evergreen and annual herbs that would have self-seeded on this Suffolk land for centuries.

Colour is used sparingly yet strikingly, with purple and gold predominating. Purple chives partner the golden marjoram that rings the sundial; orange-gold bearded iris team with purple *Allium cristophii* and aquilegia in a bed that commands attention beside a further topiary garden, and violet-flowered abutilon meanders over the mellow house walls.

In early summer, the scent of the rose garden extends way beyond its boundaries. Bordered on three sides by a hornbeam hedge and decorated with a long, flower-spattered pergola, this romantic area of the

garden has been created around an old church font and planted with a collection of old-fashioned roses in deep magenta, softest lavender and palest sugar-almond-pink, rich buttery yellow, pale apricot and only-just-cream – beautiful, blowsy and many-petalled blooms. It is a pure, sensual, perfumed delight.

SITTING ROOM

This is a garden for strolling, admiring, pondering and – the owners have ensured – sitting. Four blue-painted rocking chairs invite quiet reflection around a lavender hedge – the perfect way to appreciate environmental fragrance. A single chair is half-hidden among more lavender and brushed by a cascade of rambling roses and overhanging branches of apples. A Gothic-style bench encourages one to linger beside the herb-ringed sundial. An ogee-arched 'throne' seat, nestling beneath a yew hedge, is set in isolation among more tumbling herbs. And then there is the natural pond, reached through a gate. Bounded by rushes and irises and floating with water lilies, it has a sturdy decking promontory furnished with – who could resist them? – a pair of Adirondack chairs.

In autumn, when the woodland leaves are russet and gold, a 'hot bed' beside the kitchen garden wall is aflame, too. Fiery-red and orange dahlias predominate, their vibrancy echoed by towering red hot pokers, heleniums and the dramatic, scarlet outlines of redwood stems. The challenging copper beech maze is at its most vibrant then, and squirrels scamper around the gazebo in the nuttery.

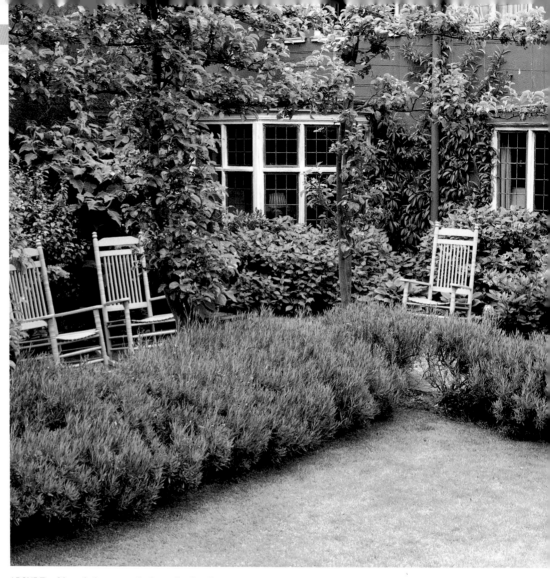

ABOVE **Rocking chairs around a lavender border**

There is a woodland walk to the south-facing vineyard, planted in 1988 and now producing award-winning wines. Chickens strut in the orchard and have decorative houses of their own. Peacocks jump down from the trees and are liable to greet visitors here, there and everywhere with glorious tail feathers outstretched. Llamas roam the fields. So much to see, so much to inspire, in a garden designed to delight all the senses.

ABOVE **Mingling fragrances of chives and golden oregano**

CREATING THE LOOK YOURSELF

* The pairing of golden-orange bearded iris and purple *Allium cristophii* makes a specially strong impact against the dark green clipped hedges of the Wyken Hall knot garden. They are ideal 'plant partners' because of their contrasting colours, textures and forms. Iris grown from rhizomes and allium from bulbs both enjoy fairly rich, slightly alkaline and well-drained soil and a position in full sun.

* To achieve a similar effect, plant rhizomes and bulbs in autumn or early spring. Increase your 'show' by dividing them in autumn or spring the following year, or by pulling away any offsets they have produced and planting them in the ground or in pots. Rhizomes and bulbs propagated in this way will flower one or two years earlier than those grown from seed.

* Alliums produce seedheads that are almost as beautiful as the purple flowers and you may choose to leave these creamy-brown starry globes to dry on their tall, erect stems. Remember to cut the stems off close to ground level before the next flowering season.

RIGHT **A familiar sight in the garden**

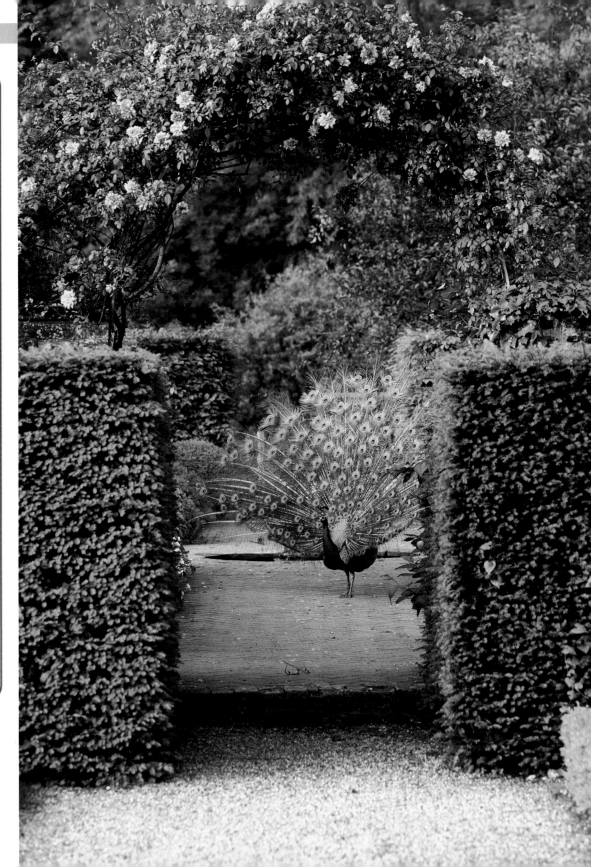

VEDDW GARDEN

GEOMETRIC ENCLOSURES, UNDULATING HEDGEROWS AND EXPRESSIVE PLANTING

ABOVE **Box hedge 'corridors' by the pool**

A garden with a sense of history that combines a formal ground plan with imaginative planting.

On the Welsh border above Tintern, there is a garden where wild flowers grow, where hedges are shaped to echo the gentle curves of the surrounding countryside, and low box hedges based on a mid-19th-century tithe map form a parterre planted with ornamental grasses.

The garden, designed by Charles Hawes and Anne Wareham, expresses a variety of moods, and the spotlight falls on one section and then another as the seasons change.

DRAMATIC GROUND PLAN

In winter, when the evergreen ground plan that defines several areas is veiled in snow or rimed with heavy frost, the layout of the garden is at its most distinct and dramatic, taking on the intensity of a black-and-white photograph. Most dramatic of all,

WHAT'S THERE:	2-acre romantic modern garden and 2-acre woodland
WHERE:	Devauden, Monmouthshire NP16 6PH
GETTING THERE:	8km (5 miles) NW of Chepstow off B4293
WHEN TO VISIT:	Open Sun and Bank Holiday Mon afternoons Jun to Aug; groups of 10 or more on other afternoons and evenings by appointment
CONTACT DETAILS:	01291 650836; www.veddw.co.uk

the hedge garden with gently undulating, shoulder-high box hedges, one behind the other, forms rows of formal evergreen corridors separated by brick paths.

Anne used the tithe map as the basis for a pattern of low, clipped box hedges forming a parterre of grasses on a sloping area. The enclosures, representing miniature fields, some accented with rounded-cone yew topiaries, are filled with wayward ornamental grasses in strong contrast to the strict neatness of the hedges.

In a similar way, a small 'cornfield' garden, enclosed by a yew hedge and sub-divided by four box-hedge enclosures, was once planted with cornfield annuals. This, too, is now planted with ornamental grass, in this case *Calamagrostris* x *acutifolia* 'Karl Foerster', which carries buff panicles from June through to October. Steel tubes bring water, a pleasant extra dimension, to the almost secret garden.

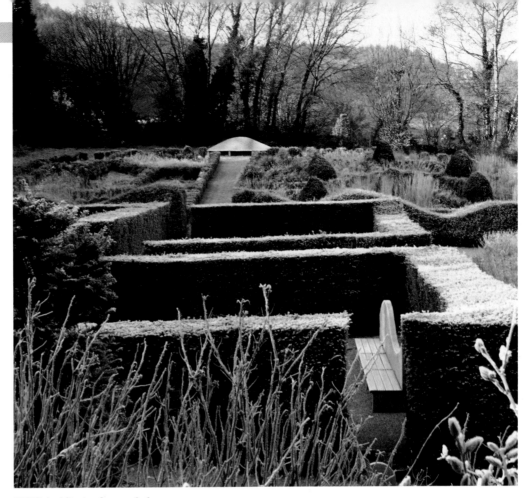

ABOVE **Architectural ground plan**

SIGNATURE PLANT

Cotoneaster hedges, trellising and a field hedge define the former vegetable garden, where low, elegant topiary domes are enfolded in the far-reaching, silver-grey foliage of cardoons, fast becoming one of this garden's statement plants. Underplanting in plots that once grew cabbages and kale, onions and leeks is a vivid orange and purple blend of nasturtiums and heuchera.

Cardoons have a leading role to give height and substance to a border underplanted with ground-covering silver-leaved plants. With all the foliage in the

signature shades of silver-grey and blue-grey, there is a background of eucalyptus, *Buddleja fallowiana* 'Lochinch', with its lilac-blue flowers, and *Rosa* 'Felicia', which has delightfully fragrant pale pink double flowers.

WILD GARDEN

A meadow that, in spring, is speckled with naturalized wood anemones and violets, and with white and cream daffodils, in summer explodes with orange-peel bright crocosmia and golden solidago, hardy perennials that, experimentally, Anne has planted into the turf. Stone headstones

sited through the meadow commemorate not former inhabitants but popular variations of local names, including a nearby hamlet, a local spring and a local river. Rows of Turkish hazel trees (*Corylus colurna*) bisecting the meadow have been clipped to form standards.

A long, low pink seat facing a black reflecting pool has been designed with Veddw Garden's signature sinuous curves. The pool presents a mirror image of the coppice and forest trees behind it, as, in its way, the garden reflects the contours and the history of the surrounding Monmouthshire countryside.

CHAPTER 8

LANDSCAPE GARDENS

Blending artlessly into the environment and
capitalizing on local geographical and geological
features, these gardens follow or replicate the
undulations, watercourses, rock formations
and treescape of the land around them.

ATTADALE

THE PRESENT-DAY GARDENS MAINTAIN STRONG LINKS WITH THE PAST

With acres of rhododendrons, a fernery and stunning coastal views, this Highland garden has much to offer.

One can walk for miles through this magnificent coastal scenery of north-west Scotland and never leave the Attadale estate, which stretches from the south shore of Loch Carron inland to Loch Monar, 24km (15 miles) to the east. Protected by the hills, there is a series of extensive but contained gardens that still reflects a former owner's knowledge and love of plants, rhododendrons and crinodendrons especially.

The estate was historically part of the Clan Matheson lands, and it was a member of that family, Sir Alexander Matheson, who was responsible for building the railway from Inverness to Strome. In the 1880s, Attadale was leased and subsequently, in 1910, bought by Baron Schroder of the German banking family. His son, Capt. William Schroder,

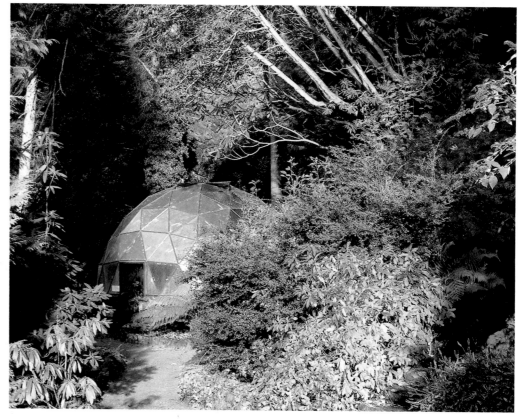

ABOVE **The fern house, a geodesic dome**

BELOW **Himalayan blue poppy**

WHAT'S THERE:	Gardens on part of 30,000-acre estate on NW Scottish coast; rhododendrons, woodland walks, water gardens, sunken garden; teas; sales area, map and booklets of the gardens; reading room; holiday cottages
WHERE:	Strathcarron, Wester Ross, Highlands IV54 8YX
GETTING THERE:	On A890 between Strathcarron and South Strome
WHEN TO VISIT:	Open Mon to Sat, Apr to end Oct
CONTACT DETAILS:	01520 722603 or 01520 722217; www.attadale.com

RIGHT **Waterfalls are fed by natural streams**

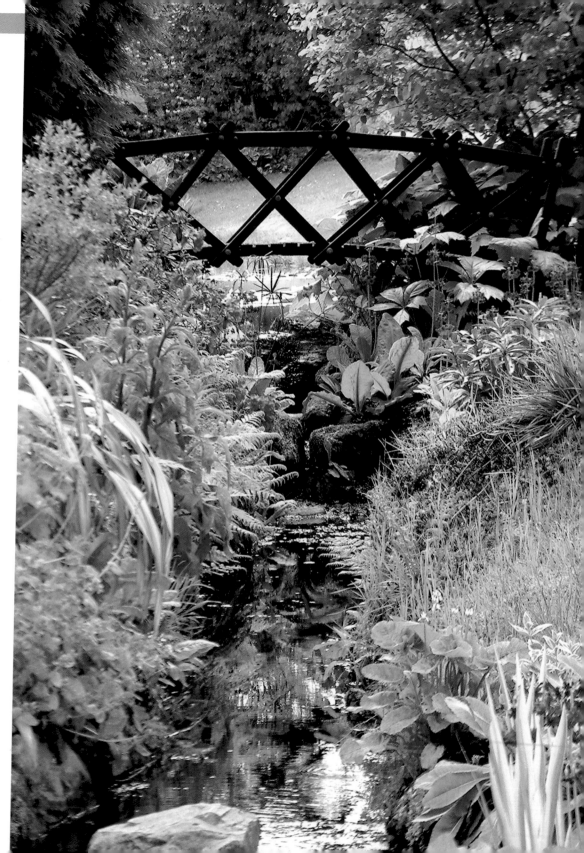

a keen plant collector, was responsible for laying out the gardens. Ian Macpherson, the father of the present owner, Ewen Macpherson, bought the estate in 1952.

FAMILY COLLECTION

The Schroder family collected specimen trees, rhododendrons, crinodendrons and azaleas from around the world, especially from the damp west-coast states of North America, Chile and the Far East. Many of these, more than 100 years old, survive in the gardens today.

RECENT DISCOVERIES

The estate gardens had largely been neglected during World War II, and were further damaged by the devastating storm in 1989, which destroyed thousands of trees. This natural disaster, however, revealed many old paths and flights of steps that had been concealed by undergrowth for nearly half a century. Subsequent restoration and development of the gardens by the present owners have therefore been able to turn back the clock and restore some features of the original layout. Since the storm, over 2,000 trees and shrubs have been planted to replace those that were lost.

RHODODENDRON WALK

The shelter of steep hills and cliffs, and the proximity of the Gulf Stream have made it possible to plant many species that would not be successful on a more exposed site. In spring and early summer, the rhododendron walk, which is also lined with other acid-loving plants and covers

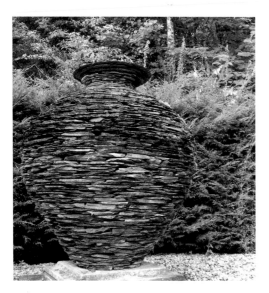

an area of approximately 20 acres, is a sensational progression of pink, red and coral shades, with a backdrop of unusual conifers. These include Korean fir (*Abies koreana*), which has dramatic violet-blue cones, and the blue-leaved Bhutan pine (*Pinus wallichiana*). Damp areas along the walk are planted with iris, primula, rheum and ligularia with its brilliant orange-yellow flowers. A large bronze sculpture of an eagle, suddenly coming into view,

LEFT **Slate urn by Joe Smith**
BELOW **River of Life in the Japanese garden**

looks as if it is prepared for flight, and a life-size bronze cheetah by Hamish Mackie is poised on a rock. Visitors will see other sculptures throughout the garden.

SUNKEN GARDEN

The sunken garden was designed to echo the characteristics of the landscape. Dry stone walls and rose hedges define the compartments and create the ground plan for a cool colour scheme of pink, white and lilac ground-covering plants around a central sundial. A tall slate obelisk in this area commemorates the millennium.

QUIET REFLECTION

The sound of water is ever-present throughout the almost sub-tropical water gardens, where there are trickling and cascading waterfalls fed by natural streams. Shady pools, elegant bridges and stone paths are all flanked by lush planting, which forms a dense cover. Damp- and shade-loving plants thriving in the dappled light, many of which are reflected in black pools, include the glorious blue meconopsis, mauve and white irises, Himalayan primulas and ferns. Giant gunnera provide structure at the watersides, and bamboos are planted to form walls and curtains. In autumn, *Gunnera chilensis*, with its reddish-green flowers, and other large-leaved plants complement the rich autumnal shades of the surrounding trees and shrubs.

JAPANESE GARDEN

An avenue of Japanese birch leads through a gateway to the Japanese garden, where lichened rocks and gravel imitate the river of life and the mystic islands of the mist. Using the art of shakkei, the hills of Applecross become a substitute for Mount Fuji. Now a quiet area designed for contemplation, the Japanese garden was reclaimed in 2002 from a basin previously flooded and infested with pervasive knotweed.

FERNS AND EXOTICA

Two former quarries behind the kitchen garden provide ideal conditions not only for further rhododendrons but also for a collection of ferns. More tender species

ABOVE **Plants are propagated for sale**

are housed in a geodesic dome made of triangular panels and closely resembling a miniature Eden Project dome.

The conservatory has recently been remodelled with dry stone wall beds and a stream running into a small pool. It is planted with a growing collection of exotic plants from around the world.

EDIBLES

The kitchen garden and greenhouse, legacies from the early garden design, are productive still. Plants are propagated in the glasshouses for the garden and for sale, and in summer, rows of pink, red and white geraniums and fuchsias are a gloriously nostalgic sight. The plant sales area is in the kitchen garden, and there is an eccentric 'do-it-yourself' tea room called The Old Larder in the back yard, with

garden books to read and photographs of the development of the garden.

WILD DEER

Most of the estate is composed of bare hillside with about 200 acres of flat land covering the floor of Attadale Glen. Wild deer roam freely throughout the estate, the main species being red deer (*Cervus elephus*), which might be seen anywhere from the highest peaks down to sea level and the shores of Loch Carron. The more reclusive roe deer and the non-native sika deer, which are rapidly spreading throughout the Highlands, are more usually seen in the forested areas. All around the estate and beyond, there are magnificent walks, views of a wild-looking but friendly coastline and, away in the distance, the Isle of Skye.

225

CHANTICLEER

IMAGINATION HAS FREE REIN AND THERE IS INSPIRATION AROUND EVERY CORNER

ABOVE **Exotic planting beside the pool**

Landscaped 100 years ago with intriguingly individual features, the garden takes the visitor on a virtual tour of Arts and Crafts design with American overtones.

Following the paths through Chanticleer is like making a voyage of discovery. The journey starts in front of the main house, where a circular bed of deep red gravel is complemented by red hydrangeas and native phlox. Streaking over open grassland and across the Serpentine avenue of trees, the path skirts an Asian wood where most plants are native to Korea, Japan and China. Then, bordering the stream, the way leads to a triple-pond garden and, dramatically, to the Ruin Garden, a unique construction on the site of a former house.

Decision time! The path forks, this way leading to the orchard where half a million pink, white and yellow daffodils and narcissi are planted like swirling

WHAT'S THERE:	35-acre garden with treescape, themed areas, expansive planting
WHERE:	786 Church Road, Wayne, Pennsylvania 19087, USA
GETTING THERE:	24km (15 miles) west of Philadelphia
WHEN TO VISIT:	Open Wed to Sun, Apr to Oct; group guided tours by arrangement
CONTACT DETAILS:	(001) 610 687 4163; www.chanticleergarden.org

ABOVE **Sharp citrus colours in a dry garden**

rivers, and moves on to woodland with a deeply purple understorey of hellebores. In the other direction, the path takes in the symmetry of the potager and the fruitfulness of the vegetable garden before leading to the charmingly named Teacup Garden. Each area, unique in its own way, is intriguing. The journey is a slow one.

When Christine and Adolph Rosengarten bought the land in 1912,

they had the gardens laid out by Thomas Sears, a landscape artist. His design for the Chanticleer house terraces, which followed the Arts and Crafts style but with American overtones, substantially survives today, although the plantings are significantly different. The last owner, Adolph Rosengarten, Jr, who established the property as a charitable trust in 1976, lived most of his life in the Minder House close

to the stream. On his death in 1990, the garden was given to the trust and opened to the public three years later.

ARCHITECTURAL FANTASY

The Minder House was demolished in 1999 and a fanciful reconstruction put in its place. The new 'ruin', open to the elements, makes majestic use of a variety of natural materials to create themed rooms. In the Great Hall a reflecting pool shaped like a sarcophagus stands on a mosaic 'rug' of tile, granite and slate. In the Library the rows of books are sculpted from stone, and in the Pool Room marble faces encounter anyone who gazes into the fountain. The surrounding area has the look of a once-productive cottage garden that has been allowed to grow wild. Drifts of orange and pink flowers are towered over by random delphiniums and one wonders, perhaps, whether they were all growing there when the Minder House was inhabited.

At the next stop along the way, where a low undulating stone wall follows the course of the stream, there are waves and waves of light blue *Camassia leichtlinii* 'Blue Danube', a May-flowering bulb particularly suited to water margins. A large iron water wheel, a magnificent piece of industrial machinery that once pumped water from the stream, stands neglected among rocks, ferns and tree stumps. There are plans to restore it to working order.

MOOD SWINGS

In this undulating landscape trees are used variously as design features, to create perspective and to punctuate open

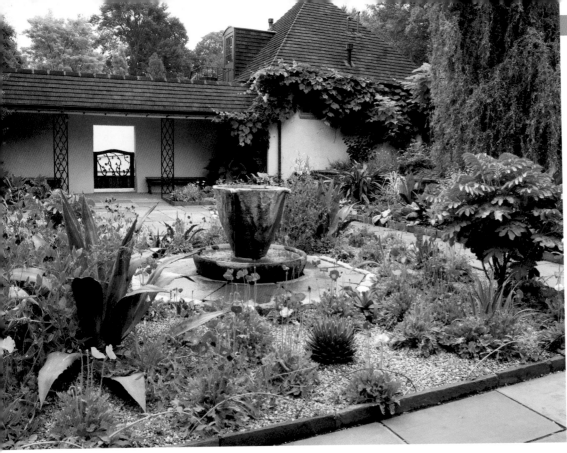

ABOVE **Poppies grow freely in gravel**

BELOW **Natural planting around the 'ruin'**

spaces. The middle distance would hold far less interest without the Minder Wood and the enveloping treescape. In the Serpentine area a curving avenue of young junipers banded by wide, orderly strips of agricultural crops such as wheat and barley leads to a semi-circle of young ginkgo trees, evoking pagan symbolism and dedicated to the goddess Flora. From the formal framework of this area the mood changes. The Asian wood with its pretty stone, ironwork and bamboo bridge is awash with seemingly random foliage and floral colour, gingers such as *Asarum splendens* mingling with pink and white candleabra primulas and Asian jack-in-the-pulpits (*Arisaema sikokianum*), with their distinctive brown and white striped spathes.

As the path nears its end the Teacup Garden takes the visitor on a virtual voyage to the tropics, where bananas, gingers and pineapple lilies grow in profusion, papyrus are underplanted with bromeliads, and apricot devil's trumpets harmonize with deep orange coleus. The tropical illusion is heightened by the sound of ever-trickling water and, on a summer's day, perhaps hummingbirds.

MULTI-TALENTED

At each stopping point around the garden there are boxes resembling birdhouses, postboxes, filing boxes and so on, with plant lists for visitors to take away. Delightful examples of the talent and craftsmanship of the Chanticleer staff, who have designed all the changes to the garden since 1990, greet the visitor at almost every turn: the interior walls of the green Apple House are covered with a striking mural and a dried apple wreath encircles the window; a turf tapestry close to the main house takes grass mowing to the highest level; stone paths, here and there, are as pleasing and complicated as mosaics; and everywhere there are pieces of hand-made wooden and stone furniture with the implied invitation of 'try me'.

WHAT'S IN A NAME?

Two roosters keeping watch over the entrance gate give a clue to the significance of the house name, Chanticleer. The fable of Chanticleer the cock and Reynard the fox is thought to have its origins in the 14th century. In *The Canterbury Tales*, Chaucer took up the notion that 'pride cometh before a fall' with the story of Chanticleer and the Fox in *The Nun's Priest's Tale*, where the reader is advised not to 'truste on flaterye'.

RIGHT **A cockerel, the estate 'logo'**
LEFT **Wayside flowers bordering a stream**

DESERT BOTANICAL GARDEN

SURREAL SHAPES AND BRILLIANT BLOOMS – AN IRRESISTIBLE COMBINATION

On offer at this garden are nature trails, guided walks and a hands-on desert experience.

Ranged among the hills and peaks – known as the red buttes – of Papago Park, the botanic garden shimmers in spring and early summer with some of the most exhilarating flowers in the world. Thriving on the arid conditions of the Sonoran Desert, cacti and succulents produce flowers in the most dazzling reds, pinks and yellows, the whitest of whites and the sharpest of blues, all startling in their clarity. And butterflies are irresistibly attracted to them.

Part of the mission statement of the botanic garden, which was founded in 1937, is to conserve cactus and other succulents from around the world, and to promote and sustain educational and research programmes. Among over 20,000 specimen plants in the desert garden, there are nearly 150 rare, endangered

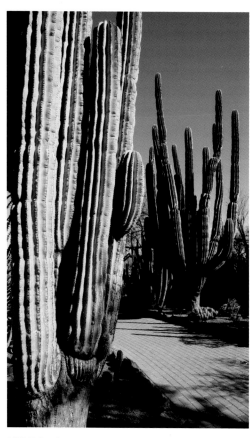

ABOVE **Cardon cacti reach for the sky!**

or threatened species now growing and multiplying in their natural habitat.

CARTOON CHARACTER

One succulent sure to provoke a chorus of oohs and aahs among visitors is the saguaro (*Carnegiea gigantea*), a very slow-growing perennial cactus, which has a thick, 12–24-ribbed, spiny, green stem. This tall, erect pillar cactus, so often featured in films and cartoons as a caricature of desert life, can reach a height of 12m (40ft) with a spread of 3m (10ft). Compared to the plant's magnificent stature, the white, funnel-shaped flowers that appear at the stem tips in summer are unremarkable. By contrast, it is the tall flower spikes of the agaves and yuccas that attract attention, rising like illuminated yellow and white torches from clusters of sharp-toothed, sword-shaped basal rosettes.

WHAT'S THERE:	50 acres of cacti and other succulents from around the world; museum; workshop; plant shop
WHERE:	1201 N Galvin Parkway, Phoenix, Arizona 85008, USA
GETTING THERE:	SE edge of Salt River Valley near Scottsdale and Tempe; adjacent to Phoenix Zoo
WHEN TO VISIT:	Open daily, except 4 Jul, Thanksgiving Day and 25 Dec; winter and summer times vary; special evening events
CONTACT DETAILS:	(001) 480 941 1225; www.dbg.org

ABOVE **'Lady Fingers' cacti**

DESERT TRAILS

There are four designated trails through the garden, each one emphasizing a group of species, and each between 0.4 and 0.5km (about ¼ mile) long. The oldest plantings from around the world – from Chile, Peru, Argentina and Bolivia, as well as native North American species – are ranged along the Desert Discovery Trail,

DON'T FORGET

* The desert is cooler in the mornings and evenings.
* If you have to visit at midday during the summer, wear a hat and comfortable shoes, not sandals, drink plenty of water, and also use sunscreen or sunblock.
* Always stay on the designated trails.
* Take binoculars, especially if you plan to join a morning guided walk along a bird-spotting route.

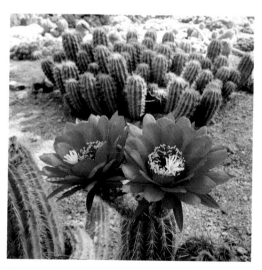

ABOVE *Echinopsis huascha* 'Charlie Cobeen'
RIGHT **Barrel and saguaro 'pillar' cacti**

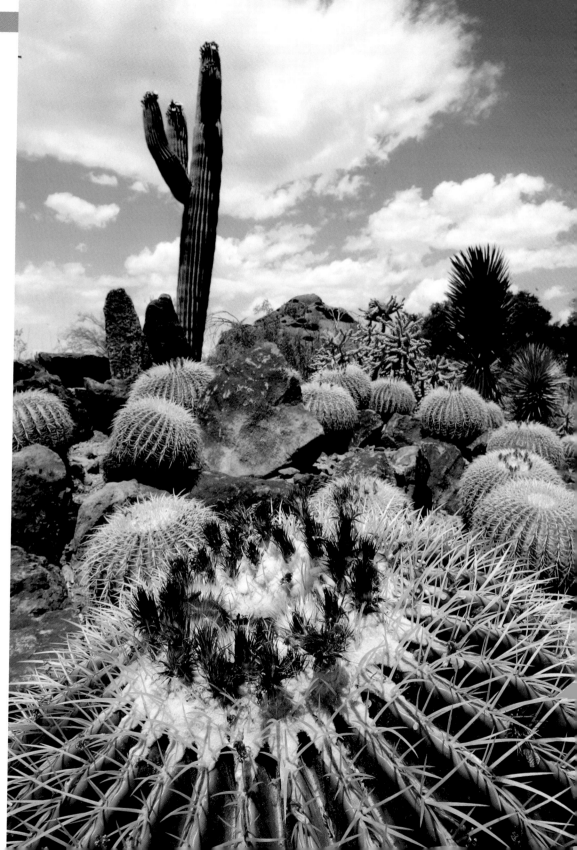

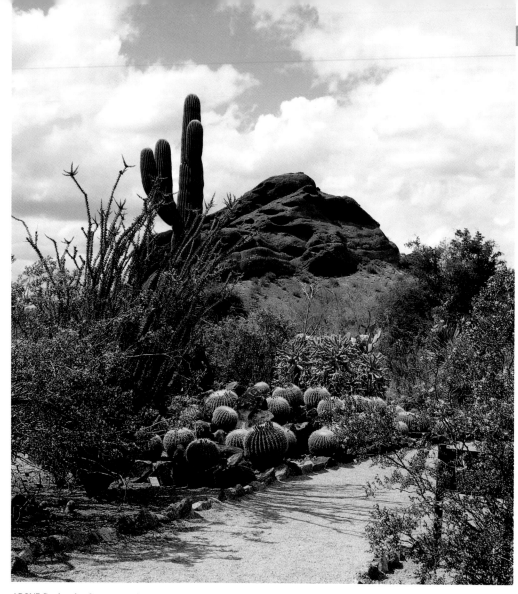

ABOVE **Spring in the mountains**

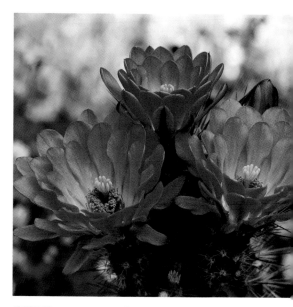

ABOVE **Claret cup cactus flowers**

which, meandering around the base of a small mountain, provides an exciting introduction to the desert experience.

Walking through the desert, one almost inevitably wonders what it would be like to live there, and that question is addressed in the trail called The People and Plants of the Sonoran Desert. This can be a hands-on experience, where visitors learn how to make a brush from yucca fibre, practise grinding corn as the Native Americans did, and understand how the indigenous peoples used the native plants for making food and medicines, baskets and tools, and also their shelters.

BARRIER FRUITS

The Desert Garden is home to one of the world's most complete collections of prickly pears (*Opuntia*), numbering over 80 per cent of the known species and varieties. (Contact with the bristles on the green, yellow, red or purple fruits can cause intense skin irritation, and if the bristles pierce the skin, they can be very difficult to remove.) The collection includes *Opuntia aciculata*, with small, scarlet, cup-shaped flowers clinging to the side of the stem, and *O. robusta*, which, in spring and summer, has yellow, saucer-shaped flowers that seem to illuminate the silvery-blue stem segments. Similar flowers decorate the heavily spiked cylindrical segments of *O. tunicata*, while the cylindrical, usually spineless and considerably less threatening stems of *O. verschaffeltii* bear bright orange-red flowers. The garden's major collection of *Echinocereus* provides bright pools of colour, too, with *E. pentalophus* having thick clusters of vivid pink flowers close to the ground, and *E. reichenbachii* more delicate-looking pale pink blossoms.

FLOWERS OF THE DESERT

In spring and early summer especially, a wild flower trail leads to areas of breathtaking colour, focusing on such desert blooms as the brilliant scarlet *Echinopsis huascha* and the shocking pink 'Lady Fingers' cactus. Here, too, there will be hummingbirds, butterflies and bees.

BUTTERFLIES

Butterflies are as much a part of the desert scene as the brightly coloured flowers, trees and shrubs that attract them. Thousands of these ephemeral symbols of spring, mainly North American species, hover, flutter and settle, sometimes making it seem as if a plant has suddenly erupted into full flower.

There are giant swallowtails and zebra swallowtails, painted ladies, queens,

malachites and julias – lepidopterists have a busy time making observational notes.

So that visitors can observe butterflies at even closer range, a Butterfly Pavilion was opened at the millennium. It has display areas featuring butterfly host plants and a discovery station, where visitors can watch the colourful creatures sipping nectar from flowers and basking in the sun. Children who want the butterflies to settle on them are advised to wear bright clothing!

AMBIENT TOURS

In summer, there are sunrise and dusk tours, when the desert has an ephemeral ambience, and different forms of wildlife are at their most active and vocal. It would be easy at such times to imagine an oasis on the distant, shimmering horizon.

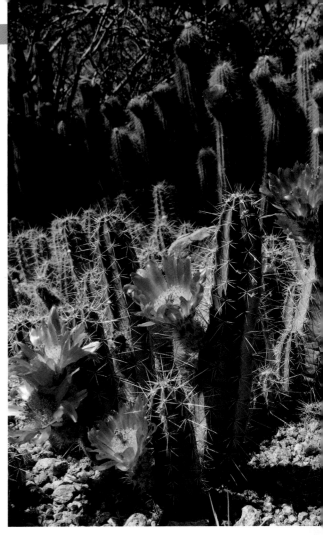

ABOVE **Turned to face the sun**

ABOVE **A pretty Julia butterfly**

KATANDRA GARDENS

IF VICTORIA STATE WERE NATURALLY COVERED WITH FLOWERS, IT WOULD LOOK LIKE THIS

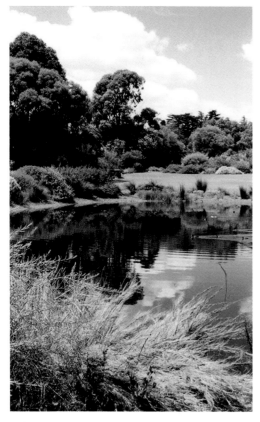

ABOVE **Wild-looking planting around the lake**

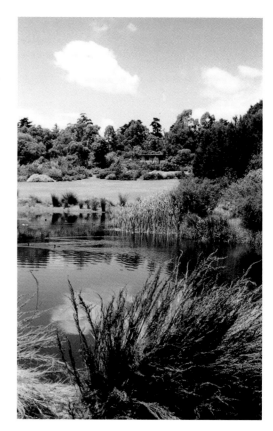

Working with nature and using mainly indigenous Australian plants, the owners have created a garden that has arid zones and alpines, lush forest and wetlands.

A mile-long path and an extensive boardwalk meander through this responsibly planned garden that is scarcely an hour's drive from Melbourne. Planted with mainly native Australian species, the garden seems to span more than one time zone, with its arid-looking rock mounds, banks of evergreens alight with flowers in primary colours, a lush area resembling a rain forest, and small shady glades opening on to wetlands around an ornamental lake.

The garden that some have dubbed 'a mini Australia' started in a small way and almost by accident. When Bob and Dot O'Neill bought a plum and cherry orchard in 1976, they intended to be working fruit farmers, taking out only about an acre to start the first garden. The fruit trees were removed in 1989, and as Bob and Dot's

WHAT'S THERE:	8-acre garden of mostly native Australian plants; shop, holiday cottages and B&B
WHERE:	49 Hunter Rd, Wandin, Victoria 3139, Australia
GETTING THERE:	10km (6 miles) E of Lilydale, 1km (¾ mile) E of Warburton Highway
WHEN TO VISIT:	Thu to Mon; other days by appointment. Guided tours any day by arrangement
CONTACT DETAILS:	(0061) 3 5964 4523; www.katandragardens.com.au

RIGHT **Showers of spring blossom**

enthusiasm grew, so did their garden until, eventually, the whole property became one garden. In 2005, Bob won the coveted Gardener of the Year award from ABC Gardening Australia.

NATURAL THEATRE

Throughout the garden the planting is theatrical yet apparently completely natural. Small 'shy' plants spilling over pathways are overshadowed by densely packed, tiered rows of flowering evergreens that flourish in the shade cast by eucalpytus and other native trees. Such borders take colour and texture contrast for granted, and visitors would do well to take a notebook to record the complementary plant pairings used to stunning effect.

In the citrus-to-sun-gold shades there are the bright yellow, saucer-shaped flowers of hibbertia and correa, whose flowers range from greenish-yellow to crimson. Dryandra, with its orange-yellow blooms and sculptured foliage, makes a dramatic statement; grevillea contributes yellow, orange and the brightest of red blooms, and prostanthera, with its mint-scented foliage, is covered with bell-shaped lavender flowers, like an invasion of so many butterflies. Perhaps telopea, known as waratah, is the real showstopper. With its dense crimson, almost pineapple-like heads, it is certainly noteworthy.

WATER TABLE

In complete contrast to the hot, fiery colours of the borders, the wetland, viewed from the boardwalk, is an idyll of soft, hazy blues, reeds rustling in the

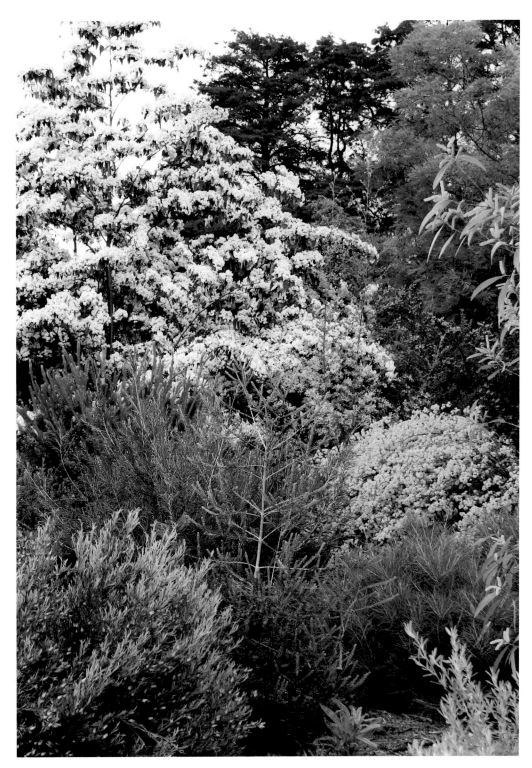

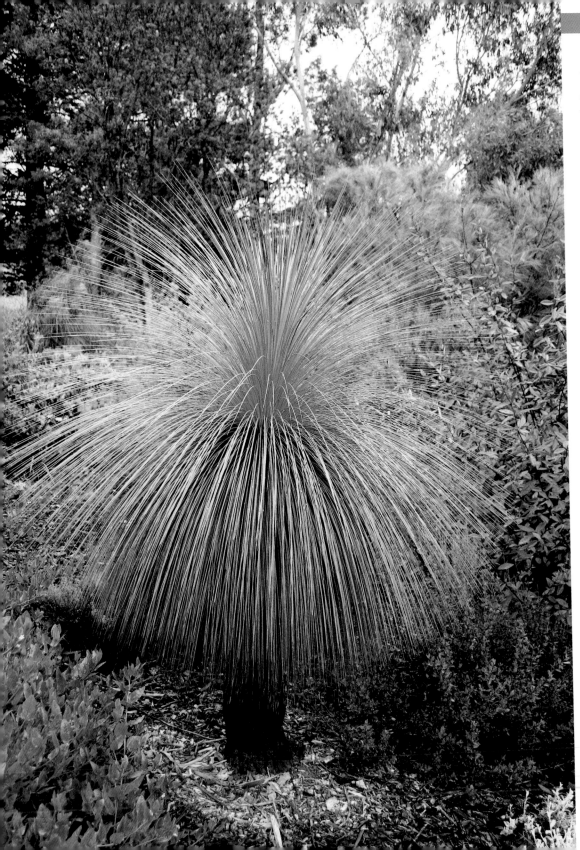

breeze, reflections on the water, and the comings and goings of energetic wildlife. Water birds make their home there, frogs contribute to a deafening chorus, and it is all a far cry from the arid, almost desert-like, areas just a few minutes' walk away.

The garden's take-over bid on the orchard did not spell the end of fruit growing at Katandra Gardens but it did mean that gradually a much wider variety of fruit has been planted. There are still cherries and plums but now loquats, feijoas, figs, kiwi fruits, nashi fruits, persimmons, grafted avocados and macadamia nuts have been added to the harvest. Although Katandra Gardens is no longer a working orchard, it is an award-winning garden that works with and for the environment. Responsibly.

ABOVE **One of the correa plant collection**

LEFT **Spectacular 'grass tree' foliage**

ABOVE **A walk on the wild side**

NATIONAL COLLECTION

Bob and Dot O'Neill hold the OPCA (Ornamental Plant Conservation Association of Australia) collection of correas, evergreen shrubs grown – spectacularly at Katandra – for their flowers. Correas prefer full light or partial shade, and fertile, well-drained neutral to acid soil. They flower in late summer to late winter, and are propagated by seed in spring or by tip cuttings in the warmer months.

SUSTAINABILITY

In this area of the Yarra Valley, known for its rich red volcanic soil, the O'Neills practise sustainable gardening, watering plants only when they are first put in and until they are established. They draw water when they need to – and when it is possible – from the lake that is fed by any run-off, and rarely use fertilizers. Birds, especially wrens, thrushes and wattle birds, play a large part in pest control, although rabbits are always a problem.

WHAT'S IN A NAME?

'Katandra' is an Aboriginal word meaning 'song of birds', a name well chosen for this garden where 75 bird species have been noted, many of them living on and around the lake and the wetlands. Their song does indeed fill the air here.

Among the birds regularly found at Katandra Gardens, and which thrive in the natural environment, are New Holland honeyeaters, blue wrens, thornbills, willy wagtails, fantails and grebes.

LES JARDINS AGAPANTHE

THIS FRENCH GARDEN EVOKES TIMELESSNESS, STYLE, CHARM AND BEAUTY

A 'must-see' Normandy garden of mingling plant combinations, lingering fragrances and pure romance.

Alexandre Thomas, the landscape architect who designed this garden around his parents' home in Normandy, had a vision statement: 'to create the illusion of taking a very long walk through what is essentially quite a small area'. Over 15 years, his mission has been delightfully accomplished. If the garden were planned as a maze, one would be looking in eager anticipation to see what was around the next twist and turn – which is exactly what one does.

A complex of narrow – some very narrow – paths cutting through lush and lavish plantings snake over bridges – one delightfully framed by tall, swaying stems of *Verbena bonariensis*, golden ornamental grasses and lady's mantle (*Alchemilla mollis*). The paths continue up some steps and down others, under archways and a rose-

ABOVE **Heady fragrance in the Sunken Garden**

BELOW **Agapanthus**

WHAT'S THERE:	1¹/₂ acres of romantic garden with imaginative planting, pools, terraces, antique garden ornaments and furniture, intimate views; plant stall
WHERE:	Grisneuseville, Normandy, France
GETTING THERE:	Between Dieppe and Rouen on N29 E of Totes
WHEN TO VISIT:	Apr to Oct afternoons except Wed. Guided tours for groups any day by appointment
CONTACT DETAILS:	(0033) 235 333205; www.jardins-agapanthe.fr

covered pergola, leading this way and that to a sunken garden heady with the scent of lavender and to a Mediterranean terrace basking in the shade of olive trees. And along the way, there are elegant pieces of antique furniture, sculpture, urns, fountains, even an iron balustrade acting as a decorative climbing frame for mingling plants. There is always something to capture the attention and cause one to linger.

ILLUSION OF SPACE

The levels of the garden change considerably, yet not distractingly. It does not actually feel as if one is going purposefully up or down – it is more like moving from one intriguing tableau to the next. Yet the change of levels is an important element in creating the illusion of space. Another illusion is that the garden appears as if it has always had gentle slopes and high banks, rises and hollows, but it has not.

FAR-REACHING CHANGES

The raw material from which Thomas created this labyrinthine garden was a flat, treeless, featureless field; it is difficult to imagine that now. He installed high banks where plants could be arranged theatrically in tiers, creating areas of deep shadow, and contrasted them with open, sun-baked terraces where both the light and the plant selection are dazzling. He introduced water – the original plot had none – and created flowing streams, fountains and still, dark though not always reflective, pools. Some pools are almost concealed

ABOVE **Antique ornaments become the focus**

beneath a blanket of water lily pads and other floating plants, adding to the intense greenness of shaded areas.

FEELING OF UNITY

Thomas admits to a passion for topiary and he has indulged this with skill. The repeated use of clipped yew and box (*Buxus sempervirens* 'Suffruticosa') shapes gives this garden of many moods a feeling of unity. Box topiary shapes edge paths, stand as sentinels in herbaceous borders, compose a ground-level frame around large containers planted with hostas, and

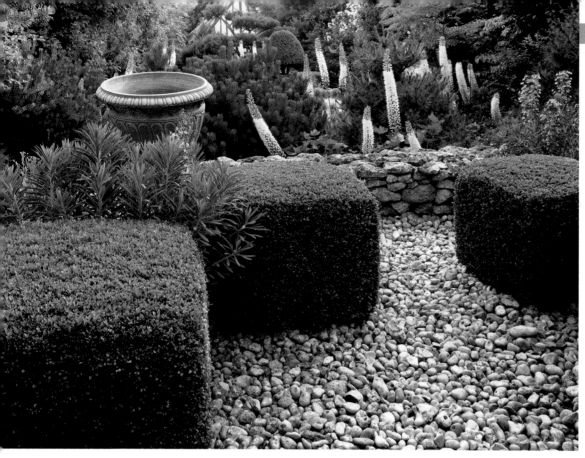

ABOVE **Twin passions, topiary and pebbles**

stand alone as statuesque monoliths on terraces. Intriguingly, when the plants are used as edging, they are not grown simply as functional, low-level hedges but as closely planted football-sized balls.

PRICKLY SITUATIONS

The planting in the garden is dramatic, yet subtle. Thomas uses prickly plants – mahonia, agaves, palms and even a monkey puzzle tree – to contrast with hostas and ferns, hydrangeas and euphorbias in ways that look natural. In another attraction of opposites, a large Chusan, or windmill, palm (*Trachycarpus fortunei*) casts its all-enveloping shade over the soft mophead flowers of a white hydrangea.

THE ROLE OF TREES

Mature trees imported from Belgium, Germany and Italy are grown in large pots so that they can be moved around to complement other plants as the seasons and their relative colours change. A *Prunus serrula* tree earns its place in a border not because of its small white flowers or its tiny reddish-brown fruits in autumn, but for the artistic appeal of its coppery-red bark that naturally peels to reveal a layer of paler, toning shades.

SPRING LIGHT

Corsican hellebores (*Helleborus argutifolius*) are planted in thick bands to edge paths and borders with their pale green stalks

DOUBLE TAKE

Alexandre Thomas has played an amusing little joke with a well-established bonsai juniper tree (*Juniperus*). He clipped the foliage so that each near-horizontal branch ends in a thick cloud shape and surrounded this wide-spreading evergreen cloud formation with a bed of grey-sky-coloured foliage plants.

and glossy green foliage throughout the year and – a bonus at the end of winter – their pale lime-green flowers. To light up the garden still further in spring, Thomas uses tulips as one might light candles in the house – only these are in a far greater quantity. Not quite in rows and never in blocks, yellow and white lily-flowered tulips such as 'White Triumphator' are planted among shrubs, hellebores and other perennials, where they strike a vivacious note. The tulips are planted in thousands every year and yet, in this meandering garden, they complement the neighbouring plants without ever dominating.

SIGNATURE PLANTS

Thomas uses only natural materials for paths: granite chips, gravel, honey-coloured stone and pebbles – another of his passions. No grass. This is a year-round garden and grass paths get muddy. One south-facing garden is outlined with dry stone walls, creating a hot, dry, Mediterranean ambience, emphasized by

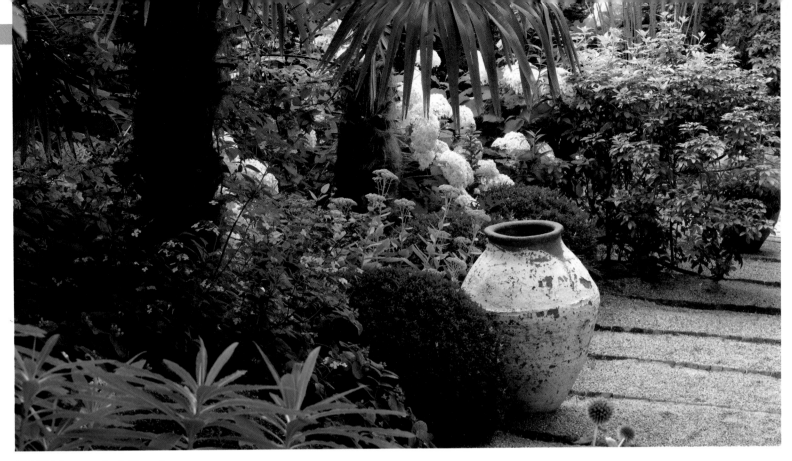

ABOVE **Hydrangeas shaded by palms**

the large, fruiting olive trees and curry plants (*Helichrysum italicum*), which have aromatic, silvery-grey leaves and bright yellow flowers in summer. These contrast refreshingly with a dense border of sky-blue agapanthus globes carried on tall upright stems; these are Thomas's signature plants and gave their name to the gardens. They appear majestically again in a beautiful antique terracotta pot surrounded by a sea of deep green dwarf pines (*Pinus mugo*).

MOODY BLUES

An avenue of granite paving leads to a sunken garden, where yew and box topiaries in myriad sizes and shapes form the backdrop to a nostalgic display of lavenders and sky-blue ceanothus. There is a cherubic fountain, stone artefacts and the sound of trickling water, all contributing to an away-from-it-all feel. Through this seemingly remote part of the garden, there is a beautiful 19th-century orangery that Thomas rescued and then meticulously restored.

ROMANTIC SHADES

Over the years, Thomas has become ever more selective in his choice of plants and now will not tolerate short-term flowering plants, using only what he considers to be the best varieties of each species. His preference turns more and more to romantic shades, too, with soft blue, mauve, pink and white predominating – colours that are repeated delightfully throughout the gardens in many mingling combinations of shades and delicious lingering fragrances.

Climbing roses and pinks; a mass of 'Kashmir' geraniums beneath towering foxgloves; purple sage, marjoram and thyme encroaching on pathways: everywhere in the gardens, there are charming cameos. It is a heady and delightful mix.

Les Jardins Agapanthe do give one the illusion of taking a long, meandering walk. And if the gardens were a maze, one would not be inclined to make very strenuous efforts to find the way out.

PETTIFERS

AFTER SEVERAL MOOD CHANGES THE GARDEN FINALLY BLENDS INTO THE LANDSCAPE

A well-defined garden plan sets the scene for country-style planting in a bold colour palette at Pettifers.

As the garden sweeps down gracefully from the 17th-century farmhouse, it becomes gradually less formal until it eventually merges into the Oxfordshire countryside. This is a garden completely at ease in its setting, harnessing the distant views to glorious advantage.

The garden at Pettifers, the home of Mr and the Hon. Mrs James Price, has taken over 15 years to create – one is tempted to write 'to perfect' – and it is evolving still. It has a ground plan of moss-covered brick paths and dry stone walls, with clipped box hedges forming parterres and defining borders. There are clipped box globes of varying sizes, and both randomly spaced and rows of flat-topped yew pillars. Even these, so often marks of formality and conformity in a garden, do nothing to detract from the

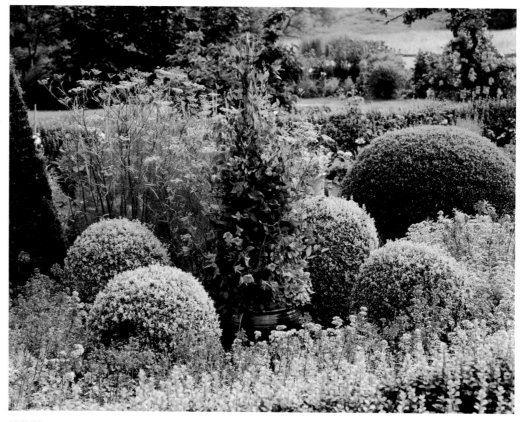

ABOVE **Romantic appeal in the cutting garden**

BELOW *Kniphofia rooperi*

WHAT'S THERE:	Country garden with long borders, topiary and parterres merging into glorious countryside; plant list; garden plan
WHERE:	Lower Wardington, Banbury, Oxfordshire OX17 1RU
GETTING THERE:	8km (5 miles) NE of Banbury, off A361, in centre of village, opposite church
WHEN TO VISIT:	By appointment. No dogs allowed
CONTACT DETAILS:	01295 750232

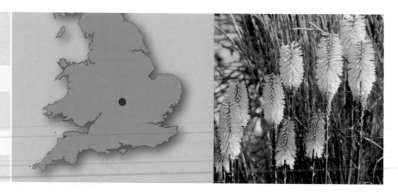

RIGHT **Where the garden ends**

wonderful impression of originality and
freedom at Pettifers.

FOREIGN INFLUENCES

It is the uninhibited use of colour and
unusual plant pairings that make this
garden so innovative. Gina Price attributes
her freedom with plant colour to her many
trips to India. It is interesting to note that
bold colour pairings can so successfully
cross continents. Her appreciation of the
use of colour crosses national borders,
too. The glorious carved stable doors with
their terracotta and blue criss-cross trellis
pattern, taken from the castle of Würzburg
in Bavaria, make fascinating backgrounds
to a variety of plant combinations. The
wrought-iron windows were inspired by
the decoration of flowers on the Taj Mahal.

COLOUR IMPACT

Below a terrace close to the house,
there are low retaining walls planted with
alpines. At a lower level, a large central
lawn separates two long flower borders
backed by hedges and trees. Low clipped
hedges outline parterres, which take on
different characteristics season by season.

Planting always in groups of at least
nine or eleven, Gina achieves the
maximum impact with each plant colour.
Even viewed from a distance, each plant
group can be clearly identified, never
merging into a faded palette.

Gradually, Gina has been replanting
some borders, replacing shrubs and
perennials that have a short flowering
season with grasses that change colour so
effectively through summer and autumn.

ABOVE **Ornamental grasses punctuate bold colours**

Most of the perennials are chosen for their good leaf shape or long flowering season.

In one border, bronze and maroon achillea and purple Michaelmas daisies are interplanted with an explosion of golden, red and green grasses, whose lively forms and varying hues will span the seasons. In a similar way, grasses enhance a patch of terracotta achillea, purple alliums, the violet-blue flowers of aconitum and lemon-yellow evening primroses.

The purple/yellow/orange theme is repeated in autumn in a border where the golden *Crocosmia* 'Walberton Yellow' and orange and yellow *Kniphofia rooperi* mingle with daisy-like heleniums and the pinkish-purple flowers of Joe Pye weed (*Eupatorium purpureum* 'Reisinschirm').

OUTDOOR STUDIO

In a summer planting, where the colour influence is unmistakably Indian, purple

RIGHT **Gina's favourite dahlia, 'Mum's Lipstick'**

alliums and asters and the violet-flowered *Rosa* 'Reine des Violettes' vie with scarlet poppies and the orange-red *Euphorbia* 'Fern Cottage'. A wooden bench painted in a toning shade of lilac is 'planted' among the flowers, perhaps in readiness for an artist to capture the painterly scene.

WAYS WITH WHITE

Where Gina Price has used white, it is to emphasize and complement rich or strong shades in other plants. In a parterre, white agapanthus contrast so strongly with deep maroon dahlias that, in bright sunlight, those blooms seem almost black. In a cool border planted with *Achillea* 'Coronation Gold', the golden grass *Miscanthus sinensis* 'Cabaret' and greeny-yellow euphorbia, the nearly-white regal lilies and towering spires of white delphinium seem to make their plant neighbours take on an even brighter shade of gold.

PLANNED INFORMALITY

Each of the parterres that defines parts of Pettifers' design is like a miniature garden within a garden. Edged by low clipped box hedges, each one contains permanent features in the shape of four tall, flat-topped cones and a cluster of stubby spheres. The implied formality of the enclosure is belied by the planting – in one, a confusion of apricot shrub roses and dahlias is edged by sky-blue agapanthus, their long, arching stems forming unruly wavy lines. Another parterre has cluster planting of apricot, maroon, pink and yellow dahlias, with blue glazed pots of peach-coloured single dahlias.

ABOVE **Inspirational: the Bavarian doors**

ROMANTIC APPEAL

Edged by a brick path and a low hedge, the cutting garden has the nostalgic appeal of an old-fashioned cottage garden. Sweet peas clamber up both sides of a wigwam row, purple clematis covers a lone cane wigwam, and brightly coloured poppies ramble and nod their heads among clipped box shapes that can do nothing to impose an air of formality.

A wide grass path cuts through an avenue of tall, flat-topped topiary cones that, arranged in this way, do momentarily look classical. Beyond that, there is a meadow spattered in spring with purple and white flowering bulbs, and through a gap in a ring of trees, there is the countryside, hedges, meadows and tree clusters that seem a natural extension of this glorious Oxfordshire garden.

THE GARDEN HOUSE

DRAMA AND PURE ROMANCE ARE INTERWOVEN IN A CHARMING FLORAL TAPESTRY

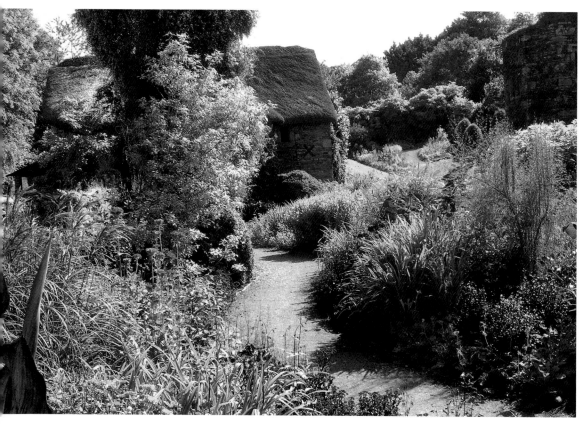

ABOVE 'Hot' borders in the walled garden

A passionate plantsman created this innovative yet delightfully naturalistic garden around a ruined vicarage on the edge of Dartmoor.

A walled garden surrounding the ruins of a 16th-century vicarage; a rugged stone 'sculpture-garden' of snaking paths and overgrown walls; a wild flower meadow that merges seamlessly into the moorland scenery beyond; a from-gold-to-russet acer glade; a 'magic' stone circle in a grassy knoll, and, everywhere, skilful and inspirational planting – it is tempting to say that this Devonshire garden has everything.

At its heart is the 2-acre walled garden created in 1947 by Lionel Fortescue, an Eton schoolmaster and avid plant collector, who lived at The Garden House with his wife Katharine from the 1940s until his death in 1981. The wow factor is not accidental. Enter the enclosed garden and it is as if the lights have been switched on in a room. Cascades of wisteria, colourful

WHAT'S THERE:	8 acres of romantic planting including 2-acre walled garden around 16th-century ruined vicarage, acer glade, 'magic circle' of standing stones; tea rooms; plant sales
WHERE:	Buckland Monachorum, Yelverton, Devon PL20 7LQ
GETTING THERE:	Between Crapstone and Buckland Monachorum, 2.4km (1½ miles) W of Yelverton, off A386
WHEN TO VISIT:	Open daily end Feb to early Nov; groups by prior arrangement
CONTACT DETAILS:	01822 854769; www.thegardenhouse.org.uk

RIGHT A watercolour palette of wild flowers

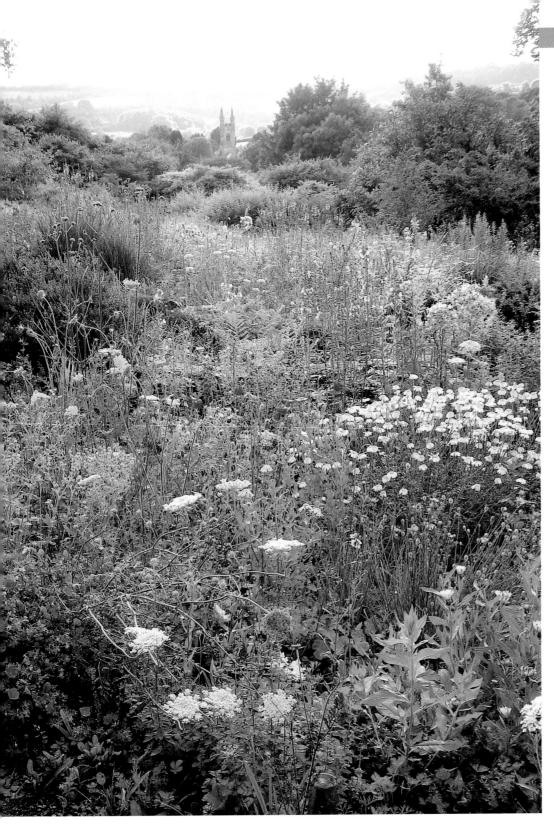

clusters of rare shrubs – mahonias, azaleas and rhododendrons – and species herbaceous plants are woven around the ruins of the imposing granite tower and thatched stone kitchen that were part of the vicarage.

The four terraces in the walled garden are linked by narrow flights of steps and ramps made with local stone, the natural materials – featured elsewhere in the garden in walls and follies – forming an important link with the countryside beyond. Fortescue's chosen successor at The Garden House, Keith Wiley, and the current head gardener, Matt Bishop, have maintained his practice of using only the best plants and arranging them in a naturalistic way.

COUNTRY CASUAL

This principle, now carried out by three successive gardeners, creates the impression that the walled garden has just happened. Cushions of purple asters and orange-peel heleniums, bronze achillea,

LIONEL FORTESCUE

The son of a painter, Lionel Fortescue was notoriously exacting not only in his choice of plants – nothing but the very best was good enough – but in their precise colour. It is said that he once tore up large clumps of Himalayan poppies (*Meconopsis betonicifolia*) – not the easiest plants in the world to grow – because they had turned out to be the wrong shade of blue.

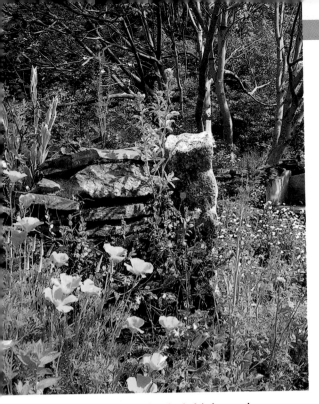

ABOVE **Poppies and eschscholzia harmonize**

citrus-yellow helianthus, and groups of flame-red canna are punctuated by billowy plumes of miscanthus. The planting is skilful and yet appears random.

In a similar way, the hollyhock-like flowers of sidalceas, feathery, frondy astilbes in red, pink and mauve, brilliant scarlet spires of penstemon, and clusters of more orange, blue and yellow flowers mingle and merge like colours on an artist's palette. Seeds scatter and are allowed to thrive as they would in the wild, and the impression is delightful. If the walled garden were the only area open to visitors – and thankfully it is not – it alone would be worth the journey.

RIGHT **The colourful Acer Glade**

SOUTH AFRICAN GARDEN

Beyond the walls, the garden adopts a number of different characteristics. The South African Garden, originally inspired by Keith Wiley's travels, was replanted in 2004 by Matt Bishop. The drama of the planting is enhanced by a range of shaped, slightly elevated beds representing an undulating landscape. Here, there are drifts of the daisy-like flower heads of arctotis in colours ranging from orange and yellow to purple and red, several prolific varieties of osteospermum – daisy shapes again – and, in pretty profusion, the golden-orange eschscholzia, all linked together with clusters of evergreen grasses from New Zealand. It is a brilliant kaleidoscope of sun-bright colours.

HILLSIDE SCULPTURE

A round, thatched summerhouse on a high bank is the focal point of one of Wiley's innovations, known as the Ovals. It is a 'sculpture-garden' in stone, with dry stone walls and narrow paths zigzagging down to an enveloping oval brick path.

NAMESAKE PLANT

One of the most beautiful mahonias, which is grown in many parts of the Royal Horticultural Society garden at Wisley, Surrey, was bred by Lionel Fortescue and bears his name. He crossed two different species – *Mahonia lomariifolia*, noted for its long, elegant leaves, and *M. japonica*, admired for its sweetly scented flowers – and kept five of the seedlings he raised. One is *Mahonia* x *media* 'Lionel Fortescue' and another bears the name 'Buckland' after the village close to The Garden House. Both cultivars have gained the RHS Award of Garden Merit.

These large, evergreen shrubs thrive and flower more prolifically in full sun but will tolerate shade. They can reach a height of 2.8m (9ft). Flowering in early winter, they have spikes (racemes) of fragrant, bright yellow lily-of-the-valley-like flowers. These clusters, which can be up to 40cm (16in) long, are followed by small blue-black berries.

ABOVE **Primary colours in the South African border**

The planting is special. Large clumps of glossy green-leaved hostas intermingle with light, bright green ferns, swathes of cream astilbes and a single clump of red salvias. This is the background to a casual spattering of yellow Welsh poppies. If an artist had flicked yellow paint randomly and generously onto a largely green canvas, it would have looked like that.

LEVELS OF COLOUR

On a north-facing slope, brought under cultivation only in 1993, the Acer Glade vibrates with colour at different levels throughout the year. In March, at ground level, it is bejewelled with thousands of crocus. In April and May, attention is focused at a higher level as Lionel Fortescue's spectacular azaleas and rhododendrons paint the glade pink, red and purple. And then, in October, the area is a breathtaking harmony of the red and russet, bronze and yellow foliage of Japanese maples with – as if that were not enough – misty views of the South Devon countryside, with Buckland Monachorum parish church at its heart. An avenue of limes linking the acer garden and the church is a reminder that this was, once, the vicarage garden.

CHANGING MOODS

Different moods have been created throughout the garden: in the nostalgic cottage garden, where foxgloves, poppies and eschscholzia harmonize; in the quarry garden, shimmering with alpines; around the front lawn area where, in winter, there are now snowdrop walks; and in a flowery, colour-splashed meadow that might just have sprung up unaided and untamed from the rocky Dartmoor soil.

MAGIC CIRCLE

The 'magic circle', a ring of fallen stones encircling a quartet of irregular-sized monoliths on a grassy knoll, might perhaps have pervaded this land with its mystical aura for centuries. One thing is certain: the whole of this inspirational and innovative garden has a supremely magical quality.

INNISFREE

DRAMATIC SURPRISES HIGHLIGHT THIS GARDEN THAT LOOKS SO COMPLETELY NATURAL

Despite being based on an ancient Chinese design, Innisfree, with its constructed streams and waterfalls, cup gardens and copses, manages to remain in complete sympathy with the surrounding North American landscape.

For 30 years, the garden at Innisfree was the private indulgence of Walter and Marion Beck, a mining heiress, and the workplace of 20 men. Walter, an artist, designed the then 950-acre landscape along oriental lines, seemingly inspired by an eighth-century scroll painting of the garden owned by the Chinese poet and painter Wang Wei.

Where Wang Wei had used the river as the floor of his garden, at Innisfree there was a 40-acre glacial lake and, similarly, cliffs and enclosing hills. On Walter's death in 1954, the garden came under the direction of landscape architect Lester Collins and, in 1960, was opened to the public. Like Wang Wei's garden, Innisfree

ABOVE **A bathouse on the lakeside**

WHAT'S THERE:	200-acre garden of lake, pools, cliffs and hills
WHERE:	Millbrook, New York 12545, USA
GETTING THERE:	Millbrook exit from Taconic State Parkway, E onto Route 44, then 12.8km (8 miles)
WHEN TO VISIT:	Usually daily from early May to late Oct
CONTACT DETAILS:	(001) 845 677 8000; www.innisfreegarden.org

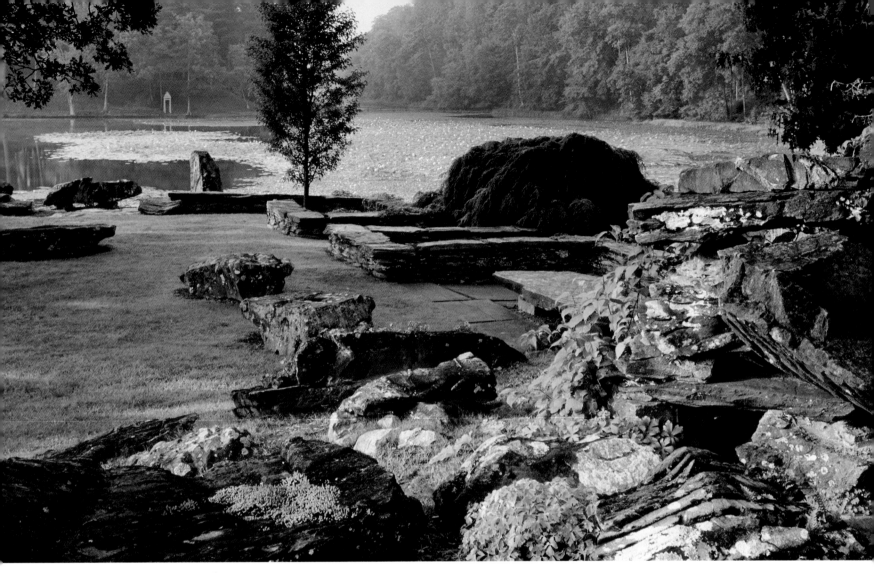

ABOVE **Craggy mounds create a cup garden**

has been designed with a series of enclosed cup gardens (see over), each shaped with rocks and plants, and sometimes dripping or cascading with water. Rocks of almost unimaginable size and weight were moved, some to create these linked features, others to stand as monoliths. Plants that naturally inhabit rocky terrain were encouraged and so, increasingly, mosses, lichens, sedum, columbine and Kenilworth ivies soften the craggy outlines.

WATERY EFFECTS

Grassy walks lead neatly to the water's edge. A bathouse and a group of sentry maple trees furnish the lakeside as amusing exclamation marks, and yellow iris and white lotus flowers create luminous reflections on the water. Wild purple loosestrife has long been a persistent weed in boggy areas of the garden, and bullfrogs, a particular *bête noire* of Marion Beck's, perform a persistent chorus.

Drama at a cliff edge is achieved by a water nozzle inserted into a rock that makes a plume of mist, which drifts this way and that in the breeze. And sometimes it makes rainbows! In other areas, water has been manipulated to drip, drizzle or cascade, depending on the required effect, and in a shady glade overhung by trees a tall jet of water spurts from a platform of stone slabs, creating magically colourful effects at sunrise and sunset.

GARDEN ART

Deer have roamed the garden for decades, nibbling trees at will – although most have now grown out of their reach – and several weeping Sargent hemlocks (*Tsuga* cultivated varieties) are ragged examples of the living sculptures they have created.

Man-made wooden structures are limited to a few sturdy, zigzag wooden bridges, a 42m- (46 yard-) long bridge across the lake, a bathouse beside it and two frequently visited birdhouses. Elsewhere, the garden is intended to look as Nature might have created it.

Grottoes and megaliths, islands and copses, streams and waterfalls – they all seem so perfectly natural, yet were conceived by Walter Beck, a painter-turned-garden designer, who had astonishing clarity of vision.

In the centre of a pool, Walter planted a white lotus tuber. Today, 100 flowers bloom in August.

WHAT IS A CUP GARDEN?

With its origins in Chinese garden art, as defined by Walter Beck and, later, Lester Collins, a cup garden can be a grotto built into the side of a hill, a striated rock rising out of the water and surrounded by pickerel weeds, a lotus pool, or a bank of day lilies surrounded on three sides by trees and almost dipping into the water. Most of the cup gardens at Innisfree are in or around the lake.

LEFT **Golden bamboo cascades downhill**

WHAT'S IN A NAME?

Walter Beck chose the name Innisfree for the garden from the poem *The Lake Isle of Innisfree* by W B Yeats:

> *'I will arise and go now, and go to Innisfree,*
> *And a small cabin build there, of clay*
> *and wattles made…'*

In fact, what the Becks built was an elegant mansion (now demolished) with timber arches, a slate roof and elaborate chimneys, closely resembling the RHS headquarters at Wisley, in Surrey, England.

CREATING THE LOOK YOURSELF

✳ Since the term cup garden can mean a number of things, there are many ways to create a water feature evoking the spirit of Innisfree Garden. A simple garden pool could have a large columnar stone embedded in its centre or to one side. This, in time, would become covered with algae or moss and attain the look of ages. A cluster of perennial sedge with leafless stems planted at the side of a pool would soon multiply and form a dense, lush-looking clump. A suitable plant that withstands brackish water is *Schoenoplectus lacustris* 'Zebrinus', whose stems are horizontally striped with white. Another interpretation would be to set one or two trollius plants in the moist soil beside a pool. Like giant brilliant yellow buttercups, these plants bloom in spring or summer, and you can divide them in early autumn.

RIGHT **The water jet can make rainbows!**

INDEX

ACKNOWLEDGEMENTS

The Automobile Association would like to thank the following photographers, gardens and picture libraries for their assistance in the preparation of this book.

Abbreviations for the picture credits are as follows: (t) top; (b) bottom; (c) centre; (l) left; (r) right; (b/g) background; (AA) AA World Travel Library.

4bl Harpur Garden Images; 5tr © NTPL/Ian Shaw; 8-9 Clive Nichols; 10t Harpur Garden Images; 10tc Courtesy of East Ruston Old Vicarage; 10bc Andrew Lawson/Mosaic by Maggy Howarth; 10b Vivian Russell; 11t © NTPL/Claire Takacs; 11tc Courtesy of Forde Abbey; 11bc Derek Harris/The Garden Collection; 11b Geoff Stephenson, Head Gardener, Attadale; 12b/g Will Giles; 12l Vivian Russell; 12c Charles Hawes; 12r Marianne Majerus; 12-13 Derek St Romaine; 14 Marianne Majerus; 15 GAP Photos/Mark Bolton; 16-17 Clive Nichols/Designer: Tony Heywood; 18-25 Derek St Romaine; 26-27 Vivian Russell; 28-29 Charles Hawes; 30-33 Will Giles; 34b/g Andrew Brogan; 34l Derek St Romaine; 34c Vivian Russell; 34r Clive Nichols; 34-35 Virginia Hayes courtesy of Lotusland; 36-37 AA/J A Tims; 38-39 Derek St Romaine; 40-43 Gil Hanly; 44-47 Harpur Garden Images; 48-49 Clive Nichols; 50t Marianne Majerus; 50b Andrew Brogan; 51 Marianne Majerus; 52t Clive Nichols; 52b AA/Pete Bennett; 53 Clive Nichols; 54-57 Vivian Russell; 58-61 Harpur Garden Images; 62t Virginia Hayes courtesy of Lotusland; 62b Jerry Pavia; 63-64 Jerry Pavia; 65 Virginia Hayes courtesy of Lotusland; 66-69 Mick Hales courtesy of Wave Hill; 70-73 Derek St Romaine; 74b/g Clive Nichols; 74r Clive Nichols; 74l Andrea Jones; 74c Harpur Garden Images; 74-75 Clive Nichols; 76-77 Derek St Romaine; 78 Nigel Queree/Sculptor: Kate Denton; 79 Andrea Jones/Garden Exposures Photo Library; 80-81 Nigel Queree; 82-85 Harpur Garden Images; 86-87 Nicola Stocken Tomkins; 88-91 Clive Nichols; 92b/g Louise Tanguay Garden; 92l Clive Nichols; 92c Courtesy of East Ruston Old Vicarage; 92r National Trust for Scotland/Brian Chapple; 92-93 © Portmeirion Ltd; 94t Courtesy of East Ruston Old Vicarage; 94b Marianne Majerus; 95-97 Courtesy of East Ruston Old Vicarage; 98-99 Jo Whitworth; 100-101 Rob Whitworth; 102t Andrea Jones/Garden Exposures Photo Library; 102b National Trust for Scotland/Brain Chapple; 103 National Trust for Scotland/David Robertson; 104l National Trust for Scotland/Brian Chapple; 104r National Trust for Scotland/Kathy Collins; 105 National Trust for Scotland/Brian Chapple; 106 Louise Tanguay; 107l Louise Tanguay; 107r La Boite Noire/Designers: Stéphane Bertrand, Jasmin Corbeil, Jean-Maxime Dufresne, International Garden Festival, Reford Gardens. Photographer: Michel Laverdière; 108t Brigitte and Philippe Perdereau; 108b Joelle Mayer and Gilles Le Scanff; 109-111 Brigitte and Philippe Perdereau; 112-113 Clive Nichols; 114 Andrea Jones/Garden Exposures Photo Library; 115 Clive Nichols; 116-119 Clive Nichols; 120-121 © Portmeirion Ltd; 122b/g The Huntington; 122l © NTPL/Ian Shaw; 122c Mervyn Rees/Alamy; 122r Rex Butcher/Garden Picture Library; 122-123 © NTPL/Ian Shaw; 124 © NTPL/Andrew Butler; 125 © NTPL/Ian Shaw; 126l © NTPL; 126r © NTPL/Andrew Butler; 127 © NTPL/Ian Shaw; 128t Japanese Travel Bureau/Photolibrary Group; 128b Harpur Garden Images; 129 © Angelo Hornak/Corbis; 130 AA/J Holmes; 131 Harpur Garden Images; 132-133 The Huntington; 134 Clive Nichols; 135 The Huntington; 136l © NTPL/Andy Tryner; 136r © NTPL/Stephen Robson; 137 © NTPL/Stephen Robson; 138-141 Erica Hunningher; 142-145 Marianne Majerus; 146l Norma Joseph/Alamy; 146r Don Tonge/Alamy; 147 Ed Westmacott/Alamy; 148l Mediacolours/Alamy; 148r Dennis Cox/Alamy; 148b Dennis Cox/Alamy; 149 Robert Fried/Alamy; 150-151 Harpur Garden Images; 152b/g Clive Nichols; 152l Clive Nichols; 152c AA/T Mackie; 152r David Dashiell courtesy of The Mount; 153 Vivian Russell; 154t Raymond Boswell/Alamy; 154b GAP Photos/S&O; 155-157 Clive Nichols; 158-159 Courtesy of Forde Abbey; 160 Courtesy of Heather Edwards; 161 Courtesy of Forde Abbey; 162-163 Vivian Russell; 164l Verner/Alamy; 164r AA/E A Bowness; 165 Derek Harris/The Garden Collection; 166 Marianne Majerus; 167 Derek Harris/The Garden Collection; 168 Marianne Majerus; 169 Clive Nichols; 170 Marianne Majerus; 171 Clive Nichols; 172 Kevin Sprague/Studio Two courtesy of The Mount; 173l David Dashiell courtesy of The Mount; 173r Kevin Sprague/Studio Two courtesy of The Mount; 174 Vivian Russell; 175 Adam Eastland/Alamy; 176l Vivian Russell; 176r Tibor Bognar/Alamy; 177 Charles Hawes; 178-181 Carole Drake; 182 GAP Photos/Jo Whitworth; 183 Marianne Majerus; 184 GAP Photos/Jo Whitworth; 185 Andrew Bargery/Alamy; 186 Rough Guides/Alamy; 187l Marianne Majerus; 187r GAP Photos/Jo Whitworth; 188b/g Harpur Garden Images; 188l © NTPL/Mark Bolton; 188c © NTPL/Claire Takacs; 188r Clive Nichols; 188-189 GAP Photos/John Glover; 190-193 Clive Nichols; 194l Harpur Garden Images; 194r Clive Nichols; 195 Harpur Garden Images; 196 Andrew Lawson; 197 Andrew Lawson/Mosaic by Maggy Howarth; 198-199 Andrew Lawson; 200-201 Carole Drake; 202l © NTPL/Derek Croucher; 202r © NTPL/Stephen Robson; 203 © NTPL/Stephen Robson; 204l © NTPL/David Sellman; 204r © NTPL/David Dixon; 205 © NTPL/Mark Bolton; 206t Marianne Majerus; 206b GAP Photos/John Glover; 207 GAP Photos/John Glover; 208 Marianne Majerus; 209 GAP Photos/John Glover; 210-213 GAP Photos/John Glover; 214-217 Derek St Romaine; 218-219 Charles Hawes; 220b/g Geoff Stephenson, Head Gardener, Attadale; 220c Geoff Stephenson, Head Gardener, Attadale; 220l Derek St Romaine; 220r Clive Nichols; 221-225 Geoff Stephenson, Head Gardener, Attadale; 224t Artist, Joe Smith; 226-229 Larry Albee courtesy of Chanticleer; 230 Adam Rodriguez; 231l Charlie Cobeen; 231r Adam Rodriguez; 232 Adam Rodriguez; 233t Adam Rodriguez; 233b John Van Decker/Alamy; 234t John Erbacher; 234b Daniel Carey; 235-237 Dot O'Neill; 238-241 Joelle Mayer and Gilles Le Scanff/Le Jardins Agapanthe 76 France; 242-245 Clive Nichols; 246l Matt Bishop; 246r Rachel Young; 247 Matt Bishop; 248 Yvonne Nicholson; 249 John Swithinbank; 250t Derek St Romaine; 250b Harpur Garden Images; 251 Harpur Garden Images; 252-253 Derek St Romaine.

Every effort has been made to trace the copyright holders, and we apologize in advance for any accidental errors. We would be happy to apply the corrections in the following edition of this publication.